STREAMING VIDEO

CRITICAL CULTURAL COMMUNICATION

General Editors: Jonathan Gray, Aswin Punathambekar,
 and Adrienne Shaw
Founding Editors: Sarah Banet-Weiser and Kent A. Ono

Dangerous Curves: Latina Bodies in the Media
Isabel Molina-Guzmán

The Net Effect: Romanticism, Capitalism, and the Internet
Thomas Streeter

*Our Biometric Future: Facial Recognition Technology and the Culture
 of Surveillance*
Kelly A. Gates

Critical Rhetorics of Race
Edited by Michael G. Lacy and Kent A. Ono

Circuits of Visibility: Gender and Transnational Media Cultures
Edited by Radha S. Hegde

Commodity Activism: Cultural Resistance in Neoliberal Times
Edited by Roopali Mukherjee and Sarah Banet-Weiser

Arabs and Muslims in the Media: Race and Representation after 9/11
Evelyn Alsultany

Visualizing Atrocity: Arendt, Evil, and the Optics of Thoughtlessness
Valerie Hartouni

The Makeover: Reality Television and Reflexive Audiences
Katherine Sender

Authentic™: The Politics of Ambivalence in a Brand Culture
Sarah Banet-Weiser

Technomobility in China: Young Migrant Women and Mobile Phones
Cara Wallis

Streaming Video

Storytelling Across Borders

Edited by Amanda D. Lotz and Ramon Lobato

NEW YORK UNIVERSITY PRESS

New York

NEW YORK UNIVERSITY PRESS
New York
www.nyupress.org

References to internet websites (URLs) were accurate at the time of writing. Neither the author nor New York University Press is responsible for URLs that may have expired or changed since the manuscript was prepared.

Cataloging-in-Publication data is available from the publisher.

New York University Press books are printed on acid-free paper, and their binding materials are chosen for strength and durability. We strive to use environmentally responsible suppliers and materials to the greatest extent possible in publishing our books.

Please contact the Library of Congress for Cataloging-in-Publication data.

ISBN: 9781479816835 (hardback)
ISBN: 9781479816842 (paperback)
ISBN: 9781479816866 (library ebook)
ISBN: 9781479816880 (consumer ebook)

Manufactured in the United States of America

10 9 8 7 6 5 4 3 2 1

Also available as an ebook

With gratitude to Stuart Cunningham

for his foundation-building work.

CONTENTS

Introduction

Streaming Stories

AMANDA D. LOTZ AND RAMON LOBATO

For as long as most can remember, the majority of stories aired on television sets around the globe typically got there because television channels decided to fund their creation. Often, channels sought the creation of those stories because they believed they would attract many viewers. Maybe those viewers would be sold to advertisers, or maybe they would enjoy the benefit of the stories as a result of a channel's public-service remit. In either case, the imagined audience was defined by the channel's transmission zone, and the channel deliberately scheduled the story to be shown at a certain time. Stories would be created specifically for that channel, but many would also go on to be licensed to other channels in other places as well.

Of the many changes to audiovisual cultures at the turn of the twenty-first century, the emergence of new funders for television stories is of considerable importance. Over the last decade, subscription video-on-demand (SVOD) services—including Netflix, Prime Video, Disney+, and various other national as well as regional SVODs—have become major commissioners, financing hundreds of their own original series and movies and dramatically scaling-up the storytelling output of our global screen industries. These new players in many ways appear quite like the channels audiences had long relied on to fund stories but are also profoundly different. Subscription rather than advertising is their primary business model (at least

as of 2023), and they do not commission content for purposes of public service.*

The largest SVODs—those available in nearly every country, such as Netflix and Prime Video—no longer need to conceptualize audiences in exclusively national terms but instead can aggregate viewers from multiple countries. And SVODs commission their shows to become part of a library of offerings rather than arranging them into a schedule.[1]

Of course, not all SVODs commission their own stories, and commissioned content generally accounts for only a fraction of titles in most SVOD libraries. Nonetheless, their emergence as new arbiters of twenty-first century commercial video storytelling has provoked wide-ranging debate about their disruptive impact on producers, production practices, and the role of video storytelling in culture. Developments in recent years such as the launch of Disney+, HBO Max, and Paramount+ have made clear that a massive reorganization in distribution norms has arrived and that major media conglomerates are now prioritizing creating stories foremost for streaming services. Dozens of national and regional services—including Viu, Viaplay, Sky, Jawwy, Viki, Movistar Plus+, Shahid, Zee5, and Stan—have also begun producing their own stories, in many different languages.

The purpose of this book is to investigate the stories that SVODs are commissioning around the world. Focusing on the first decade of global streaming, up until 2022, our inquiry is guided by several research questions: To what extent, and how, are SVODs expanding norms of television and film storytelling? Are SVODs enabling the creation of content that would not otherwise exist? What are the implications for different viewers, in different countries, with different tastes? We focus on SVOD-commissioned titles, as opposed to acquired or licensed titles, because funding the creation of content generally entails a greater degree of creative input and thus allows a clearer assessment of the impact of SVODs on storytelling practices.

* The chapters here were written between 2020 and 2021, before advertising was added to Netflix and Disney+. The arguments here about SVODs assume pure subscriber funding. It is likely different strategies will guide these services if advertising becomes a significant part of their revenue strategy.

Of course, the scale of production makes general diagnoses difficult. Almost 1,500 SVOD originals were released between 2010 and 2020, and more than 1,000 per year have appeared since then (Ampere Analysis 2021). Rather than sweeping assertions, each chapter instead offers analysis grounded in a specific place or a particular type of programming. Many chapters locate their case studies in a single nation, exploring how SVOD commissions, such as Netflix's *Las chicas del cable/Cable Girls* (Spain) or BluTV's *Doğu* (Turkey), intervene in the historical trajectory of storytelling norms in their home countries. Others focus on specific genres, like crime and romantic comedy, to identify cross-national trends in commissioning that reveal how SVODs are shaping the textual evolution of those genres.

Given the book's focus on international production, we have deliberately sought accounts from locations less frequently covered in the literature—including India, Nigeria, Turkey, Mexico, Brazil, China, South Africa, and South Korea—as well as from the major centers of audiovisual production. The range of services considered is likewise diverse, encompassing Netflix, Prime Video, BluTV (Turkey), Stan (Australia), iROKOtv (Nigeria), Tencent Video (China), and Showmax (South Africa). Of course, as the largest global SVOD commissioner, Netflix is strongly represented here. In both subscriber numbers and production scale, Netflix is in a class of its own, at least for now. Yet it is important not to assume that all services must be like Netflix or that the only path to success is a broad library and multinational reach. Many of the services we suspect might be most interesting a decade from now will find ways to complement Netflix's strategy, perhaps with more localized programming.

What makes these streaming services so interesting to us is the question of how their different affordances, deriving from their distribution technology and business model, enable them to differentiate themselves from existing linear services and the industrial priorities we have come to expect. This interplay of difference and similarity across, and between, SVODs and linear services is a recurring concern, and a shared fascination, for all our contributors.

Another concern of the book is to explore instances of local-global exchange in SVOD production. Breakthrough Netflix originals like *Squid Game* (South Korea), *La casa de papel/Money Heist* (Spain), and *Lupin* (France) have demonstrated the potential of non-English-language originals to become global pop-culture hits, challenging decades of received wisdom about what Hoskins and Mirrus (1988) term "cultural discount," or the idea that content has less value to viewers unfamiliar with the culture represented on-screen. These exceptional cases of cosmopolitan consumption remind us of the power of multi-territory SVODs to distribute content globally and to aggregate audiences from around the world. Meanwhile, a different approach to commissioning is being adopted by some national and regional services that produce content closely attuned to the tastes of particular markets. The Dubai-based Arabic-language SVOD Shahid VIP is known for its edgy crime, horror, and drama shows, for example, while Chinese services including Tencent Video and iQiyi have become major commissioners of historical drama, romance, comedy, animation, and lifestyle series. While the pool of potential case studies is vast, we have focused on those SVOD originals—chosen by experts familiar with specific national contexts—that represent distinctive interventions into national storytelling traditions, or that reflect how SVODs are enlarging, reconfiguring, or simply extending such traditions. The accounts here begin the work of assessing the extent to which SVOD original production is opening up new kinds of creative possibilities for creators around the world, what modes of storytelling the affordances of SVOD allow, how creators in different countries have responded to these opportunities, and what textual forms have resulted. Given the breadth of service types, national contexts, and continued rapid and profound adjustments of these services, many more investigations of such questions are still needed.

Locating SVOD Scholarship

The essays collected here contribute to what is now a substantial and growing literature on SVOD services. Within this literature, the specific

"location" of this book is the intersection of critical industry and textual studies: contributors are interested in the business, aesthetics, and politics of screen storytelling, and seek to integrate these different perspectives in their analyses. Our work also forms part of a larger conversation about the impact of SVODs on audiovisual markets and storytelling traditions around the world. It is helpful, then, to consider how scholarly discussions of SVOD have evolved over time. What issues have been debated, then and now? Where does this book fit into the landscape of positions, ideas, methods, and critiques?

Early contributions to the literature often considered the disruptive impact and novel experience of SVOD services or sought to make sense of emerging viewer practices. Monographs by Alvarez-Monzoncillo (2011), Cunningham and Silver (2013), Evens and Donders (2018), Johnson (2019), and Lotz (2014, 2017, 2022) documented the initial disruption streaming services introduced, charting a historical evolution from industrial experiments to a mainstream mode of distribution. Book-length studies of Netflix by Jenner (2018), Lobato (2019), and Straubhaar et al. (2021) investigated the world's most widely used SVOD service and considered issues such as catalog strategy, internationalization, and user experience. Numerous edited collections and special issues have appeared on topics such as binge-viewing, algorithmic recommendation, and the circulation of specific genres and national cinemas in SVOD catalogs.[2]

Within this expanding literature, two topics—internationalization and production practices—are of particular relevance to the chapters here. On the internationalization side, there is now a growing number of studies that locate the analysis of SVOD services and their content within particular geographic "zones of consumption" (Pertierra and Turner 2012), approaching SVOD through a national or regional lens rather than as a deterritorialized phenomenon. This includes studies on the impact of specific SVODs, most often Netflix, in countries and regions.[3] Other work has explored the emergence of national and regional SVOD services, including those offered by legacy broadcast, cable, and

satellite operators or telcos—such as Blim in Mexico and Streamz in Belgium.[4] Scholars have used comparative approaches to understand the impacts of SVODs across multiple territories (Rios and Scarlata 2018; Lobato 2019; Straubhaar et al. 2021; Szczepanik et al. 2020; Wayne and Castro 2021). A related literature considers how national public-service broadcasters interact with national and global SVOD services (D'Arma et al. 2021; Sundet 2021).

Rejecting the idea of SVOD as a universalizing force delivered from afar, these studies emphasize how services engage local tastes and preferences, as reflected in programming, pricing, and marketing. Together, the work gives texture to an undifferentiated language of disruption and shows instead how SVODs *emerge from* or become *integrated into* national mediascapes. It also begins to consider how SVOD production can be effectively localized by means of national regulation (e.g., via production obligations, as in some European Union member states), state-funded production incentives, or commercial partnerships with national operators (Iordache, Raats, and Donders 2022).

More recently, a body of work on SVOD production and content has also appeared. Some of this work focuses on specific shows, such as Netflix's *Sense 8* (Shaw and Stone 2021). Other work observes trends across a corpus of originals (Hidalgo-Mari et al. 2020; Afilipoaie, Iordache, and Raats 2021), or focuses on a particular genre, format, or production model (notably Barra and Scaglioni [2021], which considers how SVODs interact with European pay-TV services and other commissioners within a "premium production" model). Such work helps to explain what many observers consider to be a shared aesthetic tendency—"a common feel to the narratives, characters and genres adopted" (Barra and Scaglioni 2021, 3). There is also an emerging body of work that uses interviews with producers and screenwriters to explore production norms for nonlinear services (Potter 2020; Haddad and Dhoest 2021; Lin 2022). A key consideration for authors working in this production studies tradition is to explain how "creative autonomy and professional norms have been affected by the transformations engendered by internet distribution" (Potter 2020).

These over-arching themes—the aesthetic tendencies of SVOD productions, their industrial context, and their interactions with local, national, and regional storytelling traditions—animate the work presented here. Contributors to this book use various methods and approaches to drill down into these themes. Some chapters focus on specific SVOD commissions, exploring the complex relations between a text and its social and industrial context (Castro and Cascajosa; Chambwera; Llamas-Rodríguez; Rocha and Arantas; Wayne). Others explore common tendencies across a genre or format, such as crime, comedy, biopics, and teen drama (Barra; Ildir; Kang; Lin; Meir; Potter; Scarlata; Serpe; Simon). Methods also vary across the chapters. Some use production studies methods and draw on original interviews with creative personnel (Barra; Castro and Cascajosa; Tiwary), and others foreground the processes of negotiation occurring between foreign services and offerings for "global" audiences with restrictive national content regimes—between SVODs and restrictive national content regimes (Ildir; Samy; Tiwary). Such cases make clear the continued relevance and distinction of "the state" despite technological affordances and discourses that downplay national structures. Together, the chapters reflect the growing diversity of approaches that scholars are bringing to SVOD research, as well as the diverse critical questions under debate.

Features of This Collection

Given this concern with industrial context, *Streaming Video: Storytelling Across Borders* is not a book about masterpiece SVOD originals or those reported to have attracted the most viewers. Our aim is not to celebrate award-winning shows, nor is it to proclaim a new golden age of quality television. Instead, contributors explore how production cultures in different countries are being affected by SVODs and their storytelling priorities. This entails a focus, in several chapters, on "routine" SVOD production (Pearson 2019)—shows that are not dissected by critics but that nonetheless make important contributions to the cultural role

of screen storytelling. Examples include children's shows, talk shows, and romcom movies. We hope that this focus on the routine aspects of SVOD storytelling can complement the focus in existing scholarship on "prestige" dramas—titles that are no longer characteristic of SVOD production as a whole.

Our contributors are also concerned with understanding SVOD production within the context of national cultural practice. What happens when SVOD services of different scales, occupying diverse locations and market niches, become producers of original content? How do services draw on, adapt, and challenge national storytelling traditions? What textual forms, genres, and formats emerge? Whose stories are told, and how different are these from what has gone before? The chapters in this book offer a range of answers to these questions, and there is no clear consensus on an SVOD "effect," unsurprising given the marked differences in services' reach, libraries, and ownership. Some contributors identify a significant expansion in the range of stories and storytelling styles. They describe novel changes to established formats, genres, and durations; a new commitment to representing social complexity; an attention to socially marginalized perspectives; and a willingness to challenge patriarchal and conservative values. Other contributors observe a "more of the same" dynamic in which SVOD storytelling aligns with rather than challenges established norms. They argue that SVOD stories repeat problematic tendencies of the national screen canon, such as the silencing of marginal voices and classes.

Collectively, the chapters also suggest lines of analysis that warrant further investigation. Several chapters reveal how SVOD-commissioned dramas have challenged established norms of long-running domestic series, including by diversifying the roles available to women. They explore how SVODs have introduced limited series that emphasize character development and careful plotting—made possible by plotting the full story before beginning production. Of course, such series do not *replace* existing norms, but they do *expand* the range of narrative options; notably, the imposition of new regulatory regimes does not hinder this

formal diversity even if it extends regulation of themes and topics to the streaming realm. Several chapters also raise important questions about how and to what extent series are "of" the places they are produced and address the inherent tensions in producing in multiple territories while prioritizing widely accessible storytelling. Together, the chapters provide many reminders of how "norms" in one place are unusual in others.

Early chapters set the stage for the analyses in the contributions that follow. In chapter 1, Lotz establishes the motivation for the investigations collected here by explaining the industrial adjustments that have led to subscriber-funded streaming services' characteristics that are distinct from linear distribution and other revenue models. She also identifies how stories made for multi-territory services adjust the conditions and priorities of audience-making for the imagined audiences of streamers' commissions. Lobato, Scarlata, and Cunningham then map the terrain of subscriber-funded streamers to recognize the significant variation within the category, which challenges the ability to make consistent claims of streamers. Distinguishing between national and global SVODs that differ markedly in their programming strategies, the chapter uses a case study of titles produced in Australia for Prime Video and Stan to explore the varieties of localism and globalism that characterize each service.

Contributors were given a wide remit. Based on their expertise, some were asked to reflect specifically on the national contexts with which they were most familiar, while others set out to deliberately consider certain program forms such as children's programs or movies. The aim was to aggregate chapters that each brought a view from somewhere— not to accumulate the "whole" story, but to have an array of contexts to compare. Nearly all the chapters speak in some way to how streamers have intervened in the conditions of video storytelling in a particular place, as well as in relation to format or genre. The variation tends to derive from the chapter's primary focus—on the context or the program form—and be based on whether the authors survey the form broadly or derive evidence from a single case. The result is fifteen chapters that

both cohere and vary, organized around a mixture of thematic and scalar connections.

Wayne's chapter extends the examination of Lobato, Scarlata, and Cunningham in chapter 2 to consider the varied strategies used in Netflix police dramas that provide cultural specificity while also constructing narratives likely attractive to a multi-territory audience. Wayne contrasts two European-commissioned police dramas, *Young Wallander* and *Dogs of Berlin*, to explore how cultural specificity is a matter of strategy and execution at the title level rather than predicted by genre, country of production, or the scope of reach of the service. Chapters by Tiwary, Ildir, and Serpe provide rich accounts of the prestreaming particularities of India, Turkey, and Argentina, tying those contexts to the streaming commissions that emerge. Tiwary's chapter explores three drama series commissioned in India by Prime Video, Voot, and SonyLIV: *Paatal Lok*, *Asur*, and *Scam*. Drawing on her interviews with scriptwriters, Tiwary charts recent transformations to scriptwriting norms in India—including a new realist aesthetic—and addresses the implications of a changing VOD content regulation system that reflects ongoing government attempts to manage what is seen in India. Ildir investigates two comedies produced for the Turkish streamer BluTV, and how they deviate from linear television norms to include taboo humor and openly play with that differentiation in their texts. She explores how both the niche audiences of subscriber funding and different—though shifting—content regulations account for their approach. Serpe explores commissions by Netflix and Prime Video in Argentina, including biopics such as Prime Video's *Maradona: Blessed Dream* and high-profile dramas such as Netflix's *Estocolmo*. He concludes that the new services largely build on existing storytelling practices. In his exploration of these Argentine titles, Serpe ties these series to Argentina's complicated recent history of shifting public funds supporting production.

The subsequent chapters about Netflix commissions in Brazil, Spain, and Jordan identify a common theme in early SVOD originals from these countries: they explore uncommon stories about women, their

lives, and friendships. Rocha and Arantes examine *Coisa mais linda/ Girls from Ipanema* to identify how the series, set in the 1950s Bossa Nova culture of Rio de Janeiro, defies Brazilian telenovela norms by using an uncommon narrative structure, featuring multiple (female) protagonists, and foregrounding a feminist politic. The account Castro and Cascajosa offer of *Las chicas del cable/Cable Girls* in Spain provides many parallels in its emphasis on the relationships among the female protagonists, their empowerment—particularly through involvement with the Spanish Civil War—and the inclusion of a transgender character. Here the authors contrast *Cable Girls* with the historical dramas its producer, Bambú Producciones, produced for a Spanish linear channel. Samy's chapter exploring the Jordanian production *AlRawabi School for Girls* also identifies the series' contrast with the dominant drama form in the market—Egyptian soap operas—and its uncommon story about teens, and female teens specifically. The creative talent behind the series is also female, another feature uncommon in the region.

Other chapters make the production conditions of specific program forms in specific contexts particularly central. In her chapter, Kang explores how the different priorities of Netflix as a streamer have enabled alternatives to Korean drama norms. Kang explores how dramas developed by Netflix, which have been termed "genre dramas," feature greater narrative complexity and downplay romantic relationships in contrast to K-drama conventions. Likewise, Lin addresses the specific context of China and interventions in talk show norms ushered in by Tencent. The chapter addresses how Tencent talk shows contrast with those of state broadcasters to emphasize personal voices, stories, and criticism.

Chapters by Chambwera and Llamas-Rodríguez address how streamers' commissions intervene in different nations' construction and portrayal of racial and ethnic identity, albeit to different ends. Chambwera contrasts the perpetuation of South Africa's post-apartheid aspirations as a "rainbow nation" in commissions by Showmax (*Tali's Wedding Diary, The Girl from St Agnes*) and Netflix (*Queen Sono, Blood and Water*). Similar to Lobato et al.'s unexpected findings when comparing commissions of

a national and multi-territory service in Australia, Chambwera identifies much more South African specificity and acknowledgement of the country's racial politics in the Netflix commissions than in those developed for Showmax. In examining Mexican Netflix commissions including *Luis Miguel: La Serie* and *Ingobernable*, however, Llamas-Rodríguez finds little difference in its approach and instead argues that it tends to acknowledge cultural difference (indigenismo) while prioritizing White culture in Mexico. Where U.S.-based streamers might defy norms of Mexican media hegemons, the evidence suggests they have done this only in a limited fashion.

Chapters by Barra and Potter begin the shift into exploring particular formats and genres of storytelling. Potter's account focuses on Netflix and Disney+ originals to explore distinctions in storytelling emerging on streaming services targeted at tween viewers. She particularly highlights "clean teen" dramas and shows how the industrial conditions of streamers—their ability to aggregate audiences of a narrow age-range across many nations and to offer content on demand—support the emergence of a dedicated narrative address to tweens, as opposed to teens seeking more mature themes. Barra's chapter then contrasts two teen dramas commissioned by Netflix in Italy, *Baby* and *Summertime*, to explore how these quite different series manage national specificity within the context of a globally legible popular genre. Based on Barra's interviews with screenwriters, the chapter reveals the delicate negotiations that took place between producers, writers, and Netflix in order to prepare these shows for a global SVOD audience.

Commissioned movies are the focus of chapters by Meir, Scarlata, and Simon. Meir considers the phenomenon of SVOD commissioning and its implications for the boundaries of commercial film. His account addresses ramifications for Hollywood filmmaking and draws examples from Netflix, Prime Video, and AppleTV+ commissioning in Europe to identify two contrasting interventions: financing of "monumental auteur" filmmaking by directors such as Martin Scorsese and Paolo Sorrentino, and support for early-career directors, including those

historically underrepresented in studio filmmaking. Meir explores the industrial strategies behind each approach to filmmaking, and how each SVOD service seeks to balance them. Scarlata investigates the Hollywood romantic comedy (romcom), a once-reliable performer for the studios that waned as a cinematic priority in recent decades and has since been resuscitated and renovated by Netflix in particular. Foregrounding Netflix's ability to revive and reinvigorate popular genres, Scarlata's account also connects with Potter's identification of greater ethnic diversity—particularly among protagonist characters—and the heightened feminist politics identified in chapters by Rocha and Arantes and Castro and Cascajosa. Finally, Simon's chapter examines the "family film," a national genre that has emerged from Nigeria's booming Nollywood video industry. Simon shows how original movies commissioned by Nigeria's leading streaming service, iROKOtv, feature an uncommon and progressive depiction of women, and how these films appeal to diasporic Nollywood fans living outside Nigeria. In this way, Simon explores how the industrial conditions that are part of Nollywood's expansion into streaming are also reconfiguring the characteristics of the films produced in Nigeria.

Together, these chapters provide diverse and intriguing perspectives on a global production system centered around subscriber-funded video. The questions they address and the issues they raise are complicated, and likely to require multiple sources of evidence and a more mature phase of technological adoption to fully appreciate. So there is much more work ahead for screen and media industry scholars. In this respect, we hope that *Streaming Video: Storytelling Across Borders* provides a useful foundation upon which to build, and a set of ideas and cases to guide future research in this area.

Notes

1 The history of movie financing is more multifaceted as a greater range of funding supported those produced industrially or "independently," although SVODs have emerged as significant funders of movie storytelling as well.

2 Key edited collections include *Digital Disruption* (Iordanova and Cunningham 2012), *Connected Viewing* (Holt, Steirer, and Petruska 2016), *The Netflix Effect* (McDonald and Smith-Rowsey 2016), *Age of Netflix* (Barker and Wiatrowski 2017), and *Netflix at the Nexus* (Buck and Plothe 2019). Special issues on SVOD and streaming culture have appeared in journals including *Media, Culture & Society, Media Industries, MedieKultur, International Journal of Communication, Convergence,* and *Critical Studies in Television*.

3 Examples include studies of Netflix in Spain (Albornoz and García Leiva 2022; Ibarra and Navarro 2022), Australia (Turner 2018; Cunningham and Scarlata 2020), Brazil (Meimaridis, Mazur, and Rios 2020), Turkey (Ildir and Rappas 2021), the UK (Ward 2016), Canada (Wagman 2017), Mexico (Cornelio-Mari 2020), and Germany (Stiegler 2016), and work by the Global Internet TV Consortium (www .global-internet-tv.com). Other scholars have taken a regional view, exploring impacts of SVOD in Latin America (Straubhaar et al. 2021) and the Arab world (Khalil and Zayani 2021).

4 See, for example, work by Llamas-Rodríguez (2016), Ebelebe (2017), Dovey (2018), Rios and Scarlata (2018), Meimaridis, Mazur, and Rios (2020), and Raats and Evens (2021).

References

Afilipoaie, Adelaida, Catalina Iordache, and Tim Raats. 2021. "The 'Netflix Original' and What it Means for the Production of European Television Content." *Critical Studies in Television* 16 (3): 304–25.

Albornoz, Luis A., and Ma Trinidad García Leiva. 2022. "Netflix Originals in Spain: Challenging Diversity." *European Journal of Communication* 37 (1): 63–81.

Alvarez-Monzoncillo, Jose M. 2011. *Watching the Internet: The Future of TV?* Porto, Portugal: Formalpress.

Ampere Analysis. 2021. Analytics—SVOD Database. https://www.ampereanalysis.com.

Barker, Cory, and Myc Wiatrowski. 2017. *The Age of Netflix: Critical Essays on Streaming Media, Digital Delivery and Instant Access.* Jefferson, NC: McFarland & Company.

Barra, Luca, and Massimo Scaglioni, eds. 2021. *A European Television Fiction Renaissance: Premium Production Models and Transnational Circulation.* London: Routledge.

Buck, Amber M., and Theo Plothe. 2019. *Netflix at the Nexus: Content, Practice, and Production in the Age of Streaming Television.* New York: Peter Lang.

Cornelio-Mari, Elia M. 2020. "Mexican Melodrama in the Age of Netflix: Algorithms for Cultural Proximity." *Comunicación y Sociedad,* e7481. https://doi.org/10.32870 /cys.v2020.7481.

Cunningham, Stuart, and Alexa Scarlata. 2020. "New Forms of Internationalisation? The Impact of Netflix in Australia." *Media International Australia* 177:149–64.

Cunningham, Stuart, and Jon Silver. 2013. *Screen Distribution and the New King Kongs of the Online World*. London: Palgrave Macmillan.

D'Arma, Alessandro, Tim Raats, and Jeanette Steemers. 2021. "Public Service Media in the Age of SVoDs: A Comparative Study of PSM Strategic Responses in Flanders, Italy and the UK." *Media, Culture & Society* 43 (4): 682–700.

Dovey, Lindiwe. 2018. "Entertaining Africans: Creative Innovation in the (Internet) Television Space." *Media Industries* 5 (2): 93–110.

Ebelebe, Ugo Ben. 2017. "Reinventing Nollywood: The Impact of Online Funding and Distribution on Nigerian Cinema." *Convergence* 25 (3): 466–78.

Evens, Tom, and Karen Donders. 2018. *Platform Power and Policy in Transforming Television Markets*. Cham: Springer International Publishing.

Haddad, Fadi G., and Alexander Dhoest. 2021. "Netflix Speaks Arabic, Arabs Speak Netflix: How SVOD is Transforming Arabic Series Screenwriting." *Journal of Arab & Muslim Media Research* 14 (2): 261–80.

Hidalgo-Mari, Tatiana, Jesús Segarra-Saavedra, and Patricia Palomares-Sanchez. 2020. "In-Depth Study of Netflix's Original Content of Fictional Series: Forms, Styles and Trends in the New Streaming Scene." *Communication and Society* 34 (3): 1–13.

Holt, Jennifer, Gregory Steirer, and Karen Petruska. 2016. "Introduction: The Expanding Landscape of Connected Viewing." *Convergence* 22 (4): 341–47.

Hoskins and Mirrus. 1988. "Reasons for the US Domination of the International Trade in Television Programmes." *Media, Culture & Society* 10 (4): 199–515.

Ibarra, Karen Arriaza, and Celina Navarro. 2022. "The Success of Spanish Series on Traditional Television and SVoD Platforms: From *El Ministerio del Tiempo* to *La Casa de Papel*." *International Journal of Communication* 16:482–503.

Ildir, Asli, and Ipek A. Celik Rappas. 2022. "Netflix in Turkey: Localization and Audience Expectations from Video on Demand." *Convergence* 28 (1): 255–71.

Iordache, Catalina, Tim Raats, and Karen Donders. 2022. "The 'Netflix Tax': An Analysis of Investment Obligations for On-Demand Audiovisual Services in the European Union." *International Journal of Communication* 16:545–65.

Iordanova, Dina, and Stuart Cunningham, eds. 2012. *Digital Disruption: Cinema Moves On-line*. St Andrews: St Andrews Film Studies Publishing House.

Jenner, Mareike. 2018. *Netflix and the Re-Invention of Television*. Cham: Springer International Publishing.

Johnson, Catherine. 2019. *Online TV*. London: Routledge.

Khalil, Joe F., and Mohamed Zayani. 2021. "De-Territorialized Digital Capitalism and the Predicament of the Nation-State: Netflix in Arabia." *Media, Culture & Society* 43 (2): 201–18.

Lin, Lisa. 2022. *Convergent Chinese Television Industries*. Basingstoke: Palgrave.

Llamas-Rodríguez, Juan. 2016. "'Blim and Chill': Telenovelas and Class Ideologies in the Online Streaming Wars." *Flow*, November 28, 2016. https://www.flowjournal.org /2016/11/blim-and-chill-telenovelas-and-class-ideologies-in-the-online-streaming -wars-juan-llamas-rodriguez-university-of-california-santa-barbara/.

Lobato, Ramon. 2019. *Netflix Nations: The Geography of Digital Distribution*. New York: NYU Press.

Lotz, Amanda D. 2014. *The Television Will Be Revolutionized*, 2nd ed. New York: NYU Press.

Lotz, Amanda D. 2017. *Portals*. Ann Arbor: University of Michigan Press.

Lotz, Amanda D. 2022. *Netflix and Streaming Video: The Business of Subscriber-Funded Video on Demand*. Cambridge: Polity.

McDonald, Kevin, and Daniel Smith-Rowsey, eds. 2016. *The Netflix Effect: Technology and Entertainment in the 21st Century*. New York: Bloomsbury.

Meimaridis, Melina, Daniela Mazur, and Daniel Rios. 2020. "The Streaming Wars in the Global Periphery: A Glimpse from Brazil." *Series* 6 (1): 65–76.

Pearson, Roberta. 2019. "*Sherlock* and *Elementary*: The Cultural and Temporal Value of High-End and Routine Transatlantic Television Drama." In *Transatlantic Television Drama: Industries, Programs, and Fans*, edited by Matt Hills, Michele Hilmes, and Roberta E. Pearson, 110–29. Oxford: Oxford University Press.

Pertierra, Anna Cristina, and Graeme Turner. 2012. *Locating Television: Zones of Consumption*. London: Routledge.

Potter, Anna. 2020. *Producing Children's Television in the on Demand Age*. Bristol: Intellect.

Raats, Tim, and Tom Evens. 2021. "'If You Can't Beat Them, Be Them': A Critical Analysis of the Local Streaming Platform and Netflix Alternative Streamz." *MedieKultur* 70:50–65.

Rios, Sofia, and Alexa Scarlata. 2018. "Locating SVOD in Australia and Mexico: Stan and Blim Contend with Netflix." *Critical Studies in Television* 13 (4): 475–90.

Shaw, Deborah, and Rob Stone. 2021. *Sense 8: Transcending Television*. London: Bloomsbury.

Stiegler, Christian. 2016. "Invading Europe: Netflix's Expansion to the European Market and the Example of Germany." In *The Netflix Effect: Technology and Entertainment in the 21st Century*, edited by Kevin McDonald and Daniel Smith-Rowsey, 235–46. New York: Bloomsbury.

Straubhaar, Joseph, Melissa Santillana, Vanessa de Macedo Higgins Joyce, and Luiz Guilherme Duarte. 2021. *From Telenovelas to Netflix: Transnational, Transverse Television in Latin America*. Cham: Palgrave Macmillan.

Sundet, Vilde Schanke. 2021. *Television Drama in the Age of Streaming: Transnational Strategies and Digital Production Cultures at the NRK*. Cham: Palgrave Macmillan.

Szczepanik, Petr, Pavel Zahradka, Jakub Macek, and Paul Stepan, eds. 2020. *Digital Peripheries: The Online Circulation of Audiovisual Content from the Small Market Perspective*. Cham: Springer.

Turner, Graeme. 2018. "Netflix and the Reconfiguration of the Australian Television Market." *Media Industries* 5 (2): 129–42.

Wagman, Ira. 2017. "Talking to Netflix with a Canadian Accent: On Digital Platforms and National Media Policies." In *Reconceptualizing Film Policies*, edited by Nolwenn Mignant and Cecilia Tirtaine, 209–21. New York: Routledge.

Ward, Sam. 2016. "Streaming Transatlantic: Importation and Integration in the Promotion of Video on Demand in the UK." In *The Netflix Effect: Technology and Entertainment in the 21st Century*, edited by Kevin McDonald and Daniel Smith-Rowsey, 219–34. New York: Bloomsbury.

Wayne, Michael L., and Deborah Castro. 2021. "SVOD Global Expansion in Cross-National Comparative Perspective: Netflix in Israel and Spain." *Television and New Media* 22 (8): 896–913.

1

Why SVOD Commissions Matter

AMANDA D. LOTZ

By the middle of March 2020, most of the Northern Hemisphere had begun some form of lockdown in response to the rapid and uncontrolled spread of COVID-19. As many worried for their health and jobs, tried to sort out a new normal of work from home, or struggled to maintain sanity amidst either ever-present family or extended alone time, a spectacle of American culture previously unimagined played out on their screens.

Netflix offered a look inside a subset of America that had never graced the many sitcoms, dramas, or films that have emerged from its prolific and pervasive video industries. With its true-crime tale of conflict among big-cat conservationists and collectors, *Tiger King* offered one of 2020's many surreal moments. *Tiger King* quickly ranked on Netflix's "most viewed" lists across the globe, reaching second in the weeks following its debut, according to FlixPatrol's proprietary ranking system. The series spent sixty-two days in the top ten and ended the year ranked thirty-sixth globally and first in the United States in the proprietary ranking system FlixPatrol developed to track most-viewed titles. *Tiger King* became a pop culture referent and generated a library of memes that reached many more than ever viewed an episode.

Though its reach and popularity were stunning, so too is its existence. It is impossible to imagine this series being produced for American television in the "network era" (1952–mid 1980s), and difficult—though not unthinkable—to envision it commissioned by an American cable channel in the decades that followed. Even on cable, it would have been buried in a schedule and difficult to discover, and its eight-hour miniseries

format would have made it unlikely to be sold widely abroad to key buyers, who prefer American series with at least 100 episodes.

Tiger King may not be the most profound illustration of how subscriber-funded streaming services are altering the video ecosystem, but it illustrates how SVODs' different industrial conditions can lead to the creation of content different from that prioritized by the industrial conditions supporting the commissioning of video for linear channels or cinematic distribution. Those differences are important because they present the most radical shift to the conditions of commercial video production in decades.

SVODs' Industrial Distinctions

Three characteristics of SVODs deviate from the industrial conditions previously dominant: subscriber funding, transnational reach, and on-demand access (Lotz 2022). These industrial differences lead SVODs to prioritize different metrics, enable different content strategies, and explain why the titles they develop might differ from other sectors of television and film. The titles SVODs commission represent the purest expression of their content strategy, and SVODs are increasingly important in the audiovisual ecosystem as substantial commissioners of scripted series in many markets.

In brief, the first difference in industrial condition derives from SVODs' reliance on subscriber funding, which supports different program strategies than characterize the ad-funded services that have long dominated in-home viewing. *Tiger King* is an odd example in that regard considering that its highly viewed status makes it consistent with the aspiration of ad-funded services. Importantly, an SVOD derives value from more than just widely viewed shows, but also those that viewers value deeply. Titles and types of content unavailable from ad-funded services are needed to motivate monthly payment. An ad-free, on-demand experience may be enough to warrant a low fee, but higher fees require distinctive content—and the costs of making content for heterogeneous

taste clusters necessitates subscriber funding to cover costs. Identifying titles that viewers value deeply is difficult though; Netflix's introduction of a "two-thumbs-up" rating in 2022 suggests that depth of resonance, or what I've called a "satisfaction coefficient" (Lotz 2022) to indicate the differential value viewers ascribe to different titles, may be difficult to discern from viewing behavior alone.

A second difference is that many SVOD services—particularly those funding the creation of new titles—release content simultaneously to an audience spread around the globe. This practice enables coterminous popular culture consumption in a manner previously uncommon for in-home video despite long histories of transnational distribution technologies and services. The simultaneous multi-territory availability aids promotional efforts by enabling subscribers to access content at the same time, eliminating waits tied to temporally tiered windowing that required subsequent promotion and left some viewers feeling behind. In an era of so much content production and unprecedented availability of library titles, it is difficult for even the most widely promoted title with the biggest stars to break through all the other content fighting for attention, and the singular release leverages the transnationality of social media conversations. But the bigger strategy shift results from the ability to aggregate viewers across national borders to achieve audience scale for tastes and interests unlikely to be significant enough within a single national market, which has been the requirement of content supported by national, ad-supported sectors.

This transnational scale ties to the third industrial distinction of SVODs: on-demand access. Propelling viewers to *Tiger King* was not Netflix's only overture to subscribers in early 2020, but offered a library of some 5000 titles (this also relates to the first point here). Millions of immediate views weren't especially valuable to a service based on monthly subscriber payment, a big difference from the timeliness critical to linear, ad-funded services or theatrical box office. Viewers could find *Tiger King* as word spread and watch it the moment their curiosity was piqued, just as those who saw discussion of it and found it abhorrent

could choose among thousands of other titles. This library-rather-than-schedule organization and the content development strategy it engenders suits many more types of shows—not simply in terms of content, but also in form (miniseries, those with a few seasons)—than were privileged in global distribution under linear industrial norms. And a final condition that aided Netflix in benefitting from this series is its discovery and recommendation functions that can promote *Tiger King* as currently "trending" because it aligns with an individual's previously viewed content, or because the service wants to offer it a promotional boost.

These different industrial conditions suggest the value of examining SVOD commissions with minds open to the possibility they may diverge from the content decades of titles have taught us to expect because those titles were created for ad-supported distribution to audiences imagined in national groupings. Embracing such examination is most usefully engaged dispassionately and aimed neither at heralding the commissioning of streaming services as changing the boundaries of storytelling in revolutionary ways nor committed to the assertion that they reproduce all of what critical writing about other industrial conditions has identified.

The case is clear that industrial conditions of SVODs differ from those of advertiser support, linear distribution, and national audience making, and the rest of this chapter seriously considers what those implications could be by thinking about the new lines of inquiry needed in two major conversations of media studies: those that explore the role of audiovisual storytelling in culture and those that explore the sociopolitical implications of media flows. The analysis proceeds from a belief that adjustments in industrial conditions—even if still structured by capitalism—encourage changes in the strategies of content that can adjust the boundaries of commercial storytelling. Such adjustments in those boundaries then alter the cultural functions of video among those who consume it. It is possible these adjustments do not substantively change much about the ideological operation of series and movies, but they also warrant careful and legitimate inquiry.

It is necessary to investigate streaming service commissions because their industrial conditions differ from those of past industries, but it is unlikely that a singular claim can be made for streaming commissions. Many are likely to enact continuity that makes them consistent with other commercial video titles on ideological or aesthetic grounds. But there is also reason that some of their commissioned titles will defy those norms. Even if such titles are not preponderant in number, such cases are worthy of analysis for the expansion in the cultural roles they provide. Systematic analysis surpasses what a single chapter can achieve and may be impossible given the volume of hours some services now produce. Here the aim is establishing an explanatory foundation for how and why the entrance of streaming services into the role of commissioning warrants reconsideration of industrial and intellectual lore about the nature of commercial video in culture and theory-building bespoke to their industrial norms.

Why Do SVOD Commissions Matter to Media Studies?

These differences of SVODs and their commissioned content are important to two key conversations in media studies that are centrally concerned with questions of culture and power. First, investigating the commissions of streaming services provides evidence about how technological change connects with adjustments in economic practices to yield shifts in production norms. Earlier media studies scholarship exploring television's textual features in relation to culture rarely considered technological conditions with much depth because the staid features largely seemed inherent to television. However, as multichannel services such as cable and satellite fragmented television's mass medium norms, researchers attended to the shifts in television forms, formats, and storytelling (Steemers 2004; Chalaby 2005; Banet-Weiser, Chris, and Freitas 2007). Investigating the continuity of streaming services with practices of cable and satellite, and their differences, extends our understanding about the relationship between industrial conditions and

textual possibilities. It also may suggest new areas of inquiry needed to address changes in the cultural roles of video that is made foremost for viewers regardless of national location and seeks specific tastes rather than mass acceptability.

The second conversation involves practices and consequences of transnational video flows. The technological capability of internet distribution to more easily traverse national boundaries allows multi-territory services to exploit economies of scale more extensively than past distribution technologies enabled. For decades, audiovisual industries have trended away from national organization and given priority to multi-territory and global organization. Several SVODs have built content strategies based on serving a multi-territory base of subscribers, which adds to other mechanisms of internationalization such as program/film trade, transnational satellite channels, and foreign acquisition of production companies, channels, and infrastructures that have progressively shifted audiovisual industries from nationally organized roots.[1] This scale makes businesses based on servicing more narrow content tastes and sensibilities viable, as well as enables services to aggregate a blend of strongly niche and more-mass-interest content. The transnational, direct-to-consumer structure of some of these services is truly novel relative to those analyzed in existing scholarship and allows for content strategies that imagine audiences without national borders.

Storytelling

SVODs are both like and different from the video distribution technologies and businesses that form the basis of existing knowledge of in-home video and the role it plays in culture as explained by scholars such as Brunsdon (1998), Hartley (1999), Ellis (2002), and Gray (2009), among others. Decades of scholarship have built a compelling case for the cultural significance of video entertainment, but the adjustments resultant from the different affordances of subscriber funding and on-demand delivery require bespoke investigation of how they adjust that cultural role.

Notably the approach here acknowledges like and difference—or continuity and change—but prioritizes the difference and change because the continuities don't require such extensive new thinking.

A key industrial difference of SVODs derives from the on-demand affordances of internet-distributed video. The on-demand capability allows the primary offering of a video service to shift from providing a schedule to providing a library. The task of and strategies for cultivating a library differ from those of cultivating a schedule. The nonlinear organization of video services remains largely untheorized and quite different from the scarcity-based norms of linear distribution, especially as tied to mass audience priorities.

Most of our language for understanding commissioning priorities derives from linear conditions. Channels spend most heavily on shows aired in "prime time" because of the high viewing levels, and these series were most likely to be widely shared within a culture. The enforced scarcity of twenty-four hours per day required schedulers to prioritize shows expected to be most viewed and organize them in the hours most people watch. This activity of scheduling typically happened at a national level and thus aimed to construct an audience among a nation-based universe of viewers, even if programming was purchased from outside the nation. Thinking about streaming video tends to default to ideas made meaningful by the scarcity of scheduling and the priorities of ad support even though little applies.

In contrast, streaming services are not constrained by schedule, and those relying on subscriber funding pursue a different primary metric than seeking for each piece of content to attract the largest audience. SVODs also face constraints; a finite licensing budget requires streamers to make strategic choices about content licensing and commissioning. But the ability to simultaneously service multiple audiences supports commissioning content perceived to resonate with discrepant audience tastes rather than predominantly prioritizing content likely to attract the most viewers at particular times.

Relying on subscriber funding further necessitates different strategies and metrics of success from those typical of advertiser-funded services pervasive on television (Lotz 2007). This too affects content strategy. The business model of SVODs requires them to develop content viewers regard as worth paying for. The combination of on-demand accessibility, which allows viewers to simultaneously select from an array of choices, with subscriber funding enables SVODs to prioritize different strategies in program commissioning. Where linear services must construct a common audience, on-demand services can cultivate a multiplicity of audiences, what I (2017) termed "conglomerating niches" to describe a strategy that makes titles regarded passionately by some viewers valuable even if they aren't widely viewed. Such titles are difficult to identify in "general" library services because only most-viewed titles are commonly reported and the most-viewed will inevitably be those less particular in their address. SVODs with "specific" libraries, for example, Crunchyroll and Acorn, have built a value proposition around a single content niche and offer libraries with fewer titles but significant depth in particular types of content. Both services with general and specific libraries seek differentiation from existing services and to offer a value proposition that attracts subscribers—not necessarily all viewers, but enough relative to content costs.[2] These strategic features that tie to technological attributes are crucial lenses through which to investigate why SVODs might pursue audiences with content different than commonly prioritized by linear and ad-supported services.

These intertwined industrial and economic features differentiate SVODs from the industrial conditions long observed in scholarship and enable different priorities and strategies in commissioning titles. The industrial dynamics of SVODs reconfigure—but do not eliminate—the gatekeeper or intermediary relationship between service providers and audiences as has been theorized for channels (Ellis 2002; Johnson 2018). Notably, the digital infrastructure used by SVODs allows them to accumulate much more extensive data about viewer behavior of specific

accounts and profiles, and this data supports decisions about commissioning and allows personalized targeting based on past behavior, which is much different than the strategies and tools of mass audience appeal.

To be clear, internet distribution doesn't cause these changes—this is not an argument that the technology alone is responsible for adjustments to the business of television or the titles commissioned. But as a distribution technology, the internet does have different affordances than distribution technologies such as broadcast, cable, and satellite, and many of the most novel adjustments to these services derive from the decision of SVODs to leverage these distinguishing affordances in business and content strategies.

Research delimiting and theorizing these industrial distinctions has not robustly considered their implications for the content offered by these services. At first, the issue was made moot by the SVODs' origins offering content created for other video services as a new "distribution window" in the industry parlance. However, as some services became more established in consumers' use and services grew more prevalent, a need for differentiation emerged that is effectively solved through original and exclusive commissioning. The corpus of services that can afford to commission content, especially scripted content, remains quite narrow, and commissioned series typically constitute a limited amount of the library of content offered. AppleTV+ remains unusual in its library of only commissioned content, a strategy uncommonly feasible because of its status as a service that supports the company's primary business of technology sales and as unclearly intended to stand as a value proposition on its own.

The significant differentiation among streaming services in terms of scale—tied to geographic accessibility and general versus specialized library composition—ownership of significant intellectual property, and the varied reasons video is offered by different corporate owners should lead us to expect variation in commissioning strategy from different services. Thus the commissioning priorities of Netflix are likely to differ from those of Disney+, as are both likely different from Prime Video

because each of these services offers video for different business priorities (the limited time in market makes it impossible to derive meaningful claims of newer services' commissioning). Though all may offer video on demand, the underlying business model and aims of services vary notably, at least at this stage in their development.

Flows

Concerns related to transnational circulation of video and its implications for national cultures and cultural power have been perennial topics in media studies. It is a complicated and conflicted scholarship that has aimed to tease apart contradictory dynamics of viewer taste for both national and foreign production amidst industrial forces that push for multi-territory scale. The intellectual history is full of tension and insufficiently empiricized theories. Many of those tensions are well covered elsewhere (Cunningham and Jacka 1996; Steemers 2004) and do not require yet another rehearsing.

The affordances of internet-distributed video and the multinational reach of many services warrant extension of the conversation framing John Sinclair, Elizabeth Jacka, and Stuart Cunningham's 1996 book that considered "new patterns of video flow." Though a case study approach is not systematic enough to identify patterns, industrial conditions also likely remain too preliminary for effective analysis in this regard. Nevertheless, cases grounded in the particular historical, economic, and industrial conditions in which each streaming service derives its relative meaning to subscribers begin to suggest preliminary thinking from which patterns might eventually be recognized and investigated more holistically. The questions asked in Sinclair et al.'s account in light of the impacts of satellite television, as well as Joseph Straubhaar's 2007 *World Television*, which draws from more than a quarter century of Straubhaar's thinking and empirical study of the ideas supporting theories such as cultural dependence, media imperialism, asymmetrical interdependence, and cultural proximity, frame investigation of multi-territory

streaming services and their role in culture. These key works—and of course many others—set out elaborate grounds for making sense of the patterns of audiovisual flows and debates about the structures of power that may operate through them. The different industrial conditions of SVODs provide reason to expect they may rely on different strategies in serving subscribers who pay specifically for their service (not a bundle of channels), particularly those that reach subscribers across a multitude of territories.

SVODs deviate from the conditions of transnational flows that developed for linear distribution and video industries based on national audiences—even for those national audiences that have long been offered transnational content. The dynamics between global and national is not a simple dichotomy, such that things were once national and are now "global" or at least much more so; and it should be noted that scholarship has assumed national specificity is embedded in audiovisual content without much detailed accounting. Rather both registers contribute to shaping the industrial conditions of SVODs. The economic and technological conditions that structure the video storytelling of SVODs increasingly position them as multinational enterprises, but much policy remains set at the national level (Flew, Iosifidis, and Steemers 2016). Even among single-territory SVODs, national regulatory regimes have been uncertain whether and how to bring services using internet distribution in line with policy developed for distribution technologies with different affordances. All of the differentiating technological and content strategies noted above have implications for received understandings of transnational program flows and need to be reconsidered in light of industrial formations introduced by SVODs.

As a distribution technology, the internet enables the creation of services that can span audiences across nations and simultaneously circulate the same content across those national boundaries. Although there is a lengthy history of television program trade and multi-territory satellite operation, it has been uncommon for a single service provider to conceive of the audience they commission for to be undifferentiated by

national border in the first case. Rather, multinational satellite services developed more as a federation of nation-based audiences because the commercial structures supporting the industry were organized nationally (Chalaby 2005). This has implications for content. Services selecting foreign content for linear systems chose that content based on perceptions of whether it would attract a broad audience within the nation—largely a consequence of the reliance on funding from ads sold at the national level. Channels bought different foreign programs because they were perceived likely to conform to the tastes of the most viewers at a particular time in the schedule relative to the brand of the channel.[3] Thus, when a channel with national reach commissioned or licensed a show, it was on the basis of its appeal to the general population of that country because the reach of the channel was defined as national.

The key here is that despite the transnational reach of satellite services, they operated on a national basis in their aggregating and selling of attention to advertisers and were often governed by national-level policies. A company might provide service in multiple countries (e.g., Sky or DirectTV), but the offerings were tailored significantly by country. This again illustrates the complicated mix of change and continuity in how services such as satellite and SVODs can be both multinational in character and nationally bespoke. Multi-territory SVODs do conform to nation-specific policies as they have emerged (e.g., France) and do not offer precisely the same libraries of content in every country (although they are more consistent than varied; Lotz, Eklund, and Soroka [2022] found 60 percent overlap in titles across seventeen Netflix libraries in major markets). Because they contract directly with subscribers there are fewer national-level intermediaries than was previously the case with cable and satellite.

Multi-territory SVODs do most of the commissioning at this point and thus warrant particular focus. These services developed direct-to-consumer relationships across national boundaries and can more effectively target sensibilities deemed too insignificant at the national scale because the services are able to amass audience scale over the

multi-territory subscriber base. Titles attractive to particular niches or "taste cultures" are often obscured from popular conversation about streaming services, especially when the niche does not align with the sensibility of television opinion leaders, but such titles are important to the services' value proposition. Being able to derive commercial value from targeting a niche sensibility across national boundaries is profoundly different than has been the norm, though the implications are untested and unclear.

Scholars have begun to explore how internet-distributed video affects the dynamics of content and expectations derived from concepts such as cultural proximity, cultural discount, and geolinguistic regions as predictive of viewing (Wagman 2017; Lobato 2019; Straubhaar et al. 2019). The current context remains too nascent to derive well-evidenced support for how these concepts do or do not apply—although the proprietary data of these services likely offers rich insight that remains unavailable to scholars. The established theory that connects the business pursuits of the television industry with their cultural implications was built upon the norms, capabilities, and dynamics of broadcasting and then slightly adapted for cable/satellite technologies. Many of the norms and characteristics of these preliminary technologies weren't interrogated because they seemed so natural, just part of how "television" was. The contemporary multiplicity of business models and distribution technologies reveals those norms as constructed by and contingent on earlier distribution technologies and business models. Appreciating the range of industrial and technological factors structuring the patterns of imports and exports was difficult because alternatives were difficult to imagine.

Explanations of the success of different programs and shows in transnational trade have used proximity—the idea that audiences most like content similar to or proximate to them—to explain why particular types of content have succeeded. Initially, theorists emphasized geolinguistic and cultural factors in explaining proximity—the idea that people tended to prefer programs produced in nearby countries or in

the same language over those that were not, a factor undoubtedly related to the expense of high-quality dubbing and expanded audience labor required by reading subtitles. Theorists also identified patterns of migration and diaspora as significant and helpful to explain cases less clearly aligned with geography or language (Straubhaar 2007). Just before the emergence of these multinational SVODs, Straubhaar and La Pastina (2007) expanded the idea of cultural proximity to include "genre proximity," "thematic proximity," and "value proximity." These new proximities were aimed at dealing with the complexity uncovered in fieldwork but have not been systematically studied—either in the context of linear, ad-supported television, or in terms of how these proximities may work distinctly in the case of on-demand, subscriber-funded services. The extension of proximity in this way also makes it so broad as to risk erosion of explanatory value such that it simply means people prefer things that are like and familiar, rather than its earlier tie to geographic, cultural, or linguistic similarity. Moreover, the primacy of proximity was established based on an era of scarcity. Choice was widely constrained such that the features of content preferable among the scarce options of pre-multichannel television may not predict preference en masse when greater choice and variety exist.

Notions of proximity were helpful but may be tied to the industrial conditions they were created in. Recent work by Straubhaar et al. (2021, 180) has emphasized how asymmetrical interdependence also requires reassessment in an era of multi-territory streaming services and suggested "transversality" to conceptualize the interplay of SVODs with existing dynamics of video flow. The substantial range of choice in types of stories and in where they are created begs scholarly attention to better understand new bits of data offered in promotional rhetoric by SVOD executives claiming the popularity of "local stories" that are difficult to contextualize without the breadth of data they see. The success of many Netflix titles across the multi-territory scope of the service, and the fact that those titles have originated from multiple countries, are among the most interesting developments of this new era, but it is also

very difficult to make sense of these developments given the paucity of public data about viewing on these services beyond the most viewed programs. These services have the data from which rich scholarly understandings could be built. The lack of detailed qualitative audience study of viewer selection and preference in an era of abundance also handicaps our ability to theorize the implications of developments such as the widespread—at least in some countries—adoption of Netflix as a streaming service that overwhelmingly offers "foreign" (though not majority American) content (Lotz, Eklund, and Soroka 2022).

Analysis of proximity in video selection has been based on the fairly narrow range of content that was produced for its likelihood to attract a mass audience. Consequently, existing thinking is based on limited textual possibility such that the content viewers most like may not have been available, so they have watched the next best option. Of course, theories about multinational television flows never started by asking individual people what they liked or why. Moreover, what was never considered—because it was so obvious, natural, and could be no other way—was that the taste driving the programs made available was a composite of preference, described tellingly as that "least objectionable." As a result, our theories about proximity embed "the nation" and mass audience construction into constructs because industrial practices have necessarily defined audiences by these parameters. The practices of buying, selling, and distributing television programming defined audiences as national, though it is unclear whether and to what extent that national identity is key to individual tastes.

SVODs with multinational availability and limited "local" content are revealing that local relevance is one of a composite of factors in taste—used here generally, not in the Bourdieusian sense. And importantly, multi-territory SVODs have taken different approaches to addressing the national specificity of their subscribers. Netflix is largely an outlier in terms of the extent of its multinational commissioning and has a more bespoke approach to libraries than SVODs emerging from companies with deep intellectual property (IP) libraries such as Disney+ or HBO

Max, although it remains early days for these services. Notably, library strategy is not required by the technology; it is a choice.

Multi-territory streaming services pursue different commissioning strategies. Amazon, with its much more differentiated national priorities tied to supporting its discrepantly developed retail business, may rely on proximity to amass audiences in key countries. There may be cases in which Netflix uses something more like proximity to guide its content strategies, but there is also evidence that Netflix uses a multiplicity of library strategies. These differences make it challenging to claim behaviors or practices as characteristic of SVODs. The pluriform audiovisual environment of the twenty-first century requires theory that accounts for the variation among services, and the variation among audiovisual services may require a toolkit of theories to explain the diversity of behaviors emerging.

The industrial and technological developments of the last half century have pushed commercial storytelling to imagine viewers as not bound to a particular country. In the comparatively early digital context of 2007, Straubhaar wrote, "Television's national focus of control has been strongly challenged, but not necessarily overturned" (4), and his assertion remains true even though multinational SVODs are overwhelmingly nonnational.

This is not a story of linear change, from condition A to condition B. Rather, at this point in 2023, new distribution technologies have further pluralized the video storytelling available in many national video cultures. Television remains highly national and linked to national public service and commercial broadcasters *and* now shares attention with an ecosystem that allows "foreign" channels and "foreign" and "domestic" streaming services that rely on a variety of strategies that appeal to desires for local, regionally proximate, niche, and universal attributes (see chapter 2). The scale of viewing attention once devoted to national broadcasters—both public and commercial—has diminished in many cases, but the take-up of multinational services should not be primarily viewed as substitution. Rather, these new services are often complementary and chosen by viewers

because they offer content broadcasters did not offer—especially considering many services offer an array of content both like and different from that offered by public service broadcasters. The SVODs also offer a strongly differentiated experience of the content—at least in some countries since accessibility of on-demand content through other technologies and services is highly varied by nation. The desire for audiovisual storytelling and entertainment is complex and multifaceted, and theories that proceed from assumptions of linear change or replacement miss the complexity of practices that undergird engagement with twenty-first century screen cultures.

This is important to consider given the extent to which television has become more multinational while at the same time no new technology has surpassed its "nationing" role (Turner 2018). As argued by Straubhaar and others, in the twentieth century, television served as "the primary means of building and reinforcing national identity. Television was a crucial medium to unify geographically and ethnically dispersed and diverse people into a sense of nationhood" (2007, 61). Although twenty-first century conditions involve adding all sorts of digital technologies and social media to core tools of daily communication, none of these tools in any way approximates the nation-building capability and function of television. Rather, these tools aid in the building and strengthening of parallel communities that may have little relevance to the nation and perhaps supersede it in significance.

Thus, we exist amidst paradoxes and pluriformity. We must add new tools for understanding how video storytelling plays roles in culture that are not tied to nationing and for explaining viewers opting to pay for services that lack proximate content. Exploring the storytelling created exclusively for these services—and exploring it relative to the diverse video cultures around the globe—begins to reveal the nature and shape of those tools.

Notes

1 Crucially, though these services may be accessible to subscribers in many countries, the core content strategy does not regard all audiences as equally

important. Subscriber figures are often given "globally" or United States and rest of world, but closer examination reveals a strong priority on Anglophone/English-speaking markets as of 2023.

2 The value proposition of internet-distributed services is not only one of content, but also of experience. Subscriber-funded services differentiate themselves through their on-demand access and commercial-free experience and often by offering full series availability less common on internet-distributed catch-up services that are typically ad-supported. Experience is very important and is often overlooked in examining contemporary video ecosystems; it is not as central to this discussion, however.

3 Some publicly funded channels also focused heavily on audience numbers as a metric of success, while others conceived of their mission as providing alternatives to the types of content commercial services prioritized in their pursuit of mass audiences.

References

Banet-Weiser, Sarah, Cynthia Chris, and Anthony Freitas, eds. 2007. *Cable Visions: Television Beyond Broadcasting.* New York: NYU Press.

Brunsdon, Charlotte. 1998. "What is the 'Television' of Television Studies?" In *The Television Studies Book*, edited by Christine Geraghty and David Lusted, 95–113. London: Arnold.

Chalaby, Jean K. 2005. *Transnational Television Worldwide*. London: Tauris.

Cunningham, Stuart, and Elizabeth Jacka. 1996. *Australian Television and International Mediascapes*. Cambridge: Cambridge University Press.

Ellis, John. 2002. *Visible Fictions: Cinema, Television, Video*. London: Routledge.

Flew, Terry, Petros Iosifidis, and Jeanette Steemers. 2017. *Global Media and National Policies: The Return of the State*. Basingstoke: Palgrave.

Gray, Jonathan. 2009. *Television Entertainment*. London: Routledge.

Hartley, John. 1999. *Uses of Television*. London: Routledge.

Johnson, Derek, ed. 2018. *From Networks to Netflix: A Guide to Changing Channels*. London: Routledge.

Lobato, Ramon. 2019. *Netflix Nations: The Geography of Digital Distribution*. New York: NYU Press.

Lotz, Amanda D. 2007. "If It Is Not TV, What Is It? The Case of U.S. Subscription Television." In *Cable Visions: Television Beyond Broadcasting*, edited by Sarah Banet-Weiser, Cynthia Chris, and Anthony Freitas, 85–102. New York: NYU Press.

Lotz, Amanda D. 2017. *Portals: A Treatise on Internet-Distributed Television*. Ann Arbor: Michigan Publishing.

Lotz, Amanda D. 2022. *Netflix and Streaming Video: The Business of Subscriber-Funded Video on Demand*. Cambridge: Polity.

Lotz, Amanda D., Oliver Eklund, and Stuart Soroka. 2022. "Netflix, Library Analysis, and Globalization: Rethinking Global Flows." *Journal of Communication* 72 (4): 511–21.

Sinclair, John, Elizabeth Jacka, and Stuart Cunningham. 1996. *New Patterns in Global Television: Peripheral Vision.* New York: Oxford University Press.

Steemers, Jeanette. 2004. *Selling Television: British Television in the Global Marketplace.* London: British Film Institute.

Straubhaar, Joseph D. 2007. *World Television: From Global to Local.* Thousand Oaks: SAGE.

Straubhaar, Joseph D., and Antonio La Pastina. 2007. "Multiple Proximities Between Television Genres and Audiences." In *World Television: From Global to Local,* by Josephs Straubhaar, 195–220. Thousand Oaks: SAGE.

Straubhaar, Joseph D., Deborah Castro, Luiz Guilherme Duarte, and Jeremiah Spence. 2019. "Class, Pay TV Access and Netflix in Latin America: Transformation within a Digital Divide." *Critical Studies in Television* 14 (2): 233–54.

Straubhaar, Joseph, Melissa Santillana, Vanessa de Macedo Higgins Joyce, and Luiz Guilherme Duarte. 2021. *From Telenovelas to Netflix: Transnational, Transverse Television in Latin America.* Cham: Palgrave Macmillan.

Turner, Graeme. 2018. "Television: Commercialization, the Decline of 'Nationing' and the Status of the Media Field." In *Making Culture: Commercialisation, Transnationalism, and the State of 'Nationing' in Contemporary Australia,* edited by David Rowe, Graeme Turner, and Emma Waterton, 64–74. London: Routledge.

Wagman, Ira. 2017. "Talking to Netflix with a Canadian Accent: On Digital Platforms and National Media Policies." In *Reconceptualizing Film Policies,* edited by Nolwenn Mignant and Cecilia Tirtaine, 209–21. New York: Routledge.

2

Conceptualizing the National and the Global in SVOD Original Production

RAMON LOBATO, ALEXA SCARLATA, AND STUART CUNNINGHAM

SVOD services have integrated into national markets in complex and surprising ways. From global behemoths such as Netflix and Amazon's Prime Video that are available in almost every national market through to smaller SVODs operating in only one or a few countries, the landscape of services has grown increasingly diverse, as have their business models and programming strategies. How, then, should we think about the topic of this book—SVOD original production—within a context of growing service diversity? What adjustments to our analytical concepts are required?

The present chapter takes up this challenge. Our aim is to disaggregate the category of SVOD into smaller units, reflecting differences between services and the markets in which they operate. Key to our analysis is the distinction between *global* and *national* SVOD services. For example, Netflix, Prime Video, and Disney+ are U.S.-based, global SVODs operating in almost every country, with multilingual catalogs and interfaces. These services commission originals across multiple countries and make them available to a global userbase. In contrast, services like Globo Play (Brazil), BluTV (Turkey), Movistar (Spain), and Stan (Australia) are nationally focused SVODs deeply rooted in a single, specific market, although they may also be available to other countries within their regions.

In this chapter we show how national and global SVODs operate differently when it comes to commissioning, and we explain what this means for the kinds of stories they commission. Our chapter proceeds in two parts. First, we offer some general observations about national

and global SVODs. Second, we explore how two SVODs—Stan and Prime Video—have adopted contrasting production strategies for a single national market, Australia. (Note that our focus in this chapter is on broad-based "TV replacement" SVODs; as such we do not consider niche, genre-specific SVODs such as Shudder or Acorn.)

The general pattern we describe in this chapter is that smaller national SVODs tend to produce a restricted number of local-language originals per year, featuring stars and genres familiar to the relevant national market. In contrast, global services produce across multiple countries and adjust their investment accordingly, resulting in a more cosmopolitan (but less local) approach to production. Some SVODs are also expanding from national to transnational scale, reflecting the mutable nature of service categories, while others coproduce with international partners, complicating matters further. Consequently, we argue that the national and global should be understood as distinct categories at the service level but are intertwined when it comes to storytelling, aesthetics, and style.

Defining National and Global SVODs

Researchers from the European Audiovisual Observatory (EAO) have documented the evolving SVOD service landscape in a series of meticulous reports (Grece 2018; Grece and Jiménez Pumares 2020). Their analyses note important distinctions between the more than 260 SVODs that currently operate across Europe. Of these SVODs, some—such as Player (Poland) and SFR Play (France)—cater primarily to a single market. The EAO describes these services as *national SVODs* and argues that they have characteristics that set them apart from their global competitors such as Netflix and Disney+.

First, these national SVODs have smaller catalogs than these global services. Second, they tend to carry a higher proportion of local content (titles produced in the service's home nation); on average, 72 percent of TV series offered by national SVODs are local compared to 22 percent for global SVODs (Grece and Jiménez Pumares 2020, 83). Third, na-

tional SVODs are often owned by national pay-TV or telecom operators and have deep institutional roots in the countries in which they operate. This embeddedness allows for a strong understanding of audience tastes, viewing cultures, competing services, and production possibilities and constraints within their home market.

Locally based and managed, these national SVODs are firmly focused on their home markets and geolinguistic regions—in contrast to global SVODs that seek to aggregate viewers from around the world and commission content that can travel widely. This is a dynamic that we have noted in our own research. Since 2017, we have been studying SVOD catalogs and production in Australia and have observed the different character of national services, notably Stan (owned by the commercial broadcaster Nine), compared to global services Netflix and Prime Video.[1] These Australian SVODs have a relatively higher degree of local content than the global mega-platforms as well as, importantly, national sports rights. Stan is a "completely locally focused proposition," as its former CEO Mike Sneesby described it (quoted in Reilly 2016)—in practice, this means supplying a mix of Australian and U.S. content—but it steers clear of the European, Latin American, and Asian content that can be found on Netflix and Prime Video.

The European Audiovisual Observatory's concept of national SVODs is also helpful for clarifying dynamics of other SVOD markets—especially in countries where language forms a natural protective barrier. Consider India, home to a number of powerful national SVODs such as Hotstar and Zee TV, which are far more popular than Netflix. Another striking case is China, where Tencent Video, iQiyi, Youku Tudou, and LeTV dominate the market (state regulation requires that all SVODs be Chinese owned).[2] In these countries and elsewhere, national SVODs have a strong hold on mainstream audience interest because of the deep industry roots of their parent companies, which often encompass content production, broadcasting, pay-TV, and advertising. These national SVODs know their audiences well, have significant experience producing for them, and have rich back-catalogs of content to offer them.

In contrast, the major global SVODs—Netflix, Prime Video, and Disney+—operate in a fundamentally different way. Their catalogs are larger but profoundly U.S.-dominated, with what Albornoz and Garcia Leiva (2022, 64) describe as "a transnationalized American offering with an international-flavoured seasoning." Global SVODs benefit from enormous scale, resources, and network effects, but they often struggle to understand local audience preferences and may be excluded from licensing deals with local rightsholders. This makes original production an essential strategy for these global SVODs because it is often the only way they can offer quality local content to their international audiences. However, their willingness to finance such local content depends on the perceived strategic value of particular markets. To date, Netflix originals have been produced in 26 different markets across Western Europe, East and Southeast Asia, Africa, and the Americas, while Prime Video's original production is concentrated in 16 countries (with Amazon targeting those markets that align best with its e-commerce platform strategy, notably the United Kingdom, Germany, India, and Japan). The rest of their 190-odd national markets make do either with licensed local content or no local content at all.

For SVODs, the decision on whether or not to commission content in a particular country is also shaped by national policies that incentivize or require domestic content investment or production. Following the adoption of the European Union's (EU) revised Audiovisual Media Services Directive in 2018, numerous EU member states—including France, Italy, Switzerland, and Denmark—have introduced local production obligations for major SVODs, which are now obliged to put a certain amount of their national subscriber revenues back into local production. Similar measures are also being debated in other countries including Argentina and Brazil, and also in Australia, where SVODs have pre-emptively increased their local production in anticipation of (and to undermine) official regulation.

What does all this mean for SVOD storytelling? There is a paradox here for cultural critique, precisely because different catalog strategies

provide different, yet equally legitimate, kinds of diversity. National SVODs are often *localist*, in the sense that they extend national screen traditions, languages, star systems, and self-representation into the streaming space. This may resonate with audiences who prefer to see content in their own language, accents, and idioms. It also has particular appeal within smaller markets ignored or underserved by global media players, where such an offering is often viewed positively in terms of a commitment to local content and framed as a progressive counterweight to Americanization, cultural imperialism, and other ideologies of cultural homogenization. Of course, with localism there is often parochialism and narrowness. In contrast, the largest global SVODs—Netflix and Prime Video—seem to offer an increasingly *cosmopolitan diversity* that is an effect of their catalog scale rather than their priori commitment to national culture. These services integrate content and genres from around the globe, bringing "the world to your screen" and offering everything from Japanese and Mexican movies to Korean and Turkish TV dramas. This globalist SVOD offering, while not "distinctively local" in its appeal, may be very attractive to audiences, depending on the prior conditions of the relevant national market. For example, the entry of Netflix has often been welcomed in many countries as a "breath of fresh air" that contrasts positively with the stale, repetitive nature of national media institutions (Lobato 2019). Straubhaar et al. (2021) argue that, in the Latin American context, this preference for international versus local content and services is often organized along class lines, with educated, well-traveled, and English-speaking elites preferring Netflix to local broadcast and cable services.

Recent scholarship on SVODs has noted this structural difference between national and global SVODs and has begun to probe its implications for longstanding debates about audiovisual diversity and the relationship between national and global media. Studies of nationally oriented SVODs, such as Blim (Mexico), Stan (Australia), and Globoplay (Brazil), have shown how these services often seek to market themselves as distinctively local (i.e., different from Netflix) and as distinct

from legacy broadcast services, while nonetheless building on the catalog offerings of their parent companies, often with roots in broadcast and pay-TV (Rios and Scarlata 2018; Meimaridis et al. 2020). Related studies of SVOD content and commissioning, especially in Europe, have explored underlying market, financing, and policy drivers (Afilipoaie et al. 2021; Albornoz and Garcia Leiva 2022). Meanwhile, conceptual work (Elkins 2019; Szczepanik et al. 2020; Lotz 2021) suggests new vocabularies through which we can analyze interactions between national and global SVODs. Key questions remain, however. How, and to what extent, do these structural tendencies between national and global services manifest textually in original shows and movies? How do the stories told by national and global SVODs differ, if at all? To answer these questions, the next section considers how two very different SVODs—the Australian service Stan and the global service Prime Video—have approached and cultivated the task of producing originals in the Australian market in inverse ways.

The Production Strategy of a National, Single-Market SVOD: Stan

Stan is an Australian SVOD service with a distinctively national focus in its production, operations, ownership, and branding. It launched on the Australia Day public holiday (January 26) in 2015, shortly before the entry of Netflix into the Australian market. In contrast to Netflix, Stan brands itself as a homegrown SVOD with a catalog tailored specifically to the tastes of Australian audiences. Its original production strategy reflects this: by January 2022 Stan had released twenty-three locally made Stan Originals—including drama series, scripted and stand-up comedy, and a suite of films—all carefully calibrated to appeal to well-established local tastes, and in some cases to the preferences of international network partners.

Initially a joint venture between two Australian media companies, the national broadcaster Nine Network and the news publisher Fairfax

(these entities merged as Nine in July 2018), Stan pursues a Hollywood-hits-plus-local-originals strategy (Sneesby 2019). Its catalog has consistently comprised around 10 percent local content, with the rest being mostly made up of Hollywood movies and network and cable shows (Lobato and Scarlata 2019). To secure this library content, Stan was quick to strike content deals with Sony Pictures, Disney, Warner Brothers, and, later, NBCUniversal to augment the service's existing library of titles from the Nine Network library. In other words, Stan has long recognized that demand for U.S. content is in fact a defining feature of Australia's national TV market, and that a national SVOD service in Australia needs a mix of imported and local titles. Its originals strategy shores up the "local" part of this equation, while U.S. licensed content provides the "Hollywood" part.

In its early commissions, Stan invested in Australian comedy to differentiate its offerings from Netflix and other U.S.-based services. The absurdist police comedy *No Activity* (2015–2017)—Australia's first SVOD original series—lampooned the unprofessionalism of Australian police officers during stakeouts, tapping into a tradition of laconic, low-budget sketch comedy that was immediately recognizable, and appealing, to Australian audiences. *The Other Guy* (2017–), a semi-autobiographical comedy series based on the experiences of well-known Australian radio host Matt Okine soon followed. While aiming for a slow-burn style of comedy and a dark tone characteristic of many international SVOD commissions, *The Other Guy* also recalled Australian broadcast half-hour comedy series like *Please Like Me* (2013–2016, ABC) and *Fisk* (2021–, ABC); in this sense, it extended, rather than disrupted, local genre traditions. Stand-up comedy—a format rarely broadcast on Australian television—was another strategic genre investment. In 2017, Stan released a series of six stand-up comedy specials, *One Night Stan*, featuring popular Australian comedians performing in comedy venues to a live audience.

Alongside these lower-budget comedy titles, Stan has also commissioned several prestige titles—flagship series that presume an engaged,

binge-watching audience and explore adult themes unsuited to broad-cast television. Key titles include Stan's outback horror series *Wolf Creek* (2016–2017) and the gritty, racism-themed urban drama series *Romper Stomper* (2018). Both of these shows made extensive use of outdoor location shooting and were adapted from well-known Australian films, thus leveraging an existing audience while also positioning Stan's originals within a tradition of successful Australian cinema. *Bloom* (2019–) was a six-part supernatural mystery with elements of action, crime, adventure, and science fiction, set in regional Victoria. Set in the aftermath of a devastating flood, *Bloom*'s mix of sentimental adult drama and magic realism was firmly located within a long tradition of state-funded Australian film and television drama once described by Dermody and Jacka (1987) as the "AFC [Australian Film Commission] genre." Indeed, this link with Australian cinema funding and institutions remains important for the service: Stan has partnered with state government screen agencies on new idea and talent development schemes that now feed into its future pipeline of originals. In contrast to Netflix's preference to commission fully developed concepts, Stan's willingness to support speculative script development (including by emerging writers) signals its intent to establish a long-term pipeline of content and advertises its engagement with Australian screen institutions and industry. Once more, we see Stan claiming the role of a *national* media service.

Stan's most successful original series to date is the hyper-local family drama *Bump* (2021). Set in Sydney's multicultural Inner West, *Bump* is about an ambitious teenage girl, Oly (Olympia), who unknowingly falls pregnant and delivers her baby in a toilet cubicle. The show explores the complications that ensue for Oly, the baby's father, Santiago, and their respective parents. Scripts explore the culture clash between the two families (Australian and Chilean) as well as their different understandings of family life and experiences of everyday life in a large, complex city. *Bump* is reminiscent of popular 1990s Australian television shows such as *Heartbreak High* (1994–1999, Network Ten) and *Love My Way* (2004–2007, FOX8), yet it also incorporates some contemporary twists

on these old traditions, in line with Lotz's (2022) description of SVOD original style as "shifted 45 degrees" from what is familiar and readily available on ad-supported linear television. For example, the show uses a half-hour format (a relative novelty within premium scripted Australian drama production). Like *Bloom* and *Romper Stomper*, *Bump* has a majority-local cast—yet its multicultural orientation and youth focus gives it a more cosmopolitan character than previous Stan flagship dramas. As a generationally appropriate update to the teen/family drama, *Bump* also has strong genre credentials, allowing a certain kind of international legibility, as reflected in its licensing by the BBC, The CW in the United States, CBC in Canada, and HBO Max in Latin America.

Stan's production strategy cannot easily divorce national from international markets. Like most Australian screen productions, Stan originals are commonly presold to international studios or—more recently—coproduced with international partners; this is a longstanding practice that sustains ongoing national production by providing essential supplementary finance. A recent example is the Stan/BBC One action series *The Tourist* (2021), a transnational thriller set across remote Australia, which was produced by the UK-based Two Brothers Pictures. *The Tourist* is an unusually expensive, "premium" offering for Stan, within an uncommon and risky genre for Australian television producers (action-adventure). The show's strategic use of the Australian outback landscape, its globe-trotting story, and its transnational casting (Northern Irish actor and *Fifty Shades* star Jamie Dornan plays the lead role) suggest *The Tourist* has been designed to be both legible and engaging for audiences outside Australia as well as within it. The show marks a turning point for Stan's original production strategy, which is increasingly investing in big-budget, internationally oriented prestige shows rather than the more modest, self-consciously "local" titles it started out with (such as *No Activity* and *The Other Guy*).

What can we learn from Stan's original production strategy? Clearly, as a single-market service Stan is following a different strategy from its global competitors Netflix, Prime Video, and Disney+. Stan cannot

compete with these services when it comes to resources and production scale; it has focused its energies instead on a small number of carefully developed story ideas that make the best use of its deep knowledge of national tastes and viewing histories, capitalizing on its parent company's sixty-five-year history of media production in Australia. To succeed, Stan shows have attempted to offer something different from Netflix—something more locally resonant. Yet, as we have shown in our analysis, Stan also realizes that strong international sales and successful international coproductions are an essential part of building a sustainable national-SVOD business model.

Global SVOD Production Strategy in a Peripheral Market: Amazon's Prime Video

A contrasting approach can be seen in Prime Video, which has been available in Australia since 2016, first as a standalone service and then—following the local launch of Amazon's Prime membership scheme in 2018—as an integrated service within the Prime membership bundle. Unlike Stan, which has been producing originals since its launch, Prime Video did not commission any Australian content until 2019. However, by early 2022 it had released three sports documentary series; ten local comedy specials; discrete variety, reality, sketch comedy, and drama series; and commissioned six more titles. Since then, it has pursued a strategy that is, paradoxically, the inverse of Stan's approach—beginning with a global, multi-territory focus in its local commissioning choices before venturing into more distinctly local programming. Prime Video's approach to production in Australia is also different from other international SVOD services, including Netflix and Disney+, thus providing an instructive contrast that reflects the distinct character of Prime Video as a service integrated within a wider package rather than a standalone SVOD service.

To understand the Australian Prime Video originals we first need to consider the evolution of Prime Video as a service. The streamer has a

distinctive early history of supporting amateur, aspirational, and pro-am screen productions. After buying the industry standard Internet Movie Database (IMDb)—the data source bible for the industry—Amazon then, in 2008, followed this up with the acquisition of Without A Box, a fledgling internet company that helped independent filmmakers submit their films to more than 700 festivals in 200 countries and helped festival organizers manage and market events. This allowed Amazon to enter the streaming video market well *before* Netflix, using the brand Amazon Unbox. Compared to Netflix's storied reliance on big data to make creative decisions, Prime Video also demonstrated a more traditional reliance on pilots. However, much like Netflix, after Amazon Unbox, Prime Video initially adopted an original television production strategy that prioritized big budgets, recognizable actors, and high concepts, resulting in criticism that it had moved quickly away from "participatory culture" to "quality TV" (Barker 2017).

Netflix had its breakthrough originals *House of Cards* (2013–2018) and *Orange is the New Black* (2013–2019), and Prime Video laid down its early quality markers—*Transparent* (2014–2019) and *The Marvelous Mrs. Maisel* (2017–)—in turn. Netflix shifted its attention to a global rollout; Prime Video followed suit. But whereas Netflix has purposefully prioritized large subscriber bases and broad language communities, Prime Video investment in originals and licensing has been tracking international Prime subscriber growth closely. All standard subscriptions to Amazon Prime include free delivery of most purchased items (guaranteed free in North America), ad-free Amazon Music, a selection of free games, access to free in-game loot, and a Prime Gaming channel subscription with Prime Gaming, e-books, travel guides, and more with Prime Reading, along with Prime Video. The strategic approach with which Amazon had entered the audiovisual market is "not as a television provider per se, but as a seller of video products densely interlinked to multi-sided markets in retail, advertising, music, data and finance" (Tiwary 2020, 88). According to Ampere Analysis, by February 2021 Prime Video had produced 229 original titles. Just over half of

all Amazon Originals were produced in the United Stated, followed by India, the UK, Australia, Spain, Germany, and Mexico, among others (Ampere Analysis 2021)—representing Amazon's key established and emerging e-retail markets.

When Prime Video began to commission original Australian content in 2019 it adopted a risk-averse, multiterritory production strategy built around familiar topics and formats. First, Prime Video had been building up a range of sports documentary programming under the *All or Nothing* banner since 2016 (e.g., *All or Nothing: Manchester City*, *All or Nothing: Dallas Cowboys*). These documentaries followed miscellaneous international football, soccer, rugby union, and ice hockey associations/national teams and were clearly designed to appeal to both specific regional communities and fans of particular sports dispersed across Amazon's key retail markets. It was inevitable that Prime Video would use this strategy in Australia too. Coproduced by Cricket Australia, *The Test: A New Era for Australia's Team* followed the Australian men's cricket team during the 2018/2019 season, in the aftermath of a ball-tampering scandal. According to Prime Video's head of content ANZ, Tyler Bern (2021a), the series did well in India, the UK, South Africa, and Canada, as well as Australia. Prime Video went on to release Australian documentary series about the Australian Football League and the country's Olympic swimmers, as well as a documentary film about the nation's arguably most famous cricket player, Shane Warne.

Next, Prime Video utilized a range of reliable and relatively inexpensive formats to venture further into the local market, but again in a way that would be familiar and translatable in different regions, and that tried to mimic what other SVODs were making at the time. Following both Stan and Netflix (Scarlata 2020), Prime Video commissioned a suite of *Australia's Funniest Stand-up Specials* (2020) featuring local comedians performing on stage. It hired Australian actress Rebel Wilson (well known to international audiences from movies such as *Bridesmaids*) to host an Australian version of the Amazon original concept *LOL: Last One Laughing* (2020). Versions of the variety format, which

follows ten comedians and comedic actors trying to make each other laugh, had already been produced by Amazon in Japan and Mexico, and Prime Video has since produced eight more, in line with the established international format adaptation model that supplies customized local versions of shows for local audiences. Finally, the docu-reality series *Luxe Listings Sydney* (2021–) sought to capitalize on the success of Netflix's *Selling Sunset* (2019–) and Bravo's *Million Dollar Listing* franchises. Prime Video was producing in Australia, but with a strategic safety net and with targeted multiple international markets.

It was not until 2019 that Prime Video commissioned its first Australian drama series, *Back to the Rafters* (2021–). Mitigating risk in the time-honored way used by streamers, this was not based on an original concept but was a revival of the popular broadcast series *Packed to the Rafters* (2008–2013, Seven Network), a mainstream Australian prime-time drama about a multigenerational family living under the same roof. *Packed to the Rafters* was considered a "stylistic renovation and innovation" of popular Australian soap operas and "evidence of a shift on the part of Australian TV networks to perceiving potential in local drama as flagship programming" (Ward et al. 2010, 163). The reboot reunited the original cast and creative team behind the long-running favorite, picking up six years after where the original series left off. According to James Farrell, VP of international originals at Amazon Studios, "*Packed to the Rafters* is among the most beloved Australian series, and this revival will allow us to give our customers the locally relevant entertainment they want" (quoted in Haring 2019). It is ironic, but indicative of Prime Video's multi-options approach, that a U.S.-based global platform with only a short history in Australia would launch its local drama commissions with a surprisingly retro show, the most nostalgic "Australiana" series made in recent years.

In May 2021 Prime Video announced a slate of new titles that would take its investment in Australian productions since 2019 to $AU150 million (Slatter 2021). Focus had finally shifted to what Stan had started with: fully funded local scripted comedy and drama. The premium

drama *The Lost Flowers of Alice Hart* will arguably serve as a global flag-ship series for Prime Video. While based on the best-selling book by Australian author Holly Ringland, it is set to star Sigourney Weaver and will be produced by Bruna Papandrea of *Big Little Lies* (2017–2019, HBO) and *Nine Perfect Strangers* (2021, Hulu) fame. But most of the Prime Video Australian originals recently commissioned are distinctly local: *Class of '07* is an eight-part comedy series about a post-apocalyptic high school reunion, written and directed by *The Other Guy*'s Kacie Anning; *Deadloch* is a feminist noir comedy series by Kate McCartney and Kate McLennan, two veterans of the Australian public-service Australian Broadcasting Corporation (ABC). Bern described these new commissions as representing an "inflection point" in Prime Video's Australian pipeline (quoted in Slatter 2021). These are more akin to series that Stan first prioritized: serving a specific national market rather than exploiting global sports fandoms and popular formats. According to Bern (2021b), Prime Video is not looking to "sanitize the Australian-ness out of a project" and is no longer "trying to make a show that's going to do well in the UK."

Rethinking National/Global Distinctions

Our analysis of SVOD originals in Australia has taken us in some surprising directions. We began by emphasizing the important differences between national and global SVOD services, which have distinct institutional forms and follow different logics of production investment: national services cater primarily to a single market, while global services have a prerogative to commission content that engages viewers in many different countries. Yet in exploring how this plays out in Australian SVOD commissioning we found—to our surprise—that the institutional logics do not map neatly onto the content that these services produce. Indeed, our case study of Australian SVOD originals commissioned by Stan and Prime Video found that the production strategies of these two very different SVOD services seem to have more in common than one

might expect (or, more specifically, they have evolved in inverse ways but have landed in roughly the same place). Now, both are producing broadcast-like shows, using local stars and trusted formats, alongside a small number of more adventurous premium titles; and both have produced a mix of locally focused and more cosmopolitan titles.

The trajectory each service has followed in the national market tells us something about its current priorities. Stan started off producing defiantly local comedy shows but has since graduated to higher-budget, globe-trotting titles such as *The Tourist*. Prime Video has gone in the other direction, shifting investment from internationally adaptable formats attractive to viewers in multiple countries (e.g., sports, documentaries, reality) towards nostalgic, broadcast-like scripted dramas (*Back to the Rafters*) and recently announced comedies that tap deeply into the collective TV-viewing histories of the Australian audience.

The Australian case is of course specific, and each country has its own context. Some of what we have observed can be explained by the dynamics of a small-to-midsize national market, where there are a finite number of production companies, scripts in development, and writing talent; hence, SVODs must work with the resources available, which inevitably lends a common texture to some of the shows that emerge. The specificity of local policy conditions also plays a part: the threat of a legislated local content obligation on SVODs in Australia prompted pre-emptive investment in the production of "Australian stories," especially by global SVODs, to demonstrate their commitment to the local screen sector. Finally, while we have not discussed Netflix's local commissions here (other chapters in this book offer close attention to Netflix), we would note that its commissioning decisions shape in complex ways those of Stan and Prime Video, with the effect that all SVODs in Australia are now operating within a competitive field of deals, announcements, and releases. Taking all this into consideration, we are wary of extrapolating too far from this one case. However, it serves to illustrate the complex reality that, while there are clear distinctions to be made between the territorial and business strategies of national and global

SVOD services, their original production strategies exhibit dynamic diversity and surprising convergence.

Notes

1 Local content levels are much lower on Australian national SVODs than in Europe—a legacy perhaps of being part of a global Anglosphere market (Lobato and Scarlata 2019).
2 The distinction between SVOD and AVOD is blurry in China's case, as services can be viewed free with ads but also have a premium paid tier.

References

Afilipoaie, Adelaida, Catalina Iordache, and Tim Raats. 2021. "'The 'Netflix Original' and What It Means for the Production of European Television Content." *Critical Studies in Television* 16 (3): 304–25.

Albornoz, Luis A., and Ma Trinidad García Leiva. 2022. "Netflix Originals in Spain: Challenging Diversity." *European Journal of Communication,* 37 (1): 63–81.

Ampere Analysis. 2021. Analytics—SVOD Database. https://www.ampereanalysis.com.

Barker, Cory. 2017. "'Great Shows, Thanks to You': From Participatory Culture to 'Quality TV' in Amazon's Pilot Season." *Television & New Media* 18 (5): 441–58.

Bern, Tyler. 2021a. In "Meet the Buyers: Scripted 1" Panel, Screen Forever Conference, Brisbane, February 17, 2021.

Bern, Tyler. 2021b. In "SPA Pitch on Demand" Online Panel, Screen Producers Australia, November 3, 2021.

Dermody, Susan, and Elizabeth Jacka. 1987. *The Screening of Australia.* Sydney: Currency Press.

Elkins, Evan. 2019. *Locked Out: Regional Restrictions in Digital Entertainment Culture.* New York: NYU Press.

Grece, Christian. 2018. "Films in VOD Catalogues—Origin, Circulation and Age—Edition 2018." European Audiovisual Observatory, Strasbourg.

Grece, Christian, and Marta Jiménez Pumares. 2020. "Film and TV Content in VOD Catalogues—2020 Edition." European Audiovisual Observatory, Strasbourg.

Haring, Bruce. 2019. "*Back to the Rafters* Will Bow as First Amazon Original Scripted Drama in Australia." *Deadline,* December 5, 2019. https://deadline.com/2019/12/back-to-the-rafters-amazon-original-scripted-drama-australia-1202801914/.

Lobato, Ramon. 2019. *Netflix Nations: The Geography of Digital Distribution.* New York: NYU Press.

Lobato, Ramon, and Alexa Scarlata. 2019. "Australian Content in SVOD Catalogs: Availability and Discoverability—2019 Edition." http://apo.org.au/node/264821.

Lotz, Amanda D. 2021. "In Between the Global and the Local: Mapping the Geographies of Netflix as a Multinational Service." *International Journal of Cultural Studies* 24 (2): 195–215.

Lotz, Amanda D. 2022. *Netflix and Streaming Video: The Business of Subscriber-Funded Video on Demand*. Cambridge: Polity.

Meimaridis, Melina, Daniela Mazur, and Daniel Rios. 2020. "The Streaming Wars in the Global Periphery: A Glimpse from Brazil." *Series* 6 (1): 65–76.

Reilly, Claire. 2016. "From 'Twin Peaks' to 'Star Trek': Stan Partners with Showtime." CNet, January 27, 2016. https://www.cnet.com/news/from-twin-peaks-to-star-trek -stan-partners-with-showtime/.

Rios, Sofia, and Alexa Scarlata. 2018. "Locating SVOD in Australia and Mexico: Stan and Blim Contend with Netflix." *Critical Studies in Television* 13 (4): 475–90.

Scarlata, Alexa. 2020. "Stand-Up Comedy: The Great Netflix Localiser?" *In Media Res*, June 26, 2020. https://mediacommons.org/imr/content/stand-comedy-great-netflix -localiser.

Slatter, Sean. 2021. "Amazon Unveils Seven New Australian Originals." *Inside Film*, May 18, 2021. https://if.com.au/amazon-unveils-seven-new-australian-originals.

Sneesby, Mike. 2019. "In Conversation with Stan" Panel. Screen Forever Conference, Melbourne, November 13, 2019.

Straubhaar, Joseph, Melissa Santillana, Vanessa de Macedo Higgins Joyce, and Luiz Guilherme Duarte. 2021. *From Telenovelas to Netflix: Transnational, Transverse Television in Latin America*. Cham: Palgrave Macmillan.

Szczepanik, Petr, Pavel Zahradka, Jakub Macek, and Paul Stepan, eds. 2020. *Digital Peripheries: The Online Circulation of Audiovisual Content from the Small Market Perspective*. Cham: Springer.

Tiwary, Ishita. 2020. "Amazon Prime Video: A Platform Ecosphere." In *Platform Capitalism in India*, edited by Adrian Athique and Vibodh Parthasarathi, 87–106. Cham: Palgrave Macmillan.

Ward, Sue, Tom O'Regan, and Ben Goldsmith. 2010. "From *Neighbours* to *Packed to the Rafters*: Accounting for Longevity in the Evolution of Aussie Soaps." *Media International Australia* 136:162–76.

3

Place in Netflix Original Police Drama

Local Signifiers and Global Audiences

MICHAEL L. WAYNE

Netflix executives frequently characterize the company's global content strategy as being centered on commissioning "local for global" drama series (Hopewell and Lang 2018). Within this discourse, executives assert the importance of the connections between the national background of producers and the cultural specificity of series themselves. For example, Netflix's head of global TV, Bela Bajaria, explains local producers are "extraordinarily empowered, local decision makers" who "make the decisions in their own time zone in their own country and in their own language" which results in the export of "local authentic stories and shows [to] everywhere around the world" (Ramachandran 2021). Yet, there are multiple reasons to be skeptical of such discursive efforts to frame locally produced series as authentic national productions. At the macro level, scholars argue that large-scale industrial shifts, including the increasing transnationalization of television production and the tendency to produce for the international market, limit the understanding of content like drama series in national terms (Esser 2017). At the micro level, the impact of such shifts is also visible in Netflix's global originals. As Scarlata, Lobato, and Cunningham (2021) observe in the case of the streamer's first major Australian commission, *Tidelands* (2018), local producers are asked to balance the demands of international legibility and local cultural specificity in their creative choices regarding locations, casting, and genre.

To continue exploring cultural specificity in Netflix-commissioned series, this chapter examines the role of place at the level of the text in the police dramas *Dogs of Berlin* (Germany, 2018) and *Young Wallander* (Sweden/UK, 2020–). Both series feature the type of antiheroic detective protagonist that has become increasingly common since the premiere of FX's *The Shield* in 2002 (Wayne 2014). The role of the detective, an agent of the state, is particularly significant as such characters frequently confront social issues and concerns prevalent in a society. Despite the relatively recent emergence of this specific type of television protagonist, scholars commonly approach police dramas, as a genre, as texts that simultaneously foreground "local narratives of moral and legal problems that are not only cross-cultural but also universal" (Hansen, Peacock, and Turnbull 2018, 2). This interplay of the local and global has additional implications in light of the dominant academic and industrial understandings of international television program flows, which tend to posit that local specificity limits the potential for global appeal (Bielby and Harrington 2008).

Given the value Netflix claims to derive from culturally specific yet multinationally legible stories, this chapter unpacks the significance of place in *Dogs of Berlin* and *Young Wallander* as police dramas attempting to become recognizable for local viewers while remaining familiar and accessible for nonlocal audiences. Within the storytelling, these conflicting imperatives are balanced by situating narrative conflict in conditions characterized by socially specific inequalities but framing narrative resolution in broad, universal terms. The emphasis on class identity in *Dogs of Berlin* and reactionary anti-immigrant politics in *Young Wallander* works to place these police dramas in the context of the multiethnic European city. Yet, both series offer placeless narrative closure unconnected to the social context in which the larger story has been situated. Ultimately, the shifting importance of place in the narrative arcs of these police dramas provides a useful starting point for further explorations of cultural specificity in transnational television series.

TV Police Drama, Global Television Flows, and Place

Although a productive analysis of cultural specificity in Netflix-commissioned series could utilize a variety of perspectives, this chapter approaches *Dogs of Berlin* and *Young Wallander* as television police dramas. According to Nichols-Pethick (2012, 3), "Perhaps more than any other genre, the police series in all its manifestations embodies the cultural dynamics of television in the way it necessarily incorporates (ingests) a range of current social and political issues (in the name of timely realism and relevance), filters them through the 'rules' of the genre, the demands of coherent narrative, and the structure of the industry itself, and then projects them in the form of stories about individuals (police, lawyers, criminals, victims, witnesses, citizens) caught in the messy webs of politics and power."

Scholars observe that the genre's narrative conventions have become more varied over the past two decades (Jenner 2016). On one hand, crime-of-the-week series like those of the *CSI* and *Criminal Minds* franchises remain common. These shows largely rely on "a closed episodic structure in which all major narrative threads (usually one particular case and a secondary narrative) are resolved by the end of each episode" (Nichols-Pethick 2012, 7). But also, police dramas have been central to the discourses of "complex" television (Mittell 2015) as serialized narratives like HBO's *The Wire* (2002–2008) are celebrated for depictions of crimes that cannot be solved and the willingness to deny audiences a sense of moral certainty. Despite such variations, the connective tissue within the genre remains the narrative conflict initiated by criminal activity and the narrative resolution (or lack thereof) that emerges in response.

Historically, police drama has always traveled well. As Weissman (2012) observes, the genre was central to the flow of television content between the United States and the UK in the 1970s and 1980s. The global reach of the *CSI* franchise led scholars to claim that the show was the most popular TV series in the world at the turn of the millennium (Turnbull 2007). This popularity has continued in the era of internet streaming television with "Crime & Thriller" composing the

second largest portion of Netflix libraries by genre in data aggregated from major countries. Explanations for crime drama's popularity, however, have changed significantly in recent years. Traditionally, scholars concerned with the global flows of television content have mirrored traditional industry wisdom regarding audience preferences for local (de Sola Pool 1975) or culturally proximate (Straubhaar 1991; 2007) content. Although a detailed discussion of this scholarship is outside the scope of this analysis, these theorizations assert that local specificity limits international appeal. As a result, the most successful properties in the global television market are thought to be the product of strategic efforts to "deculturize" narrative content (Bielby and Harrington 2008, 89). From prime-time soap operas (Liebes and Katz 1990) to more recent reality formats (Stehling 2013), academics note that globally popular content frequently includes elements to which audiences from a variety of cultural backgrounds can relate, and police drama has this universality. It is this notion of universal appeal that is often used to explain the success of a particular series in spite of national audiences' preferences for local content.

Industrial developments in the past decade tied to digital distribution have reduced the importance of linear scheduling and created alternatives to advertiser-supported economic models, leading many scholars to reevaluate these dominant theories of global television flows. The international success of non-English-language dramas from small national markets in the early 2010s, like the Danish series *The Killing* (2007–2012, DR1) and the Danish-Swedish coproduction *The Bridge* (2011–2018, SVT1/DR1), calls into question the supposedly inverse relationship between cultural specificity and global popularity. As Waade, Novrup Redvall, and Jensen (2020, 6) note in the introduction to their edited collection on Nordic television drama, "The fact that a small nation such as Denmark can produce content that is attractive to a broader global media market, and influence cultural trends, challenges the center/periphery dichotomy that has dominated global media culture." More recently, global SVOD platforms' significant investments in local drama series intended for transnational audiences reflect similar shifts within

industry logic. As Wayne and Uribe Sandoval (2021) observe, Netflix executives consistently link the global popularity of original series to cultural specificity. This specificity, typically described as "authenticity," is understood as a reflection of the local culture in which a series' narrative is situated. Netflix's longtime chief content officer and now co-CEO Ted Sarandos is explicit about the connection between global streaming success and local authenticity. He explains, "Well, we've kept one strict principle around it, which was that these shows have to be very locally relevant and to do that you have to be pretty authentically local. So (what) we're trying not to do is try to inauthentically make a global show, because just basically that doesn't work for anybody. So the more authentically local the show is the better it travels" (Netflix 2019). Of course, like most of Netflix's public discourses related to the success of specific series (Wayne 2022), Sarandos's comments regarding local authenticity here convey little substantive information regarding the relationships between such vaguely defined textual features that create "authenticity," a show's larger narrative arc, and what compels viewers to watch.

To avoid the muddiness of Netflix's discursive reliance on ambiguous notions of local authenticity, this chapter employs the less problematic concept of place. As Hansen and Waade (2017, 8) observe, place is central in police drama since "the entire genre revolves around crime scene investigations, which means that the basic narrative catalyst in crime fiction is a spatial one." Typically, scholars understand a television series' relationship to place as existing at the level of the series itself. Fuqua (2012, 238) provides a characteristic example in her analysis of HBO's *Treme* (2010–2013): "While some television is generic in its denial of place specificity, other series going all the way back to *Dragnet* [1951–1959], with its focus on Los Angeles, are dependent on place, on the particularity of context, for their meaning." Similarly, Lotz and Potter (2022) posit that series can be situated along a continuum of increasing specificity from "placeless" to "place-based" with "placed" series being somewhere in the middle. To complicate these series-level understandings, this analysis examines the role of place within the nar-

rative contexts of *Dogs of Berlin* and *Young Wallander* by focusing on the representation of class identity and anti-immigrant sentiment, respectively. As I argue in the following sections, the narratives in both of these Netflix-commissioned police dramas are driven by conflict that is initially framed as place-specific. However, this specificity fades as the story unfolds and, ultimately, the audience is offered placeless narrative resolution.

Dogs of Berlin

Created and directed by well-known filmmaker and screenwriter Christian Alvart, *Dogs of Berlin* was Netflix's second German original series (Netflix 2017). The ten-episode narrative begins with the murder of Orkan Erdem, a German-Turkish football star, the night before an international match between Germany and Turkey. The main investigator and primary protagonist is corrupt detective Kurt Grimmer, who cheats on his wife, owes significant gambling debts to Croatian organized criminals, and was a member of a neo-Nazi gang in his youth. Erdem's body is discovered in the run-down area of Marzahn, which, as a part of what was East Berlin, is home to a population known to hold right-wing views. A variety of criminal groups are suspected of the murder including Kameraden Marzahn, a neo-Nazi organization led by Grimmer's brother and mother and whose territory includes the murder scene. Members of Tarik-Amir, the Lebanese mafia, are also suspects as a result of their efforts to take over Berlin's illegal gambling market from the Croatians and blackmail professional football players into fixing matches. For political reasons, Grimmer is forced by superiors to partner with Turkish-German investigator Erol Birkan who is already investigating the Tarik-Amir clan for drug trafficking and has a personal history with the Tarik-Amir as a result of growing up in the fictional Kaiserwarte neighborhood with Hakim, now the clan leader. Although Kaiserwarte differs from Marzahn in that the former is fictional while the latter is not, the area has clear parallels with Berlin's Neukolln district,

which German media often portray as being controlled by criminal Arab groups (Somaskanda 2019).

With regards to the relationship between representations of social class and the murder investigation that drives *Dogs of Berlin*'s narrative, the difference between Grimmer's middle-class life as a detective in West Berlin and the economically marginal world of his youth in East Berlin is stark. The upscale home Grimmer shares with his wife Paula and their two children sits on a tree-lined street in an idyllic neighborhood. Paula, presented as educated and proper, owns an unprofitable interior design shop located in a middle-class shopping district. In contrast, characters associated with Grimmer's youth, including his mother, brother, and girlfriend, live in the Marzahn area of East Berlin. Here, the residential areas and apartment blocks, including the scene of Erdem's murder, are depicted as harsh and industrial. Grimmer's girlfriend Bine is an online sex worker who also receives social assistance. His mother Eva and brother Ulf work together on a residential painting crew. The most significant difference, however, between Grimmer's middle-class life in West Berlin and his family of origin's working-class life in East Berlin is their political and racial ideology. As members of Kameraden Marzahn, Eva and Ulf Grimmer are proud neo-Nazis. When a Turkish boy takes her granddaughter's turn on the playground slide in an early episode, for example, Eva chastises the girl, saying, "You can't let some Kanak [derogatory term] take your place." She then shouts at the boy's father to "go back where you came from."

In addition to the anti-immigrant sentiment associated with the contemporary nationalist right, the ideology of Eva and other Marzahn residents includes a politics of resentment regarding the economic collapse of East Germany during reunification. Describing the period following the fall of the Berlin Wall, Eva says that "they took away from me and my husband everything a second time," and she was forced to work in a shopping mall. Throughout the series Grimmer displays consistent distain for the ideologies that defined his youth and continue to hold sway in Marzahn. Yet, his transition from working-class neo-Nazi youth

to middle-class police detective is not extensively detailed. Instead, he opaquely identifies his wife as the impetus for the shift. Nonetheless, the class distinctions represented by these characters and the social worlds they inhabit are particularly important to the narrative resolution provided in the season's last three episodes.

In the midst of multiple storylines involving Berlin's various criminal groups and family conflicts in the personal lives of the protagonists, the first break in the investigation of Erdem's murder comes at the conclusion of the seventh episode when, on a hunch, Grimmer locates the victim's missing Lamborghini in a garage belonging to apartment 36, which overlooks the crime scene. Albert Meiser, the middle-aged man living in apartment 36, appears in the first episode of the series as a potential witness. He tells Grimmer and a young police officer that he heard the victim's car after the murder and saw three boys with a baseball bat who all were wearing "jogging pants stuffed into their socks," a style distinctive to Turkish youth. Although Meiser does not definitively identify the ethnicity of the individuals he saw, he is quite explicit that they are not German youth from Marzahn, noting, "German kids roll up their pants. I've only seen the thing with pants in socks in the subway." The caricature of Meiser as a stereotypical Marzahn resident is supported by the World War II memorabilia, model airplanes, and portrait of a German shepherd that decorate his apartment. In fact, his apartment is quite similar in appearance to Kameraden Marzahn's clubhouse, albeit without the explicit Nazi imagery.

Meiser does not make another appearance until episode eight when Grimmer brings photos of potential suspects and asks if he can identify the individuals he claims to have seen on the night of the murder. Looking at the photos of Croatian gangsters to whom Grimmer is indebted, Meiser fails to make an identification, saying, "Southern Europeans all look the same to me." Here, the sense of ethnonationalist superiority acts in conjunction with Grimmer's knowledge that Meiser is hiding the victim's car in his garage—priming the audience's expectation that the murder had something to do with Erdem's ethnicity.

Yet, in the season's penultimate episode, Meiser admits to the murder but denies that the crime was racially motivated. After telling Grimmer about his careers in both the East and West German militaries and asserting that he "never once" broke the law, Meiser explains that he hates all people equally. He says, "[Turkish immigrants] come over here; they shit on our rules; they shit on our lawns. Not that our people are any better. Don't get me wrong. They're idiots, every last one of them. I'll be honest. I hate them all." He continues:

> But do you know what I hate even more? Their fucking dogs. They shit everywhere. They shit on my little patch of grass, and I take care of that grass. They shit right under my window, and I shouted at them. I dropped buckets of water. Even put up a sign, "No dog shit," on the lawn. I used that sign [as the murder weapon] when that filthy Turk got out of his flashy car, a car that costs a quarter mil[lion], so his dirty dog could shit on my poor man's lawn. Mylittle piece of green.

Meiser's claim that the murder was an interpersonal conflict is affirmed later in the episode during a conversation between the series' protagonists. After Grimmer explains that Mesier killed Erdem, Erol asks if the precipitating incident was a "stupid argument?" Grimmer responds that Erdem's dog "took a shit on [Meiser's] patch of grass." But instead of arresting Meiser immediately, Grimmer convinces Erol that delaying the arrest would be in the interest of the greater good and allow their task force to finally take down the Tarik-Amir clan. The last time the audience sees Meiser, Grimmer delivers a warning: "If I ever catch you even stealing gum, I will put you away for murder, got it?" The scene ends with Grimmer telling Erdem's killer, "And, Meiser, I hate assholes like you. So don't test my patience." However, the threat of a pending murder charge is significantly diminished by developments in the following episode when Grimmer and Erol frame Tarik-Amir's second-in-command for the crime. Following a raid during which the rest of the clan's leadership is arrested

or killed, the season ends with a sense that the greater justice has been served even though Meiser remains a free man.

Young Wallander

Premiering in September 2020, the six-episode first season of Netflix's original series *Young Wallander* is a prequel (of sorts) to Henning Mankell's best-selling Wallander detective novels. The twelve books featuring Swedish detective Kurt Wallander have already served as the basis for multiple television series including a BBC adaptation (2008–2016) starring Kenneth Branagh and a Swedish series produced by Yellow Bird (2005–2013) starring Krister Henriksson (both titled *Wallander*). Although *Young Wallander*'s protagonist is younger than any of the versions of the Wallander character to appear in the novels or other television series, this most recent series is set in the present. Another important difference between *Young Wallander* and the earlier series is that the narrative is situated in Malmo rather than the small coastal city of Ystad. The series was filmed in Vilnius, but head writer Ben Harris observes that he drew inspiration from the social conditions in Sweden. He explains, "If you're going to do a story about [Malmo], it has to have immigration as a central theme and the gang problem it's created, but it's more complex than that. The immigration problem is used by more powerful entities for their own ends" (Pickard 2020).

The series begins with rookie police officer Wallander and his partner Reza Al-Rahman dealing with nuisance complaints like noise violations. After his shift, Wallander returns home to a dilapidated apartment complex in the Rosengård neighborhood of Malmo. Like Berlin's Neukolln district that serves as the basis of Kaiserwarte in *Dogs of Berlin*, media reports involving Rosengård frequently emphasize the relationship between high crime rates, poverty, and the district's large immigrant population (Gozal 2019). In the series, the neighborhood is controlled by Bash, an East African immigrant whose gang runs the local drug

trade. As it appears to the audience, Rosengård is so rough that Wallander must conceal his professional identity as a police officer for his own safety.

Later that night, Wallander is woken by alarms resulting from a fire set in a maintenance room as a distraction. Outside in the courtyard, he finds Hugo Lundgren, a white Swedish teenager, tied to a chain-link fence and with duct tape across his mouth. His face has been painted yellow and blue to resemble the Swedish flag. Wallander pushes his way through a group of neighborhood (presumably immigrant) youths mocking Lundgren and taking pictures. After Wallander identifies himself as a police officer, someone in the crowd shouts, "Wait, you're a pig living here with us?" But before Wallander reaches the fence, an unknown Middle Eastern man in a black hoodie approaches Lundgren and rips the tape from his mouth, revealing a grenade that soon denotates, killing the teen.

As indicated by the face paint and the demographic composition of the Rosengård crowd, Lundgren's murder is framed in the broader social context of immigration and reactionary anti-immigrant politics occurring in Malmo. That evening, the police quickly arrest Ibra, a neighborhood teenager living with his mother Mariam, after learning of a prior fight he had with the victim. Earlier in the episode, the audience learns that Ibra has recently been offered a professional football contract. As the child of an immigrant, however, the fight and any behavior that might be perceived as risky threatens the family's only option for upward social mobility, as demonstrated when Mariam asks Ibra, "Are you out of your mind? You want to throw away your entire future? Everything we fought for?" Although Wallander believes Ibra to be innocent, the young man refuses to talk to the police.

Even with a suspect in custody, there are concerns that the murder will cause further violence at a planned anti-immigration march the next day. At the police station, Wallander and his colleagues watch a news report in which the anchor semi-rhetorically asks, "Will the horrific nature of Hugo Lundgren's murder be a tipping point in public

opinion of migration and asylum policies?" The report then cuts to a response offered by billionaire philanthropist Gustav Munck whose family foundation redeveloped the Rosengård estate and funds humanitarian organizations that support immigrants. After characterizing the murder as "the insane actions of one or two individuals," Gustav says that he doesn't believe that "people would be ignorant enough to see an isolated incident as the rejection of Swedish values." Some of Wallander's fellow officers explicitly reject Gustav's conflation of pro-immigration politics with Swedish values. After turning off the television, Wallander's boss remarks that a "billionaire telling people their worries don't matter" is "not exactly helpful" as they prepare to keep the peace at the anti-immigration march.

At the march, the police (including Wallander's unit) are protecting a group of anti-immigration protesters from a larger group of pro-immigration/antiracist counterprotesters. After breaking up a small fight, a woman with the counterprotests asks Wallander, "Is this why we pay our taxes? So police can protect fascists?" Wallander replies that he is just doing his job, to which the woman retorts, "How can you live with yourself?" The exchange ends with the woman calling Wallander a "fascist pig." The march descends into chaos when the police are overwhelmed by members of the Norse Protection League, a nationalist white supremacist group who are attempting to storm a church secretly housing illegal immigrants. In the melee, Wallander spots the Middle Eastern man from the night of Lundgren's murder and leaves his colleagues to give chase. The suspect stabs Wallander after a brief struggle. When he wakes up in the hospital, Wallander learns that his partner, whom he abandoned at the march, was beaten and is now lying in intensive care.

In subsequent episodes, the racism displayed by the anti-immigration protesters becomes linked with middle-class, not working-class, social identities. In the third episode, the police question Otto Norlen, a prominent member of the Norse Protection League and the individual identified as assaulting Wallander's partner. After learning that Norlen is a married real estate agent and father of three, Wallander remarks, "He

looks so normal." During questioning, Norlen frames his anti-immigrant sentiment in legal rather than racial terms and characterizes sheltering illegal immigrants in a church as a "disrespectful" example of "flagrant lawbreaking." In the narrative universe of *Young Wallander*, similar anti-immigrant racism is expressed by multiple characters presented as middle-class. For example, the victim's father, Rickard Lundgren, tells Wallander that the police will be unable to provide justice for his son. He says, "Even if you do [find the killer], nothing will happen. You can't prosecute [illegal immigrants]. People [will] think we're discriminating. There is no justice anymore."

Despite *Young Wallander*'s emphasis on the lack of opportunity for immigrants in Sweden, the social influence of out-of-touch billionaires, and common anti-immigrant sentiment among the seemingly respectable middle classes, these issues are largely narrative misdirection. Although Lundgren's killer is revealed to be an immigrant from Afghanistan, the crime was set in motion by Gustav Munck's older brother Karl-Axel. After following a complex trail of clues through four episodes, in the season's penultimate episode, Wallander learns that Leopold Munck, the family patriarch dying of liver cancer, recently changed his will to give the entire estate to Gustav, the second son. In the following episode, Leopold explains to Wallander that Gustav is being rewarded for his charitable work with the family foundation. With this knowledge, Wallander pieces together the motive for Lundgren's murder and the various criminal acts that follow. In response to losing his inheritance, Karl-Axel attempts to demonstrate his worthiness by exposing Gustav's activities hiding immigrants, thereby embarrassing his brother. When Wallander confronts Karl-Axel with his suspicions and circumstantial evidence, it becomes clear that the murder was driven by pride rather than money. Wallander asks, "What must that feel like? I mean, losing out on the money is one thing, but to be the only eldest Munck to be shamed like this so publicly in favor of your younger brother." But Karl-Axel doesn't crack and his lawyer ends the interrogation. Wallander follows Karl-Axel outside and tells him, "You're gonna pay for

the things you've done. Your money won't always be there to save you."
Karl-Axel replies, "Whatever keeps you warm at night." The season con-
cludes with Wallander, frustrated by his inability to prove Karl-Axel's
guilt, asserting that he is not "cut out for this" and resigning from the
Malmo police force.

Conclusion

Approaching *Dogs of Berlin* and *Young Wallander* as police dramas, this
chapter highlights the similar ways in which these Netflix-commissioned
series use place-specificity to ground narrative conflict before offering
the sort of placeless narrative resolution that could occur anywhere. De-
spite the nuanced depictions of class-based identity in contemporary
Berlin, *Dogs of Berlin* explains the murder of a wealthy, prominent mem-
ber of an ethnic minority group by a racist, economically marginalized
member of the dominant ethnic group as the result of strangers arguing
over dog shit. Although *Young Wallander* is, in comparison, less invested
in Malmo's social complexity, the series uses the lack of economic op-
portunity for immigrants and the spread of reactionary anti-immigrant
politics among the Swedish middle classes as the narrative context for
a murder stemming from a billionaire's wounded pride. In both series,
audiences are offered closure that is unconnected to the markers of
place that help situate these stories socially and geographically. And, as
a scholar interested in television's representations of inequality and as a
committed viewer of police drama, I sense that something has been lost
when narrative resolution is framed in universal terms that are discon-
nected from the specificity of place constructed by these stories. None-
theless, it seems premature to draw substantive conclusions about the
relationship between cultural specificity in these series and broader is-
sues related to the ways in which Netflix understands its transnational
audiences.

Instead, the placed-to-placeless shift that occurs in these narratives
offers an interesting wrinkle to the typical series-level understandings of

cultural specificity in television drama. On one hand, the importance of place in framing the central crime in both *Dogs of Berlin* and *Young Wallander* could lead one to reasonably situate these series among strongly place-based shows like *The Shield* and *The Wire* where the particular urban landscapes of Los Angeles and Baltimore, respectively, seem inseparable from the narrative that unfolds within them (García 2017). On the other hand, by assigning primary importance to the resolutions offered by police dramas, it is equally reasonable to think of these Netflix originals as including narrative elements that resemble those of series that "could be located in any major city" (Horan 2007, 200) and that have traditionally dominated the international content trade. Just to be clear, this chapter does not take a position regarding how cultural specificity in *Dogs of Berlin* and *Young Wallander* should be understood, nor is the narrative-level approach to place that has been sketched here intended as a challenge or a critique of series-level perspectives. Rather, this analysis indicates the types of questions and further analysis needed to interrogate executive rhetoric about local "authenticity" and develop a broader conversation about the significance of place and cultural specificity in Netflix-commissioned dramas.

References

Bielby, Denise D., and C. Lee Harrington. 2008. *Global TV: Exporting Television and Culture in the World Market.* London: NYU Press.

de Sola Pool, Ithiel. 1975. "Direct-Broadcast Satellites and Cultural Integrity." *Society* 12 (6): 47–56.

Esser, Andrea. 2017. "Form, Platform and the Formation of Transnational Audiences: A Case Study of How Danish TV Drama Series Captured Television Viewers in the United Kingdom." *Critical Studies in Television* 12 (4): 411–29.

Fuqua, Joy V. 2012. "'In New Orleans, We Might Say It Like This . . .': Authenticity, Place, and HBO's *Treme*." *Television & New Media* 13 (3): 235–42.

García, Alberto N. 2017. "Baltimore in *The Wire* and Los Angeles in *The Shield*: Urban Landscapes in American Drama Series." *Series-International Journal of TV Serial Narratives* 3 (1): 51–60.

Gozal, Samare. 2019. "Malmo, a Segregated City—Separating Fact from Fiction." *EUobserver* (blog), November 18, 2019. https://euobserver.com/social/146538.

Hansen, Kim Toft, Steven Peacock, and Sue Turnbull. 2018. "Down These European Mean Streets: Contemporary Issues in European Television Crime Drama." In *European Television Crime Drama and Beyond*, edited by Kim Toft Hansen, Steven Peacock, and Sue Turnbull, 1–19. Cham: Springer.

Hansen, Kim Toft, and Anne Marit Waade. 2017. *Locating Nordic Noir*. Basingstoke: Palgrave Macmillan.

Hopewell, John, and Jamie Lang. 2018. "Netflix's Erik Barmack on Ramping Up International Production, Creating Global TV." *Variety*, October 11, 2018. https://variety.com/2018/tv/global/netflix-erik-barmack-international-production-global-tv-1202976698/.

Horan, Dermot. 2007. "RTÉ and the *CSI* Franchise." In *Reading CSI: Crime TV under the Microscope*, edited by Michael Allen, 198–200. London: I.B. Tauris.

Jenner, Mareike. 2016. *American TV Detective Dramas: Serial Investigations*. London: Palgrave Macmillan.

Liebes, Tamar, and Elihu Katz. 1990. *The Export of Meaning: Cross-Cultural Readings of Dallas*. Cambridge: Polity Press.

Lotz, Amanda D., and Anna Potter. 2022. "Effective Cultural Policy in the Twenty-First Century: Challenges and Strategies from Australian Television." *International Journal of Cultural Policy*, https://doi.org/10.1080/10286632.2021.2022652.

Mittell, Jason. 2015. *Complex TV*. New York: NYU Press.

Netflix. 2017. "Netflix Announces *Dogs of Berlin* Created by Christian Alvart as Its Second German Title," press release, April 28, 2017. https://about.netflix.com/en/news/netflix-announces-dogs-of-berlin-created-by-christian-alvart-as-its-second-german-title.

Netflix. 2019. "Q1 2019 Netflix Inc Earnings Call." April 16, 2019. Available at https://ir.netflix.net/financials/quarterly-earnings/default.aspx.

Nichols-Pethick, Jonathan. 2012. *TV Cops: The Contemporary American Television Police Drama*. London: Routledge.

Pickard, Michael. 2020. "The Young One." *Drama Quarterly* (blog), September 2, 2020. https://dramaquarterly.com/the-young-one/.

Ramachandran, Naman. 2021. "APOS: Netflix's Bela Bajaria Pinpoints the Duality of Local Authenticity on a Global Platform." *Variety*, April 20, 2021. https://variety.com/2021/streaming/asia/netflix-bela-bajaria-local-content-global-platform-1234955421/.

Scarlata, Alexa, Ramon Lobato, and Stuart Cunningham. 2021. "Producing Local Content in International Waters: The Case of Netflix's Tidelands." *Continuum* 35 (1): 137–50.

Somaskanda, Sumi. 2019. "'Not Just Horror and Crime': Parallel Worlds in Berlin's Neukolln." *Al Jazeera*, January 12, 2019. https://www.aljazeera.com/features/2019/1/12/not-just-horror-and-crime-parallel-worlds-in-berlins-neukolln.

Stehling, Miriam. 2013. "From Localisation to Translocalisation: Audience Readings of the Television Format *Top Model*." *Critical Studies in Television* 8 (2): 36–53.

Straubhaar, Joseph D. 1991. "Beyond Media Imperialism: Assymetrical Interdependence and Cultural Proximity." *Critical Studies in Media Communication* 8 (1): 39–59.

Straubhaar, Joseph D. 2007. *World Television: From Global to Local.* Thousand Oaks: SAGE Publications.

Turnbull, Sue. 2007. "The Hook and the Look: *CSI* and the Aesthetics of the Television Crime Series." In *Reading CSI: Crime TV under the Microscope*, edited by Michael Allen, 15–32. London: I.B. Tauris.

Waade, Anne Marit, Eva Novrup Redvall, and Pia Majbritt Jensen. 2020. *Danish Television Drama: Global Lessons from a Small Nation.* Basingstoke: Palgrave Macmillan.

Wayne, Michael L. 2014. "Mitigating Colorblind Racism in the Postnetwork Era: Class-Inflected Masculinities in *The Shield, Sons of Anarchy,* and *Justified.*" *Communication Review* 17 (3): 183–201.

Wayne, Michael L. 2022. "Netflix Audience Data, Streaming Industry Discourse, and the Emerging Realities of 'Popular' Television." *Media, Culture & Society* 44 (2): 193–209.

Wayne, Michael L., and Ana C. Uribe Sandoval. 2021. "Netflix Original Series, Global Audiences and Discourses of Streaming Success." *Critical Studies in Television*, 1–20. https://doi.org/10.1177/17496020211037259.

Weissmann, Elke. 2012. *Transnational Television Drama: Special Relations and Mutual Influence between the US and UK.* London: Palgrave Macmillan.

4

"OTT Is Exactly What TV Is Not"

Structural Adjustment and Shifts in Indian Scriptwriting

ISHITA TIWARY

The first episode of *Paatal Lok* begins almost innocuously. A schoolyard setting. The scene opens in soft focus and closes in on a gang of three male friends, lulling the audience into thinking that they would play a major role in this episode. The camera angle changes. It now tracks them from behind, as if they are being followed. Extreme close-up of one friend's head. A hammer striking against it. The camera circles around the attacker, covered in blood. A sense of dread and horror seeps in. One of the friends runs; the camera captures the action in a series of long and mid shots. The attacker strikes him with his hammer now; the audience sees his brain seeping from his skull. Blood and gore. The attacker then approaches the remaining friend and asks him to finish the story. Mid-long shots of them from behind, while their conversation is filmed in a series of mid-close shots. The friend's face trembles. The stoic, intense, blood-covered attacker listens to him. Then strikes him with his hammer. Cut to credits. *Paatal Lok* (series title), "A History of Violence" (episode title).

I begin with this example to illustrate the distinctive storytelling decisions that add heft to the portrayal of caste, religion, crime, and the propagation of fake news in India in *Paatal Lok*, an original drama commissioned by Prime Video. An adaptation of Tarun Tejpal's novel *The Story of My Assassins*, *Pataal Lok* was uncommon for Indian screens.[1] The series showcases different fault lines in contemporary Indian culture that in a Hindi feature film would be relegated to an insignificant

five-minute subplot. With its use of the cold open detailed above, five-act structure, and frenetic imagery, it became an overnight sensation—at least among those viewers with access to Prime Video, a U.S.-based streaming service eager to establish a foothold in India's large market.[2] *Pataal Lok* received significant media coverage, dominated social media conversation, and spawned countless memes.

In addition to *Pataal Lok*, this chapter examines two other successful Hindi-language commissions by streaming services: *Scam 1992: The Harshad Mehta Story* (Sony LIV) and *Asur* (Voot). These three shows, and the services that commissioned them, reflect the storytelling possibilities emerging from the rapidly evolving streaming landscape in India today. Sony LIV and Voot are OTT services (the term commonly used in India to refer to "over-the-top" streaming services) that combine subscription funding with advertising-based free streaming. Sony LIV, owned by Sony Picture Networks India, has an optional premium tier for live sports matches and originals, which it has been producing since 2017. Voot is owned by Viacom 18—a joint venture between the U.S. media conglomerate Viacom and the Mumbai-based TV18 network—and has been producing originals for its premium tier since 2016. In contrast, Prime Video, which is integrated into Amazon's Prime membership offering, is a U.S.-based global SVOD service that actively commissions original content in India and in several of Amazon's other strategic national markets.

These three series—*Pataal Lok*, *Scam*, and *Asur*—were the most successful Hindi-language OTT commissions to debut in India in 2020. Together, they illustrate how streaming originals are deviating from restrictive industrial norms previously established in India. These SVOD series have placed greater emphasis on the role of the writer, which has facilitated more complex stories and narrative structures in contrast with industrial norms established for Indian television and film. To explore this transformation, the chapter draws on textual analysis combined with interviews conducted with key scriptwriters in India that explore the changing status and practice of screenwriting in relation to streaming originals. In the final section, the chapter

also reflects on implications of current shifts in content regulation for Indian streaming services and the stories that can be told.

Changing Norms in Screenwriting in India

The literature about screenwriting in Indian film and media studies refers to "scenario writing" and establishes clearly different norms for television versus film (Mukherjee 2015; Sengupta 2019). Screenwriting is discussed substantially in instructive terms with careful attention paid to techniques for managing the organization of cinematic time and space. Sengupta points out that a crucial distinction has to be made between the discourse about and practice of screenwriting. The discourse about screenwriting in India draws upon its origins in Parsi theater, which was a frontal mode of representation.[3] Sengupta also draws attention to amateur screenwriting manuals as a source of training and professional practice, highlighting distinct norms across different media, or what is termed "intermedial" roots of media specificity in Indian screenwriting discourse. Drawing from Sengupta and Mukherjee's work, I will explore how SVOD services in India encourage adaptation of screenwriting norms to prioritize finite storytelling and organic detailing, and require the negotiation of new censorship norms. The industrial conditions of SVOD platforms have enabled diverse stories dealing with everyday life in India and strong characterization that had been considered commercially unviable and in opposition to film and television storytelling practices that are broadly melodramatic in nature.

There are significant differences in the role of the screenwriter and the practice of writing in different sectors in India. One screenwriter, Niren Bhat (2021), explained that local theater is a dialogue-heavy medium, with the emphasis placed on the spoken word because there are limits to what can be communicated visually. In contrast, he described film as a visual medium, where one does not have to verbalize aspects that can be visualized along with the dialogue. The use of visuals applies to television and streaming services as well, but there are key differences in narrative

length that have led to differences in the role of writers producing for television series as compared to SVODs. In India, the medium of film is a space for conveying finite content—that is, taking a small idea and fleshing it out for 120 minutes—whereas storytelling on Indian television has emphasized potentially endless stories that can run for five to seven days a week over several years. Given this structure, Indian television series developed in the last decades typically commence without a specific ending in mind. In contrast, series produced for streaming tend to have a known plot arc that develops within a limited seven to ten hours of narrative. In this way, SVOD television narratives produced in India are perhaps more akin to long films than broadcast television series (Bhat 2021).

The experiences of Indian screenwriters who have worked across various media can helpfully explicate this practice. The different narrative and visual tools across theater, film, and television are also circumscribed by a mix of industrial norms and cultural storytelling practices to embody medium-specific tendencies. However, many of these are not inherent to the medium but have been delimited by industrial and technological conditions. For instance, in the Bollywood film industry, where spectacle is paramount, writers are not particularly valued or regarded as essential to the storytelling process. The emphasis on visual storytelling tools within the Bollywood tradition led the role of writers to be highly informal and afforded them little agency in the filmmaking process. Bollywood films often begin shooting without a script, or with the roughest of outlines, and narrative details are worked out on set by the director and the film's (typically male) leading star.

Writers I have interviewed explained that before the opportunity to develop series for streaming services, the job of the writer was to narrate the story. In other words, producers, directors, or stars would listen to a script read aloud to them and would not read it themselves. Hence, the writer had to be a good oral narrator as well, and talented writers who were not engaging narrators often found themselves bereft of opportunities. However, in the past few years there have been significant adjust-

ments in the perception of writers and their role in the creative process. One writer explained that streaming services "prepared the professional in us to be a screenwriter for these formats as opposed to before, where writing was a very haphazard system . . . the director would be everything, director can tell writer to change stuff, actor can also tell writers to change the script. With the advent of OTT platforms, writers, trained to be film screenwriters, thus learn to write for platforms" (Mehta 2021).

A particular craft of writing series is now emerging. The training includes watching foreign-produced television shows and breaking down their episodes and then observing how structural elements could be used for Indian series—such as where to place the cliffhanger, and what would be the header and the midpoint. As part of this training infrastructure, Netflix organized a workshop for leading Indian screenwriters with Chris Daccato, the creator of the Netflix show *Narcos*. The week-long event invited well-known talent within the Bombay film industry to workshop ideas for feature-length narratives (90–120 minutes) suitable for streaming services, as opposed to a traditional series duration of four to ten hours. This emphasized the need for screenwriters to be trained to write for streaming platforms as opposed to legacy media services (Bhat 2021).

With the emphasis on screenwriting, authors of novels and other literary source material have become a more important resource in India. The arrival of SVOD original commissioning has expanded the opportunity to produce series based on these existing Indian properties. Many streaming services have bought rights to Indian novels written in various languages. Several are currently in the process of adaptation (notably, *Paatal Lok* is an adapted screenplay as well). This preference by SVOD commissioners to rely on established source material over original scripts helps them anticipate potential legal challenges, as explained in the next section (Rahul, 2021).

Additionally, industrial norms are shifting to incorporate different features that prioritize the script and formalize the role of the writer: for instance, introduction of the conventional writers' room and the

position of showrunner/creator. In the case of *Paatal Lok*, scriptwriting involved a showrunner and three writers. The process started at the end of 2016 and ended in November 2018, indicating a substantial amount of time was devoted to constructing the full narrative with character development and plots across nine episodes. The writers would submit their versions of an episode to the showrunner, who would read their drafts and give weekly feedback (Mehta 2021).

The implications of greater emphasis and formalization of writing can be identified on screen. For example, consider another big success in 2020, *Scam 1992: The Harshad Mehta Story*, which swept all the streaming awards in the country. Commissioned by Sony LIV, *Scam 1992* is a financial thriller that depicts the 1992 Indian stock market scam that included stockbrokers like Harshad Mehta, the protagonist of the show. The ten-part series is based on the book *The Scam: Who Won, Who Lost, Who Got Away* by journalists Sucheta Dalal and Debashish Basu (who are also depicted in the show as uncovering the story).

The key challenge in this adaptation was to make the stock market legible and dramatic to audiences. While an entertaining heist is at its core, *Scam 1992* had to convey financial complexity to a degree unusual in popular entertainment. Saurav Dey, cowriter of the series, insisted that writers had to understand how the stock market worked and then translate their research visually onscreen. Within the first twenty minutes of the first episode, the series depicts the protagonist, Harshad, angling to get a job as a "jobber."[4] He is framed in a two-shot and being evaluated on his ability to take and convey the food order of his rapid-talking prospective employer by telephone. This detail is important as the stock market rapidly fluctuates and the ability to grasp details quickly is a necessity for the profession. The scene then shifts to the Bombay Stock Exchange, where we see Harshad on the first day of his job with Bhushan, a longtime jobber, leading him through the daily routine. The excitement and frenzy of the market is captured by framing Bhushan and Harshad via a tracking shot and interspersing their dialogue with cuts of other jobbers making their bids. It then focuses solely on Harshad with a crane-tip

shot that closes in and out on him with interspersed cuts of the trading floor.

The sequence is compelling and an innovative solution to the lack of references for how to visually represent the stock market in Indian popular media. The biggest challenge the writers highlighted was creating a visceral sense of realism and verisimilitude as befits an SVOD original as opposed to a Bollywood melodrama. The writers explained that they were initially discouraged from writing this show as people told them that Sensex—an index of thirty companies listed on the Bombay Stock Exchange—"main koi emotion nahi hai" (has no emotion). As such, it was expected that audiences would struggle to understand the stock market and the nuances of the scam (Dey 2021). The popularity of *Scam* consequently took the industry by surprise. Where industry lore regarding audience tastes had led the industry to pander to melodramatic, overwrought stories, *Scam* revealed that a show depicting the money market in all its complexity could be the biggest streaming hit of the year.

Scam 1992 thus broke through the abundance and revealed a market for stories different from those typical in Indian film and media. Dey describes a key difference of series on streaming services as their use of "organic detailing" that allows technical conversations that require a very specific style of writing. Reviews, too, singled out the organic detailing within the narrative as a reason for the success of the series, with one stating, "The writing is terrific, and the re-creation of that era and its people authentic" (Gupta 2020). The casting and quality of acting in the series was also seen as an asset in creating the carefully drawn world and story. The lead actor, Pratik Gandhi, stated, "I had to create Harshad Mehta's ego, arrogance, but nothing could look made up. It all had to appear natural on the screen. I gained 18 kgs of weight in nine months to look like him." (Bhargava 2020).

The increased attention to plot sophistication and character construction has also been regarded as valuable by actors who find expanded opportunities for more quality work. There is a perception that streaming

services are enabling different types of stories and greater variation (Bhargava 2020). Artists from regional film and television industries are getting more exposure and can create something new. In addition to telling a different type of story in a context largely unfamiliar, the writers I interviewed also noted that detailing minor characters is something they have not typically been able to do in films. Moreover, in India there is significant pressure to use known talent when it comes to casting. The lead actor of the series was an unknown face to Indian audiences who primarily worked in Gujrati theater. This is a role he would not likely have been cast in if it were a mainstream television series. *Scam 1992* illustrated the success of diversity in casting practices accepted by viewers, such as allowing character actors lead roles, which is unlikely in Indian films. The writers of *Scam 1992* echo this sentiment, noting that streaming series are a terrific space for writers and actors, and for the first-time writers feel respected as they are the ones who pitch ideas and get contacted first, not the director (Dey 2021).

SVOD series feature narrative structures otherwise uncommon in Indian television and film because of the shifts in how writing is incorporated into the creative process. "OTT is exactly what TV is not," Bhat (2021) explained, elucidating further that it is one of the most challenging media to write for because content can be watched on a phone, which means the audience has a multitude of distractions available to them. Producing a structure that encourages "bingeability" was cited as the biggest challenge. Maintaining viewers from hour to hour is a complicated balance of compelling action such as episodic cliffhangers as well as complexly textured characters that viewers find engaging and grow curious about. Interviewees explained that a writer has to write 650 to 700 pages and then engage in a cumbersome process of rewriting that can take anywhere between one-and-a-half and two years.

In the case of the adaptation of *Paatal Lok*, one of the cowriters of the show highlighted that the long-form nature of the series allowed the writers to represent India as a mix of different castes, classes, and religious dynamics—what Indians speak of as a "melting pot," unlike

films, where the main hero takes more than half the screen time (Mehta 2021). The series format allows more character depth and exploration of different "Indias" in a way that is not possible given the brief length of movies (Mehta 2021).

Paatal Lok provides this diversity through its layered narrative of intertwining arcs. The series explicates the story through three levels: the main arc traces the investigation into the assassination plot; the second arc focuses on the newsroom and a character's willingness to defy efforts to censor him; and a third arc focuses on the personal life of the lead investigator and his rapport with his wife and son. These different levels were incorporated into every episode with around 60 percent of narrative time dedicated to level one and around 20 percent each to levels two and three. The writers of the show argue such multiple and intertwining storytelling arcs are not possible in films, and this storytelling approach allows the writers to divulge more detail in subplots that allow the audience to "feel the journey of the character, as opposed to film, where it would result in a confession sequence in the police station" (Mehta 2021). Every episode starts with a cold open (as the one described in the opening of this chapter) that is explained within the episode and ends with a cliffhanger to give the series a bingeable quality.

Reviewers lauded the series for its "courageous screenplay" and how its depiction of crime was not limited to unresolved or resolved crime cases, but "our collective failure at questioning the status quo . . . it holds a mirror to our society's damaged dynamics and structure" (Vyavahare 2020). Moreover, it was lauded as a "stunning achievement on virtually every level," with one reviewer noticing its similarity to the "work of David Fincher in tone and tendency, but the story being brazenly Indian" (Naahar 2020).

A third case, the series *Asur* (*Demon*), illustrates the importance of Indian mythology to storytelling practices and the successful use of complicated plotting possible only through detailed attention to screenwriting. The show was a sleeper hit that featured a cat-and-mouse storyline between a serial killer and the detectives chasing after clues and trying

to identify the killer. What makes *Asur* different from the countless versions of this storyline is its reliance on Indian mythological tropes. The story distinguishes between good and evil, yin and yang, as a constant interplay of opposites. This interplay is based on the Hindu religious mythos of the creation and the battle between Sur (gods) and Asuras (demons). This is explicated in episode six in which the backstory of the serial killer is explained in a sequence that alternates between the ancient city of Varanasi and the metropolis of Mumbai. In the Varanasi sequence, the detective visits an ailing grandfather who details the childhood of the killer. Intercut with this story are sequences set in the Mumbai police office, where other detectives sift through clues to identify the killer. Aesthetically, both of these sequences are medium two-shots infused with chiaroscuro lighting. There is also a hand-drawn animated section that links the two sequences and delineates the history behind the Asuras. The entire sequence is entrenched in mythos and religious practices familiar to the Indian viewer.

The show was lauded as an "immensely well shot series . . . [with] a visual grammar that is quite arresting" (Parasuraman 2020). It was singled out for its use of dual timelines and how they were "shot and edited crisply" so that the viewer doesn't feel "disconnected at any point" (Parasuaman, 2020.). Noticing its similarities with other international series, reviewers foregrounded the role of the writers, noting that "the writers have tried their best to bring out an engaging series and, to a large extent, they manage to pull it off too. The story, screenplay, cinematography and music are on point. A special mention needs to be made for the gripping climax, which leaves the fan guessing till the end" (Iyer 2020).

To understand the extent and impact of this change, one needs to appreciate the genealogy of storytelling in Bollywood. Bollywood style descends from a long history of collective dramatic creation that disavows the concept of individual authorship. Consequently, the two great national epics, *Ramayana* and *Mahabarata*, have been retold, regionalized, and re-mediated over the course of centuries through Urdu-Parsi

theater, indigenous regional folk dramas, and oral storytelling traditions. Since the early years of silent cinema, when "mythologicals" based on the stories of Hindu gods emerged as the dominant genre, themes and plots from the epics have continued to resonate in Indian popular cinema. Thus, in popular Hindi cinema, a story does not offer a causal chain of events like Hollywood, but instead unfolds in a preknown sequence with the aim of arousing different "rasas" (emotions) as it unfolds (Lutgendorf 2006).

This "nonrepetitive sameness" of a story is also enabled through film narratives that refute the notion of linear continuing time. Sumita S. Chakravarty (1993) writes that realism is alien to the Indian aesthetic and philosophical tradition that holds that the world we see is an illusion. Chakravarty contrasts the Aristotelian mimetic model of art against the classical Sanskrit view that art should elevate the mind through the agency of character typology, ritualized emotional states, and a delicately balanced moral universe. Vijay Mishra (2002) calls Bollywood a genre in itself, whose dominant form is epic or romantic melodrama. Thus, storytelling in the Indian mediascape is based on affect and not realism and rooted in mythos of the land. *Paatal Lok, Scam 1992*, and *Asur* notably shift away from affect-based storytelling towards realism-based storytelling. However, references to mythos still persist as reference points for most of these shows.

As these examples suggest, the arrival of SVODs and their efforts to commission series have brought new scriptwriting norms to the Indian screen industry, including a novel emphasis on season-length story ideas. As a result, a key intervention of streaming services to the nation's culture of audiovisual storytelling involved adjusting the underlying structures and practices of making television, particularly in a manner that has endowed the writer with greater status, supported more detailed characterization, and expanded the array of plots deemed viable. Incorporating norms typical in other national industrial contexts has been a process of negotiation, and eventually, creatives recognized that the

best stories were not those that aped Western television shows but were rooted in the societal fabric of the country and could be compelling to viewers both in and outside of India.

Questions of Content and Censorship

Finally, we must consider the regulatory environment in India as a structuring factor shaping the content of SVOD originals. Questions of how national content regulations apply to transnational services, and concerns about the boundaries of acceptable content have surfaced repeatedly in India. Initially, the absence of clear regulation extended the storytelling possibilities of SVOD original content, allowing creatives to experiment with risky content. While a new framework has recently been brought in at a national level to regulate streaming content, it is important to recognize that streaming services have expanded the storytelling field in ways that are unlikely to be curtailed by the introduction of content prohibitions on these services.

Among the examples of content debates instigated by streaming series are the attention *Paatal Lok* attracted from right-wing groups who labeled it "anti-national" and "Hindu-phobic" for its portrayal of how minorities are treated (Barua 2020). The show's producers were also served a legal notice for a scene where a woman is raped by Sikhs. Moreover, criticism from the Gorkha community in northeast India claimed the series was racist and regressively stereotyped the northeastern population (*The Indian Express* 2020). The hashtag #BoycottPaatalLok trended on Twitter as the series released and gained traction.

Despite the controversy, *Paatal Lok* was released without cuts. However, other original series have required changes. A sequence was edited out of *Tandav*, a Prime Video series that was regarded as denigrating to Hinduism.[5] Crucial to note here is that the creator and main actors of the series are Muslims. After the show was released, first information reports (documents prepared by the Indian police when they receive information about a specific offence) were filed in Uttar Pradesh and Bihar

against the show's makers, including director Ali Abbas Zafar, writer Gaurav Solanki, and Amazon Prime's head of India originals, Aparna Purohit. Uttar Pradesh Chief Minister Adityanath's media advisor, Shalabh Mani Tripathi, weighed in, warning that *Tandav* was "spreading hatred disguised as a cheap web series" (quoted in Ramnath 2021). Tripathi added ominously, "Prepare for arrest soon." Prime Video eventually caved and agreed to make alterations to the series. "We have utmost respect for the sentiments of the people of our country," said a statement from the cast and crew (quoted in Ramnath 2021).

If, as Ashish Nandy (1999) once noted, Hindi films reveal the secret politics of our desires, perhaps censored films reveal the secret politics of the law's desires. In February 2021—after the release of *Tandav*—the government announced the Information Technology (Intermediary Guidelines and Digital Media Ethics Code) Rules, which pertain to social media intermediaries as well as online news publishers and online curated content providers. These new censorship rules illustrate the desires of a majoritarian state that seeks to control all forms of media creativity and production. Prior to these rules, films released in theaters were under the purview of the Cinematograph Act, while a program broadcast on television was regulated under the ambit of Cable Television Networks Rules.[6] With the new rules, the Indian government introduced a three-tier mechanism and deemed it a "soft touch regulatory architecture" (Jha 2021). While the first two tiers bring in place a system of self-regulation by the content services and the self-regulatory bodies of content publishers, the third calls for an oversight mechanism by the central government of India.[7] A government-mandated committee has the power to take down objectionable content and take cognizance of any issue pertaining to OTT content (Jain 2021).

How do these rules affect storytelling practices on streaming services? In her study of censorship, gender, and sexuality in Bombay cinema, Monika Mehta (2011) offers an expansive vision of censorship that encompasses not only the act of "cutting" by the state but also of the actions of directors, editors, and audiences. Examining censorship through this

lens produces a rupture between subject and practice and thus allows one to focus on the application of censoring practices with film production and reception. We see this in the realm of streaming originals and the new censorship rules that ambiguously describe "objectionable content" affecting storytelling practices as well. Streaming services were given free rein to tell any story they wanted. Such free rein will come under pressure with the new rules (Jha 2021). It is often argued that law, through the regimes of censorship and licensing, prevents the circulation of images, and the liberal response of free speech argues that there is a need to separate the domains of law and aesthetics (Gopalan 2002). Scholarship on the history of censorship has already recognized the importance of moving away from a simple account of censorship as prohibition to censorship as a productive discourse (Kuhn 1990). An example of such productivity would be how censorship creates the subject position of the ideal viewer: one who does not actually exist but has to be discursively crafted. How do we see this discursivity taking place in this new industrial context?

Post *Tandav*, SVOD platforms came under immense pressure, and writers anticipate that from now on all content will undergo a process of self-censorship. Scripts will need to be changed, and everything would need to be reconsidered; a more sanitized version of stories being told would result. In the aftermath of *Tandav*, there is apprehension about depicting any incident that bears any remote resemblance to real life, as there is a fear that it would offend religious sentiments. Historical shows are anticipated to be most impacted, as well as shows that criticize the establishment or address religion in their subject matter. However, one screenwriter I spoke to still seems optimistic. Referring to Iranian cinema, he notes that "art will find its way. One has to be subtle about it, create and make your point all the time and illustrate your concerns" (Dey 2021). This could be achieved, for instance, by creating a fictitious town; although he notes that this would compromise audience identification with characters and undermine the narrative's specificity.

Many of the interventions of SVODs highlighted earlier in the chapter are not impacted by these rules. For instance, the extended runtime

of a series (as opposed to a theatrical film) gives creators more narrative space to explore the story and its characters, and the priorities of streamers have elevated the role of writers and their craft in ways new rules on content will not curtail. Regardless of next steps in regulation, this chapter captures a certain moment of transformation in the Indian audiovisual space vis-à-vis storytelling practices. The implications of new censorship rules introduced by the Indian government remain to be seen in terms of their impact on the themes and aesthetics of the stories being told on these services. While the new services and their particular industrial conditions have encouraged a turn towards realism, mythos is still an essential part in maintaining the "Indianness of the content." This turn towards realism has also encouraged a shift from a melodramatic style to a world that is populated by plots culled from everyday life, from star-driven vehicles to spotlighting character actors. Further, the formalization of scriptwriting will continue to enable different types of stories than persist in melodramas with many episodes.

Notes

1 The book is claimed to be used as a starting point of the series. Amazon U.S. had initially axed *Paatel Lok* following the #metoo phenomenon in 2018 as the author Tarun Tejpal was awaiting trial regarding accusations of rape.

2 A drama is then divided into five parts, or acts, which some refer to as a dramatic arc: exposition, rising action, climax, falling action, and catastrophe.

3 Frontal mode of representation refers to an aesthetics of frontality noted in discourses of popular Hindi cinema. This is related to the practice of darshan, in which the devotee looks and offers prayers to the deity and the gaze is returned to the devotee. This is most commonly seen in the mythological genre, in which the deity/actor is almost centrally framed within a static tableau that invites sustained eye contact with the viewer.

4 A jobber is one who buys and sells securities in his own name. A broker is an agent who deals in buying and selling of securities on behalf of his client. A jobber carries out trading activities only with the broker.

5 In the first episode of the fictional Prime Video series *Tandav*, set in modern-day India, the country's prime minister is reelected by a landslide, but before he occupies the position once more, he is murdered by his power-hungry son. A

protest by farmers against a proposed special economic zone involves students from a major university in Delhi. They are quickly labeled as "terrorists" by the police. Also at the university, an allegorical stage production is in progress. The main character is called Bholenath, another name for the god Shiva. A magnetic student leader, also called Shiva, plays Bholenath and is reminded by a Naarad Muni-like character that "these Ram followers" are increasing their social media reach. Bholenath jokes, "Should I update my display picture?"

6 It is important to note that each visual medium in India (press, film, television) has its own regulatory body with its own set of rules.

7 These guidelines are called the Information Technology (Intermediary Guidelines and Digital Media Ethics Code) Rules 2021, as per a government statement. The three major prongs of regulation are age-based content classification (the five categories being Universal, 7+, 13+, 16+, and adult), parental locks for content market until 13+, and a three-tier grievance mechanism. The first tier is an internal grievance officer for each OTT platform, who must address user complaints within fifteen days. Complaints that are not resolved within fifteen days are referred to the second tier—a self-regulatory body representing various digital news publishers and OTT platforms, headed by a retired Supreme Court or high court judge. The third tier is the Ministry of Information and Broadcasting, which will form an interdepartmental committee to ensure that OTT platforms adhere to these guidelines.

References

Barua, Meehika. 2020. "*Paatal Lok*: Bollywood's Most Controversial Hit Series." *The Guardian*, June 29, 2020. https://www.theguardian.com/tv-and-radio/2020/jun/29/paatal-lok-bollywoods-most-controversial-hit-series.

Bhargava, Eshita. 2020. "OTT Platforms Are a Blessing, Says *Scam 1992: The Harshad Mehta Story* Actors." *Outlook*, October 9, 2020. https://www.outlookindia.com/website/story/entertainment-news-ott-platforms-are-a-blessing-says-scam-1992-the-harshad-mehta-story-actors/361822.

Bhat, Niren. 2021. Interview with Ishita Tiwary. May 18, 2021.

Chakravarty, Sumita. 1993. *National Identity in Indian Popular Cinema, 1947–1987*. Austin: University of Texas Press.

Dey, Saurav. 2021. Interview with Ishita Tiwary. April 20, 2021.

Gopalan, Lalitha. 2002. *Cinema of Interruptions: Action Genres in Contemporary Indian Cinema*. London: British Film Institute.

Gupta, Shubhra. 2020. "*Scam 1992* Review: A Captivating Cautionary Tale." *The Indian Express*, October 12, 2020. https://indianexpress.com/article/entertainment/web-series/scam-1992-the-story-of-harshad-mehta-review-a-captivating-cautionary-tale-6719732/.

Indian Express, The. 2020. "*Paatal Lok* Controversies: Here's Everything that Has Happened So Far." May 26, 2020. https://indianexpress.com/article/entertainment/web-series/paatal-lok-controversies-everything-that-has-happened-6428414/.

Iyer, Shreya. 2020. "*Asur*: Welcome to Your Dark Side Season 1 Review: A Binge-Worthy Thriller that Makes for a Compelling Watch." *ETimes*, March 2, 2020, https://timesofindia.indiatimes.com/web-series/reviews/hindi/asur-welcome-to-your-dark-side/asur-welcome-to-your-dark-side-season-1/seasonreview/76172323.cms.

Jain, Janay. 2021. "From Censorship to Classification: Digital Media Rules and Their Impact on OTTs." *Financial Express*, March 16, 2021. https://www.financialexpress.com/opinion/from-censorship-to-classification-digital-media-rules-and-their-impact-on-otts/2213383/.

Jha, Aditya Mani. 2021. "New Information Technology Rules Threaten the Creative Freedom Enjoyed by OTT Platforms." *The Hindu*, March 14, 2021. https://www.thehindu.com/entertainment/movies/new-information-technology-rules-threaten-the-creative-freedom-enjoyed-by-ott-platforms/article34051111.ece.

Kuhn, Annette. 1990. *Cinema, Censorship and Sexuality 1909–1925*. London: Routledge.

Lutgendorf, Philip. 2006. "Is There an Indian Way of Filmmaking?" *International Journal of Hindu Studies* 10 (3): 227–56.

Mehta, Hardik. 2021. Interview with Ishita Tiwary. May 20, 2021.

Mehta, Monika. 2011. *Censorship and Sexuality in Bombay Cinema*. Austin: University of Texas Press.

Mishra, Vijay. 2002. *Bollywood Cinema: Temples of Desire*. London: Routledge.

Mukherjee, Debashree. 2015. "Jaddan Bai and Early Indian Cinema." In *Women Screenwriters: An International Guide*, edited by Jill Nelmes and Jule Selbo, 70–81. London: Palgrave Macmillan.

Naahar, Rohan. 2020. "*Paatal Lok* Review: Anushka Sharma's Show is Amazon's Black-Hearted Yet Brave Answer to Sacred Games." *Hindustan Times*, May 16, 2020. https://www.hindustantimes.com/tv/paatal-lok-review-black-hearted-but-brave-anushka-sharma-s-show-is-amazon-s-answer-to-sacred-games/story-qRWlTo9JshThXjtJkK288K.html.

Nandy, Ashish. 1999. *The Secret Politics of Our Desires: Innocence, Culpability and Indian Popular Cinema*. London: Zed Books.

Parasuraman, Prathyush. 2020. "*Asur* Review: A Briefly Compelling but Largely Limp Psychological Thriller." *Film Companion*, March 17, 2020. https://www.filmcompanion.in/features/asur-review-a-briefly-compelling-but-largely-limp-psychological-thriller/.

Rahul, Manoj. 2021. Interview with Ishita Tiwary. April 8, 2021.

Ramnath, Nandini. 2021. "It Isn't Just an Amazon Web Series Under Fire from Hindutva Groups—The Real *Tandav* Is Yet to Come." *Scroll.in*, January 20, 2021. https://scroll.in/reel/984539/it-isnt-just-an-amazon-web-series-under-fire-from-hindutva-groups-the-real-tandav-is-yet-to-come.

Sengupta, Rakesh. 2019. "Writing from Margins of Media: Screenwriting Practice and Discourse During the First Indian Talkies." *Bioscope: South Asian Screen Studies* 9 (2): 1–20.

Vyavahare, Renuka. 2020. "*Paatal Lok* Season 1 Review." *ETimes*, July 30, 2020. https://timesofindia.indiatimes.com/web-series/reviews/hindi/paatal-lok/seasonreview/75787340.cms.

5

Challenging Cultural and Political Taboos

A Turkish SVOD's Experiments in Taboo Comedy

ASLI ILDIR

In Turkey, as elsewhere, the audiovisual ecosystem has been adapting to the entry of subscription video-on-demand (SVOD) services. A local SVOD service, BluTV, launched in 2016 following that of Netflix the same year, and grew to become the leading local SVOD platform in Turkey. BluTV has experimented with different types of original content and has collaborated with many other players in the local and global markets, including S Sport 1 and 2 (a major sports channel) and Discovery+.

This chapter examines two comedy series commissioned by BluTV—*Me, Bartu* (2017) and *Doğu* (2021)—and explores their distinction from linear television comedies in Turkey. Following Bucaria and Barra's (2016) conceptualization of "taboo" or "controversial" humor for television, this study finds evidence that SVOD services create space for storytellers to challenge culturally or politically taboo issues in Turkey through humor. This is particularly important within the Turkish context because SVOD content often uses humor to challenge the hegemonic ideological position of mainstream television, mainly through narratives that critique patriarchal and conservative values in society. Two main factors enable the sociopolitical freedom and generic experimentation emerging in these comedies: the lack of strict, formal content regulation, and the availability of limited series (six to ten episodes) and shorter episodes (of between 30 and 69 minutes) without ad breaks. The second factor is mainly a consequence of the subscription-based model,

which is not bound by the constraints of traditional broadcasting, such as the pressure to attract the largest possible audience for advertisers.

Bucaria and Barra (2016, 5) argue that a subject is made humorous by breaking boundaries or societal conventions, an idea they trace back to the Freudian concept of displacement. The ad-supported, linear norms of television required it to function as a mass medium, in other words to aim to make its programming accessible and attractive to a broad and heterogeneous audience, and this established particular boundaries for humor. Streaming services differ due to their discrepant industrial norms of subscriber funding that require them to stand out from ad-supported services in order to attract payment (Lotz 2022). They can also serve many viewers with different content at the same time instead of selecting single titles to fill a schedule at a certain time. Bucaria and Barra also acknowledge that taboo humor appears in cable, satellite, and digital television within a context of "quality television" targeting niche audiences. Similar to many types of premium programming considered "quality television," SVOD humor also breaks boundaries to distinguish itself from the mainstream rather than adjusting to the rules as in network television (Bucaria and Barra 2016).

As a Turkish service, BluTV is located within specific cultural and sociopolitical contexts and operates under different regulatory conditions from the U.S. and UK productions Bucaria and Barra examine. These contexts shape the use of taboo humor in BluTV series. For example, making a homophobic joke is considered as taboo humor in the United States or UK, but homosexuality itself remains a taboo for mainstream television in Turkey. Furthermore, homophobic humor is the hegemonic norm in Turkey, connected with conservative "family values" that have been arbitrarily defined and enforced by the regulatory institutions as discussed in detail below. To better situate the chapter, the next section contextualizes BluTV and the regulation and censorship of internet television in Turkey to prepare this chapter's discussion of *Me, Bartu* and *Doğu* in the context of SVODs and taboo humor.

Dynamics of Turkish Television Production

To understand the significance of BluTV and its programming, we first need to consider the current state of television regulation and production in Turkey. Turkish television is known for its repetitive melodramatic narratives with extended durations and excessive ad breaks (comprising up to 20 percent of airtime). Yet, outside Turkey, audiences for Turkish television have increased significantly in recent years. Bhutto (2019) defines Turkish series as a "new form of mass culture" comparable to Bollywood and K-pop that disrupts the influence of American pop culture. Most high-budget, successful series are exported internationally for additional profits both for the channel and the production company. Series that fail to find a local audience also try their chances in the foreign market, mostly to compensate for their financial loss.

Domestic risk is mainly a consequence of the new ratings system that created financial instability and "a precarious workspace" in the market as audience taste became less predictable (Bulut 2016). Before 2012, ratings were measured based on the education level and cultural capital of viewers living in big cities (Bulut 2016). In this system, the "A & B" group considered most attractive to advertisers was the secular upper-middle class, known for its "Western taste" (Atay as quoted in Özçetin 2016). The new rating system provided by Transaction Network Services (TNS) now categorizes audiences according to their income level and includes regions with a population of under 2,000 people. These new regions include many parts of the countryside, including electoral districts dominated by Justice and Development Party supporters and the Muslim bourgeoisie.[1] Consequently, the whole industry had to adjust its production dynamics and storytelling to engage these more conservative audiences by emphasizing tradition and family values.

This change to the rating system has disrupted production norms in many ways. For example, television channels now find it difficult to reach the necessary rating levels due to the expansion of the rating measurement region. In response, they extend the duration of the few series that

find an audience (from 90 to 135–145 minutes) as a way to increase their ad revenue, since the Radio and Television Supreme Council (RTSC) requires 20 minutes of content for every 7 minutes of advertising. Many producers also seek foreign distribution, especially for series featuring globally recognizable Turkish stars and generically familiar stories (soap operas and historical epics perform best). Producing exportable dramas to decrease financial risk in the domestic market has led to the adoption of certain narrative and generic conventions. Producers prefer content that is internationally legible, such as romantic comedies, dramas, or "Cinderella stories" (Bhutto 2019), and choose locations identifiable to tourists. The positive effect of exported series on tourism, mostly from the Middle East, increases the interest in period dramas with militarist or nationalist overtones, which aligns with the government's soft power discourse.

The cultural impact of Turkish series is not limited to their global circulation. Their worldwide appeal and financial success also influence production dynamics and storytelling practices within Turkey. For example, the demand for exportable, star-driven series puts extra pressure on producers who are already dealing with the challenges of the new rating system. Faced with the challenge of fulfilling the expectations of both foreign and domestic audiences simultaneously, producers have adopted three main strategies derived from market research on stars and stories: managing production so that it conforms to state content regulations; adopting the "government's soft power discourse and public diplomacy aspirations"; and following global television trends (Algan 2020, 446). Producers, who have mainly bowed to the government's ideological demands, are expected to exalt the national values and history in their productions as "representatives of the country" (Kaptan and Algan 2020, 13) and to avoid politically or culturally controversial subjects in their narratives. Fulfilling these expectations required producers to reproduce the culturally and politically repressive mainstream media environment and has left limited space for alternative voices. Producers' willingness

to experiment with genre and style has also diminished under the new ratings system.

Formal regulation has also played a defining role in what is seen on-screen in Turkey. Initially, SVODs were not subject to RTSC monitoring, but the regulator's remit was expanded in 2019 to encompass web broadcasts, a category that includes SVODs. The RTSC has been monitoring radio and television broadcasts since its establishment in 1994 and has regularly provoked controversy due to its ideological position. For example, broadcasting in languages other than Turkish is prohibited in accordance with "the state's nationalistic and discriminatory policies against the Kurdish minority" (Kaptan and Algan 2020, 8).

In addition to censorship on nudity, sex scenes, cigarette and alcohol use, and strong language, the RTSC's enabling legislation also includes an article that paves the way for a more conservative ideological agenda. Article 6112/8 states that broadcasters should not violate "the general morality and the national/spiritual values of the family" (Koçer 2020). The regulation mainly works through direct monitoring by the RTSC based on complaints from viewers. This intensifies the ideological grounds for content regulation and increases industry practices of censorship and self-censorship. The direct evaluation of RTSC experts, and the specific complaints they choose to consider and respond to, reflects "the relations between the government and the media-politics-capital triangle" and cannot be seen "as separate from intentional efforts to make the society more conservative" (Demirdöğen as quoted in Akin et al. 2018, 174). On the other hand, Akınerdem (as quoted in Akin et al. 2018, 170) argues that "storylines involving sex have visibly declined as of late and been replaced by those revolving around violence and machismo" in response to RTSC decisions. The council's criteria are highly relevant to the conservative ideological position of mainstream television in Turkey and also highly effective in establishing the "boundaries" that taboo humor challenges.

The balance of more secular programming—including entertainment channels and comedy programs—alongside more conservative and

"family-oriented" programming has been in decline in the last decade as a consequence of an increasing authoritarian political scene and intensified regulation over the media sector. Akin et al. argue that the extension of Turkey's state of emergency, declared after the failed coup attempt in 2016, has had "a direct impact on media institutions and media workers and nurtured an atmosphere of fear, intimidation, and habits of self-censorship" (2018, 6).[2] Even though many Islamist channels—as well as Kurdish broadcasters—were also affected by the post-coup d'etat measures, the arbitrary nature of the RTSC law continues to consolidate the conservative and ideological positions of the mainstream media.

BluTV and SVOD in Turkey

This brings us to BluTV and its place in Turkey's television landscape. Although BluTV initially escaped the strict content regulation that applied to linear television, it, too, soon became subject to those same restrictions. Founded by media mogul Aydin Doğan, BluTV developed as part of D Productions, the in-house production studio of Channel D, a prominent linear television channel. After Channel D was sold to another company, BluTV had to downsize and function as a standalone SVOD service. This transformation affected BluTV's business model and content policy. BluTV began to follow international SVOD trends by commissioning high-profile original series instead of operating as a catch-up broadcast video-on-demand (BVOD) service. Today, BluTV offers a mix of original and licensed content, including high-profile foreign series such as *The Handmaid's Tale* and *The Young Pope* and many international and local art house films, including exclusive titles.

BluTV's original productions include multiseason and limited series with long and short durations (unlike Netflix Turkey, it does not commission features). Three categories feature prominently: comedy series, genre shows (vigilante stories, police, and fantasy shows), and short documentary series about culturally "edgy" topics such as nightclubs, gambling, and dating apps.

Yanardaoğlu and Turhalli's (2020, 196) research, based on interviews with showrunners and producers, notes two crucial tendencies of production and narrative priorities of BluTV originals. First, the service mainly commissions small-scale, lower-budget productions and works with independent producers rather than established names in the industry. Second, BluTV series position themselves as distinct from linear television in terms of storytelling and plot as "on-demand series seem to create more space for different character types and story development. In addition, they allow more space for creativity and the application of different shooting techniques . . . to better meet audiences' expectations for more creative and different content" (Yanardaoğlu and Turhalli 2020, 199).

Yanardaoğlu and Turhalli also observe that producers see SVOD as an alternative to the limitations of the new ratings system, not only in terms of long episode durations and ad breaks but also in narrative and style. Producers develop "edgier storylines" in SVOD as an alternative to the family dramas and the melodramatic tone characteristic of Turkish linear television. Instead, directors use different camera angles or lighting styles when creating SVOD originals (Yanardaoğlu and Turhalli, 2020). BluTV's original content policy also promotes this "artistic vision" as a central part of its marketing strategy. For example, many BluTV originals are directed by art house directors, including those known for success in international film festivals, such as Emin Alper, Tolga Karaçelik, and Seren Yüce. For these reasons, BluTV describes its original content as "appealing to those who no longer want to watch Turkish series" (Kalfaoğlu as quoted in Sapmaz 2019).

As we have seen, BluTV's founding promise was to offer alternative content that challenges storytelling norms of Turkish linear television. However, the aforementioned extension of RTSC regulation to include video-on-demand (VOD) services has partially hampered BluTV's ability to deliver on this promise. The enforcement of the new VOD law is still arbitrary, and the content of BluTV is not regularly checked, but there have been instances where the service has self-censored its content

to avoid the attention of the authorities. For example, the recent BluTV original *Çiplak*—a miniseries about a young female sex worker that featured explicit sex scenes and nudity—was controversially removed from the BluTV library, prompting a flurry of online commentary.[3] This reflects the delicate balance that BluTV must strike between creating edgy, distinctive content and adhering to restrictive government censorship policies.

Pushing the Boundaries of Linear Television: Taboo Comedy in *Me, Bartu* and *Doğu*

BluTV strives for a discourse of distinction for its original commissions and emphasizes the freedom it offers creators. Names of showrunners, directors, and screenwriters are included in BluTV press releases, something rarely done in linear television. In line with international SVOD trends, BluTV also invests in low-budget comedies starring emerging talent, including younger artists popular on YouTube. Initially, BluTV commissioned three miniseries created by showrunners mainly known for their work in the art house scene: *Innocent*, a crime drama about the investigation of a murder within the family of a former police commissioner; *Seven Faces*, a seven-episode anthology series on facing the darkest fears and sins; and *Me, Bartu*, a comedy series telling the tragicomic story of a real-life actor. Experimenting with different formats, durations, and stories, these productions were distinct from conventional Turkish television narratives in terms of their political/cultural criticism and stylistic choices.[4]

Me, Bartu and *Doğu* are of particular interest because of the way they self-consciously mock the norms and practices of linear television in Turkey. Their storylines directly reference the strictures of linear television through scenes featuring television production sets, talent contest footage, auditions, and other signifiers of television tradition. In other words, linear television—with its restrictive norms, rules, and narrative conventions—becomes a part of the humor and is framed and problem-

atized as a "cultural other": an institution/medium that reproduces and consolidates the cultural/political taboos challenged within the same texts.

Me, Bartu, tells the story of Bartu, a failed and penniless actor who nonetheless resists performing in television shows or ads because he finds them "inferior." Bartu moves between jobs in different media, where his occupation becomes a means for the series to explore the dynamics of the local entertainment industry. The series includes direct references to popular series and "exportable dramas" in linear television and teases them as typical productions that reproduce cultural stereotypes without any artistic purpose. This criticism is mainly conveyed through its main character's failure to fit into linear television as an actor, which is explained as caused by his artistic and cultural incompatibility with the industry.

Television itself becomes an object of taboo humor in these texts—an external boundary that can only be addressed or challenged within the more intimate, "safe space" that SVOD provides. This safe space is defined by creative and sociopolitical freedom that results from a "tolerant and trustworthy" audience, presumably one that would not submit complaints to RTSC. In Turkey, internet users often respond to state censorship by emphasizing that they actively consent to what they watch on SVOD because they voluntarily subscribe to these services. Therefore, this space is "safer" for producers in terms of both official RTSC regulation and audience engagement. Based on mutual trust, SVOD stories exist outside the boundaries of linear television and enable taboo humor to emerge—albeit in subtle and indirect forms.

In *Me, Bartu*, and *Doğu*, the first layer of taboo humor is the mere "visibility" of topics such as sexual identity, which is a complete taboo for linear television in Turkey. Since explicit scenes depicting sexual acts are strictly regulated in linear television, the relative lack of regulation provides these series space to not only normalize sexuality in their narratives but to also refer to them as direct themes—at least until the regulations were extended to SVODs. (Just like *Innocent* and *Seven Faces*,

Me, Bartu was produced prior to the passing of Turkey's VOD law and thus took advantage of the "total freedom" in 2017 when the RTSC did not interfere with SVOD services. These titles are still in BluTV's catalog and can be viewed free of censorship.)

Another distinctive feature of *Me, Bartu* is its unconventional exploration of sexuality within the context of a comedy show. Traditionally, mainstream humor in Turkish television reproduces the stereotypical representations of LGBTQ+ characters and women enjoying casual sex and nonmonogamous relationships (often presented as "bad" or "immoral" women), thus reinforcing the dominant ideology of patriarchal "family values." *Me, Bartu* subverts this kind of humor through its politicized use of taboo humor and through its story about an actor and his "family of choice." The series pokes fun at the traditional family as a patriarchal institution in which women are "protected" by their fathers from sexuality and LGBTQ+ people are excluded or rendered invisible. In contrast, *Me, Bartu* depicts an alternative family where all are free in their sexuality—a highly significant position given Turkey's recent withdrawal from the Istanbul Convention in 2021 to prevent the "normalization of homosexuality—which leaders declared as incompatible with Turkey's social and family values."[5]

In *Me, Bartu*, two characters are notable in this respect: Bartu's cousin Gizem, a young aspiring actress, and his close friend Mercimek, a jovial, incisive, and openly gay man. Both freely discuss their sex lives and enjoy casual sex, sometimes with more than one partner. Even though these characters form part of the show's comic narrative, they are more than caricatures: both have significant influence over the progress of the story and the transformation of Bartu's character. Mercimek, whose taboo-breaking identity has been noted by the local LGBTQ+ community (Alpar 2018; Bahattin 2021), openly criticizes mainstream television by stating that gay characters only appear on screen as the butt of jokes or as the heroine's best friend. Notably, *Me, Bartu* rejects this longstanding tendency: nonheterosexual identity does not become the sole object

of the humor or something the audience laughs *at*, which is the case in most Turkish television comedies.

Through Gizem's character, *Me, Bartu* also subverts a very common archetype in Turkish cinema and television since the 1970s: the young, naive, and virginal woman coming from the *taşra* (country/periphery) to the big city—Istanbul. Conventionally, these women meet the "wrong people" and become prostitutes (the specific idiom in Turkish used for these women is *kötü yola düşmek*, literally translated as "falling into a bad way"). The series depicts Bartu and Gizem in bars, nightclubs, and parties or the "bad places" where these women are tricked, abused, drugged, and raped. But *Me, Bartu* tells very different stories about these mainly urban spaces. Gizem sleeps with two of Bartu's friends in his apartment and enjoys the night without regret, even praising their sexual performance explicitly to Bartu the next day. Shocked, Bartu is caught between Gizem and her father, who trusts him to care for Gizem and her "dignity and honor"—or virginity. The issue of *namus* (honor) is a popular theme in Turkish television, constantly victimizing women with agitating and didactic narratives, and reproducing male violence through stories showing women being exposed to domestic abuse. These shows are often cautionary tales that police women by depicting the consequences of losing their honor and sometimes also implying they are to blame for not "protecting" themselves enough. In contrast, *Me, Bartu* offers a highly empowered female character while also problematizing the aforementioned stereotypical representations of women through Gizem's story.

Secondary characters in *Me, Bartu* are also used to remind the audience of linear television tropes. The series opens with Bartu performing the role of a "sultan" for a linear television production, an obvious reference to popular Turkish series such as *Magnificent Century* and *Kösem Sultan*. During this scene, the director also wants Bartu to try a "Laz" role, a reference to another popular trend within mainstream dramas of portraying people from the Black Sea region as thin caricatures with

heavy Black Sea accents. After Bartu fails again, the director wants him to call his friend (another real-life actor, Ömür Arpaci, who is known for his "Laz" roles). In the following episodes, we see Arpaci speaking Turkish with no Laz accent, a surprise used repeatedly to comedic effect. He explains that he is "stuck" in the role of "Laz" because it is considered funny on mainstream television. In this way, *Me, Bartu* critiques linear television caricatures of ethnic identities and plays on viewers' familiarity with these tropes. It positions viewers of *Me, Bartu* as in on the joke.

Doğu, another original miniseries by BluTV, marks its distinction from linear television comedy by using different kinds of humor: sacrilegious and blasphemous (Bucaria and Barra 2016, 3). The series tells the story of Doğu Demirkol, its eponymous character, who also wrote and codirected the series. As an aspiring young comedian, Demirkol became popular after he played the leading role in an art house film, *The Wild Pear Tree* (2018), directed by Nuri Bilge Ceylan, Turkey's Palme d'Or-winning director. Doğu constantly becomes the object of ridicule and self-deprecating humor in the series as a result of his inappropriate jokes. His jokes break boundaries that are generally based on cultural binaries such as West and East, secular and conservative, or modern and traditional. Contrary to *Me, Bartu*—set in central Istanbul, which is known for its more secular and middle-class lifestyles—*Doğu* features characters from the peripheral regions of Istanbul with more religious, conservative backgrounds. (These two groups can also be interpreted as two audience segments. *Doğu* mostly represents people the new rating system takes into account, while its ideas challenge the conservative values of this segment. On the other hand, *Me, Bartu* clearly targets an SVOD audience with greater cultural capital.)

Yet *Doğu* has a distinctive tone: one that is critical of the conservative ideological position of its main character. The protagonist's religious or conservative values are repeatedly challenged through cultural confrontations. However, as a comedian, Doğu also experiments with different

kinds of taboo subjects including sexuality and religion. He constantly oscillates between distinct tastes in humor (and thus audiences) to speak to different segments of the Turkish television audience.

On many occasions, the "holiness" of religious values and Muslim traditions becomes the focus of the show's humor. Even though *Doğu's* jokes are not as offensive or radical as in an equivalent U.S. show like *Ramy*, they can still be considered subversive given the deterioration of freedom of speech and humor in Turkey over the last decade, which has resulted in "the bastardization of its long-standing cultural tradition of political satire" (De Cramer 2021). In addition to the imprisonment of journalists and politicians, many authors, artists, and comedians have also been put on trial for "insulting" the president or "the national, moral, or religious values" of Turkish society. Additionally, several humor magazines known for their political satire have been closed or censored.[6]

While taboo humor in *Doğu* is not a direct form of political satire, the contemporary Turkish political context—which operates with an extreme "inviolability" of religious values—turns it into one. In one scene Doğu visits a pharmacy shop in Cihangir—a neighborhood known for its celebrity inhabitants—that is owned by a female pharmacist wearing a headscarf. (Discrimination against women with headscarves has been politically weaponized by the government on many occasions.) During the scene, Doğu assumes she is conservative and struggles to ask for a condom but gets scolded by the pharmacist for being sexist and prejudiced towards women with headscarves. After he leaves the shop, the pharmacist humiliates him as a "loser" just trying to be famous, suggesting that Nuri Bilge Ceylan would "spit in the face" of Doğu. Apart from its comedic effect, this confrontation, and the self-referential joke, has many layers. The first layer critiques the main character and his assumption that anything related to sexuality or sexual health is taboo for a conservative/religious woman. On the other hand, the audience's extradiegetic information on Doğu's leading role in a Nuri Bilge Ceylan film adds another layer of humor to this scene. After her mocking comment

about Doğu and Nuri Bilge Ceylan, we realize the pharmacist is also prejudiced against Doğu as a comedian from the outskirts (conservative districts) of Istanbul and regards him as someone unworthy of such a role appealing to audiences with higher cultural capital.

Cultural binaries are also problematized through Doğu's confrontation with different types of comedy audiences, from a conservative elderly group to young middle-class urbanites seeking a more edgy type of comedy. A scene in which Doğu gets a negative reaction from the elderly conservative audience is significant as it reveals the ideological boundaries of humor in Turkey. After realizing that the elderly audience is not his usual crowd, Doğu starts his routine with an inoffensive religious joke about the first surah of the Qur'an, Al-Fatiha, which is well received. However, as he runs out of jokes, Doğu decides to make a joke about the futility of penis enlargement ads. The moment he uses the word "penis" the audience starts to show their discontent and stop paying attention to his routine. Finally, Doğu gets angry and scolds them: "Isn't sexuality a part of us? Why don't you listen to the rest of the joke?"[7] This scene's image of a comedian being booed and intimidated by a conservative audience is highly symbolic given the Turkish government's aggressive stance against humor. While the series uses sexual humor to criticize the conservative values assumed of the audience and of Doğu as a character, it still uses a mainstream type of humor to mock a gay character in an earlier episode. This character is portrayed in a stereotypical manner, as very clingy, sexually attracted to Doğu, and touching him all the time. The character's sexual identity becomes the object of humor in this case, rather than Doğu's reaction to it.

During these failed attempts, Doğu slowly learns how to calibrate his jokes for different audiences: when to go with the flow, when to break the rules and challenge boundaries, and of course, when to "self-regulate." In some way, this experimentation and adaptation process mirrors the series' and BluTV's attempts to understand local SVOD audiences and their specific tastes in comedy. As in *Me, Bartu*, this in-between position

of Doğu and his eponymous series is not only based on cultural confrontations in everyday Turkish society but also reflects a confrontation between linear television and SVOD.

Conclusion

Through the stories of two failed comedy actors, BluTV's *Doğu* and *Me, Bartu* use their status as SVOD originals to challenge the norms of linear television and mainstream media in Turkey and position them as extensions of a conservative, patriarchal ideological agenda. This distinction is accomplished through the use of the protagonists' occupation as a narrative device to travel among different media including television and through their encounters—often confrontational—with cultural others (including women, LGBTQ+ characters, the elderly, and conservative or religious people). The series' use of self-deprecating humor becomes self-criticism in narratives that position the male protagonists as objects of ridicule due to their own taboo behaviors or perspectives. Taboo humor—generally in the form of sexual and sacrilegious humor—is used in both series to point out the cultural/political boundaries of linear television that are shaped by the regulatory environment and the conservative taste of the mass audience.

These two series illustrate how SVOD stories can become distinct from linear television in Turkey as a result of the aesthetic and political freedom provided to creators. *Me, Bartu* and *Doğu* challenge the mainstream representations of gender, sexual, and ethnic/cultural identities through their use of taboo humor that normalizes sexuality and teases, if not criticizes outright, religious values. Such attitudes can be considered a highly political reaction to the Turkish government's intolerance towards any type of political satire or humor and its increasing emphasis on the family, nation, and morality.

As a service founded when no formal regulation of SVOD existed in Turkey, BluTV enjoyed freedom from censorship and self-censorship

until 2019. However, given increasing enforcement of the RTSC law, it can be argued that BluTV may continue to enjoy its aesthetic freedom without challenging as many political boundaries (similar to the manner argued by Tiwary in the previous chapter)—although not as explicitly as achieved by *Me, Bartu*. The decrease in the level of politicized humor from *Me, Bartu* to *Doğu* may reflect the changing policies of BluTV and its growing inclination towards self-censorship.

Notes

1 The Justice and Development Party is Turkey's leading conservative and populist political party, which has been in power since 2002.

2 After the failed coup attempt in 2016 by the Turkish Armed Forces, the government declared that the attempt was associated with the Islamist fraternal movement led by Fethullah Gülen. The events are generally interpreted as a power struggle between different factions of the political Islamist movement in Turkey.

3 A popular journalist mentioned the series in his YouTube program by ironically referencing RTSC, stating that he wondered how the council "missed" the series. Many social media users and fans of the series blamed the journalist for targeting the show and provoking the council. After a serious social media backlash, BluTV removed the series from its catalog—a move harshly criticized as an act of self-censorship. Later, the service announced that the series was removed because they were in the process of implementing a child lock for parents with children under the age of eighteen. As this example suggests, the chaotic regulatory environment of SVOD in Turkey is intensified by the conversation on social media. Demirdöğen (as quoted in Akin et al. 2018, 177) states that a regular viewer complaint can be ignored by RTSC "if it does not elicit a strong enough reaction on social media" and points out the influence of online mass reactions to the council's decision.

4 These launching series were even included in the Istanbul International Film Festival as a part of the talk series organized by the festival's coproduction, training, and networking platform, Meetings on the Bridge. The series was named as "Transformation of Series to Digital," an event in which showrunners and content managers from BluTV discussed the new possibilities internet television offers in terms of storytelling and production.

5 For further information see Gupta (2021).

6 In 2020, online access to the cover of the famous humor magazine *Leman* was blocked due to a comic about (former) Minister of Finance and Treasury Berat

Albayrak. In an interview with *Deutsche Welle*, the cartoonists stated that the government created an environment of censorship and self-censorship for humor magazines and artists (Unker 2020).

7 However, the series is cautious about not attributing this sexual taboo to a certain religious group. An elderly woman with a headscarf in the audience laughs a lot and congratulates Doğu at the end.

References

Akin, Doğan, Suncem Koçer, Murat Önok, Ceren Sözeri, Tuğba Tekerek, Asli Tunç, and Sarphan Uzunoğlu. 2018. *Media Self-Regulation in Turkey: Challenges, Opportunities, Suggestions*. P24 Media Library, İstanbul. http://platform24.org/en/Content/Uploads/Editor/Media%20Self-Regulation%20 in%20Turkey.pdf.

Algan, Ece. 2020. "Tactics of the Industry Against the Strategies of the Government: The Transnationalization of Turkey's Television Industry." In *The Routledge Companion to Global Television*, edited by Shawn Shimpach, 445–57. New York: Routledge.

Alpar, Asli. 2018. "Mercimek ile tanışın." *Kaos GL*, December 25, 2018. https://kaosgl.org/gokkusagi-forumu-kose-yazisi/mercimek-ile-tanisin.

Bahattin, Sa. 2021. "Beş dijitalin beşi bir değil." *Kaos GL*, September 13, 2021. https://kaosgl.org/gokkusagi-forumu-kose-yazisi/bes-dijitalin-besi-bir-degil.

Bhutto, Fatima. 2019. "How Turkish TV is Taking Over the World." *The Guardian*, September 13, 2019. https://www.theguardian.com/tv-and-radio/2019/sep/13/turkish -tv-magnificent-century-dizi-taking-over-world.

Bucaria, Chiara, and Luca Barra, eds. 2016. *Taboo Comedy: Television and Controversial Humour*. London: Palgrave Macmillan.

Bulut, Ergin. 2016. "Dramın Ardındaki Emek: Dizi Sektöründe Reyting Sistemi, Çalışma Koşulları ve Sendikalaşma Faaliyetleri." *İleti-ş-im*, 24 (6): 79–100.

De Cramer, Alexandra. 2021. "The Strange Death of Turkish Satire." *New Lines Magazine*, July 2, 2021. https://newlinesmag.com/reportage/the-strange-death-of-turkish-satire/.

Gupta, Komal. 2021. "Explained: Why Erdogan has Pulled Out of Istanbul Convention on Violence Against Women." *The Indian Express*, July 20, 2021. https://indianexpress.com/article/explained/istanbul-convention-erdogan-violence-against -women-7386272/.

Kaptan, Yeşim, and Ece Algan. 2020. "Introduction: Turkey's National Television in Transnational Context." In *Television in Turkey: Local Production, Transnational Expansion, and Political Aspirations*, edited by Yeşim Kaptan and Ece Algan, 1–24. Cham: Palgrave Macmillan.

Koçer, Suncem. 2020. "RTÜK'ün Elverişli İttifakları." *Altyazı Fasikül*, August 24, 2020. https://fasikul.altyazi.net/seyir/rtukun-elverisli-ittifaklari.

Lotz, Amanda D. 2022. *Netflix and Streaming Video: The Business of Subscriber-Funded Video on Demand*. Cambridge: Polity.

Özçetin, Burak. 2016. "Popüler Kültür, Din ve Sekülerlik: Tayfun Atay'la Söyleşi." *Hacettepe Üniversitesi İletişim Fakültesi Kültürel Çalışmalar Dergisi*, 3 (1): 5–20.

Sapmaz, Nihan Bora. 2017. "Türkiye'nin 'televizyon' devrimi: Fi, Masum, Görünen." *Journo*, June 15, 2017. https://journo.com.tr/televizyon-devrimi-fi-masum.

Unker, Pelin. 2020. "Mizaha sansürde son nokta: Erişim engeli." *Deutsche Welle*, February 14, 2020. https://www.dw.com/tr/mizaha-sans%C3%BCrde-son-nokta-eri%C5%9Fim-engeli/a-52384894.

Yanardağoğlu, Eylem, and Neval Turhalli. 2020. "From TRT to Netflix: Implications of Convergence for Television Dramas in Turkey." In *Television in Turkey: Local Production, Transnational Expansion, and Political Aspirations*, edited by Yeşim Kaptan and Ece Algan, 189–204. Cham: Palgrave.

Argentina on Demand

Streaming Crisis, Gangsters, and Athletes

JOAQUÍN SERPE

Argentina is the third biggest media market in Latin America behind Brazil and Mexico, which have much larger populations. With high penetration rates of broadcast television (97 percent), pay-TV (77 percent), and internet (80 percent) (Serpe 2018; Business Bureau 2021), Argentina has also eagerly embraced subscription video-on-demand (SVOD) services over the last decade, with subscriptions growing exponentially. For example, there were 850,000 estimated Netflix subscribers in 2017; this climbed to 4.5 million by the beginning of 2020, according to CEO Reed Hastings (Mármol 2020). In recent years other international SVODs have launched services in Argentina, including Prime Video in 2019, Disney+ in 2020, and Paramount+ and HBO Max in 2021. These services are progressively acquiring and commissioning Argentine fictional content as part of their strategies to attract domestic subscribers, although local titles remain a small percentage of the content libraries. In contrast, Argentine television networks have found it cheaper to either license foreign series or stop programming fiction shows altogether, which makes video streaming platforms an increasingly key financial source and distribution option for original Argentine serial fiction.

In this chapter, I analyze key SVOD commissions in Argentina from 2016 through 2021 to show how global streaming service strategies comingle with storytelling strategies rooted in the nation's audiovisual culture. In addressing this collection's central question—how do SVODs inform storytelling strategies in different national contexts?—I develop a two-pronged argument that takes into account the earliest steps in Argentine/SVOD

cocreations, as well as the explosion of biographical series (or biopics) emerging at the end of the 2010s. On the surface, Argentine SVOD content follows patterns of what Jason Mittell (2016) has called "complex TV," a phenomenon associated with premium U.S. television. However, I argue that SVODs also amplify narratives already present in Argentine television and strategically build on the tropes and talent that emerged from New Argentine Cinema, a movement characterized by its low-budget social dramas and incisive representation of the impact of neoliberal policies in the country. I show how a negotiation of the local and the global is present in the production of Argentine biopics, which have become prime content for international SVODs as they enter new national contexts, experiment with genre norms, and cultivate a repository of national popular culture.

Before I address the shows themselves, it is crucial to provide a brief overview of the Argentine media context of the early 2000s in order to gauge the full impact that SVODs have had on the nation's televisual landscape. The Argentine subscription streaming market has changed dramatically in a short period of time, and much of this change is attributable to global streaming services that are now investing in the nation's producers. At the same time, this growth emerges from a particular national framework that is marked by major economic crises as well as ongoing tension between the government and Argentina's major media conglomerates. In the next section, I will trace the history of governmental shifts that produced a series of legislative orders designed to break oligopolistic ownership of media conglomerates operating in the country, only to have these measures reversed under the following administration. To map out these transformations, this overview will introduce the major players in the Argentine industry, as well as the winners and losers of recent technological and market changes.

Twenty-First Century Argentine Television: Liberalism, Protectionism, and Crisis

During the 1990s, Argentina experienced the final transition from a closed, state-controlled television industry to one that was fully priva-

tized and liberalized (Waisbord and Jalfin 2010), with the exception of the public broadcaster Argentina Televisora Color (now TV Pública). By the beginning of the 2000s, the market was concentrated in the two major commercial networks, Telefé (property of the Spanish telecommunications company Telefónica from 1999 until 2016 and ViacomCBS thereafter) and El Trece (owned by Argentina's biggest media conglomerate, Grupo Clarín). After the 2001 economic crisis, television fiction production waned drastically. Telefé and El Trece were able, however, to maintain their dominant positions because of their high ratings as well as the cutting of costs and personnel that resulted from outsourcing their productions (Carboni 2019a, 424). Almost of all of El Trece's fiction productions were provided by the self-owned Pol-Ka Producciones—also owned by Grupo Clarín. Telefé created its own production company, Telefé Contenidos, and established joint ventures with other production firms, such as Ideas del Sur, Underground, the Cris Morena Group, Dori Media, and Endemol Argentina. These producers dominated the Argentine market for television fiction production in the mid-2000s.

Under Cristina Fernández de Kirchner's progressive administration (2007–2015), the government intervened in the national media landscape in an attempt to break the hegemony of the major media oligopolies so that "the regulation of audiovisual media became part of the government's agenda" (Rodríguez Miranda and Carboni 2018, 46–47). In 2009, a new law called the Audiovisual Communications Services Act (Ley 26.522 de Servicios de Comunicación Audiovisual, or simply, Ley de medios) was enacted to limit the number of broadcasting licenses and force media conglomerates to divest. The main target for this policy was Grupo Clarín, owner of El Trece and *Clarín*, the largest Argentine newspaper, as well as proprietor of the cable company Cablevisión and the internet service provider Fibertel. The goal was that the Audiovisual Communications Services Act would both liberalize the market and weaken Grupo Clarín, which had been attacking the government through its media outlets. In addition, the state made important investments in both the creation of new networks and the production of

television shows to fill out the schedules of the newly created channels. Support for television production came in the form of public biddings offered by different ministries—such as education or science, technology, and innovation—seeking to support educational programs (for example, *Mentira la verdad* [2011–], *La asombrosa excursión de Zamba* [2010–], and *Ver la historia* [2015–]); the National Institute of Cinema and Audiovisual Arts (INCAA) also provided competitive grants to support the production of fictional shows (such as *Los pibes del Puente* [2012], *Cromo* [2015], and *El pacto* [2011]).

The government-led effort to finance television content during the years of Fernández de Kirchner had two major effects. First, the independent production sector was strengthened, as public funds were largely devoted to small- and medium-sized companies and even fostered the formation of new ones. Second, television content was further diversified at both the levels of aesthetics and narrative, with producers often experimenting with storytelling techniques. In terms of fiction production, Argentina's primary television genre had, up to this point, historically been the telenovela, characterized by its overtly melodramatic nature, low production values, and long seasons (usually more than one hundred episodes) with new episodes airing daily. The major Argentine production companies remained primarily invested in the lucrative and stable category of the telenovela, although they also created shorter series that tapped into other genres—for example, thrillers and murder mysteries—incorporating higher production values and emulating the aesthetic and narrative patterns of the drama productions of international cable and premium networks.

In contrast, smaller firms that received public support between 2007 and 2015 focused almost exclusively on shorter serialized fictional narratives that pushed against the telenovela's excessive melodrama. These programs adopted aesthetics closer to that of cinema thanks to the availability of cheap high-definition (HD) cameras. Production design strategies also underwent a radical change: suddenly entire seasons needed to be written before the beginning of production as opposed to the long-

standing practices of telenovela production in which new scripts were delivered daily so that character arcs could correspond to audience measurement and commercial sponsorship (Carboni 2019b, 15). However, this emerging audiovisual fiction market was inherently unsustainable without state support (Carboni 2019a, 432). Most of the companies that were formed or strengthened under Fernández de Kirchner's administration were incapable of remaining in business without public funds.

This period of state investment in Argentine screen production came to a close with the election of the conservative, pro-business Mauricio Macri government (2015–2019), which forcefully undermined the previous administration's media policies. Macri annulled anti-oligopoly regulations and implemented drastic budget cuts to production funds. Nonetheless, the dominant trend of Argentine television fictional content remained that of the shorter and more textually innovative series to the detriment of long telenovelas that, given the decline in local production, were increasingly imported from Brazil and Turkey to occupy the prime-time slots of El Trece and Telefé. Major content producers such as Underground and Pol-Ka began focusing their capital and energies on the creation of shows with clearly defined story worlds and narrative arcs; each episode has its own storyline while resisting narrative closure and contributing to the larger story of the series—as was the growing norm among series with strong international distribution and characteristics of "complex TV" (Mittell 2006, 32). In order to secure funding for these series and reduce financial risks, Argentine production companies applied for government grants or partnered with foreign networks such as TNT, HBO, or Disney, and sometimes utilized a combination of the two (Carboni 2019a, 434).

Global SVOD platforms clearly entered the Argentine market as producers in an ecology characterized by strong political and industrial shifts, as well as ongoing tensions between the public and the private sectors. Today, the production of Argentine television fiction is in dire straits as a result of Macri's policies and the COVID-19 pandemic.[1] Companies including Netflix, Amazon, and HBO have entered into partnerships with

the largest domestic production firms and have helped to sustain the creation of Argentine television fiction. As production costs rose, only the big players were able to continue operating. For example, the standard production cost per episode of a prime-time telenovela is US$80,000, while the cost per episode of a "series of international quality" varies between US$300,000 and US$750,000 (Guevara 2020).

The result of these international partnerships is that Argentine SVOD commissions—like those in many places—are marked by a pull between the local and the global. On the one hand, many SVOD shows not only engage with themes and narratives that have previously proven successful in the country (such as marginality, crime, and corruption) but are also directed by renowned national talent—for example, directors like Daniel Burman and Israel Adrián Caetano. On the other hand, the pressures to appeal to international audiences and to fit into a global market may, at times, hinder the artistic potential of the shows and the extent to which they connect with domestic audiences. In the following section, I track the early years of SVOD commissions in Argentina (2016–2021) with a focus on Netflix as the service that has been operating longest in the country. By providing this snapshot in time, my analysis maps out the strategies that are beginning to be adopted by other streaming video platforms (Prime Video, HBO, and Disney+) as they insert themselves in the Argentine market.

Netflix Argentina: From the Runway to the Shanty

The first two Argentine Netflix exclusives were *Estocolmo: identidad perdida/Stockholm: Lost Identity* (2016) and *Edha* (2018). *Estocolmo* was financed by INCAA, with Netflix coming on board during postproduction (Lamazares 2016). In contrast, Netflix fully funded the production of *Edha* as its first full Argentine commission (Jaafar 2016). Despite this difference between the series, there are three reasons for analyzing these two shows together: they represent Netflix's first steps in supporting Argentine fictional series; they are comparable both in terms of genre and

cast; and both *Estocolmo* and *Edha* present similar problems and were canceled after their first season.

Estocolmo focuses on journalist Rosario Santa Cruz, who investigates a human trafficking network only to discover her own dark family secrets. In *Edha*, the eponymous main character—a successful fashion designer—is similarly embroiled in family and political intrigue when she must account for a tragedy that occurred in her family-owned sweatshop. In this way, the series are linked by their narrative strategy to entangle the main female protagonist in a mystery whose threads go deeper into the social texture than they initially appear. Both Rosario and Edha are also played by the same actress, Juana Viale.

The two series, then, are thrillers that present many of the characteristics audiences might associate with contemporary complex dramas: large casts, multiple and intersecting storylines, dead women, and political corruption. Indeed, *Estocolmo* and *Edha* might be favorably compared to Nordic noir dramas, and not simply in their photography and predominance of blue, grey, and brown tones as well as overcast exteriors and dimly lit interiors (Waade 2017, 388). More significant is the way both series graft personal tragedy onto character construction, following what Audun Engelstad (2018, 27) has argued to be a staple of Nordic noir, in which "main characters often struggle to keep their personal lives together, and the crimes they are involved in (as investigators or victims) throw a grim light on flaws in society that extend beyond the crime itself." *Estocolmo*'s main character discovers that she is the daughter of a former sex slave who became the leader of the human trafficking network at the heart of the program's mystery. Meanwhile, Edha falls in love with her new model, Teo, a Central American immigrant who is seeking revenge for his brother's death caused by a fire in a sweatshop owned by Edha's family.

Perhaps because of this transnational generic flexibility, both series struggle to articulate a coherent sense of national identity, and critics highlighted a certain lack of Argentineness in the universes built by the shows. There is nothing about the fashion world in *Edha* that could

distinguish Buenos Aires from any other major cosmopolitan city. The same can be said for the show's grittier scenes, which take place in the type of public housing that can be found in North America or Europe rather than the *villas miserias* (shanty towns) typical of Argentine metropolitan areas. Cultural and Hispanic studies scholar Ksenija Bilbija (2018, 460) criticizes *Estocolmo* for its consistent lack of national markers: "None of its 13 episodes offered the global public a single traditional icon associated with the country: no tango, no soccer, no [yerba] maté, no gauchos, no Che [Guevara], no Evita, no Maradona." Bilbija's critique, however, is not entirely merited, as the first few episodes feature *both* a gaucho witness and a football stadium. One could also argue that these signifiers represent a superficial sense of Argentine identity (even though this national iconography is providing fertile ground for the SVOD biopics, as will be considered shortly). After all, series that are more expressly devoted to soccer are not necessarily more successful (commercially or critically), as is the case with the canceled *Puerta 7* (2020, Netflix). Nevertheless, Bilbija's point can be expanded to the treatment of geographical locations of *Estocolmo*—Buenos Aires and the Patagonia region—which function almost entirely anonymously rather than with local specificity and history.

This failure to express a distinctive national marking is particularly odd, since both shows revolve around issues that have enormous potential to resonate with an Argentine public. The forced disappearances of people, acknowledged in *Estocolmo*, recall the horrors of the 1976 military dictatorship, just as the focus on human trafficking could call to mind recent high-profile and unsolved cases (for example, Marita Verón, María Cash, and Sofía Herrera). Despite these possible references, *Estocolmo* does not make any attempt to build connections with these real stories; any parallels are discerned only through the audience's pre-existing historical knowledge. The same goes for *Edha*: sweatshop labor was a recurrent journalistic topic during Mauricio Macri's presidency since his wife's clothing brand was suspected of running illegal sweatshops, yet *Edha*'s diegetic world is not sufficiently grounded in the

Argentine textile industry.[2] This is particularly striking since the show's director/creator, Daniel Burman, had been celebrated for his treatment of the dynamics within the Jewish community and the textile market in the Once neighborhood of Buenos Aires.

The cast of *Edha* was also a strange choice for Netflix's first Argentine commission. Viale is known for being the granddaughter of popular Argentine TV host Mirtha Legrand, but as an actress she worked in supporting roles for most of her career. Further, some of *Edha*'s dialogue is likely to be off-putting to native Spanish speakers: it is unclear which Central American nationality Velencoso is trying to imitate, a problem exacerbated by the actor who plays his brother (audibly Colombian). This implausible background is further complicated by the fact that Central American migration is relatively uncommon in Argentina, and especially irrelevant in the context of the considerable present-day influx of Venezuelans. Neither of the two series was renewed for a second season, and *Estocolmo* was pulled from the catalog after its contract with Netflix expired. The producers still hope to sell the show to another platform in order to produce an already-written second season (Guevara 2020).

Not all of Netflix's early Argentine projects resulted in one-off seasons, however. In tandem with these early experiments, Netflix made an investment that more clearly engaged with Argentina's audiovisual culture, thereby helping to define the platform's fictional content profile in the country: the purchase of the distribution rights of the successful series *El Marginal* (2016), which was originally produced for TV Pública. The show tells the story of an undercover cop, Miguel Palacios (played by Juan Minujín), who infiltrates the fictional prison of San Onofre in order to rescue the daughter of a corrupt judge. *El Marginal* was created by Israel Adrián Caetano together with Sebastián Ortega and produced by Underground (founded by Ortega and now owned by NBCUniversal), with capital coming from Underground and INCAA. It represents a rare contemporary case of a successful network television program on public broadcasting competing neck-and-neck with the major

commercial networks. Netflix bought the show's rights the same year as its release, added it to the catalog after its network run, and showcased it as a staple of the nation's shows on the platform.

El Marginal follows a similar premise to other renowned foreign prison dramas available on Netflix's catalog like *Orange is the New Black* (2013) and the Spanish *Vis a Vis/Locked Up* (2015), as the narrative focuses on an outsider who must quickly adapt to the social world of the penitentiary. Like *Orange* and *Vis a Vis*, the series uses the outsider as a pretext for entry into the prison, where the show then begins narrating the stories of other inmates and prison employees. In contrast to those series, which focus on female penitentiaries and reflect on gender roles, *El Marginal* is a decidedly more macho product. The San Onofre prison is a gruesome space where there is little place for compassion, and the moral corruption of most of its inhabitants is beyond salvation. The series has inspired comparisons with earlier shows centered on male prisons such as *Oz* (1997–2003, HBO) and *Prison Break* (2005–2017, Fox). However, these similarities were dismissed by Minujín himself, who claims that *El Marginal* aims to portray the living conditions of Argentine and Latin American prisons specifically (Lenoir 2017). The series' tone and aesthetics support the argument that the series is influenced by a longer South American cinematic tradition of raw portrayals of social violence, marginality, and corruption—as seen in films such as *City of God* (Meirelles and Lund, 2002, Brazil), *Carandiru* (Babenco, 2003, Brazil), and *Leonera* (Trapero, 2008, Argentina).

Argentine communication scholars Gustavo Aprea and Mónica S. Kirchheimer (2019) claim that series like *El Marginal*, which was released under Macri's administration, continue a trend that emerged during Fernández de Kirchner's presidency: gritty, limited-run series produced by independent companies and supported by government funds with narratives that shy away from the excessive melodrama of telenovelas. As part of their analysis of Argentine television fictional series of the 2010s, however, Aprea and Kirchheimer distinguish *El Marginal* from

shows that were released during the Kirchner era for its exploitative and violent depiction of criminality. They speculate that especially after Netflix's acquisition of the show, "the stereotypical nature of the characters [was] reinforced and the display of physical violence [was] intensified" (Aprea and Kirchheimer 2019, 25). This perceived shift leads Aprea and Kirchheimer to conclude that major production firms (like Underground) appropriate both the style and themes of smaller productions in order to find their footing in the international video streaming market—and likewise to help companies like Netflix find theirs in the Argentine market (2019, 26).

This analysis, however, is arguably too generous to Kirchner-era cultural production and neglects that the roots of shows like *El Marginal* cannot be attributed solely to recent publicly funded television. Given its creators and style, *El Marginal* is visibly the heir of a major Argentine audiovisual current, that of the New Argentine Cinema. This movement, which emerged during the late 1990s and early 2000s, sought to represent the social devastation brought about by the neoliberal administrations of Carlos Menem (1989–1999) and Fernando de la Rúa (1999–2001) that culminated in the economic crisis of 2001. In the words of Jens Andermann (2011, xii), New Argentine Cinema was "a crop of young 'independent' film-makers identified, to varying degrees, by their shared preoccupation with the national present at a time of crisis, often encountered through neo-realist chronicles of the social and geographical margins." One of the most emblematic pieces from this period of Argentine films was *Pizza, birra, faso/Pizza, Beer, and Cigarettes* (1998), codirected by Caetano and Bruno Stagnaro. Originally planned for television, the film revolved around a group of delinquent youths and was widely celebrated for its crude portrayal of life on the streets of Buenos Aires as well as for the way it accurately captured street slang. Due to the film's critical acclaim and box office success, the now-dissolved production company Ideas del Sur seized the talents of both Caetano and Stagnaro to bring the spirit of New Argentine Cinema to the "small

screen." The result was two miniseries: *Okupas/Squatters* (2000) and *Tumberos/Prisoners* (2002). Directed by Stagnaro, *Okupas* is centered on a group of friends from diverse social backgrounds who squat together in a house in downtown Buenos Aires. *Tumberos*, a series that foreshadows *El Marginal* in somewhat obvious ways, was released two years later. The show follows a powerful lawyer who has been wrongly imprisoned and must adapt to life as an inmate and prove his innocence. *Tumberos* was produced almost by the exact same team that created *El Marginal*: Caetano and Ortega alongside Ideas del Sur's owner, Marcelo Tinelli. Finally, both shows were shot in the same location: the nonoperational Caseros prison, which has proven to be a cheap and useful location.

The life and influence of New Argentina Cinema has also been expanded by Netflix, especially with the rerelease of Stagnaro's *Okupas* in 2021. The revival of the series, which had been out of circulation since its original network run (and otherwise only available through pirate copies), was a significant cultural moment. Netflix not only remastered the show but also changed the musical score, which had hitherto generated several copyright issues and prevented legal access to the series. *Okupas'* HD release gave the program an entirely new life, making it accessible to a new generation of viewers as well as an international audience. In addition to this, the rerelease generated a wave of reviews and think pieces from Argentine media outlets that fostered reflection upon the crisis years and sparked a national conversation over the series' stunning relevance to present-day social inequities.[3]

This is just one example of where SVODs have achieved particular success in the Argentine market: namely, the transformation of recent history into fictional content that provides both domestic and international spectators with a repository of national popular culture. In the next section, I will examine the forerunner of this type of streaming content: the serial biopic. Biographical dramas become strategic products for SVODs as they engage directly with Argentina's popular iconography and display tried-and-true generic traits for Argentine and foreign audiences.

Based on a True Story: Streaming Biopics

Beyond the Argentine context, biopics have already been operating as markers of emerging media markets, with producers drawing on specific national histories as they compete to establish themselves. This is true of markets in both the global south *and* north. Jonathan Bignell (2019, 48) recalls how, for example, "in the mid-2000s, economic, regulatory and aesthetic pressures in Britain and the United States led to a massive expansion of airtime that broadcasters wanted to fill, and the waning of some established genres and forms urgently required programme makers to find new stories and new ways of telling them. Fact-based drama of various kinds was one of the key responses to this demand." As SVOD platforms multiply and settle in new territories, these companies turn to biographical series to fill out their catalogs, hoping to attract subscribers from diverse nations. In this sense, the proliferation of Argentine serial biopics fits into a larger historical context in which recent events provide easy content to fill out SVOD catalogs.

Among the biographical drama series produced by SVOD services in Argentina are *Monzón: A Knockout Blow* (2019, Netflix), *Apache: The Life of Carlos Tévez* (2019, Netflix), *Maradona: Blessed Dream* (2021, Prime Video), and *Santa Evita* (2022, Disney+). Additionally, two independent production companies, Mulata Films and Kapow (*Estocolmo*), are developing a biopic on Argentina's former president Carlos Menem titled *¡Síganme!/Follow Me!*. Although *¡Síganme!* has been associated with Amazon, nothing has been formalized (at the time of press), and the series' producers are still hoping to place it on an SVOD. The biopic has emerged in Argentina as the spearhead product that distinguishes each SVOD in the market as these titles have been accompanied by considerable media buzz, public conversation, and cultural debate. According to Santiago Guevara (2020), line producer of *Maradona: Blessed Dream*, for example, Amazon was banking its entry into Argentina precisely on this series, released in October 2021 to increased fanfare after the recent death of the soccer legend himself. I focus on *Monzón* and *Apache* as,

during the writing of this piece, they were the two prominent examples already released for streaming. In what follows, I will introduce these two series, which are focused on Argentine sports heroes, while placing the rest into a broader framework, drawing on interviews I conducted with the producers of *Monzón*, *Maradona*, and *¡Síganme!*

Netflix became the first SVOD platform to invest in Argentine biographical drama with the commissioning of *Apache*. Following the commercial success of *El Marginal*, Caetano collaborated with creator and showrunner Leonardo de Pinto on *Apache*, which follows the early life and career of acclaimed soccer player Carlos Tévez. The series was produced by Torneos y Competencias—one of the biggest Argentine sports media companies, owned by DirectTV and a longtime commercial partner to Grupo Clarín—and was released exclusively through Netflix. Known in Argentina as "the people's player," Tévez had a dramatic and tragic personal life well suited to the biopic genre: his father died in a shootout before he was born; his mother abandoned him as a newborn after a domestic accident that scarred him for life; and he was raised by his uncle and aunt. In addition, Tévez grew up in the working-class neighborhood Ejército de los Andes, popularly known as *Fuerte Apache* (Fort Apache), a discriminatory term referring to its high crime rates and drug-related violence.

After *Apache*'s release, Netflix acquired the distribution rights to the biopic *Monzón: A Knockout Blow*, which had performed well on cable network TNT and made it a platform exclusive. The series was a coproduction between Disney and Pampa Films, a major film production company owned by Pablo Bossi, who had founded another of Argentina's paramount production firms, Patagonik Film Group. The show also received funding from INCAA. The series follows the life of 1970s middleweight world champion boxer Carlos Monzón, who became a notorious public figure because of his athletic prowess as well as his infamous personal life that was marked by multiple allegations of domestic violence and the murder of his third wife, Alicia Muñiz. The show explores Monzón's life in parallel stages: his childhood in abject poverty,

his rise to fame, the beginnings of his excesses, his retirement, domestic scandals, and, lastly, his murder trial.

Both series present crucial characteristics that make biopics strategic content for global SVODs. First is their capacity to attract audiences across multiple territories by trading on the formidable star power of their protagonists. This aligns with the SVOD business model because it eliminates the need to produce multiple versions of the same content for different national markets. In this sense, Maximiliano Lasansky (2021), Pampa Films's executive producer, reveals that when they presented the idea for *Monzón*, Disney was in search of a show that could be marketed for the Latin American region rather than Argentina alone. Likewise, in *Apache*'s case, Tévez is not simply a national hero owing to his time in Boca Juniors; he is also a globally famous star (highly recognizable also for the scars along his neck) after playing in major European clubs such as Manchester United, Manchester City, and Juventus.

Second, contemporary serial biopics address a rich variety of television audiences insofar as they usually mix diverse audiovisual genres (Aprea, Kirchheimer, and Rivero 2020, 78). Customarily, biopics are melodramatic texts at their core since they tend to focus on the rise of righteous heroes who overcome multiple obstacles as a result of their positive qualities. Aprea, Kirchheimer, and Rivero note that series like *Monzón* stand out for their ability to problematize these typified characteristics of the genre (2020, 78). *Monzón* displays characteristics of the melodrama—namely, the rags-to-riches story. At the same time, it exhibits aspects associated with noir narratives: the corrupt police investigation of Múñiz's homicide and a morally ambiguous (or, in this case, reprehensible) protagonist. The focus on the investigation, moreover, as well as the series' insistent return to the murder scene (with Muñiz's naked corpse) all carry with them the air of true crime, a particularly successful genre for Netflix. *Apache* deals with its central hero in a more traditional melodramatic manner, focusing on Tévez's positive traits as a hardworking hero, good friend, and son. The series nevertheless presents clear traits of genre blending since it not only makes use of

elements of the New Argentina Cinema found in Caetano's work but also engages with tropes typical of other Netflix *narcoseries*—for example, *Narcos* or *El Chapo* (2017)—as the series narrates the drug gang wars that took place in Tévez's neighborhood.

The producers of SVOD biopics also highlight their nostalgic character as an asset. Guevara, producer of *Maradona: Blessed Dream*, notes that biopics enable viewers to "recall historical moments that [they] might have lived through" (Guevara 2020). Reflecting on the success of *Monzón*, Lasansky similarly observes that because biographical series are based on "historically and publicly relevant characters and events, they provide a universe that can attract viewers who are new to [them] or who might know about [them] but want to see how [they are] fictionalized" (Lasansky 2020). Although set in the past, contemporary biopics offer revisionist accounts touching upon present-day hot-button issues such as domestic violence and women's rights. In this regard, Guevara asserts that contemporary biographical series seek to uncover the unacknowledged side of popular idols. Maite Echave (2020), owner of Mulata Films and producer of *¡Síganme!*, reveals that through its focus on the not-too-distant past, Carlos Menem's series will explicitly comment on contemporary Argentine politics, especially Peronism. By reflecting on the present from a historical perspective, biopics have a significant intergenerational appeal.

Yet biopics also have certain requirements that mean that only the largest production companies can produce them. Biopics, as period pieces, require high production-design budgets to recreate the spaces, fashion, and props typical of the era. Furthermore, production companies need capital and personnel to navigate logistical and potential legal issues that result from portraying the lives of well-known (and often controversial) popular figures. In this sense, *Apache* differs from the other shows discussed here as it portrays a still-living hero who appears on screen at the beginning of each episode to lend the show a kind of authenticity. This is certainly not the case for many other biopics. For instance, Lasansky mentions that, for *Monzón*, they acquired the rights to the biography *Monzón, secreto de sumario* (Staiolo 1991) and asked

permission of Monzón's family to fictionalize his life story. Pampa Films also interviewed Monzón's family members and hired various consultants including legal, boxing, and biographical experts in order to produce a well-rounded portrayal of the boxer. Finally, Pampa Films also consulted the legal archives of Alicia Muñiz's murder case. This thorough production process, nonetheless, did not prevent Monzón's family members or the author of his biography from expressing their discontent over perceived inaccuracies in the fictionalization of Monzón's life. Similarly, Maradona's ex-wife and his former manager have already suggested they will litigate over their portrayals in Amazon's biopic, even though Maradona himself approved his portrayal before his death.

Conclusion

This chapter has established that global SVOD services build on existing storytelling practices within the Argentine audiovisual industry rather than offer a radically new kind of scripted drama. In their prominent use of the biopic genre, SVODs including Netflix and Prime Video also contribute to the maintenance and extension of Argentina's national culture. Beyond biopics, the tendency towards what Bignell calls "fact-based drama" seems to be a formula that will persist given that several recently announced SVOD commissions are based on real-life accounts.[4] Furthermore, in 2021 the Argentine government advertised a new plan to subsidize audiovisual productions, Renacer Audiovisual, which features a special grant category for historical fiction.

At the level of industry, SVODs continue the trend that existed before their arrival into the Argentine market: foreign companies forging alliances with major domestic production firms, some of which form part of multinational conglomerates (such as Underground). The vast majority of titles cited in this chapter were created by companies well established in the Argentine audiovisual industry and by multinational firms (like BTF, producer of *Maradona*, and Buena Vista International in the case of *Santa Evita*). This pattern reveals what Echave (2020) describes

as a critical situation in the production ecosystem: not only do smaller companies (like Kapow and Mulata Films) need to partner to afford the rising costs of productions, but large firms also band together in order to compete in the international platform market. Although SVODs are steadily investing in Argentine fictional content, the national industry will need, once again, the support of the state to subsist. This will, however, require planning that transcends fluctuating political administrations in order for any viable audiovisual industry to grow and prevail.

Notes

1 Between 2010 and 2014, the number of hours of newly released fiction averaged over 1,000, whereas this number was reduced to half between 2015 and 2019. The impact of the COVID-19 pandemic in the Argentine audiovisual fiction market is reflected in the fact that in 2020 all free-to-air channels together released only five new fictional series, otherwise filling out their programming schedules with reruns. Moreover, there was a halt of 95 percent of fiction productions in both television and cinema. For more, see Rivero (2021) and Carboni (2021).
2 In this sense, director Burman was able to bridge his own directorial comfort here, since he had also dealt with the textile industry in successful films such as *El abrazo Partido/The Broken Embrace* (2003) and *El rey del Once/The Tenth Man* (2016)—the latter is available in Netflix's catalog in more than thirty countries.
3 To read some of the reflections triggered by *Okupas*' rerelease see Incaminato (2021) and Tuñez (2021).
4 Announced series include: *Iosi, el espía arrepentido/Iosi, the Regretful Spy* (2021, Prime Video), inspired by the story of a Jewish spy who collaborated with the 1994 terrorist attack on the Israelite Argentine Mutual Association; *El fin del amor/The End of Love* (2022, Prime Video), based partially on the life of journalist Tamara Tenenbaum; and the film *Argentina, 1985* (Santiago Mitre, 2022, Prime Video), which narrates the story of the prosecution of the leadership of the 1976 military dictatorship.

References

Andermann, Jens. 2011. *New Argentine Cinema*. London: I.B. Tauris.
Aprea, Gustavo, and Mónica S. Kirchheimer. 2019. "Del Plan Operativo de Fomento a Netflix. Transformaciones de las narraciones seriadas argentinas en la última década." *TOMA UNO* 7:15–29.

Aprea, Gustavo, Mónica S. Kirchheimer, and Ezequiel Rivero. 2020. "Anuario Obi-
tel 2020. El melodrama en tiempos de streaming." *OBITEL*, November 10, 2020:
49–81. https://obitelar.wordpress.com/2020/11/10/anuario-obitel-2020-modelos-de
-distribucion-de-la-television-por-internet-actores-tecnologias-estrategias/.

Bignell, Jonathan. 2019. "Television Biopics." In *A Companion to the Biopic*, edited by
Deborah Cartmell and Ashley D. Polasek, 45–60. Newark: John Wiley & Sons.

Bilbija, Ksenija. 2018. "Argentina, Estocolmo, Netflix y el síndrome de la identidad
perdida." *Kamchatka* 11:459–74.

Business Bureau. 2021. "Pay TV and Multiscreens Map 2021." https://bb.vision/bb-pay
-tv-and-multiscreens-map-2021/.

Carboni, Ornela Vanina. 2019a. "El mercado de las ficciones en Argentina." *Razón Y
Palabra* 23 (104): 416–37.

Carboni, Ornela Vanina. 2019b. "El trabajo de los guionistas en las telenovelas Argen-
tinas." *Cuadernos de H ideas* 13 (13). https://doi.org/10.24215/23139048e019.

Carboni, Ornela Vanina. 2021. "Plan de Contenidos Argentinos: necesidad y urgencia."
Letra P, May 17, 2021. https://www.letrap.com.ar/nota/2021-5-17-9-56-0-plan-de
-contenidos-argentinos-necesidad-y-urgencia.

Echave, Maite. 2020. Interview by Joaquín Serpe, November 17, 2020.

Engelstad, Audun. 2018. "Framing Nordic Noir: From Film Noir to High-End Televi-
sion Drama." In *European Television Crime Drama and Beyond*, edited by Kim Toft
Hansen, Steven Peacock, and Sue Turnbull, 23–39. Cham: Springer.

Guevara, Santiago. 2020. Interview by Joaquín Serpe, October 24, 2020.

Incaminato, Natalí. 2021. "La Amistad En Un Paisaje En Ruinas." *Anfibia*, July 20, 2021.
http://revistaanfibia.com/ensayo/okupas-la-amistad-en-un-paisaje-en-ruinas/.

Jaafar, Ali. 2016. "Netflix Commissions First Argentinian Series *Edha* From Daniel
Burman." *Deadline*, May 19, 2016. https://deadline.com/2016/05/netflix-argentina
-edha-daniel-burman-narcos-jose-padilha-1201759478/.

Lamazares, Silvina. 2016. "*Estocolmo*: de Buenos Aires al mundo." *Clarin*, November 11,
2016. https://www.clarin.com/espectaculos/tv/Estocolmo-Buenos-Aires-mundo_o
_HkoLOOMbe.html.

Lasansky, Maximiliano. 2021. Interview by Joaquín Serpe, May 18, 2021.

Lenoir, Anne. 2017. "*Juan Minujin* (El Marginal, Canal+): 'La série a ouvert un
débat sur les conditions de detention.'" *Télé-Loisirs*, June 26, 2017. https://www
.programme-tv.net/news/series-tv/119979-juan-minujin-el-marginal-canal-la-serie
-a-ouvert-un-debat-sur-les-conditions-de-detention/.

Mármol, Hernán. 2020. "Argentina está entre los 10 países con más suscriptores de
Netflix." *Clarin*, February 19, 2020. https://www.clarin.com/tecnologia/argentina-10
-paises-suscriptores-netflix-mundo_o_gqaLXSjU.html.

Mittell, Jason. 2006. "Narrative Complexity in Contemporary American Television."
The Velvet Light Trap 58 (1): 29–40.

Rivero, Ezequiel. 2021. "La industria de la ficción New Argentine Cinemaional
cayó casi 65% en diez años." *Letra P*, November 2, 2020. https://www.letrap.com

.ar/nota/2020-11-2-11-9-0-la-industria-de-la-ficcion-nacional-cayo-casi-65-en
-diez-anos.

Rodríguez Miranda, Carla, and Ornela Carboni. 2018. "Communications Policies and the Production of Audiovisual Content in Argentina." *Latin American Perspectives* 45 (3): 44–54.

Serpe, Joaquín. 2018. "Argentina." Global Internet TV Consortium. https://www.global-internet-tv.com/argentina.

Staiolo, Marile. 1991. *Monzon—Secreto de sumario*. Buenos Aires: J. Vergara Editor.

Tuñez, Gabriel. 2021. "Manuel Gaggero, figura oculta de *Okupas*: 'La marginalidad y la pobreza que relata la serie tiene más que ver con esta época que con aquella de hace 20 años.'" *elDiarioAR*, August 14, 2021. https://www.eldiarioar.com/sociedad/manuel-gaggero-figura-oculta-okupas-marginalidad-pobreza-relata-serie-ver-epoca-20-anos_128_8216337.html.

Waade, Anne Marit. 2017. "Melancholy in Nordic Noir: Characters, Landscapes, Light and Music." *Critical Studies in Television* 12 (4): 380–94.

Waisbord, Silvio, and Sonia Jalfin. 2010. "Imagining the National: Television Gatekeepers and the Adaptation of Global Franchises in Argentina." In *TV Formats Worldwide: Localizing Global Programs*, edited by Albert Moran, 58–79. Bristol: Intellect Ltd.

Girls from Ipanema and Netflix's Deviations from Brazilian Serial Storytelling Norms

SIMONE MARIA ROCHA AND LIVIA MAIA ARANTES[1]

Since Netflix launched its Latin America service in September 2011, Brazil has played a central role in the company's regional ambitions. In 2015, Netflix CEO Reed Hastings described the country—with its large population, growing middle class, and adequate broadband infrastructure—as a "rocket ship" because of the rapid rise in Brazilian Netflix subscriptions (Gallas 2015).[2]

Netflix began commissioning content in Brazil in 2016 and, as of May 2022, had invested in seventeen original series across different genres and formats. Its originals are produced by large- and medium-sized Brazilian production companies, with Netflix generally financing full production costs (which enables the company to retain long-term and exclusive control over rights).[3] Netflix typically appoints an executive to act as either a creative supervisor or within the creative team itself.

When Netflix began producing originals in Brazil, it did so by embracing popular genres. This naturally means the telenovela, a regionally (and globally) popular television genre that relies on melodramatic poetics and serial story structure. The main producer of telenovelas in Brazil is Rede Globo de Televisão, which owns one local broadcaster and several cable channels. Rede Globo has been a market leader for more than 60 years and has built a global reputation on the basis of its many Brazilian telenovelas that it exports around the world.

The cultural history of the telenovela in Brazil and its status as a key national export make Netflix's Brazilian originals a particularly significant site of investigation. Through an analysis of *Girls from Ipanema*

(2019–2020), this chapter explores how Netflix negotiates and reconfig-
ures the traditional features of the Latin American melodrama to serve
its own transnational business model. Our analysis identifies four key
changes—or *deviations*, as we describe them—that Netflix has made to
Brazilian telenovela norms related to plot structure, protagonists, char-
acter perspective, and national specificity. As we will show, these devia-
tions from traditional Brazilian telenovela storytelling norms reflect the
broader, international audience Netflix aims to reach.

"You Are Very Good at Melodrama"

Girls from Ipanema tells the story of four women and their personal, so-
cial, and political lives in the conservative and patriarchal society of Rio
de Janeiro in the late 1950s. The series makes extensive use of the Bossa
Nova musical wave, which provides a specific cultural and creative back-
drop to the narrative. According to the show's creator and lead writer
Giuliano Cedroni, Netflix made its expectations for the series very clear:
they wanted to commission an "elevated soap opera . . . a premium soap
opera" featuring female characters from across Brazil's socioeconomic
spectrum ("women aged 20 to 45 years, classes A, B, C").[4] Cedroni re-
calls the conversation with Netflix as follows:

> This is the genre and they [Netflix] knew it from day one . . . "You are
> very good at melodrama, you are very good at telenovela. We studied
> you. We want to make a premium soap opera. A modern soap opera that
> takes the essence of melodrama along with the narrative speed of the
> most contemporary series. [. . .] We want Bossa Nova as a background,
> we want this universe, but we want to speak to a lot of people . . . And we
> believe that the language of melodrama, of telenovelas, will speak to a lot
> of people in Brazil" (Cedroni 2019).

What were Netflix executives referring to when they claimed that
Brazilians "are very good at melodrama"? Jesús Martín-Barbero offers

an innovative and sophisticated analysis of Latin American narratives and their intrinsic relationship with popular culture (Martín-Barbero and Muñoz 1992; Martín-Barbero 1993). He locates the telenovela at the center of Latin American cultural production, tracing the encounter of serialized novels in newspapers with melodrama.

Brazilian telenovelas typically span six months, airing six days a week, with episodes interrupted by commercial breaks. This requires telenovelas to adopt a slower pace, with protracted conflict resolution that takes place across several episodes. The narration unfolds in a linear fashion, while also evoking the fragmented and repetitive temporality of everyday life (Martín-Barbero 1993). In Brazil, a key characteristic of the telenovela is its juxtaposition of melodrama and realism. The Brazilian telenovela blends themes such as romance, family, and personal dramas with public-interest issues such as land reform, political corruption, and social change. Thus, stories about personal relationships overlap with conflicts related to social issues and are anchored in national notions of space and time as constitutive of narrative universes. Telenovela narratives often take place in urban settings, use contemporary costumes and soundtracks, and employ "realistic" dramatic performances (as opposed to excessive and histrionic sentimentality, which are the stylistic hallmarks of classical melodrama).

Central to the telenovela's poetics of melodrama is what Brooks (1996) describes as the "drama of recognition"—stories of missing parents, mothers in search of lost or stolen children, separated siblings, and so on. Martín-Barbero (1993) regards this feature of the telenovela as one of the reasons for its success in Latin America; audiences identify with the cultural history of the continent, its colonization, and the failure of political institutions that ignore the "primary sociality" of kinship, local solidarities, and friendship. For Martín-Barbero, what moves the plot of telenovelas "is always the unawareness of identities, the struggle against bewitching spells and false appearances, trying to cut through all that hides and disguises . . . a struggle to make oneself recognized" (1993, 225).

Dramaturgically, telenovelas are open works. Writers propose the main plot, which must include a happy ending that reunites a troubled couple; however, because production continues even as the episodes air, changes can be made to the script in response to audience feedback. For example, a secondary character can rise to prominence or even die, depending on the audience response. Such characteristics have endured in Brazilian telenovelas for seventy years. Telenovelas still rate highly in television ratings and dominate the prime time of the country's main broadcast network, Rede Globo. Telenovelas are exported around Latin America as well as to channels in Turkey, Portugal, Portuguese-speaking African countries (such as Cape Verde), and other less predictable locations such as Armenia, South Korea, and Sweden. The international mobility of the telenovela informed Netflix's decision to commission *Girls from Ipanema*.

Girls from Ipanema, Telenovelas, and Narrative Deviations

The story of *Girls from Ipanema* begins when Maria Luiza (Malu) moves to Rio de Janeiro to meet her husband, Pedro. When she arrives in the city, however, she discovers that Pedro has stolen her money and abandoned her. In despair, she sets fire to Pedro's belongings. As the apartment begins to burn, Malu is saved by Adélia, a resident of Rio's favela who works as a maid in another apartment in the building. The two strike up a friendship and later form a partnership to open the Coisa Mais Linda music club. The series is also centered on two other characters: Lígia, one of Malu's best friends, who lives in Rio with her husband Augusto and devotes herself entirely to her marriage at the expense of her dream to become a singer; and Thereza, a journalist fighting for more female representation in the workplace and who has an open relationship with her husband Nelson (Augusto's brother). The relationships between the protagonists—bonds of friendship and family—bring the four women together throughout the series.

In some ways, *Girls from Ipanema*'s narrative abides by classic telenovela patterns. It meets the conventions of Latin American melodrama

and utilizes important norms of the genre such as the drama of recognition, love triangles, and multiple temporalities. It also deploys the typical characteristics of serial novels in newspapers, such as cliffhanger endings (Martín-Barbero 1993; 2002). Yet in other ways, significant deviations can be identified that expand the storytelling norms that typically characterize Brazilian television fiction. We highlight four deviations from Brazilian telenovela norms in *Girls from Ipanema* that change the story, features, shape, and pace of plot development.

Narrative Structure

The first deviation concerns narrative structure and format. The typical plot of the classic telenovela features two storylines: one about a conflict within a heterosexual romance and one that relates to another sphere, such as work, war, a mission or quest, or a relationship. Each storyline has its own goal, obstacles, and climax, although romance is always the main plot. In contrast, *Girls from Ipanema* focuses its storytelling on the struggles of the women confronting patriarchy and prejudice and their fight for all forms of independence. This confrontation manifests through obstacles to the protagonists' desires, either as a legal impediment (such as not being able to own property) or as prejudice or violence that they suffer.

In contrast to telenovela norms, romance is not among the characters' goals. None of the protagonists is driven by dreams of marrying "Prince Charming." On the contrary, their motivations are directed at professional achievement and the search for autonomy. Romantic relationships may introduce conflict, but they are not the central priority for the characters and therefore the show. For example, Malu's romantic involvement with the singer Chico appears as something casual and sporadic. Instead, her story is primarily focused on overcoming the trauma of being abandoned by her husband and secondarily on opening a music club. At the end of the second season, Malu doesn't even choose to stay exclusively with Chico, deciding instead to become romantically involved simultaneously with him and Roberto. In a traditional telenovela,

the fate of her relationship with Chico would have provided her central storyline.

Similarly, the conflicts of Adélia, a Black woman, relate to racism, poverty, and daily life in the favela. Her struggle is made clear to the audience when Ligia initially assumes her to be an employee of the bar rather than Malu's business partner. Her relationship with Capitão persists throughout the series, but in the background, again in defiance of the romantic priorities of telenovela story construction.

In some ways, Ligia's struggles that result from submitting to her husband's oppression—including physical abuse—in order to live a happy marriage are more typical of telenovelas. Still, throughout the first season, the series emphasizes her efforts to fulfill her dream of becoming a singer. Finally, Thereza's main dilemmas and obstacles result from her work, not her marriage. As a journalist, she faces male dominance in the office of a women's magazine and struggles incessantly to hire more female reporters and write about female topics that extend beyond cooking and domestic care.

Men frequently become obstacles to the women's efforts to achieve personal and professional goals in *Girls from Ipanema*. Chico is by no means a good man; he is an alcoholic and though he supports opening the club and all the changes that Malu undertakes, he does not help her achieve her goals or confront the patriarchal cultural norms that limit her. On the contrary, he almost ruins everything by showing up completely drunk and unable to perform on the club's opening day. Similarly, Nelson does not take part in the clashes that Thereza faces at work, and he creates complications for Thereza's friendships by resuming his old romance with Adélia.

Although relationship plotlines can be found in the series, they do not play the prominent role typical in telenovelas. This is important in two ways. First, maintaining some features of melodrama enables *Girls from Ipanema* to engage telenovela fans while simultaneously exploring a range of issues infrequently addressed in telenovelas, such as intersectional feminism, homosexuality, open marriages, and structural racism.

Girls from Ipanema also deviates from the conventional telenovela format of 150–180 episodes. The show's first season consists of only seven episodes, with six episodes in the second season. This much leaner format eschews certain stages in the storytelling of classic telenovelas; in particular, it does not depict the initial situation of the story. Traditionally, a Brazilian telenovela narrative first presents a status quo, showing what the characters' lives are like, what they do, and their relationships—essentially a preliminary state of normality. Soon after, there is a disturbance that requires that the characters struggle to conquer their goal or resolve a conflict. At the end of the telenovela, this disturbance is eliminated.

In contrast, *Girls from Ipanema* does not present us with the original status quo scenario. The series begins with Malu arriving in Rio de Janeiro in 1959 and waiting for someone who will never come. As a result, viewers know from the beginning that something is wrong. The second sequence of the first episode shows a plane flying over and images of the beach. Titles on the screen reveal the setting as "Rio de Janeiro, 1959" to locate the viewer in the space-time of the narrative. Soon we see Malu sitting in the airport lobby. She looks at the clock twice and her feet show her agitation. She leaves the airport, goes to her husband's apartment, and finds it abandoned; Malu's response is clearly one of disappointment. After that, the episode offers flashbacks showing her previous night at her father's house where she attended a farewell party in luxurious and comfortable settings. Viewers are not shown the universe to which Malu previously belonged as part of the linear narrative. It does not portray her in São Paulo, leading a happy, harmonious, and wealthy family life as a typical telenovela would. The reversed presentation structure of the story—first the abandonment, then the flashback showing some aspects of this character's previous life—both situates the viewer in her drama and intensifies it. This is clearly a significant deviation from telenovela narrative structure. The features of Malu's life previous to the fire are told expediently in five flashback scenes of about 1 minute each. In a typical Brazilian telenovela, this would take at least two weeks.[5] As

a result, the pace in which narrative information is presented is notably accelerated in contrast to the traditional structure of telenovelas.

Multiple Protagonists

The second deviation also concerns the unusual use of multiple protagonists and extensive attention to their relationships. *Girls from Ipanema* features four main characters with distinct personalities who deal with and resolve dramatic complications in different ways. These protagonists are increasingly affected by each other's problems as the story progresses and gradually intertwines the plots and narrative arcs of each woman. Although challenges related to gender oppression figure prominently in the narrative, the series embraces an intersectional construction of feminism (Bairros 1995) that highlights how race and class differently affect the women and the issues at stake in their pursuit of political recognition for equality and respect for differences. The narrative structure of the show consequently often highlights the differences in the points of view of the female characters that derive from their respective socioeconomic status and enables a multifaceted view of the female experience. This is not common in Brazilian telenovelas, where social problems posed as conflicts are almost always constructed as individual challenges.

As an illustration of how the multiple protagonists enable attention to multiple standpoints and avoid essentialist constructions of gender identity, consider their different responses to a storm destroying the club. Malu and Adélia quarrel, largely because of their divergent worldviews and societal positions. Malu, as a rich spoiled girl, sees the destruction as a catastrophe while Adélia—due to her vulnerable position—regards the storm as just another setback to be faced and surmounted. This is a pivotal moment in the series as it shows Malu becoming aware of the difficulties that Adélia faces. Soon after, the four friends come together to repair the club, and the problems they encounter from then on are always solved through mutual help. Even if they do not agree with each other's decisions—such as when Lígia remains silent about suffering do-

mestic violence or chooses to have an abortion—these conflicts provide the opportunity to negotiate different points of view rather than presenting a single, preferred response.

Another facet of the characters' different standpoints is the racism faced by Adélia. Because she is a Black woman, she is not prevented from working, as was common among White women in 1950s Brazil. But she does not have access to the same employment opportunities as the other women, revealing her subordinate status. Her struggles are portrayed even in her interactions with her friends. For Adélia, sexism and racism overlap and make her more vulnerable, an experience that diverges markedly from her three rich White friends. Throughout *Girls from Ipanema*, this multi-protagonist structure allows the series to more deeply explore the challenges faced by women and how they approach diverse life challenges. Adélia's trajectory reveals the complex layers of subordination and allows viewers to understand that racism is a structural problem rather than an individual pathology.

A Feminist Orientation

The third deviation from telenovela norms in *Girls from Ipanema* is its emphasis on feminist themes. The characters face the narrative conflicts through different trajectories, profiles, subjectivities, and motivations. The narratively rich examination of their conflicts contributes to building the women's stories through the struggle against patriarchy, which is explored in a nuanced and multifaceted manner uncharacteristic of traditional telenovelas.

Girls from Ipanema directly confronts the issue of violence against women—which has been much debated in Brazil's media since the passing of a Brazilian law called "Maria da Penha" in 2006 that strongly punishes femicide. With the passing of this law, a problem hitherto regarded as "domestic" became a collective, public issue, thus also drawing attention to other forms of female oppression in Brazilian society. Although domestic violence has appeared in previous narratives, the struggle for

women's rights has never been the main subject of any Brazilian telenovela. The traversal of this topic from multiple perspectives and its dramatic incorporation in Lígia's storyline makes *Girls from Ipanema*'s handling of this topic even more significant.

In *Girls from Ipanema* patriarchal oppression emerges as a "disembodied" villain of the story. For example, Malu—who wants to open her own music club—is prevented by law of the time from owning property. She bypasses this obstacle by forging her husband's signature. Similarly, the patriarchal nature of 1950s Brazilian divorce laws lead Ligia to endure domestic violence—and ultimately leads to her death. The greatest challenge to the main characters' self-realization ends up being the patriarchal structures they must navigate throughout the series.

In summary, the challenges faced by the women can be regarded as a central theme of the series, which consistently approaches these challenges through a feminist lens. In the typical telenovela, the villain plays a structuring role in introducing conflict and impeding the protagonist; in *Girls from Ipanema* patriarchy arguably plays this role.

Beyond National Allegory

Girls from Ipanema's fourth deviation from telenovela norms is the way it depicts the world of its characters. Traditionally, storytelling norms in Latin American melodrama connect broader social issues of the nation to the lives of its characters. Lopes (2003) refers to this narrative choice as "tales of a nation" and explains that Brazilian telenovelas constitute narratives about urban everyday life and emerging social issues. In contrast, *Girls from Ipanema* offers the national space only as a backdrop to the story of the four women and uses a thin layer of cultural specificity.

Aspects of Brazilian culture are superficially constructed rather than deeply integrated into the narrative. The setting faithfully represents Rio de Janeiro as a socially advanced city. In 1959, it was the country's capital and the birthplace of the national avant-garde. Rio is also considered the country's cultural center; culture in Rio was so effervescent that the

defining artists of Brazilian music, cinema, and art emerged there. The background of Bossa Nova depicts Rio as a place of new opportunities, innovation, and reinvention because the musical style proposed something unthinkable until then: the merging of jazz and samba. *Girls from Ipanema* does not provide a detailed account of the birth of the genre, nor does it present political events with historical accuracy. Instead, these aspects appear merely in the background to encourage Malu to reinvent herself.

Unlike most Latin American melodramas, the series does not have a commitment to reconcile "the tales of a nation" with the daily life of the characters. Further, the story only selectively incorporates laws of that time, further divorcing the narrative from any aspiration to historical accuracy. As a result, *Girls from Ipanema* gestures toward Brazilian cultural specificity by using Bossa Nova but pays little attention to the genre's cultural and historical roots. This choice seems significant in that it also serves as an attraction to the global audiences Netflix seeks. Bossa Nova is an internationally recognized Brazilian cultural product and serves to place the story in Brazil without engaging deeply with the culture and details unfamiliar to outsiders. Cedroni, the lead writer of the series, recalls that all that was left from his original project for Netflix was the background of the musical genre.

You take this phase from 1957, 1958 up to 1964, from the coup, it was a spectacular time for Brazil. Everything worked out, there were several discoveries . . . Music, architecture, we were soccer World Cup champions for the first time. Therefore, it was a very magical moment for Brazil. So, our first idea, the first one that I set down on paper, was from a magazine newsroom and I went to show it to Kelly [Luegenbiehl], who is a spectacular Netflix executive . . . She said: . . . "I really like this location so much, this setting, this whole universe, but I'm not sure about the wording . . . I think you could focus more on a female narrative." . . . Back then, I studied Bossa Nova a lot, I read several books by Castro and I started thinking . . . Bossa Nova is so elegant! I talked to musicians, who

explained to me the difference between the Bossa Nova beat and MPB and jazz, because it is different. Let's try to bring this same concept into the text, to make an elegant text that speaks between the lines. And immediately Kelly said: "Forget about it! That's not it. That is not this show. We want Bossa Nova as the backdrop. We want that universe, but we want to speak to a lot of people" (Cedroni 2019).

From there, Cedroni explains that it took ten months of research and writing until they settled on the plot for the series. The creative negotiation reported by Cedroni demonstrates not only Netflix's involvement in the details of the productions it commissions, but also its evident intention to emphasize elements of local culture that may also have strong global appeal.

As these observations suggest, *Girls from Ipanema* moves away from the storytelling and production practices of telenovelas that have historically proved significant with local audiences. Even if it is possible to identify a negotiation with popular genres and poetics long familiar in certain "zones of consumption" (Pertierra and Turner 2013), it is important to understand that Netflix seeks to complement the existing television market and, therefore, invest in alternatives as part of its business strategy.

Conclusion

The production of *Girls from Ipanema* reveals much about the relationship between Netflix and the Brazilian cultural space. At the heart of this relationship is a fundamental tension. Departing from the conventions of traditional telenovelas, *Girls from Ipanema* is clearly designed for international audiences: its reconfiguration of melodrama and telenovela traditions suggests that satisfying local audiences is not Netflix's highest priority. Nonetheless, Netflix is also providing Brazilian subscribers with the opportunity to view culturally relevant stories that challenge convention in important ways. The deviations from telenovela conventions

within *Girls from Ipanema* highlight how Netflix strategically develops series with some superficially "culturally specific" features, while pursuing a multi-territory audience strategy. Although Netflix did not set out to create an authentic history of Bossa Nova or of Rio de Janeiro of the late 1950s, the presentation of this history was recognizable to Brazilian viewers, yet also accessible to viewers who may not have knowledge of culturally specific details.

The cultural implications of this type of strategy can be interpreted in two ways. On the one hand, a global streamer such as Netflix has observed established rules and conventions of Latin American melodrama; on the other hand, they also invested in diverse forms of storytelling. It is therefore possible to understand the search for deviations and innovations as part of Netflix's commitment to not only maintain, but lead the market, since, as Milly Buonanno (2019) states, current conditions can be described as "television plenty," characterized by a profusion of content distribution.

In Brazil, global streamers serve audience niches and represent an alternative to broadcast channels. However, as the country's entertainment business encounters opportunities to produce stories that are intended for viewers beyond its borders, it must engage in a process of negotiating storytelling norms. *Girls from Ipanema*'s use of Latin American melodrama as a starting point suggests a genre hybridism and shows that strategies, decisions, and changes are not born in a historical-cultural vacuum.

Notes

1 The authors wish to thank the National Council for Scientific and Technological Development (CNPq) for their financial support of this research.
2 Gallas states that "the company does not release country-specific numbers, but two independent studies suggest Brazil has over the years become the fourth-largest market for Netflix—after US, Canada and the United Kingdom" (Gallas 2015).
3 Netflix does not yet have any contracts for cocommissioned originals with Brazilian broadcast TV channels. It has only one licensing agreement for the film *The Ten Commandments*, with Record channel.

4 In Brazil, economic classes are usually divided into A, B, and C. "A" refers to the wealthy; "B" to the aspirational middle classes; and "C" to the less fortunate, who constitute the largest group in Brazilian society. There is also a "D" class for favela residents and "E" class for people in extreme poverty.

5 For example, the telenovela *A Vida da Gente* (Rede Globo 2011) took fifteen chapters—out of 137—before the introduction of the conflict.

References

Bairros, Luiza. 1995. "Nossos Feminismos Revisitados." *Revista Estudos Feministas* 3 (2): 458–63.

Brooks, Peter. 1996. *The Melodramatic Imagination: Balzac, Henry James, Melodrama and the Mode of Excess.* New Haven: Yale University Press.

Buonanno, Milly. 2019. "Seriality: Development and Disruption in the Contemporary Medial and Cultural Environment." *Critical Studies in Television: The International Journal of Television Studies* 14 (2): 187–203.

Cedroni, Giuliano. 2019. Interviewed by Bruno Bloch and Filippo Cordeiro. *Primeiro Tratamento*, podcast, May 1, 2019. https://www.primeirotratamento.com.br/2019/05/01/primeiro-tratamento-giuliano-cedroni-ep-75-roteiro/.

Gallas, Daniel. 2015. "How to Sell Movies in the Land of Piracy." *BBC News*, November 18, 2015. https://www.bbc.com/news/business-34848094.

Lopes, Maria Immacolata V. de. 2003. "Telenovela brasileira: Uma narrativa sobre a nação." *Comunicação & Educação* 26:17–34.

Martín-Barbero, Jesús. 1993. *Communication, Culture and Hegemony: From the Media to Mediations.* London: SAGE Publications.

Martín-Barbero, Jesús. 2002. "La telenovela desde el reconocimiento y la anacronía." In *Narraciones anacrónicas de la modernidad: Melodrama y intermedialidad en América Latina*, edited by Hermann Herlinghaus, 61–78. Santiago: Ed Cuarto Propio.

Martín-Barbero, Jesús, and Sonia Muñoz, eds. 1992. *Televisión y melodrama: Géneros y lecturas de la telenovela en Colombia.* Bogotá: Tercer Mundo Editores.

Pertierra, Anna Cristina, and Graeme Turner. 2013. *Locating Television: Zones of Consumption.* London: Routledge.

Originals with a Spanish Flavor

Netflix's Cable Girls and the Reinvention of Broadcast TV Drama for Video-on-Demand Services

DEBORAH CASTRO AND CONCEPCIÓN CASCAJOSA

Between 2014 and 2020, pay-TV subscribers in Spain increased from 5.2 million to 8.2 million (out of 47 million citizens) (CNMC 2021), a radical transformation for a country still overcoming the consequences of the Great Recession of 2008. Netflix began operating in Spain in October 2015, paving the way for a boom in production of Spanish television drama that has been followed by the local launches of other subscription video-on-demand (SVOD) platforms such as Movistar Plus+, Prime Video, HBO, and Starz.[1] All of the services have embarked on the creation of original Spanish productions, which has influenced the broader Spanish audiovisual market and, to some extent, creative strategies. This chapter explores Netflix's Spanish production as a case study of that influence.

Of all the SVOD services that coexist in the Spanish market, Netflix has been the most active in terms of original production by creating films, television dramas, documentary series, and entertainment programs. In April 2019, the company opened its first European production hub in Madrid. As of July 2021, Netflix Spain had produced and released thirty-four seasons across seventeen original series, totaling 163 hours. Moreover, Netflix also coproduced ongoing broadcast projects such as *El ministerio del tiempo/Ministry of Time*; broadcast projects that were not aired yet like *La catedral del mar/Cathedral of the Sea*; and broadcast series that were created after Netflix had already entered the Spanish

market (for example, *Fugitiva/Fugitive*)—all in exchange for exclusive distribution rights outside the region.

The likely reason for this commitment to Spain lies in its position as a European country with a strong cultural and linguistic connection to Latin America. According to Diego Ávalos, Netflix's vice president of original content for Spain and Portugal, the company intended to produce original content in Spain once the strong results of Spanish series in its international catalog became evident: "The country has a great history of fiction, both in television and film, that attracted us. At the same time, Latin America had stopped buying Spanish content for distribution. Suddenly, Turkish series were growing. We started buying content such as *El barco* [2011–13], *Gran Hotel* [2011–13] and *Velvet* [2014–2017], among many others, and we saw a great appetite again in Latin America" (Ávalos 2020).

The series mentioned by Ávalos exemplify an early and underdeveloped effort at internationalization for Spanish television drama that precedes the arrival of SVOD services. Series production in Spain experienced a major boost in the 1990s with the arrival of commercial television operators heralding a liberalization of the Spanish market after decades of public-service broadcasting. After their arrival, the television fiction industry was characterized by mid-budget bland comedy and light drama (so-called dramedy) suitable for all audiences and featuring intergenerational casts as typical in the United States' network era. Independent production companies started to develop straight-to-series orders of thirteen episodes per season with seventy-minute episodes that were financed by the networks in exchange for retaining the intellectual property rights, allowing resale in other markets.

But this thriving activity also showed signs of dysfunctionality. In particular, overdependence on the local market norms prevented Spanish fiction from competing internationally (for example, including an extra advertising break made the series episodes more than seventy minutes long). This made the country especially vulnerable when local advertising went into steep decline around 2010–2011 and led Spanish commissioners to prioritize lower-cost formats. This problem, metaphorically

described as single-crop farming, became more evident in the absence of diversification in production formulas and storytelling. Public broadcaster Radiotelevisión Española (RTVE) became almost indistinguishable from commercial operators, and pay-TV channel Canal+ lacked a television drama strategy; it only produced two originals before the merger with Movistar Plus+ in 2015.

Following the recovery from the financial crisis, Spain became one of the main television markets in Europe. In the period from 2015 to 2018, it produced the second-highest number of hours of television fiction in Europe, just behind Germany (Fontaine 2020). This position primarily owes to the volume of daytime serial drama produced in the country, which can be produced for about 50,000 euros per episode. This is ten times less than the average budget of a prime-time drama and predictably inferior to the production values of the "high-end" drama.

Since 2015—the year Netflix arrived in Spain—the Spanish television industry has been adapting a production model known for its economic efficiency for the international marketplace. The emergence and arrival of SVOD services in Spain has significantly increased the amount of television production in the country and, to some extent, transformed the dynamics of Spanish television production (Castro and Cascajosa 2020). Movistar Plus+ and Netflix have led this process with equal ambition but different strategies.[2] Surprisingly, it was the international company (Netflix), not the local one (Movistar Plus+), that established stronger continuity with the local television industry. Movistar Plus+ has emphasized creating high-budget dramas and quirky comedies with known filmmakers and has slowly embraced the international marketplace with coproductions. Netflix achieved this global reach more quickly by establishing strong alliances with local production companies with proven track records in broadcast television.

This chapter examines the impact that Netflix has had in Spanish drama series. This impact was neither radical nor sudden. Instead, it was the result of negotiation between new operators that needed content and creators who were forced to step out of their comfort zone when developing

more complex and diverse stories aimed at an international audience. The chapter analyzes this process of negotiation by using *Las chicas del cable/Cable Girls* (2017–2020) as a case study. The program was not only the first series Netflix commissioned in Spain, but it also is one of the longest-running series to date: five seasons and forty-two episodes ran between 2017 and 2020. The length of this series allows us to observe the changes in the way stories were told over this period in which the company made a strong commitment to the production of international fiction—retaining the strengths of the SVOD and broadcast storytelling.

For a deeper understanding of this process, we begin with a brief examination of Netflix's initial production strategy in Spain. An analysis of *Cable Girls* follows, which we contextualize within the strategy of its production company, Bambú Producciones. This discussion emphasizes *Velvet*, a project produced for Spanish terrestrial broadcaster Antenna 3 by Bambú before *Cable Girls*, which cocreator Ramón Campos considers the distillation of the formula Bambú has developed since the company's creation (Cascajosa Virino 2021, 232).

The Birth of Netflix Spanish Commissions

Cable Girls was announced in March 2016, just as Netflix began to place commissioning production outside of the United States at the center of its corporate strategy positioning the company as "a home for creative talent and 'innovative' storytelling with a 'global audience'" (Crawford 2020, 86). The company's main challenge was to articulate a strategy based on circulating originals that could be recognized as local in the country of origin but also engage international audiences (Scarlata, Lobato, and Cunningham 2021, 146). Netflix's commitment to the Spanish-language market positioned Spain as central in its European production strategy.

From 2015 to 2019, Netflix's executive development teams were based in the United States, which forced a process of "long-distance localisation" (Lobato 2019) subject to cultural and language differences. For Teresa Fernández-Valdés, cofounder of Bambú Producciones, this intro-

duced significant challenges in the initial phase: "Almost nobody read in Spanish on Netflix's side. We also had a problem with the schedule. There is a big time-difference with Spain, nine hours" (2020).

To address this issue, Netflix hired Latin American executives with extensive experience in the Spanish market (such as Juan Mayne, director for content acquisition) as a precursor to hiring Spanish executives and eventually establishing a base in Madrid in 2019. Netflix's status as a transnational service that integrates itself into national media systems (Jenner 2018) was exhibited here in its partnerships with Spanish production companies with strong track records. In some cases, partnering with Netflix meant companies that had focused on producing movies embarked upon or strengthened their series production. This did not profoundly introduce new talent into production. Among the Spanish commissions released as of July 2021, Netflix partnered with successful broadcast series creators such as Ramón Campos, Gema R. Neira, Carlos Montero, and Verónica Fernández to produce original content. Netflix even hired Fernández as an executive, and since February of 2020 she has been director of content originals in Spain.

Unsurprisingly, Netflix has sought to continue working with showrunners who have produced successful content for the service. The most obvious example is Álex Pina, with whom Netflix signed an exclusive contract after the global success of *La casa de papel*/*Money Heist* (2017–). Originally created for broadcaster Antena 3, *La casa de papel* is one of the most watched non-English-language series in the history of Netflix (Heisler 2018) and the winner of the Best Drama Series International Emmy in 2018. As of July 2021, Pina was the creative force behind three Netflix series originals: in addition to *La casa de papel*, he also created *White Lines* (2020, coproduced with the United Kingdom), and *Sky Rojo* (2021–). Apart from specific creator deals, Bambú is the company that Netflix has partnered with the most in Spain, with a total of three television dramas (totaling nine seasons), one feature film, and one documentary series as of August 2021. Netflix also licensed Bambú's period dramas before landing in Spain.

Two factors help understand Netflix's interest in partnering with Bambú to create *Cable Girls*. First is the good results of two series outside of Spain: *Gran Hotel*, which is set in the first years of the twentieth century during the Restoration period, and *Velvet*, set during the Francoist dictatorship. Second is the attention these period dramas received from Netflix's development executives (Saiz 2016).

From *Velvet* to *Cable Girls*

Cable Girls tells the story of four young women working in a telecommunication company in 1928. It premiered in April 2017 with a first season of eight episodes. From a production point of view, *Velvet* and *Cable Girls* largely share the same staff at Bambú, including its creators, directors, screenwriters, and production team. The expectation that these creatives would be able to reproduce the success of *Velvet* reduced the risk associated with *Cable Girls*. In fact, in an interview about the development of the series, Diego Ávalos (2020) suggested that the reason for Netflix commissioning *Cable Girls* transcended the concept of the series itself and had a lot to do with Bambú's reputation as a producer: "Bambú is very attached to various talents [actors and actresses] that we found very interesting and saw a vision of a whole package. It was not a story in a logline: they [Bambú] had a broad vision of what they wanted to do, and that is where we really saw that symbiosis to move forward."

Bambú had established a strong track record with *Gran Hotel* and *Velvet* and was known for a recognizable style evident in its broadcast series. Its series blended familiar genres (thriller and romantic drama), with recognizable plots (for example, love triangles and family problems), polished aesthetics and production design (for example, more textured cinematography and interior sets designed for deep shots), and strong casts with young and senior stars.

But despite Netflix's interest in the "Bambú formula" (Cascajosa Virino 2021), Netflix imposed changes in the production of *Cable Girls* much like it had previously done in other countries. In a study on the

Norwegian series *Lilyhammer*, produced by Rubicon TV as a Norwegian Broadcasting Corporation (NRK)/Netflix coproduction, Sundet (2021, 56) explains that Netflix "seldom gave notes on the script, and NRK did retain its primarily editorial responsibility through all the three seasons." Still, the SVOD platform had an impact in the creative process not only in terms of budget but also in debates about "the appropriate amount of explicit and unjustified violence, sex, and bad language" to include. Similarly, Netflix followed the development of the first season of *Cable Girls* closely, even though Netflix executives were not in Spain but in the United States. The main director Carlos Sedes (2020) remembers, "I was very struck at the beginning, like they were getting into a lot more things than the broadcasters, for the good. We would even have to discuss with them to [plan for] the costumes, the type of hairdressing, the sets . . . They went through everything."

A crucial disruptive change had to do with the reduction in the length of the episodes and seasons. Most of Netflix's dramas are approximately twenty minutes shorter than Bambú's typical productions, with three to seven episodes fewer per season. This obviously impacts on storytelling, particularly the number of characters or number of storylines, and required Bambú to adapt the formula that it established with series like *Velvet*.

Netflix's transnational strategy of offering series with more complex stories also challenged the *Cable Girls*' creative team. Bambú's negotiation of its established style can be identified in four aspects in which the series differs significantly from broadcast period drama. These aspects may be encouraged and/or enabled by Netflix and its different industrial conditions: the number of female roles, gender and sexual diversity, representation of historical events, and the representation of space.

Cable Girls differs significantly from *Velvet* and other period dramas in its approach to gender roles and gender-related issues. At the center of *Velvet* is the love story of Alberto Márquez, heir of Galerías Velvet, a prestigious fashion house, and Ana Ribera, an orphan who works as a seamstress. Other love stories unfold around them that tend to follow

the structure of two women fighting for the love of a man. In contrast, *Cable Girls* balances romantic storylines with a strong narrative about the friendship among four women who start working at the telephone company in 1920s Madrid (see also analysis of Rocha and Arantes in this volume). According to head writer María José Rustarazo (2020), this emphasis on women's relationships and empowered female characters was requested by Netflix: "Netflix asked us for more sorority, for us to work in the female group. When *Velvet* was made, it was built entirely as a romantic comedy, with different romantic stories that worked independently."

In contrast to conventional drama plotlines that follow the obstacles facing lovers, *Cable Girls*' central plot concerns challenges to the relationship between the female characters and their process of overcoming them. Moreover, after the first season, the primary narrative arc of each season is structured around an issue that has to do with patriarchy, gender and sexual diversity, and, in the last season, Spanish history. Season two revolves around the accidental killing of Ángeles's abusive husband and the freeing of the transgender character Óscar from a psychiatric hospital; season three spins around the recovery of Lidia's kidnapped child; season four explores Carlota's political career and the group's strategies to save her when she is falsely accused of murder; and season five revolves around the search for Ángeles's teenage daughter, who joins the Republicans in the Spanish Civil War, and the women's efforts to free her from a prison camp. Empowerment, freedom, and resistance are key words in *Cable Girls*' narrative. Female characters play active and heroic roles in contrast to the more passive ones played by female characters in *Velvet* and most Spanish television dramas, in which men are typically cast as heroes/saviors. Also, conversely to *Velvet*, the romantic storylines of *Cable Girls* remain in the background and are dependent on the different threats (for example, police persecution) that the women face together. An example is the storyline in which Lidia finds herself choosing between helping her great love, Carlos, to succeed professionally or saving the work of her friends; she opts for the latter.[3] Something similar

happens with Ángeles in seasons two and three, in which her main love interest is a policeman investigating the girls.

The ending of *Cable Girls* is another key moment in this show, which illustrates the complex and innovative storyline Bambú committed to. Coherent with this sorority approach in which the narrative is reliant on empowered and independent female characters, in the series finale the female protagonists die together facing Franco's soldiers to ensure that their male partners and children can escape to France and find a new life far from the Spanish Civil War. This tragic ending is a stark contrast to the happy ending of *Velvet*'s love stories and most Spanish dramas and reflects how far *Cable Girls*' creative team was able to subvert traditional storytelling conventions regarding gender roles.

A second aspect where Netflix's impact can be observed has to do with diversity in its originals. In 2021, Netflix Spain created the contest "Tell us the stories no one tells" in collaboration with the copyright collective society Audiovisual Author's Rights (DAMA) to foster diversity in the audiovisual sector both in front of and behind the cameras.[4] Netflix's interest in diversity was already evident in *Orange is the New Black*. Jenner (2018, 174) argues that Netflix's definition of diversity includes "a stronger emphasis on non-white identities, a questioning of heteronormativity, and a broad variety of series with (often white) female leads, but also multilingualism." Although the politics of representation differ across countries, if we take the abovementioned aspects into consideration, it can be said that *Cable Girls* fits within Netflix strategy only when it comes to female lead characters and sexual diversity. Bambú does not engage in the internationalization of its cast with *Cable Girls*. In fact, it is only in seasons two and three that an Argentine actor was hired to play an antagonistic character. This not only mirrors *Velvet* and other Bambú shows but also seems to support Ávalos's remark about the company being very attached to certain actors and actresses. Second, Bambú does not emphasize non-white identities in its productions. In fact, all the characters are white and do not belong to any ethnic or religious minorities. Compared to other Netflix originals, such as *Sense 8*, Bambú does

not engage in multilingualism within the same text. Rather, *Cable Girls* is more characteristic of Bambú's broadcast series. However, Bambú certainly questions heteronormativity here, an aim it started to do in *Velvet* with a storyline that revolved around two homosexual characters in the fourth season.

Cable Girls presents sexual and gender diversity with greater complexity than typical of Spanish drama. After introducing a love triangle between Carlota, Carlota's boyfriend, and Sara in the first season, Bambú gradually progresses this storyline, revealing that Sara is a transgender man. This happens in the second season, when Sara tells Carlota that she prefers to be called Óscar. *Cable Girls* depicts the difficulties of living as a transgender man and with a transgender partner in the early twentieth century in Spain, which leads to the couple's decision to temporarily move to France so that Óscar can live his identity openly. According to series cocreator Gema R. Neira, Netflix encouraged this plot, which would have been impossible in broadcast television, where transgender characters are rarely included (González-de-Garay, Marcos-Ramos, and Portillo-Delgado 2020) and never with the prominence that Óscar acquires in *Cable Girls* by the series finale: "There are things that we had not been able to do because we were not on Pay-TV—for example, the story of Óscar. It is a story that we had not been able to tell in this way on any broadcast channel. We were not addressing the same audience. But they [Netflix] were also very brave in thinking that we are at a time when we must stress visibility, and that was important for us" (Neira 2020).

A third distinction of *Cable Girls* can be identified in the representation of historical events. Bambú was aware that the representation of the past had to be different from *Velvet*, which was criticized in Spain for presenting a "distorted" version of the Francoist dictatorship that some commentators considered "offensive" because it pretended that the regime "never existed" (Solá Gimferrer 2015). *Velvet* is an example of the nostalgic way in which television drama has represented Franco's dictatorship (Santana 2016). This is part of a broader problem in Spanish society regarding the dictatorial past, but also an example of the political

caution of television broadcast drama in Spain and the dependence on ad support. Head writer María José Rustarazo referred to the extra level of creative freedom that Netflix afforded *Velvet*'s representation of the past: "[What] Netflix offered us was to make a story with much more risk, to present characters with more edges, darker. . . . Netflix allowed us to delve a little deeper into history and politics and touch on small points and nuances that perhaps we could not deal with in a broadcast show. *Velvet* presents an imaginary post-Civil War, in which there is no dictatorship, and everything is happiness (2020)."

Furthermore, through Carlota's character, *Cable Girls* represents social tensions in a more direct and violent way than what Bambú had previously done in broadcast shows. For example, in season one, Carlota is arrested for participating in a feminist event, while in season four she is about to be raped in the radio station where she works for aspiring to the position of political officer. These narrative inclusions offer important reminders of women's treatment and place in society in the 1950s. The representation of the past in *Cable Girls* became more faithful and committed as the seasons went on, culminating with the final two seasons taking place during the Spanish Civil War and the beginning of Franco's dictatorship.

A final distinctive aspect of *Cable Girls* can be identified in its representation of space. Both *Velvet* and *Cable Girls* have a similar spatial starting point: they are period dramas set on Madrid's Gran Vía, the country's most important and recognizable shopping street. In the case of *Velvet*, the story takes place in a fictional department store in 1958, while *Cable Girls* is set in a pioneer telecommunications company in 1928. Despite this coincidence, in *Cable Girls* there is a more intense exploration of the urban space than in *Velvet*. Even though the center of the action of *Cable Girls* is the telephone company building, there are many scenes that take place on the streets (such as the entrance to the boarding house where the protagonists live) or in mansions, where parties take place. In contrast, *Velvet* relies on the department store building and exteriors without specific geographical references (the chalet where the main character Alberto's family lives; roads on the outskirts

of Madrid). Unsurprisingly, these different ways of engaging with the space are conditioned by the budget available. As executive producer Teresa Fernández Valdés explained (2020), *Cable Girls'* production team started to work with a budget that "could be like that of other series or even a little higher" considering that they had shorter episodes to produce. Also, filming two seasons at once allowed them to amortize some of the costs. Season after season, the ambition of the story increased and, with it, the number of scenes filmed in exteriors. By season five, 60 percent of *Cable Girls* was shot in exteriors (Hopewell 2020).

Beyond production values, the use of exteriors has relevant storytelling implications for female main characters who are not constrained to closed spaces. This difference between these two series is introduced in the first episodes. While the opening scene of *Velvet* shows the Gran Vía, *Cable Girls* begins with a shootout that takes place between the Fuente de los Caños Viejos (the oldest stone emblem in Madrid) and the Segovia Viaduct (which rises twenty-five meters above the street). The later locations are less well known than Gran Vía but add a more diverse representation of the city, its surroundings, and its monumental features. The independence of the four working female protagonists has an interesting spatial translation: many scenes show the protagonists moving around in night scenes shot in streets and parks (such as El Retiro) in the center of Madrid. Meanwhile, the daytime scenes take place in the offices of the telephone company on Gran Vía. In this way, *Cable Girls'* production design orients the narration toward exterior spaces and underscores the central theme of a reclaim of public space by its female characters.

Conclusion

Analysis of Netflix's first Spanish series commission, *Cable Girls*, reveals key distinctions from conventional dramas. Netflix adopted a cautious strategy to establish itself in the Spanish marketplace. It partnered with

Bambú, a production company with a strong track record whose broadcast period dramas had reportedly been well received on the platform. However, despite choosing a production company with a proven reputation consistent with the genre and features of *Cable Girls*, Netflix also pushed Bambú to adapt its creative strategy to fit within the SVOD's global production standards and brand strategy in ways that innovated Spanish television drama. These adaptations had to do with the creation of complex female lead characters who prioritized more than romantic entanglements, the inclusion of sexual diversity previously unseen on Spanish television, and a darker representation of sensitive historical and social issues. Other elements and Spanish narrative conventions remained intact. For example, *Cable Girls* does not engage in significant internationalization of the cast. This contrasts with television dramas produced by Zeta Producciones (*Élite*) or Vancouver Media (*La casa de papel*, from part three onwards) for Netflix Spain. Instead, *Cable Girls* used Bambú's star-system of local actors (Cascajosa Virino 2021). Furthermore, *Cable Girls* explores similar spatial coordinates in a similar time period as previously done by *Velvet*: the Gran Vía of Madrid in the twentieth century. However, *Cable Girls* stands out through the greater use of exteriors and also aesthetic innovations (such as color range in cinematography) to augment production values and provide a more complex narrative.

This case study suggests that Netflix did not arrive in Spain to fully disrupt the production of television drama in the country or, at least, the production of period drama created by Bambú Producciones. Instead, the analysis shows an interest in exploring elements from broadcast storytelling that could successfully permeate SVOD storytelling and determining those that could or should be challenged. As a result of these negotiations, *Cable Girls* has also made a significant contribution to the evolution of period drama in Spain. Netflix's arrival has also confirmed to Spanish creators that the local essence of their stories and creative formulas, adapted to SVOD services and expanded

creative freedom offered by Netflix, can attract viewers from around the world.

Notes

1 Movistar Plus+, part of the telecommunications company Telefónica, is the result of the merger of the satellite platform Digital+ and the IPTV service Imagenio. It was launched in July 2015.
2 Movistar Plus+ is a pay-TV platform that also offers a selection of its contents with the SVOD service Movistar Plus+ Lite.
3 However, it is worth noting that Lidia's decision resembles, although in a less romantic fashion, the choice made by Ana in the first season of *Velvet*. There, Ana pushes Alberto to get engaged to another woman to rescue not only his business, but also her and her colleagues' workplace.
4 See Cambio de Plano (2022).

References

Ávalos, Diego. 2020. Interview with Concepción Cascajosa, June 4, 2020.

Cambio de Plano. 2022. https://cambiodeplano.damautor.es/.

Cascajosa Virino, Concepción. 2021. "Bambú Producciones and the Transformation of Spanish Television Fiction Production." In *A European Television Fiction Renaissance: Premium Production Models and Transnational Circulation*, edited by Luca Barra and Massimo Scaglioni, 227–40. New York: Routledge.

Castro, Deborah, and Concepción Cascajosa. 2020. "From Netflix to Movistar+: How Subscription Video-on-Demand Services have Transformed Spanish TV Production." *Journal of Cinema and Media Studies* 59 (3): 154–60.

CNMC (National Commission of Markets and Competition). 2021. "La TV de pago supera la barrera de los 8 millones de abonados," press release, April 12, 2021. https://cnmc.es/prensa/trimestral-audiovisual-4T-20210412.

Crawford, Colin Jon Mark. 2020. *Netflix's Speculative Fictions: Financializing Platform Television*. Lanham: Lexington Books.

Fernández-Valdés, Teresa. 2020. Interview with Concepción Cascajosa, July 2, 2020.

Fontaine, Gilles. 2020. "Audiovisual Fiction Production in the European Union: 2019 Edition." A publication of the European Audiovisual Observatory, February 2020. https://rm.coe.int/audiovisual-fiction-production-in-the-eu-2019-edition/16809cfdda.

González-de-Garay, Beatriz, Maria Marcos-Ramos, and Carla Portillo-Delgado. 2020. "Gender Representation in Spanish Prime-Time TV series." *Feminist Media Studies* 20 (3): 414–33.

Heisler, Yoni. 2018. "*La casa de papel* (AKA *Money Heist*) Becomes Netflix's Most-Watched Foreign Original Series Ever." *Decider*, April 16, 2018. https://decider.com/2018/04/16/la-casa-de-papel-netflix-most-watched-foreign-original-ever/.

Hopewell, John. 2020. "How Netflix Grew Spain's *Cable Girls* as It Evolved Itself." *Variety*, July 3, 2020. https://variety.com/2020/tv/global/netflix-cable-girls-season-five-finale-1234696813/.

Jenner, Mareike. 2018. *Netflix and the Re-invention of Television*. London: Palgrave Macmillan.

Lobato, Ramon. 2019. *Netflix Nations: The Geography of Digital Distribution*. New York: NYU Press.

Neira, Gema R. 2020. Interview with Concepción Cascajosa, July 1, 2020.

Rustarazo, María José. 2020. Interview with Concepción Cascajosa, June 30, 2020.

Saiz, David. 2019. "*El regalo* de Navidad de Netflix a Bambú: así se fraguó su alianza para la primera serie en español." *Ecoteuve*, April 11, 2019. https://ecoteuve.eleconomista.es/series/noticias/7483325/04/16/El-regalo-de-Netflix-a-Bambu-asi-se-fraguo-su-alianza-para-la-primera-serie-en-espanol.html.

Santana, Mario. 2016. "Screening History: Television, Memory, and the Nostalgia of National Community in *Cuéntame* and *Temps de silenci*." *Journal of Iberian and Latin American Studies* 21 (2): 147–64.

Scarlata, Alexa, Ramon Lobato, and Stuart Cunningham. 2021. "Producing Local Content in International Waters: The Case of Netflix's *Tidelands*." *Continuum* 35 (1): 137–50.

Sedes, Carlos. 2020. Interview with Concepción Cascajosa, June 29, 2020.

Solá Gimferrer, Pere. 2015. "La ofensiva época ficción de *Velvet*." *La Vanguardia*, September 15, 2015. https://blogs.lavanguardia.com/en-el-sofa/la-ofensiva-epoca-ficcion-de-velvet-87046.

Sundet, Vilde Schanke. 2021. *Television Drama in the Age of Streaming: Transnational Strategies and Digital Production Cultures at the NRK*. London: Palgrave Macmillan.

9

The Secret Life of the Jordanian Teenager

Netflix and Storytelling Opportunities in MENA

FAIROOZ SAMY

This chapter focuses on Netflix's storytelling efforts in the Middle East and North Africa (MENA). Through a case study of the recent original series *AlRawabi School for Girls* (2021), a Netflix-commissioned Arabic-language teen drama exploring the inner lives of six Jordanian teenage girls, I argue that the company's commissioning strategies provide opportunities for diverse narratives and controversial topics that would not otherwise exist within MENA's current television landscape. Despite these opportunities, care must be taken not to hyperbolize Netflix's impact on the overall television production in the region and to acknowledge the commercial imperatives driving the company's actions.

Although each of MENA's nineteen territories has its own infrastructural and socioeconomic contexts, all share common linguistic and religious traditions that shape the region's television production, content, and consumption norms. The region's most spoken language is Arabic and its majority religion, Islam, heavily informs the cultural and legislative frameworks of most MENA countries. Of all regions, MENA has the highest level of government restrictions, with governments upholding socially conservative tenets in sectors such as education, legislative bodies, and state-owned media (Pew Research Center 2019). Because of the Middle East's integration of religion and state, mass media, whether publicly or privately owned, is subject to strict conditions aimed at limiting material that is deemed "harmful" to society or at odds with Islamic teachings (Darwish and Abu Ain 2020). Despite the growing influence of

religious conservatism over media products in the MENA region, television remains the second-most-consumed medium per capita (Mid East Media 2021). Locally produced television, in particular, continues to play a strong role in the everyday media consumption habits of MENA residents, with a focus on drama programs that are the "primary platform for sociopolitical commentary" in the region (Halabi and Salamandra 2019, 97).

Free-to-air, advertiser-supported satellite television is widespread and reaches almost 80 percent of television households in the region (Mid East Media 2018). Arabic-language television dominates, with an average of only one in ten MENA viewers consuming television from the United States, Europe, India, or Turkey (Dennis, Martin, and Wood 2016). The prevalence of satellite television is largely explained by the region's common language, which allows the programs created in the countries with the most robust television ecosystems—such as Morocco, Jordan, the United Arab Emirates, and Egypt—to travel easily across Arabic-speaking countries and attract high levels of viewership (Mid East Media 2016). Egypt's long-established production sector is responsible for almost 70 percent of the region's programs. The lack of reliable and widespread audience measurement, combined with cultural hesitancy towards in-home monitoring systems and industry inertia, has led to risk-averse television commissioning practices. Television networks and production houses follow tried-and-tested production models and seek above all else to retain advertiser backing, which comprises 70 percent of television revenue (Youssef and Piane 2013).

Scripted drama is the most popular television format in MENA countries, thanks in part to the prevalence of, and regional familiarity with, Egyptian soap operas. These thirty-episode *musalsalat*, as they are known in Arabic, are the region's "must-see viewing": *musasalat* air in primetime slots during the Muslim holy month of Ramadan (the most popular month of television viewing across MENA) and use the widely understood Egyptian dialect.

In general, MENA programs tend to stick to limited genres, primarily family dramas, soap operas, situation comedies, talk shows, and—more

recently—competition reality shows. Men are usually the lead characters, even in ensemble casts. While many shows prominently feature women, programs that feature majority-female casts are rare, and even more so for teen dramas which are, themselves, underproduced (Mid East Media 2021). Fictional programs cover topics as varied as historical injustice, war, political corruption and conspiracies, adultery, substance abuse, and gender politics. However, the extent to which such potentially subversive themes can be explored, and the manner in which they can be depicted are limited by threats of censure and, in some cases, censorship by conservatively authoritarian political and religious regimes (Halabi and Salamandra 2019). To get around restrictions, violent scenes are often rushed through, implied but not depicted, or very limited in their use of gore or physical brutality.

The influences of conservatism and the oligopoly of providers in MENA have created a tendency towards risk-averse, formulaic narratives. The result is that networks have little incentive to produce content that could be perceived as untested or which addresses a "niche" audience—which in this context, refers to women and teenagers. In turn, audiences, who are largely loyal to local television, are not encouraged to expect such content from local producers.

The Arrival of Netflix in MENA

Netflix entered MENA in late 2016 with its cache of U.S.-produced originals and an otherwise limited local content catalog. The company announced its first Arabic-language original series, the supernatural drama *Jinn*, in early 2018, followed by the Egyptian horror series *Paranormal* (2020), the Saudi mystery series *Whispers* (2020), the Emirati thriller series *The Platform* (2020), and the Jordanian teen drama *AlRawabi School for Girls* (2021). Netflix's stated MENA commissioning strategy involves working directly with local creators, producers, and writers to tell locally resonant stories and to search out properties or creators that are known locally but unknown internationally. The company has commissioned

contemporary stories from lesser-known local artists, focusing on narratives created by, or about, young people or women. Although this strategy is ostensibly an effort to offset the television industry's gender imbalance, both on and off screen (especially in markets where female-centric stories are not sought by local networks), female-centric stories primarily serve Netflix's bottom line by tapping into audience segments poorly catered to by local television operators.

Thus far, Netflix's existing television shows follow a serial drama format of five-to-ten-episode seasons and high production budgets to achieve realistic aesthetics (Keller 2020). This format differs from the long-form soap operas and melodramas of the MENA region that typically run for a minimum of thirty episodes at sixty-seventy minutes each (Saeed 2020). Although the most popular type of serial fiction—the Egyptian soap opera—has a long history of social commentary that is often critical of governmental and political elites, these shows remain creatively limited by the religious restrictions that apply to content aired on state-regulated networks (Fahim 2019). As an internet-distributed service, Netflix and other SVODs are not subject to these restrictions, which gives them greater freedom for narrative experimentation.

AlRawabi, Teen Drama, and Taboo

AlRawabi School for Girls, Netflix's second Arabic-language original series and its first Jordanian scripted drama, exemplifies these broader tendencies. Its creator, director, and primary writer is Tima Shomali—a Jordanian social media star, actress, and writer. She rose to prominence after the success of *FemaleShow*, a single-camera mockumentary web series she created, wrote, starred in, and produced through her own production company, Filmizion Productions. After gaining viewers online, *FemaleShow* was aired on Jordanian satellite channel Roya TV. Shomali had been on Netflix's radar for several years before *AlRawabi*, after participating in Netflix's 2017 "She Rules" campaign, a series of videos spotlighting creative women in the Middle East that was deliberately

timed to coincide with Ramadan (Netflix Newsroom 2017). Considering that Ramadan is typically when media consumption is highest across MENA, Netflix's timing signaled its intention to support young, female storytelling in the region, despite having done little more than provide a public advertisement for this particular campaign (Arab News 2018).

Shomali's talent and desire to create female-centric content made her an ideal candidate to produce a program for Netflix. When Shomali approached the company with the idea for *AlRawabi*, it "agreed immediately," saying Netflix believed in her "vision" and saw it as an opportunity to "go beyond local and reach global" (Shomali 2021). When the company officially confirmed that it had greenlit *AlRawabi*, then-director of international originals, Simran Sethi, described it as "essentially the first Middle Eastern young adult series that celebrates the role of women, not only on screen, but behind the scenes as well" (Netflix Newsroom 2019).

AlRawabi is an uncommon MENA program for multiple reasons. It is a MENA teen drama, targeting a young adult and teenage audience and focusing on the lives of Jordanian teenaged girls, all of which are rarely seen in MENA national media contexts, let alone on an international scale. In addition to Shomali, most of *AlRawabi*'s crew members were women (Mullally 2021). Speaking of this rarity in Arabic television production, Shomali said, "In each department—from cinematography to production design, from character to costumes—each one of these women [brought] her own touch to it, to tell the story of these young women" (Mullally 2021). This deliberate production choice speaks to the creators' intention to centralize the perspectives of Jordanian women and ensure that the series reflects the lived experiences of the Jordanian women who created it.

AlRawabi follows Mariam, an unobtrusive teenager at the titular school as she executes a revenge plot against a trio of bullies, led by primary antagonist Layan, a manipulative and charismatic bully. Layan's fellow popular girls are Rania, a beautiful and aloof redhead, and Roqayya, an aggressive instigator and the only lead teenager to wear a headscarf. Mariam is aided by her friends Dina, a conformist with a penchant for Zac Efron's abs, and Noaf, a smart outsider with facial piercings and a goth aesthetic.

AlRawabi is unique as a Jordanian television series for multiple reasons. Its first season comprises just six episodes, far below the typical twenty to thirty episodes in an Arabic serial drama. Its intended primary demographic is teenagers (Arabic-speaking and otherwise), and its plot exclusively centers on the teenage lead characters, all of whom are girls. The show's few male characters play supporting roles and receive limited screen time. These facets are notable because MENA screen media rarely prioritize women's stories or devote substantial screen time to narratives that do not also benefit male characters. This absence is even more pronounced for narratives that feature teenagers of any gender as the lives of school-aged characters are not considered to be commercially or artistically viable for mainstream consumption. Additionally, where teen girls are depicted, conventional and conservative attire, appearances, and behaviors are prioritized. Deviation from these norms is infrequent and tends to be reserved for characters who fit the "troubled teen" or "wayward" archetypes. Noaf's alternative aesthetic and facial piercings, while increasingly popular with MENA teenagers, are still considered socially unacceptable for school-aged students, so her presence as a main character—and, at times, the voice of reason against Mariam's growing antagonism—is a noticeable departure from representational norms. In contrast to the increasing tendency to depict Arab teenage girls with headscarves and modest clothing, not least in Western representations, *AlRawabi* bucks this trend by presenting the majority of its leads without any head covering and in fashionable attire consistent with "Western" trends.

In addition to the "modern" depictions of Gen Z teenagers, *AlRawabi*'s characters tackle issues that are well known to MENA youth—such as bullying, reputational threats, and domestic violence—but seen as taboo in MENA societies. Realistic portrayals of physical abuse, particularly when they involve minors, are very rare, despite the comparatively high rates of violence against women in many MENA communities (Amnesty International 2021). In contrast, *AlRawabi* makes clear from the outset its intent to explore gendered violence within domestic,

educational, and cultural spaces. The first episode begins with a cold open, itself an underused device in Arabic television, which immediately signals this story's difference from standard fare. Viewers see the show's main character, Mariam, dressed in her school uniform, lured to an empty school bus then attacked by unseen assailants. She is thrown to the ground, kicked as she writhes in pain, and her head slams into a rock, knocking her unconscious. While the scene is under a minute long, such quasi-realistic violence committed by or against girls is conventionally considered highly inappropriate for Arabic television. Such an opening scene could likely only have occurred on a globally operating SVOD like Netflix that has relatively little to lose and much to gain by subverting local storytelling conventions. Mariam returns to school and identifies her attackers as Layan, Rania, and Roqayya. To avoid punishment, Layan falsely accuses Mariam of groping her breasts, and her lie is corroborated by the rest of the class because of a mixture of peer pressure, implied homophobia, and fear of ostracization. Both Miriam's mother and the school's administration refuse to believe her and instead impose therapy to correct her antisocial behavior. This solution further cements Mariam as a social outcast because of a regionally common bias against mental illnesses and its associated medications (Elyamani et al 2021). This series of events sets Mariam and her friends on their quest for revenge.

The bullies, Layan, Rania, and Roqayya, also suffer violence and patriarchal shaming, demonstrating that social currency and wealth cannot shield them from misogyny. Rania is discovered to have snuck out on a school trip to go clubbing with her boyfriend. As punishment, her father gives her a black eye so severe that it requires a brief absence from school. Roqayya is catfished by Mariam, Dina, and Noaf, and tricked into sending them a selfie of herself with no headscarf on. After they post the photograph on her social media accounts, without her knowledge or consent, Roqayya receives a flurry of online shame. The backlash is so great that her mother withdraws her from school and blames the incident for potentially undermining Roqayya's sister's marriage pros-

pects, saying, "A girl's reputation is all she has. It's like glass. If it breaks, you can't put it back together. With what people are saying about us, who knows if your sister will stand a chance?"

It is in the show's final moments, however, that the most shocking and brutal violence occurs. After a series of humiliations and defeats, the protagonist-turned-antiheroine Mariam alerts Layan's chauvinistic brother (Hazem) to the existence of Layan's secret relationship. She sends him the address where Layan and her boyfriend are meeting, leading Hazem to misinterpret their date as a sexual encounter. Incensed that Layan's romantic actions will bring dishonor to their family, Hazem confronts the pair with a gun. As the camera pans outside, to a shot of Layan's school uniform drying in the sun, a gunshot rings out. International viewers may have assumed that Layan's boyfriend was the target of Hazem's revenge. MENA viewers, however, have the cultural competence to understand that Layan was the intended victim of a so-called "honor killing" made to rid the family of the perceived shame of their unmarried teenage daughter pursuing a relationship outside the bounds of religious rules. This reading is supported by outlets such as *The Middle East Eye*, *The Jordan Times*, and *Egyptian Streets*, which observed that "for many non-Arab (and particularly Western) viewers . . . the ending was an 'open-ended' set-up for a second season and 'anything could have happened' . . . for Arabs, the ending is clear" (Khairat and Altoukhi 2021).

So-called honor killings are hugely controversial. In Western discourse, occurrences of honor killings have been exaggerated and used to demonize Arabic and Muslim countries alongside Islamophobic and racist rhetoric. This chapter rejects the idea that gendered violence or misogyny is an inherent characteristic of MENA communities or unique to the region. However, as many MENA-based activists, feminists, and human rights organizations have uncovered, sexism against women, gender minorities, and members of the LGBTQIA+ community is widespread and, in some cases, enshrined in local and religious laws. In Jordan alone, so-called honor killings occur at a rate of between fifteen and twenty per year (Little 2021). Their inclusion in *AlRawabi* is timely

as it follows several high-profile cases of honor-related violence in the country in 2020 and 2021. Most notable was that of a woman whose father bludgeoned her to death on a public street as her cries for help went ignored by her mother. The incident was recorded by bystanders and her screams were circulated on social media, leading to widespread condemnation on Jordanian social media (Little 2021). Part of the public backlash was a campaign to revoke two legal articles (340 and 98) that provide exemptions for men convicted of killing their female relatives that drastically reduce minimum prison sentences if they acted in "great states of fury" or if the victims were doing "unlawful or immoral" acts (Middle East Monitor 2020).

The violence in *AlRawabi*'s final scene is implied rather than shown, but it is significant as a culmination of the threat of gendered violence that has lingered over the characters by virtue of their gender and position in Jordanian society. It also provides the grounds for a possible second season. In this way, *AlRawabi* offers a confronting, powerful, and narratively coherent use of gendered violence that implicates everyone in the narrative and questions the realities of male-on-female violence, including so-called honour killings, in Jordan.

The Reception of *AlRawabi*

AlRawabi arguably achieved Shomali's aim of boldly representing the experiences of Arabic teenaged girls when it debuted in 2021. It received a positive reaction from local audiences and had positive reviews internationally, including in such publications as *Marie Claire* and *The New Yorker*—a rare occurrence for Arabic-language or MENA-produced shows. In its first week of release, *AlRawabi* was the most-viewed program on Netflix in its home country of Jordan and was one of the popular hashtags on the country's social media sites (Ghaith 2021). Its reception on social media in MENA countries appeared largely positive, with users expressing pride and surprise that *AlRawabi*, with its potentially subversive topics, was a Jordanian program with a shameless focus

on the real-life issues of Jordanian teenagers. However, the show has not been universally applauded. One local outlet noted that Jordanian viewers "are divided between the 'pros' who see the series as raising taboo societal topics such as bullying, harassment and 'honor killings,' and the 'cons' who see certain scenes as daring and contrary to the habits and customs of society, with reference to clothing and the language used" (Daraj as quoted in Archyde 2021).

Although *AlRawabi* deserves praise for presenting difficult subjects to a local audience that normally lacks—and actively shies away from—such taboos in their media, it also deserves attention for providing humanizing and *contemporary* depictions of (upper-class) Arabic teenagers to local and international audiences who otherwise make do with limited or one-dimensional portrayals. In contrast to conventional portrayals of Arabic teens in both local and foreign dramas, characters in *AlRawabi* are neither thin stereotypes nor aspirational model citizens. They are power-hungry, vindictive, flawed, compassionate, driven, and multifaceted. They are social-media literate, embrace varied clothing and makeup styles, and are knowledgeable about trends and events happening outside of the country. Despite the misogynistic rules that threaten dire consequences if broken, characters wear crop tops and go on dates—a realistic depiction of girls attempting to navigate the autonomy and normalcy afforded them by their wealth within the suffocating patriarchy that exists regardless of class. *AlRawabi*'s premise goes a step further by exploring the ways in which its teenage characters internalize and weaponize patriarchal threats, leading to potentially deadly outcomes, as evident in Mariam's progression from a heroine to an antiheroine. While the previously mentioned aspects of everyday life are well known to Arabic youth, they are less known outside of the region and poorly depicted (if at all) in locally produced dramas that require swift narrative condemnation and punishment of problematic behavior. With that context in mind, *AlRawabi*'s centering of teenage girls as lead characters and its depictions of them as conniving, fallible, and most importantly, complicit in the wielding of patriarchal violence, is only

viable on an international video service with access to a range of niche audiences across the globe.

It is instructive to consider *AlRawabi*'s mixed-to-positive reception alongside that of its predecessor *Jinn*, another Jordanian teen drama and Netflix's first Arabic-language original. *Jinn*'s five-episode first season follows a group of teenagers who accidentally summon an evil spirit intent on destroying the world. Like *AlRawabi*, the high school students of *Jinn* are modern and trendy, although their cast includes both boys and girls. They also go on an eventful school trip and sneak away to indulge in disobedient behavior that eventually leads to them confronting a massive supernatural entity.

Upon release, *Jinn* garnered criticism from Jordan's Media Regulatory Body and state prosecutor, who reportedly felt the show did not represent the Jordanian way of life, and the country's grand mufti (the country's highest religious leader) called the show "a moral breakdown" (Akerman 2019). Of particular note was *Jinn*'s kissing scenes between unmarried teenagers, discussions of drugs and alcohol, and use of profanity "as explicit as *kol khara* ('eat shit') and *sharmoota* ('whore') which, while prevalent in some English-language TV, has never been heard before in Arab productions" (Fahim 2019). Jordan's Tourism Authority retracted its support, saying *Jinn*'s "lewd scenes" were "a contradiction of national principles . . . and Islamic values" (as quoted in Van Ruymbeke and Debre 2019).

Jinn was criticized by Arabic media for lacking regional authenticity (itself a loaded concept) and appearing like a "carbon copy of tired American formulas" with little sociopolitical commentary (Fahim 2019). *Jinn*'s failure to live up to Netflix's intent of "portray[ing] the issues young Arabs face as they come of age" was attributed to the show's American-raised, Lebanese writers, Mir-Jean Bou Chaaya and Amin Matalqa, and its executive producers, Elan and Rejeev Dassani, whom the *Middle East Eye* said "had nothing in their filmography remotely related to Arab culture" (Fahim 2019). (The Dassani brothers had previously written and directed one other Jordanian project, a 2017 English,

Arabic, and Mandarin-language short film titled *Seam*, but their credits were otherwise limited to such American programs as *Scandal*, *Grace and Frankie*, and *How to Get Away with Murder*.) The *Middle East Eye* also said that the program had "no real insight into Jordanian teenage lives, no position on modern Jordanian society" and claimed that "with *Jinn*, Netflix has shown a clear ignorance of a region it has yet to grasp" (Fahim 2019).

Whereas *AlRawabi* presents Jordanian teenagers with a rare opportunity to see themselves portrayed in a relatable, if confrontational, story, *Jinn* suffered from a lack of realism in its plotline and genre. Teen dramas are "risky" in a market that does not cater specifically to teenage audiences, and *Jinn*'s use of supernatural elements (a rarely used and somewhat taboo genre) hampered its ability to present a realistic depiction of the lives and challenges of Jordanian high schoolers. In contrast, *AlRawabi* utilizes the teen drama genre to explore sensitive and controversial issues from the perspective of teenage girls. Both of these outcomes are difficult to accomplish under typical MENA production and distribution circumstances because of a hesitance to discuss topics such as mental health, bullying, and misogyny and a reluctance to center the stories of teenage girls (who are perceived as morally corruptible). Furthermore, unlike *Jinn*'s American-based writers, Shomali—a popular Jordanian YouTube celebrity—was better placed reputationally to connect with *AlRawabi*'s target demographic.

In addition to *AlRawabi*, Netflix built on its female-centric commissioning strategy with *Whispers*, a 2020 Saudi Arabian original production written and directed by one of the kingdom's leading female directors, Hana Al Omair. *Whispers*, an eight-episode mystery serial drama, is unconventional among MENA programs in both narrative and format. It tells the story behind the mysterious death of a Saudi businessman using a *Rashomon*-like structure in which events are narrated from multiple perspectives of a female-led cast. This structure allows each episode to focus on the motivations and personalities of each of the female characters, reinforcing their status as protagonists rather than background wives or daughters. It also means that, similarly to *AlRawabi*, *Whispers*

devotes much of its screen time to its female leads—a rare choice in the kingdom—and depicts Saudi women as multifaceted and independent career women in areas like social media and graphic design. Al Omair notes that such portrayals are important because "these kinds of Saudi female characters are not shown to both international and Arabic audiences." He also highlights the necessity of accurately reflecting "modern life in Saudi Arabia that not many people have seen before, because it has rarely been presented that way" (as quoted in Saeed 2020).

At the least, programs like *AlRawabi* and *Whispers* offer contemporary representations of historically hidden segments of the MENA population, such as women—and particularly Saudi Arabian women—whose media presence on the world stage and often within their own national media range from nonexistent to stereotypical (Keller 2020). As a multi-territory SVOD, Netflix can commission stories that would otherwise be excluded from mainstream Middle Eastern media because of the region's strict religious or social norms. That *Whispers*, only the fourth Arabic language original to emerge from the region, presents a rarely seen perspective on the (albeit wealthy) present generation of Saudi women through the lens of a Saudi filmmaker. It is now available in almost 200 countries through Netflix, consistent with Netflix's stated position as a progressive service that is commissioning and circulating underrepresented local stories to an international subscriber base.

The end results are narratives that explore the complex, varied, and unseen (but widely experienced) realities of MENA women, made by them, for them, without the restrictions of regional censorship. Importantly, these stories are now available to an unprecedented international audience who may have otherwise never had the access or incentive to engage with a local Jordanian or Saudi story but are willing to watch it if promoted and made available by the streamer.

Netflix's (albeit limited) contributions to the region are neither altruistic nor indicative of a radical shift towards progressive, minoritarian storytelling in MENA. However, examples such as *AlRawabi* and *Whispers* demonstrate a pathway for the company, its subscribers, the MENA

creators it works with, and the underserved and underrepresented audience of young MENA women, to benefit from a cultural product that may otherwise have never been made within the current environment of MENA television.

References

Akerman, Iain. 2019. "*Jinn* Backlash Haunts Jordan's Film Industry." *Arab News*, December 1, 2019. https://www.arabnews.com/node/1590461/lifestyle.

Amnesty International. 2021 "MENA: Gender-Based Violence Continues to Devastate Lives of Women Across Region." March 8, 2021. https://www.amnesty.org/en/latest/news/2021/03/mena-gender-based-violence-continues-to-devastate-lives-of-women-across-region/.

Arab News. 2018. "Mideast TV viewership rises by 3 hours a day during Ramadan: Netflix poll." May 11, 2018. https://www.arabnews.com/node/1300716/media.

Archyde. 2021. "What *AlRawabi School for Girls* Says About Society in Jordan." August 24, 2021. https://www.archyde.com/what-alrawabi-school-for-girls-says-about-society-in-jordan/.

Darwish, Ibrahim and Noora Abu Ain. 2020. "Foul Language on Arabic Television: A Case Study of the First Jordanian Arabic Netflix Series." *Academic Journal of Interdisciplinary Studies* 9 (1): 83–90.

Dennis, Everette. E., Justin Martin, and Robb Wood. 2018. "Media Use in the Middle East, 2018: A Six-Nation Survey." Northwestern University in Qatar. http://www.mideastmedia.org/survey/2018/chapter/tv/.

Elyamani, Rowaida, Sarah Naja, Ayman Al-Dahshan, Hamed Hamoud, Mohammed Iheb Bougmiza, and Noora Alkubaisi. 2021. "Mental Health Literacy in Arab States of the Gulf Cooperation Council: A Systematic Review." *PLoS ONE* 16 (1): https://doi.org/10.1371/journal.pone.0245156.

Fahim, Joseph. 2019. "Netflix and the Middle East: How *Jinn* Became a Nightmare." *Middle East Eye*, July 2, 2019. https://www.middleeastye.net/discover/jinn-review-netflix-middle-east-salma-malhas.

Ghaith, Batool. 2021. "Jordanian Netflix Series *AlRawabi School for Girls* Garners Mostly Positive Reactions." *The Jordan Times*, August 15, 2021. https://www.jordantimes.com/news/local/jordanian-netflix-series-%E2%80%98alrawabi-school-girls%E2%80%99-garners-mostly-positive-reactions.

Halabi, Nour, and Christa Salamandra. 2019. "The Politics in and of Middle Eastern Television Drama." *Middle East Critique* 28 (2): 97–100.

Keller, Joel. 2020. "Stream It or Skip It: *Whispers* on Netflix, a Saudi Thriller About a Family Finding Out That Their Patriarch's Business Played a Part in His Death." *Decider*, June 11, 2020. https://decider.com/2020/06/11/whispers-netflix-stream-it-or-skip-it/.

Khairat, Mohamed, and Nour Altoukhi. 2021. "*AlRawabi School for Girls* Ending Explained—A Shock for Some, Reality for Many." *Egyptian Streets*, August 19, 2021. https://egyptianstreets.com/2021/08/19/alrawabi-school-for-girls-ending-explained -a-shock-for-some-reality-for-many/.

Little, Sarah. 2021. "A Viral Instagram Post Is Reigniting the Push to Reform 'Honour Killing' Laws." *Vice*, February 16, 2021. https://www.vice.com/en/article/v7mnxy/a -viral-instagram-post-is-reigniting-the-push-to-reform-honour-killing-laws.

Mid East Media. 2021. "Television." http://www.mideastmedia.org/industry/2016/tv/.

Middle East Monitor. 2020. "Street Protests Erupt in Jordan Over 'Honour Killing' of Daughter." July 23, 2020. https://www.middleeastmonitor.com/20200723-street -protests-erupt-in-jordan-over-honour-killing-of-daughter/.

Mullally, William. 2021. "One-on-One with the Creator of Netflix's New Arabic Original *AlRawabi School for Girls*." *Arab News*, August 12, 2021. https://www.arabnews .com/node/1909201/lifestyle.

Netflix Newsroom. 2017. "She Rules this Ramadan with Netflix Celebrating the Inspirational Ladies on Screen and in Real Life." May 29, 2017. https://about.netflix.com/en /news/she-rules-this-ramadan-with-netflix-celebrating-the-inspirational-ladies-on -screen-and-in-real-life.

Netflix Newsroom. 2019. "Netflix Announces *AlRawabi School for Girls*, A Middle Eastern Original by Fresh Female Arab Voices." April 13, 2019. https://about.netflix .com/en/news/netflix-announces-alrawabi-school-for-girls-a-middle-eastern -original-by-fresh-female-arab-voices.

Pew Research Center. "Middle East Still Home to Highest Levels of Restrictions on Religion, Although Levels Have Declined Since 2016." July 15, 2019. https://www .pewforum.org/2019/07/15/middle-east-still-home-to-highest-levels-of-restrictions -on-religion-although-levels-have-declined-since-2016/.

Saeed, Saeed. 2020. "*Whispers*: The First Saudi Arabian Netflix Original Reflects a More Modern Kingdom." *The National*, June 8, 2020. https://www.thenationalnews .com/arts-culture/television/whispers-the-first-saudi-arabian-netflix-original -reflects-a-more-modern-kingdom-1.1030625.

Shomali, Tima. 2021. "A Sneak Peak into the World of *AlRawabi School for Girls*." Netflix Newsroom, July 21, 2021. https://about.netflix.com/en/news/a-sneak-peak-into-the -world-of-al-rawabi-school-for-girls.

Van Ruymbeke, Laure, and Isabel Debre. 2019. "Netflix's First Arabic Original Sparks Backlash on Home Turf." *Associated Press*, June 20, 2019. https://apnews.com/article /entertainment-middle-east-ap-top-news-tv-media-ac91602c95844da6be95cc980e 7e993a.

Youssef, Jeff, and Karen Piane. 2013. "Insights: Opportunities and Challenges in the Middle East and North Africa Media Production Market." Oliver Wyman, November. https://www.oliverwyman.com/content/dam/oliver-wyman/global/en/files/archive /2013/MENA_Media_Production_Market_Nov2013.pdf.

A New Style of K-Drama in Netflix Originals

Generic and Stylistic Experiments in Korean "Genre Dramas"

JENNIFER M. KANG

In 2016, Netflix launched in South Korea (hereafter Korea) as part of its global expansion strategy. Contrary to the ominous warnings from the local industry about the prospect of Netflix disrupting the domestic media ecosystem, the early months of Netflix Korea were relatively quiet. However, all this changed when Netflix started investing in Korean originals. In addition to securing the global streaming rights to popular TV series like *Mr. Sunshine* (2018) and *Memories of the Alhambra* (2018), Netflix entered partnership deals with major media conglomerates including CJ ENM and Joongang Tongyang Broadcasting Company (JTBC). More importantly, Netflix-commissioned originals like *Okja* (2017), *Busted!* (2018–), and *Kingdom* (2019–) became available to subscribers. These original films and series were well-received not only by Koreans but also by subscribers from all over the world, which spurred Netflix to increase its investment in Korean content. In 2021, Netflix stated its annual investment in Korean originals would exceed US$500 million (Brzeski 2021).

Amidst Netflix's aggressive investment in the Korean media market, this chapter focuses on two Netflix original series, *Kingdom* (2019) and *Extracurricular* (2020), to demonstrate how they offer an alternative to Korean drama norms. Globally, popular Korean dramas are often associated with the Korean Wave, a concept that refers to the widespread popularity of Korean culture around the world since the 1990s. Television dramas have been the driving force behind the Korean Wave and

accounted for almost 90 percent of Korea's television exports in 2011 and 87 percent in 2018 (Y. Kim 2013; Korea Information Society Development Institute 2020). Given the success of the Korean Wave and its global presence, the Korean government has "identified it as a means of serving national interests at a political level" (J. Kim 2007, 53). In other words, the government claims that the Korean Wave is proof of the superiority of Korean culture and advocates that the Wave benefits the nation through economic success and cultivating a positive image. Notably, Korean Wave television dramas, often called K-dramas, appeal to a large audience by focusing on apolitical and uncontroversial stories about romantic relationships (Glynn and Kim 2017). Academic, industrial, and government conversations are focused on popular K-dramas that depict Korea in a way that does not offend national sensibilities and highlight it as a desirable place.

Netflix has opened a space for alternative drama narratives that go beyond this archetype of the K-drama, as seen with the original series *Kingdom* and *Extracurricular*. This chapter draws attention to Netflix's cultural and industrial affordances that underscore the "genre drama" (*jang-re mul deurama*), a storytelling mode defined in contrast to K-dramas to broaden the scope of the Korean Wave. Unlike K-dramas, genre dramas highlight narratively complex plot developments that drive the story forward and downplay romantic relationships between characters. Additionally, Netflix's position as a subscription video-on-demand (SVOD) service allows creators to experiment with stories that diverge from the commercially successful K-drama format. Building upon Mittell's (2001) argument to approach genre as a cultural category, this chapter examines the industrial context/practices of genre dramas as well as their common narrative features to illustrate how Netflix navigates the various dynamics operating in the Korean television industry.

Characteristics of the K-Drama Production Model

To understand the impact of Netflix originals on Korean television, we need to consider the specific production norms that have been estab-

lished since the Korean Wave. The Chinese press coined the term the Korean Wave in the late 1990s to refer to the spread of Korean popular culture overseas, particularly throughout the East Asian region (Y. Kim 2013). Originally, the Korean Wave was initiated with the export of broadcast television dramas to East Asian countries, but it has subsequently come to include the spread of Korean popular music (K-pop), film, online games, fashion, cosmetics, and food to countries all over the world. Although the Korean Wave is still concentrated mainly on neighboring Asian countries, Korean content has also been embraced in countries including the United States, Brazil, Mexico, Iraq, and England. This is the first time in history that Korean popular culture has achieved such widespread circulation (Y. Kim 2013).

The sudden global popularity of Korean culture has incentivized local television drama productions to be more export oriented. Foreign markets are usually accessible to those that have had successful domestic runs because foreign buyers are interested in dramas with proven track records in the domestic market (Oh 2018). This, in turn, limits the types of drama that are produced by encouraging risk-averse productions in line with established genre norms. There are only three terrestrial networks (KBS, SBS, and MBC) and a handful of cable channels that attract large audience numbers in Korea, and these are the only entities capable of financing a drama series. Consequently, competition among producers to secure a deal with one of these channels is fierce. As H. Kim (2011) notes, channels typically contribute 40–70 percent of a typical series budget, with the rest made up from product placements, selling soundtracks, international distribution sales, and other supplementary revenue. Given the financial power of these channels to commission new content (Ju 2017), there is considerable pressure on production companies to cater to the channels' demands even if this compromises creative freedom.

As with any media industry, there is no formula that guarantees a successful outcome for television productions. Scholars have found that industry workers try to minimize the risks by utilizing market research, industry lore, and norms to inform their decisions (Gitlin 2000; Havens

2002; Havens and Lotz 2016). Business tactics like casting well-known celebrities for promotional purposes (Bilton 1999; Fedorenko 2017), and mergers and acquisitions between production companies (Hesmond-halgh 2013) are employed to reduce risk. Oh (2018) argues that the "speculative nature" of Korean producers—rooted in a belief in the un-questionable success in the overseas markets—has strongly influenced the type of dramas that get produced. For instance, it is accepted as fact by producers that one big hit will cover multiple failed dramas. Hence, despite the unpredictability of drama production, Korean producers see the consistent expansion of the Korean Wave as an opportunity. If one can secure a local distribution deal, this is likely to open avenues of sponsorship and investments to generate profits—domestically and internationally. This has implications for Korean TV content because producers tend to follow the success of previous dramas by using con-ventional narratives and aesthetics rather than experimenting with new stories and screenwriting practices (Oh 2018). Because the majority of successful Korean dramas are melodramas, this has become the default genre associated with K-drama (Ju 2020; S. Y. Lee 2012; Oh 2018). In other words, K-drama is not necessarily about traditional Korean cul-ture but identifies dramas that are designed to be universally distributed and widely circulated across national boundaries.

Another notable characteristic of K-drama production is its acceler-ated production schedule. It is standard practice for K-dramas' episodes to complete filming only a couple days—even hours—before the air-ing date. Oh (2018) refers to this practice as "live filming" production because the script gets written while the drama airs, and sections of the script arrive on set as filming progresses. In this system, character arcs and overall narratives are modified in real time as the episodes air, and there is barely enough time for post-production. Consequently, dramas often suffer from poor-quality endings because it becomes a race to complete filming the episodes to meet the broadcast time. The rationale for this extremely tight schedule is the flexibility to adapt to audience ratings. Broadcasters and production teams observe the reactions of au-

diences after the first few episodes and modify the script accordingly by changing narrative arcs and introducing new characters (Oh 2018). This industrial practice ensures that K-dramas' narratives are typically highly responsive to audience ratings because export opportunities are strongly related to domestic market performance.

Content-wise, the typical K-drama presents a melodramatic narrative of beautiful, young people on a quest to find true love despite all obstacles in a fantasied version of Korea that upholds a conservative culture of family and society in a modern setting (J. Kim 2007). The narrative essentially recreates classical fairy-tale structure as a "modern urban love story involving characters with different family and social backgrounds" (Ju and Lee 2015, 333). One of the first K-dramas, *Winter Sonata* (2002), features a man suffering from amnesia who reunites with his first love when he returns to his hometown as a grown man. The two lead characters deal with various issues, such as terminal diseases and family disapproval of their relationship, before they finally unite at the end of the series. Another typical K-drama, *My Love from the Star* (2013), tells the story of a male alien who crash lands in the Joseon Dynasty (Korea in the 1600s) and saves a young girl. He meets the reincarnation of the same girl 400 years later in contemporary Korea, where she is now a famous actress, and falls in love with her. Dramas such as these emphasize the emotional connection between characters (rather than sexual attraction) as a staple of K-drama melodramatic narratives (J. Kim 2007).

The Korean society depicted in K-dramas is a glamorous and sanitized image of the country that is unthreatening, unoffending, and thus palatable for foreign consumption (Glynn and Kim 2017). The recurring depictions of good-looking protagonists, trendy fashion items, luxurious homes, and dutiful sons and daughters in romantic relationships is perceived to contribute to Korea's desirable image around the world. *Winter Sonata* is famous for the iconic scene of the two lead characters strolling across the snow-covered metasequoia path on Nami Island. (The site later became a popular tourist location populated by overseas

fans who bought out the clothing and cosmetics brands seen in *My Love from the Star* during its original run.)

K-dramas avoid any controversial issues that fall outside of the exportable television drama format. Only a few series challenge these storytelling norms and often suffer commercial consequences for doing so. For example, *Life is Beautiful* (2010)—which focuses on a gay romance and Korean homophobia—was excluded from the usual global export avenues, despite its high domestic audience ratings (Glynn and Kim 2017). The industrial characteristics of K-drama production consequently serve to restrict the diversity of stories that can be told on television. This, in turn, has opened up a space in the market for edgier narratives that explicitly challenge K-drama norms—especially for multi-territory services such as Netflix that seek global distribution rights.

The Emergence of Genre Dramas in Korea

The concept of genre drama has recently emerged in opposition to the formulaic tendencies of traditional K-dramas. Genre drama is not an official category on broadcast networks' websites or in regulatory documents, but it is commonly used among industry professionals, critics, journalists, and the general public to describe titles that contrast with the melodramatic characteristics of K-dramas. In its original Korean language form, genre drama (*jang-re mul deurama*) is a combination of the word genre (*jang-re*) and the suffix *mul*, which means "type of material." When put together with "drama," the term is defined as a genre-specific drama, such as crime drama, sci-fi drama, or procedural drama.

This concept of genre drama, though new to academic research, has been explored by Korean television critics. According to Heejung Gong, the genre drama's rise in Korea can be traced back to the American series *CSI: Crime Scene Investigation* (2000–2015) in 2000. Gong argues that in *CSI*, plot twists encourage viewer immersion in the story world while "the relationship between individuals and their emotions" is secondary

to "uncovering the truth" (Korea Creative Content Agency 2016, 34). Another critic, Jaegeun Ha (2016), defines genre dramas as those that do not focus on romance as the driving force of the main storyline, and which depart from the typical stories of melodrama, romantic comedy, family drama, and scandalous love affairs. Similarly, Duk-hyun Jung (2015) contrasts genre dramas with the networks' conventional emphasis on love affairs and family scandals. In contrast, genre dramas cater to a younger audience that prefers a variety of storylines, not just romance-focused narratives.

In television studies, genre usually refers to a category marked with similar styles, settings, characters, and narrative conventions that distinguish it from others (Creeber 2015). In addition to common textual features, Mittell (2001) argues that genres are cultural categories influenced by external elements such as the changing circumstances of societal, industrial, and historical contexts. Applying this definition to Korean genre dramas, I argue that genre dramas operate as a cultural category that is textually and industrially designated relative to K-drama. The focus on narrative complications and alternative stories that depart from the commercialized prototype of K-drama defines genre dramas. As an example, the genre drama series *Voice* (2017–) follows an emergency call center as its employees receive calls about crimes. The narrative focus is on how a voice profiler and detective solve the crimes using the emergency center calls as clues. The emotional relationships between characters are secondary and emerge from the main plot developments—in *Voice*'s case, the two police officers grow closer as they unravel crimes. Moreover, *Voice* critiques police investigations by showing the gruesome causalities that come from police inaction. In contrast to traditional K-dramas with their emphasis on the attractive, glamorous aspects of Korean society, *Voice* represents a distinctive mode of realism characteristic of more recent genre dramas.

Genre dramas, in contrast to K-dramas, are shown mostly on cable channels. Cable channels' blend of advertisement and subscription-based revenue motivates them to air the kind of content likely to entice

customers to subscribe. Unlike Korean broadcast networks that address a mass audience, the leading cable channels cater to a smaller, more discerning audience. Well-known drama channels like tvN claim to provide cutting-edge and distinctive dramas that cannot be found elsewhere, while OCN is branded as a powerhouse of genre drama series. While these channels have distinctive styles of content compared to broadcast, the cable outlets' content still is somewhat restricted by the expectations of advertisers due to their revenue model.

Furthermore, cable channels have fewer regulations compared to broadcast networks—and this influences both drama content and advertisement production. The Korea Communications Standards Commission (KCSC) regulates broadcast media for public accountability based on the Broadcasting Act. Regulations state that broadcast television should uphold "public morals" and "social ethics" and should be cautious when depicting topics regarding obscenity, vulgarity, drugs, alcohol, smoking, superstitions, ostentatiousness, and extravagance (Ahn 2016). The vagueness of this language has led broadcasters to overregulate themselves to avoid regulatory actions from the KCSC. These risqué topics are often featured in genre dramas, which means that they are vulnerable to enforcement actions and unlikely to be aired on broadcast channels. Cable channels are not held to the same regulatory standards, and this makes them more favorable to edgier genre dramas. Cable channels—unlike broadcast channels—also have more freedom to include product placement, which provides an additional revenue stream to finance original productions. Together, these regulatory differences create a favorable environment for subscription services to invest in genre dramas as a niche alternative to mass-market K-dramas. Netflix, following in the footsteps of these cable channels, has likewise opted to invest in the same kinds of edgy genre drama in order to distinguish itself from broadcast television norms in Korea. I will now consider two recent and well-known Netflix originals—gritty teen drama *Extracurricular* and historical zombie drama *Kingdom*—which exemplify this trend.

Extracurricular: Taboo Topics and Absent Adults

Netflix commissioned *Extracurricular* from the Korean production house Studio 329. The head of Studio 329, Shinae Yoon, received the script in 2018 and was struck by the unconventional narrative, which highlights teen crimes—a taboo topic in Korea. *Extracurricular* follows the double life lived by high school student Jisoo Oh, who runs an illegal prostitution business. The narrative unfolds as Jisoo's classmate, Gyuri Bae, learns about his secret life and blackmails him to let her become a partner in the business. They expand the business using Gyuri's money and are on their way to becoming wealthy when the police close in on their operations.

Teen dramas are strongly regulated by the KCSC under the auspices of protecting young audiences by restricting their access to disturbing or violent content (Y. J. Choi 2015). In the past, teen dramas faced consequences for running afoul of the KCSC. For instance, *Angry Mom* (2015) received a warning by KCSC for showing violent scenes of teenage characters dealing with suicide, attempted rape, and murder. Similarly, in *Explicit Innocence* (2016), the narrative of two high school students discussing sex and going to a motel for their first sexual experience was deemed "too provocative" because it could encourage inappropriate actions for high school students (Heo 2016). In both cases, KCSC declared these dramas to be improper for their predominantly teenage audience (Y. J. Choi 2015).

These examples hint at why local producers try to avoid controversial topics when featuring teenagers or students in drama series. As a result, Korean teen narratives usually stay within the boundaries of acceptable storytelling. Typical examples include coming-of-age stories about teenagers overcoming personal hardships to achieve their dreams against all odds (*Moon Lovers*, 2018); bullies turning over a new leaf and learning the value of friendship (*School 2013*, 2013); lower-class students striving to follow their dreams (*Dream High*, 2011); and kind-hearted teachers

helping students to find meaningful goals in their lives (*Master of Study*, 2010).

Compared to the typical teen drama, *Extracurricular* is vastly different for several reasons. First, the narrative of *Extracurricular* deals with taboo topics and punishes its characters (S. J. Choi 2020). Jisoo sees his prostitution business as a transactional service that satisfies clients' needs in exchange for payment. He justifies selling women for sex to fund his college education because his parents are absent from his life. Minhee, Jisoo's classmate, goes out on compensated dates (a form of prostitution) through Jisoo's business because she wants to earn money to buy her boyfriend expensive gifts. None of the high school students in *Extracurricular* are concerned about the ethical implications of their choices. Rather, the criminal activities in which they engage are a means to an end.

The narrative structure in *Extracurricular* deviates from the teen drama formula by not forgiving the teens' terrible choices. Typically, the troubled youth characters in K-dramas see the error of their ways when the adults—including teachers and parents—help them to navigate their lives (Moon 2018). In contrast, the adult figures in *Extracurricular* are either indifferent or oblivious to the teens' actions. For instance, Jisoo's father is constantly looking for get-rich-quick schemes, and he loses all the money Jisoo has saved on the stock market. This eventually pushes Jisoo to aggressively expand his prostitution business to recover the money that his father stole from him. Gyuri's parents micromanage her life to the extent that her mother plans her meals to maintain a perfect figure. Gyuri blackmails Jisoo into letting her be a partner in his business because she desires to become financially independent from her parents. The few well-meaning adults, high school teacher Mr. Cho and Detective Lee, are unable to offer any substantial help to the teens. There are opportunities in which Jisoo could have stopped his business (as he tries to do when he loses his smartphone) or Minhee could have stopped working in sex trafficking permanently (as she does when Jisoo temporarily halts his business), but no adults offer them guidance. Instead, the teens continue their spiral into crime.

In these ways, *Extracurricular* unflinchingly explores the grim realities of teen sex crimes in Korean society, adding a touch of realism to the national tradition of teen drama. Netflix told a distinctive story about teen life in Korea in a way that would have been unacceptable for broadcast networks in Korea. This approach reflects not only the demand among niche audiences for edgy storytelling but also the distinctive regulatory conditions that encourage Netflix, as a subscriber-funded service capable of multi-territory distribution, to invest in genre dramas instead of traditional K-drama fare.

Kingdom: Realism and Seasonal Arcs

Like *Extracurricular*, the historical zombie drama *Kingdom* is an example of how Netflix creates room for narrative structures and expressions that diverge from K-drama norms. Writer Eunhee Kim first developed the concept for *Kingdom* in 2011 but did not write a drama series because she felt it would never get a chance on television (Park 2019). The production company AStory proceeded with development of *Kingdom* as a Netflix-commissioned original because it wanted to produce a high-quality series that could target a global audience (M. A. Lee 2019). *Kingdom*'s global success indicates that, contrary to assumptions by the domestic industry, Korean serialized narratives about uncommon topics—in this case, zombies—can be exportable.

Kim, the writer of *Kingdom*, was already famous for her genre dramas before collaborating with Netflix. Her most recent drama before *Kingdom* was *Signal*, a fantasy procedural drama that is about a cold-case profiler who finds a walkie talkie that lets him speak to a detective in the 1980s. Using the walkie talkie, the two policemen prevent and solve cold cases from both time periods. The broadcast networks in Korea all declined to air this drama because they considered it likely to be unprofitable in domestic and global markets. *Signal* eventually aired on the cable channel tvN but it was not renewed for an additional season nor widely exported (M. A. Lee 2019). This example shows how business

perceptions about genre dramas' performances can hinder their chances in the distribution market.

After this experience, Kim did not expect to find a channel that would be favorable to a more unconventional narrative about zombies set in a historical background. The *Kingdom* series follows the journey of Crown Prince Lee Chang of the Joseon Era as he tries to uncover the dual mystery of a plague that creates zombies and the political conspiracy surrounding the death of his father, the king. In press interviews, Kim has said that the constraints upon network television dramas would not have allowed a series like *Kingdom* to be made (N. Y. Kim 2019). She felt that depictions of dismemberment, gore, and cannibalism were needed to portray the brutality of the zombies (Park 2019). This required Kim to look for distribution beyond the Korean broadcast networks, which are bound by regulation to avoid these graphic representations.

One of the most common themes in historical K-drama is the romance between characters of different social classes (e.g., *The Moon Embracing the Sun*, 2012; *Love in the Moonlight*, 2016). These K-dramas take place in a historical Korea, where the rigid hierarchical class system forbids any romance or marriage between different classes. The story usually concludes with the characters achieving their love despite all the odds against them. However, *Kingdom* moves away from this archetype by excluding romantic narrative arcs between the main characters. The female lead is Seo-bi, a lowly physician's assistant, who figures out that the resurrection plant caused the nationwide zombie outbreak. Seo-bi does not fall in love with the male lead, the crown prince; instead, Seo-bi and the crown prince are united by the same goal of saving the country from zombies. At the end of season two, the crown prince abdicates his throne to his younger brother and organizes a team (including Seo-bi) to track down the remaining zombies in the country. Seo-bi and the crown prince are driven by their quest to find the origins of the zombie plague during this expedition, and the series ends without romance between the two characters.

In contrast to K-drama production norms, Netflix operates on a pre-filming system, in which the entire production is completed before a series is released on the service. This allows for complex narrative devices, such as foreshadowing, to be written into the script. Season one in *Kingdom* suggests several elements, such as the resurrection plant and the queen consort's false pregnancy, which become crucial to the storyline in later seasons. Also, the seasons conclude with cliffhangers because longer seasonal arcs can be planned. *Kingdom* also differs from K-dramas in its duration. Prime-time Korean television series commonly comprise sixteen to twenty hour-long episodes, which is considered the ideal length to build up a sufficient audience size to maximize advertising revenue (Nam 2017). It is rare for dramas to have multiple seasons, so most narratives are completed within this fixed length. In contrast, the first season of *Kingdom* is only six episodes and the pace of the narrative is much faster compared to television dramas. The crown prince leaves the royal palace to investigate the mysterious plague in the southern part of the peninsula in the first episode. He quickly finds out there is a zombie outbreak by the next episode. The "speediness of Korean zombie [dramas]" and the consistent "dramatic tension" is often noted in press reports as a success factor of *Kingdom* (Yang 2020). This contrasts with the archetypical K-drama, which usually slowly builds up the romance between the main protagonists and introduces various conflicts that threaten the relationship through the episodes (Ju and Lee 2015). This change in length came from the specificity of Netflix's affordances that allow viewers to watch at a self-selected pace, and Netflix preferred shorter seasons because they would be optimal for binge-watching (B. R. Choi 2019).

In summary, *Kingdom*'s lack of romance story arcs, long filming schedule, and fast-paced, multi-season narrative is far from the K-drama ideal format. Yet these aspects of the show—usually regarded as risky within an industry that is dependent on audience ratings (Oh 2018)—are integral to the success of *Kingdom*, which reached Netflix's Top

10 chart in multiple countries. The show's success reflects the distinctive storytelling possibilities open to Netflix as a subscriber-funded service catering to both national and international audiences.

Conclusion

Netflix continues to aggressively invest in Korean content and to partner with prominent local production companies to produce original series. In 2021, the company promoted two Korean experts into senior creative leadership roles to strengthen its position in the Asian region and beyond (Yonhap 2021). In the context of such multi-territory interest in Korean television, this chapter examines how Netflix originals differ from typical Korean Wave dramas. Although Netflix focuses on K-dramas in content acquisition deals, its original series catalog follows a different strategy by focusing on genre dramas (Yu 2020).

Contemporary SVOD genre drama can be viewed as a cultural category (Mittell 2001), and Netflix's distinct industrial characteristics provide opportunities to create novel forms of non-romantic stories, narrative arcs, and visual styles. Netflix originals *Extracurricular* and *Kingdom* represent storytelling that is not governed by textual and industrial expectations of K-dramas. Genre dramas subvert the industrial norms of live filming and single-season production practices and offer a degree of televisual realism uncommon in conventional melodramatic narratives. The export potential of Korean genre dramas has long been restricted by the financing practices of the local industry, but SVOD services such as Netflix are now providing an alternative pathway for these stories to reach wider audiences.

As more Korean genre dramas continue to be distributed through Netflix's global network, legacy players are starting to recognize the possibility of exporting to niche audience tastes rather than following the traditional K-drama production model. Broadcast networks are slowly introducing genre dramas into their schedules, and cable channels are investing more in genre drama productions. In future research, it is

worth investigating if the rise of genre dramas brings further change to local industry practices, the Korean Wave, and to Netflix's original content strategy.

References

Ahn, Jin Yong. 2016. "Blurring is Annoying, TV Audiences are Angry." *Munhwa Daily*, July 25, 2016. http://www.munhwa.com/news/view.html?no =2016072501032412069002.

Bilton, Chris. 1999. "Risky Business: The Independent Production Sector in Britain's Creative Industries." *International Journal of Cultural Policy* 6 (1): 17–39.

Brzeski, Patrick. 2021. "Netflix to Spend Nearly $500 Million on Korean Content This Year." *The Hollywood Reporter*, February 24, 2021. https://www.hollywoodreporter .com/news/netflix-to-spend-nearly-500-million-on-korean-content-this-year.

Choi, Bo Ran. 2019. "Kim Eunhee, *Kingdom* Season 1 Exists because of Season 2." *YTN*, February 5, 2019. https://star.ytn.co.kr/_sn/0117_201902051300069487.

Choi, Sang Jin. 2020. "Can't Stop Watching *Extracurricular* Once You Start." *Seoul Economy Daily*, December 8, 2020. https://www.sedaily.com/NewsView/1ZBLRYL4DM /GL0102.

Choi, Young Joo. 2015. "Should School Dramas Be Disciplined for Realistic Portrayal of School Issues?" *PD Journal*, June 11, 2015. http://www.pdjournal.com/news /articleView.html?idxno=55690.

Creeber, Glen. 2015. "Genre Theory." In *The Television Genre Book*, edited by Glen Creeber, 1–3. London: Bloomsbury Publishing.

Fedorenko, Olga. 2017. "Korean-Wave Celebrities Between Global Capital and Regional Nationalisms." *Inter-Asia Cultural Studies* 18 (4): 498–517.

Gitlin, Todd. 2000. *Inside Prime Time: With a New Introduction*. Oakland: University of California Press.

Glynn, Basil, and Jeongmee Kim. 2017. "Life Is Beautiful: Gay Representation, Moral Panics, and South Korean Television Drama Beyond Hallyu." *Quarterly Review of Film and Video* 34 (4): 333–47.

Ha, Jae Geun. 2016. "Broadcast Dramas Move Away from the Future." *Sisa Journal*, March 9, 2016. http://www.sisajournal.com/news/articleView.html?idxno=148114.

Havens, Timothy. 2002. "'It's Still a White World Out There': The Interplay of Culture and Economics in International Television Trade." *Critical Studies in Mass Communication* 19 (4): 377–97.

Havens, Timothy, and Amanda D. Lotz. 2016. *Understanding Media Industries*. New York: Oxford University Press.

Heo, Soo Young. 2016. "KCSC Gives 'Recommendation' to KBS Drama Special About Teen Sex." *PD Journal*, December 8, 2016. http://www.pdjournal.com/news /articleView.html?idxno=59845.

Hesmondhalgh, David. 2013. *The Cultural Industries*. Thousand Oaks: SAGE Publications.

Ju, Hyejung. 2017. "National Television Moves to the Region and Beyond: South Korean TV Drama Production with a New Cultural Act." *Journal of International Communication* 23 (1): 94–114.

Ju, Hyejung. 2020. "Korean TV Drama Viewership on Netflix: Transcultural Affection, Romance, and Identities." *Journal of International and Intercultural Communication* 13 (1): 32–48.

Ju, Hyejung, and Soobum Lee. 2015. "The Korean Wave and Asian Americans: The Ethnic Meanings of Transnational Korean Pop Culture in the USA." *Continuum: Journal of Media & Cultural Studies* 29 (3): 323–38.

Jung, Du-hyun. 2015. "2015 Broadcast Genre Overview: Drama." *PD Journal*, December 22, 2015. http://www.pdjournal.com/news/articleView.html?idxno=57299.

Kim, Hoon. 2011. *Korean TV Drama Industry Profit Structure and Current Issues*. Paju: Hanul Academy.

Kim, Jeongmee. 2007. "Why Does Hallyu Matter? The Significance of the Korean Wave in South Korea." *Critical Studies in Television* 2 (2): 47–59.

Kim, Na Young. 2019. "Writer Kim Eunhee, '*Kingdom* Couldn't be a Broadcast Drama . . . Due to Restrictions on Expression.'" *Maeil Business Newspaper*, January 21, 2019. https://mksports.co.kr/view/2019/42585/.

Kim, Youna. 2013. "Introduction: Korean Media in a Digital Cosmopolitan World." In *The Korean Wave: Korean Media Go Global*, edited by Youna Kim, 1–28. London: Routledge.

Korea Creative Content Agency. 2016. "The Possibility for Korean Genre Dramas as Seen with *Signal*." *Broadcasting Trend & Insight* 5:33–37.

Korea Information Society Development Institute. 2020. "Trend Report on Korean Drama Exports." KISDI STAT Report. https://www.kisdi.re.kr/report/view.do?key=m2101113025790&arrMasterId=4333447&masterId=4333447&artId=554200.

Lee, Min Ah. 2019. "Breaking into Hollywood Is Closer after Working with Netflix." *Economy Chosun*, February 18, 2019. http://economychosun.com/client/news/view.php?boardName=C00&t_num=13606543.

Lee, Soo Yeon. 2012. "The Structure of the Appeal of Korean Wave Texts." *Korea Observer* 43 (3): 447–69.

Mittell, Jason. 2001. "A Cultural Approach to Television Genre Theory." *Cinema Journal* 40 (3): 3–24.

Moon, Sun young. 2018. "Move to the Web and Expand, Recent Trend of School Contents Drama." *The Journal of Korean Drama and Theatre* 62:95–122.

Nam, Ji Eun. 2017. "4, 9, 10 Episodes, Dramas' Forms Start to Change." *Hankyoreh*, January 15, 2017. http://www.hani.co.kr/arti/culture/entertainment/778741.html.

Oh, Youjeong. 2018. *Pop City: Korean Popular Culture and the Selling of Place*. Ithaca: Cornell University Press.

Park, Jae Hwan. 2019. "Kim Eunhee, 'Netflix Was an Attractive Platform for *King-dom*.'" *KBS Media*, January 30, 2019. https://entertain.naver.com/read?oid=438&aid=0000022892.

Yang, So Young. 2020. "*Kingdom 2* Is Hot Overseas." *Maeil Business Newspaper*, March 21, 2020. https://www.mk.co.kr/star/movies/view/2020/03/292927/.

Yonhap. 2021. "Netflix Promotes Korean Executives to Strengthen Its Asian Strategy." *The Korea Herald*, June 16, 2021. http://www.koreaherald.com/view.php?ud=20210616000697.

Yu, Konshik. 2020. "The Influence of Netflix on the Domestic Drama Market." *Media Issue & Trend*. Korea Communication Agency. https://www.kca.kr/fileDownload.do?action=fileDown&mode=&boardId=TRENDS&seq=3737978&fileSn=1.

11

A New Era of Creative Freedom

How Tencent Originals Are Reinvigorating Chinese Talk Shows

LISA LIN

With international cable and satellite channels restricted in mainland China, and SVOD services such as Netflix and Prime Video banned outright, Chinese television is instead powered and reshaped by the technological ascendency of its domestic streaming services—notably Tencent Video, iQiyi, and Youku Tudou.[1] The rise of these services during the second decade of the twenty-first century has not only transformed the regulatory structure of Chinese television (disrupting the existing "four-tier" broadcasting system of county, city, provincial, and national broadcasters), but has also provided an alternative space for creative expression by media producers. As such, the rise of streaming services epitomizes the industrial transformation of convergent Chinese television industries, triggering the formation of new business models, production strategies, and storytelling aesthetics in the post-socialist society.[2]

The Chinese television landscape has undergone significant shifts since the 1980s, from the monopoly of China Central Television (CCTV) to a wide range of offerings expanded by satellite, cable, and home video services in the 1990s, followed by the current rise of online video platforms (Curtin and Li 2018, 351). While China's post-broadcast production strategies, practices, and cultures are marked to some degree by the ideological controls and fears identified by scholars such as Michael Keane (2001; 2015), Michael Curtin (2012), and Anthony Fung (2008), there is also space for individual media practitioners to find creative freedoms and sites of resistance—but not always on terms that would be

recognized by Western scholars of production cultures and media work. The current online environment extends these longer-term tendencies in the sense that it facilitates creative and critical expression among Chinese cultural intellectuals and media producers, many of whom joined commercially run streaming services in search of greater creative freedoms than those afforded by traditional broadcasters. The term "creative freedoms" here connotes not only artistic and inventive freedoms *to create* but also freedoms *to express* one's voice and critical views. Chinese television has seen a slow-burning emergence of creative freedoms since the reform and opening-up in 1978, and marketization reforms since 1992. These shifts have been increasingly embraced by Chinese media in pursuit of greater creative autonomy.

This chapter explores how producers at one Chinese streaming service—Tencent Video—have responded to the creative freedoms of China's current streaming environment. Through case studies of two Tencent original talk shows, I show how Tencent has positioned itself as an alternative space for "authentic" factual television that pushes the boundaries of creative and critical expression in Chinese society, echoing what John Ellis (2012, 10) describes as television's constant quest for a "more honest, more truthful" style. Through case studies of the Tencent originals *13 Invites* (2016–) and *In Conversations with Strangers* (2017–), I explore the changes and continuities in Chinese talk shows from broadcast television to streaming services. I focus specifically on talk shows—a genre that historically serves as an ideological propaganda tool in the Chinese broadcasting system through the confluence of state ideology and long-established broadcast cultures, where personal expressions and critical views must give way to mainstream socialist values and collective nationalism. Drawing upon my ethnographic research into production strategies and practices at Tencent Video, as well as textual analysis of Tencent original series, I argue that Tencent talk shows intervene in and shift the historical trajectory of storytelling norms and modes of address in Chinese talk shows, offering a public forum for personal voices, stories, and critical expression in the one-party state.

The Rise of Tencent Video

Founded in 1998, Tencent is one of the three internet giants—along with Baidu and Alibaba—in mainland China known colloquially as "BAT" (Baidu, Alibaba, and Tencent). Each of these corporations has its own major video service, namely Baidu's iQiyi, Alibaba's Youku/Tudou, and Tencent Video. These three services, along with smaller competitors such as Sohu Video and Bilibili, cater to China's 989 million internet users, of whom 99.7 percent use smartphones and 93.7 percent consume online video (CNNIC 2021).[3]

Following the models established by American multinational technology and internet companies, Tencent operates according to a convergent platform model that integrates a wide range of digital marketplaces and services, including e-commerce, social media, and SVOD services. In Western terms, Tencent therefore resembles a hybrid of Amazon, PayPal, Facebook, and Netflix. Launched in 2011, at the time of writing Tencent Video has an estimated 385 million mobile monthly active users and 123 million premium subscribers (Sina Tech 2021). Its enormous reach is supported by the integration of Tencent's in-house social media platform WeChat (with more than 1.26 billion monthly active users across the world including Chinese overseas diasporas and foreigners outside mainland China) (Sina Tech 2021).

Unlike the SVOD model established by Netflix, Tencent Video provides a connected viewing experience that integrates video streaming services with social platforms, e-commerce, music services, and online payment, embodying what van Dijck (2013) calls "a culture of connectivity." The content offered by Tencent Video includes domestic and foreign programs, talk shows, documentaries, drama series, and films, along with live-streamed events and user-generated video. Unlike the Western SVOD model that relies on subscriber funding, Tencent Video combines free-to-view, ad-funded content with premium ad-free content, thus blurring the boundaries between SVOD and AVOD services. It also integrates other revenue pipelines—such as pay-per-view for premium films and VR concerts—beyond subscription and advertising. Notably, the home

page of Tencent Video offers a search bar through which users can discover video content across a wide range of Chinese video platforms and broadcast online portals, thus linking to third-party websites outside of Tencent Video. Tencent Video thus resembles what Catherine Johnson (2019) describes as online aggregator television (i.e., a platform operator that is integrated into other video platforms and broadcast channels).

Prior to 2012, Tencent Video offered content licensed from broadcasters and film studios. This was a period characterized by a set of partnerships between Tencent Video and legacy Chinese media outlets in both coproduction and content acquisition. Since the launch of Tencent's original programming strategy in 2012, it has shifted its strategy from being a content distributor to being a content producer and has set up two in-house studios for this purpose: Penguin Pictures (in Beijing) and Tencent Pictures (in Shenzhen).[4] As one Tencent executive producer stated, "You could consider Tencent Video as a video portal comprising a variety of video content, from news, documentary, entertainment, film and television . . . We produce in-house drama series, factual entertainment and documentaries, covering the whole value chain in content production."[5] During my fieldwork, a development producer used the term "blood" as a metaphor for original programs to emphasize the importance of producing original SVOD content within China's fiercely competitive online video market.[6] Tencent original programming has since then transformed and disrupted the traditional hegemony of the Chinese television industry, offering an alternative space for creative expression and diverse voices with abundant funding support.

In contrast to binge release strategies whereby original series are released all at once (as per the U.S. SVOD model), Tencent original series are released on a weekly basis, with timing matched to the peak internet usage periods for their targeted audiences. As a Tencent development producer remarked, "We released the shows when the users finish work and start looking up video content online, and I would say the most active time for our users is eight to twelve p.m. on weekdays."[7] The immense amount of data that Tencent extracts from its internet services has

informed not only its commissioning decisions but also its production processes. Often referring to themselves as "product managers," Tencent producers have been exploring innovative ways of storytelling and user engagement through a wide range of production and distribution forms, such as data visualization, to incorporate data analysis into every stage of research and development, content production, marketing, and promotion.[8] For example, social media interaction and online surveys have been integrated into the production process of Tencent factual programs, such as *Are you Normal?* (2014–16)—an online WeChat-embedded quiz show in which the answers are based on the responses from online users through interactive WeChat surveys.

Compared to iQiyi's emphasis on drama series and feature films, Tencent's roster of originals emphasizes documentary and factual entertainment programs, including reality television and talk shows, ranging from mass-oriented offerings to more niche-targeted shows. Unlike the cinematic aesthetics of Western streaming models that do not seek to replicate news and current affairs genres in broadcast television (Wang and Lobato 2019, 366), Tencent Video has inherited production and distribution strategies from its broadcast predecessor, from TV-digital coproduction partnerships in early years (such as *We15* [2015–16, Tencent Video/Dragon TV] and *Go Fridge* [2015–17, Tencent Video/Zhejiang TV]) to news and current affairs productions at Tencent News. Recent years have seen Tencent modifying those to suit its current technological and audience environment. Through case studies of two Tencent originals, *13 Invites* and *In Conversations with Strangers*, and one CCTV talk show, *The Art of the Life*, the next section explores the changes and continuities in Chinese talk shows from broadcast television to streaming services—a genre that serves historically as an ideological propaganda tool in the Chinese broadcasting system.

Chinese Talk Shows: From On-Air to Online

The cultural influence of Tencent Video is especially noticeable in the domain of television talk shows. Prior to 2010, government-controlled

broadcasters including CCTV set the industry standards and production norms for this genre with programs such as *Oriental Horizon* (1993–, CCTV-1), *The Art of Life* (2000–2017, CCTV-3) and *Dialogue* (2000–, CCTV-2). These and other top-rated talk shows have long shaped public discourse and policy discussions. As China's party-state apparatus trumps both the economic interests of individual stations and journalists' professional ethics, broadcasters have largely failed to engage in activities that challenge the pedagogical model and the legitimacy of the one-party state (Berry 2009). The dilemma that CCTV faces, as an outcome of the era of scarcity, reflects both its origin as a broadcast institution as well as its need to maintain relevance and allegiance to the Communist Party of China (CPC). All broadcast talk shows are therefore vetted by channel executives at every stage of production, from concept onwards, and must internalize the standards for what is and is not acceptable to the party-state apparatus (Berry 2009, 82). Noticeably, the CCTV flagship talk show *The Art of the Life*—canceled in 2017 due to low ratings—has become a reference point among Chinese media professionals and viewers for its outmoded stylistic features, such as requiring the anchor to be neutral, depersonalized, and seemingly omniscient.

Under the camouflage of greater sophistication, the "dialogue" staged by these traditional Chinese talk shows has been described by Zhong (2004) as "a deceptive game"—a reinvented one-way passage of messages from the center to the periphery, from the speakers to the listeners. Zhong (2004, 821) argues that Chinese talk shows like CCTV-2's *Dialogue*—which features interviews with business leaders, scientists, government officials, and economists and is aired on CCTV's business and finance channel—adopt a didactic communication model where the hosts and guests are the authoritative source of information with a passive, indistinguishable mass audience. Similarly, Berry (2009, 83) observes that, for the party-state apparatus, "the public space of television is a classroom and the viewers are the pupils." Historically, producers at Chinese broadcast networks have faced strict censorship from both state regulators and communist party cadres within the broadcasters.

However, with the rise of China's streaming services, many experienced broadcasters have chosen to leave the state-owned media system to join commercially run streaming services including Tencent Video in pursuit of greater creative autonomy. Seven of the eight producers interviewed during my fieldwork at Tencent Online Media Group came from a broadcasting background, with most joining Tencent between 2013 and 2016. These producers have encountered a different regulatory and creative environment at Tencent Video. As Chinese media authorities do not issue journalistic accreditations to streaming services, factual entertainment programs such as talk shows and documentaries are seen as a crucial alternative space for Chinese digital producers to work through social issues and current affairs and express their critical viewpoints via nonfictional storytelling rather than news reporting.[9] Instead of confronting official censorship and regulations on news programs directly, Chinese producers have been able to work around restrictions by adopting an approach commonly known as *edge ball* (擦边球) which involves "working through" news and social issues in a conversational manner across a range of nonfictional genres. Chinese digital producers have employed *edge ball* practices to incorporate political and critical ideas into nonfictional programs, thus balancing creative and regulatory requirements while still telling a good story. In line with John Grierson's notion of "creative treatment of actuality" (1971), these factual genres enable Chinese producers to critique and comment on social issues and, potentially, to indirectly question the legitimacy of the party apparatus.

Departing from the neutral tone of broadcast talk shows such as *The Art of the Life* and *Super Interview* (2000–2016), many of which were canceled due to low ratings, presenters of online talk shows largely embrace a subjective interview perspective. Zhu Jun, the presenter of *The Art of the Life,* was known to inundate his guests with ideologically driven dispassionate questions infused with CPC doctrines that triggered widespread debates among viewers who demanded a new presenter and claimed that "Zhu Jun should stop acting like a teacher"

(Sohu Entertainment 2006). In contrast to the traditional hierarchical distinction between expert speakers and the indistinguishable mass of the voiceless audience (Zhong 2004, 839), Tencent online series such as *13 Invites* and *In Conversations with Strangers* promise greater intimacy, equality, authenticity, and inclusivity where presenters can incorporate their emotions and personal reflections into conversations in a more informal and spontaneous way. With presenters and their guests positioning themselves as imperfect human beings rather than figures of authority, Tencent online talk shows reflect several key transformations in production cultures and storytelling norms that have fostered greater space for Chinese producers to exert their creative freedoms in original SVOD commissions. As such, this distinct approach to interviewing in *13 Invites* and *In Conversations with Strangers* embodies a more individualistic perspective that emphasizes personal expression and critical understanding of current Chinese society.

The New Public Sphere of *13 Invites*

First released on Tencent Video in May 2016, *13 Invites* attracted more than 200 million views in its first season and was critically acclaimed by Chinese trade press and cultural critics. As Chinese cultural critic Zeng (2019) observes, online talk shows such as *13 Invites* have embraced location filming and participatory interview techniques, encountering guests in their work environment in a relaxed and naturalistic manner that contrasts markedly with the declining genre of studio-based broadcast talk shows. The promotional tagline of *13 Invites*—"a specimen of the epoch, a slice of the zeitgeist"—illustrates the ambition of the online talk show to capture popular sentiments and pose questions of a fast-developing Chinese society, a hybrid society of new-liberalism (commercial power) and socialism (political power).

Commissioned by Lun Li, the deputy chief editor and the head of factual production at Tencent News, *13 Invites* is written and hosted by

Zhiyuan Xu, a Chinese writer, publisher, and bookstore owner famously known for his book *Those Sentimental Young People*, written in his final years at Peking University in the late 1990s. Li joined Tencent News in 2016, after resigning from his executive role at CCTV when his documentary series *Where Am I Coming From?* was canceled for broaching a taboo discussion topic (the impact of China's Cultural Revolution on a family tragedy).[10] With his background in documentary and news production, Li advocates that documentary storytelling should center on human beings and their personal stories—a belief articulated in the opening sequence of each *13 Invites* episode, which begins with the presenter's monologue "looking at the world with personal bias" over a rapid-cut street-scene montage.

13 Invites emphasizes the unofficial nature of its creators' perspective on current issues. In this sense it echoes the theme of Xu's *Those Sentimental Young People*, which explores the struggles facing Chinese young generations such as the tension between aspiration and reality, the search for meaning in life, and the moral crisis in China's market-driven society. Known as a public intellectual for his advocacy of intellectual debate and inspired by German philosopher Walter Benjamin's philosophical-literary work *Einbahnstraße/One Way Street* (1928), Xu founded OneWaySpace—a venture encompassing bookstores, publishing houses, and book clubs across mainland China. His Tencent original series *13 Invites* assures the audience that Xu's personal perspective guarantees the authenticity and sincerity of the conversations and encounters with his guests.

Each season of *13 Invites* explores issues and conflicts in contemporary Chinese society through thirteen interviews, with episodes released biweekly. As a free-view online series available on Tencent Video, *13 Invites* has triggered a wave of online discussion: its Weibo super topic (online fan community page) has attracted 55 million views, while its official Weibo account attracted 360 million views. Users frequently comment on Xu's interviews and encounters with his guests while also expressing their views on social issues explored in the series. Tencent Video subscribers

FIGURE 11.1. Promotional Poster of *13 Invites* Season 2 (Xu Zhiyuan's portrait sketch with the slogan "looking at the world with personal bias"). Source: Tencent Video.

also have options to watch longer versions of *13 Invites* that include uncut interviews and raw footage, allowing online users to experience Xu's encounters with guests *verité* style. For instance, a second-season episode features Xu's encounters with Chinese film director Wen Jiang, exploring his youth in Beijing hutongs and the impact of historical turmoil—from Chinese Cultural Revolution to market reforms—on his films. The pretitle sequence ends with on-screen texts "looking at the world with personal bias and misreading" where Jiang expresses his motives behind his films and argues that "one can only represent their own perspective".

The public sphere, famously theorized by Habermas (1989) as a bedrock of the democratic process, centers on the engagement of citizens within public culture. In his classic study, Habermas understands the public sphere as an area in social life where people can meet and freely

discuss societal issues—a discursive space that mediates between society and state. Though it may appear that the public sphere concept does not fit the Chinese context, the metaphor is nonetheless important for studies of Chinese digital media, especially in the current era of rapid social and economic change (Viviani 2014). The unofficial nature of *minjian* (popular) knowledge represented by shows such as *13 Invites* clears a space for the development of an independent public sphere in China (Davies 2007, 61–62) and invites viewers to construct their understanding and critique of the contemporary Chinese society and the zeitgeist.

In line with its emphasis on personal experience, *13 Invites* makes extensive use of *verité*-style location shooting, handheld cameras, and rapid-cut montages. The interview style is clumsy and spontaneous rather than formal: Xu and the guests often show their own vulnerability, confusion, and struggle. In a fifth-season conversation with Bao-qiang Wang, a Chinese grassroots film actor who worked his way up from a farmer and film extra to become one of China's A-list stars, Xu immersed himself as a film extra to get his first-hand experience of the below-the-line working conditions in the film industry. From eating takeaway meals at midnight with low-wage film laborers to acting as a gambler in a film, Xu relates to the experiences of his guest. The episode has a strong participatory style, with hand-held camera shots and Dutch tilts of spontaneous encounters. Unlike the formal, banal editing style used in broadcast talk shows, *13 Invites* experiments with parallel cutting and visualizes a stream of consciousness with jump cuts and subjective shots in a cinematic style that embodies post-modern aesthetics and sensibilities.[11]

A recurrent theme in *13 Invites* is the failure of China's broadcasting system. As an example, consider Xu's candid encounters with Zhenyu Luo—a digital media entrepreneur who resigned from his executive producer role at CCTV-2's prime-time, current affairs show *Dialogue* (CCTV-2, 2000–) due to the ratings slump.[12] In this conversation Luo

reflects on the golden age of his CCTV experience when the state broad-
caster was in control of the national news agenda. During the interview,
Luo jokingly points out that Chinese broadcasters have been declining
over the last decade and uses the rhetorical metaphor of "singing elegy
in the sunset" (唱挽歌) to voice a perspective unacceptable on a broad-
cast channel. This thought-provoking interview can be seen as a reflex-
ive commentary between two ambitious media producers who escaped
the decadent broadcasting system to exercise the creative freedoms al-
lowed within China's streaming television services. Similar themes are
explored in Xu's conversations with Dong Ma, digital entrepreneur and
CEO of MeWe Media.[13] Ma, who previously worked as the producer
for a flagship CCTV program, *Cultural Dialogue*, confides to Xu that
he was producing the program primarily for CPC leaders and channel
executives (who are also CPC members) rather than for the public—an
unusually direct critique of the Chinese broadcasting model. Ma ex-
pressed his view on how the state-owned broadcasting system has re-
stricted content creation and creative expression and resulted in the loss
of younger, digital-first audiences. He claims that it is only with the ad-
vent of the internet that China has properly entered the real "television
era" of abundant and diverse choices.

In summary, the intellectual discourse of *13 Invites* provides a rela-
tively liberal environment for critical commentary on public culture
and personal voices and poses a stark contrast to the two dominant
programming trends on Chinese broadcast channels—commercially
driven, escapist entertainment shows and ideology-oriented propaganda
programs. Instead, *13 Invites* forges a public space for online debates and
intellectual critiques of Chinese society to promote a media environ-
ment that is more inclusive, equal, and humanistic. As David Shambaugh
(2016, 22) postulates, it is problematic to "create a modern economy with
a premodern political system." Such tensions could eventually prove ir-
resolvable in China's current model of state socialist-(techno)-capitalist
development—and *13 Invites* engages explicitly with this tension.

In Conversation with Strangers: Creating Space for Grassroots Voices

"Listening with no assumption and no judgment. Every interviewee also has the right to become the interviewer."
—Opening monologue of *In Conversation with Strangers*

If *13 Invites* exemplifies elite-oriented dialogues with influential guests, *In Conversation with Strangers* (Tencent News, 2017–) explores the untold, grassroots stories of underrepresented communities in China, such as pickpockets, vagrants, bullying victims, gamblers, organ donors, and underground rock singers.

With a reference to the Chinese saying "don't talk to strangers," the program title acts as an ironic antonym of the highly rated Chinese television series *Don't Talk to Strangers* (Nanjing TV, 2001–2002), which alerted women to stay away from dangerous male perpetrators. In contrast, the talk show adopts a female perspective to actively approach a range of marginalized "strangers" and unveil a diverse world of human emotions, stories, and struggles. The talk show follows Chinese journalist Xiaonan Chen as she explores the social conflicts underlying China's economic boom through intimate encounters with marginalized citizens. As the tagline of the series describes, "In the era of 'Don't Talk to Strangers,' let's follow Chen Xiaonan to have some conversations with strangers and connect ourselves with every lonely human being in the modern society with shared empathy and humanity." Each episode begins with Chen's monologue and an image of two chairs on a black background along with the superimposed words "life or death, being sick or old; hello, strangers!"

Unlike the sophisticated editing style of *13 Invites*, *In Conversation with Strangers* embodies a simplistic visual style with minimal editing and sound effects that shows candid encounters and conversations. With two chairs, a black studio background, and several spotlights, the series features interview crosscuts and documentary inserts with little

set dressing. In December 2021, the episode "Boxers Father and Son" was awarded Best Online Documentary by the *China Academy Awards for Documentary Film* in Beijing. The episode features a touching story about a boxer father of a boy with cerebral palsy who teaches his son boxing skills to protect himself from school bullying. With empathy and compassion towards filmed subjects, *In Conversation with Strangers* uses distinctive aesthetic strategies to evoke these personal stories among marginalized communities. For example, Chen interviews a prison employee who is responsible for writing wills for prisoners on death row. Rather than an objective standpoint used in news reporting, Chen adopts an empathetic approach toward the experience of prisoners facing death and the complex relationships that develop among prisoners and staff who are involved in writing wills.

A recurrent theme of the series addresses the illusion of the "Chinese Dream" and vicissitudes among ordinary Chinese citizens upon the rapid rise of the Chinese economy.[14] In dialogues with ordinary citizens who went through different life events and personal turmoil, Chen adopts a compassionate interview style and acts as a nonjudgmental listener rather than an investigator. This approach forms the main narrative strategy for her intimate encounters with filmed subjects across four seasons. For instance, in season four, Chen encounters a whistleblower who escaped from a Myanmar-based Chinese online fraud network that utilizes online dating to fraudulently request money from young Chinese women. The episode follows the whistleblower's journey from targeting young intellectual Chinese women to becoming an undercover police informant. Though criticized by some online viewers for being subjective with too many personal viewpoints as a journalist, Chen expresses her emotional shock when she heard about how one businesswoman committed suicide in Shanghai after realizing her blind date was a fraud. Another example is the episode on crypto currency that unveils the rollercoaster journeys among low socioeconomic status communities in south China that hope to go from rags to riches via bitcoin investment. While most of those bitcoin adventurers ended up in

heavy debt and bankruptcy, the series provides an open public space for Chinese bitcoin investors to share nuanced personal stories behind their decision-making processes.

In contrast to didactic modes of address used in broadcast talk shows, Chen adopts a nonjudgmental tone that opens up an online public space of free conversation with the interviewees, who then share untold stories openly from their marginalized communities. In the special season *Tabooed (不可说特辑)*, ordinary citizens were asked to interview each other without Chen being present (reflecting Chen's commentary in the opening sequence of the show: "Every person has the right to ask questions") (Tencent Video 2018). Participants included childless (DINK—dual income, no kids) couples, plastic surgery fetishists, and victims of house demolition. These four special episodes pair people holding divergent opinions on the same issue to create a constructive dialogue between disparate views. In the opening sequence, Chen provides her introduction to the special season with no presenters—"every interviewee has the right to become the one who asks the questions"—before fading out to the background. In the special season, participants were given equal opportunity to inform the interview structure in the absence of the presenter, who commonly serves as the voice of authority. For example, the first episode paired a female novelist who believes in natural beauty with a plastic surgery fetish model to participate in a debate about whether plastic surgery enhances confidence or diminishes the sense of self. Together, they discussed different definitions of beauty and the sociocultural implications of plastic surgery in contemporary China. In episode four, on the morality of DINK families, pro-DINK and anti-DINK participants interviewed each other about their opinions. The narrative strategy provoked stark debates on humanity, morality, and freedom of choice among the participants, who expressed their pains and struggles to live with social stigma and pressure from both close family members and strangers. For instance, a 39-year-old writer explained the conflicts and tensions with his family: "They said I am an anti-human criminal by choosing to be DINK." He was paired with a 26-year-old film director, a single mom of one, who

responded, "Are you too fearful to have a child?" and "You are missing out on the wonderful life to have a child." The dialogues between communities holding divergent opinions build a bridge for understanding in what some have termed "post-truth society" to describe the cultural and political polarization aggravated by echo chambers on social media.

Like 13 *Invites*, *In Conversation with Strangers* exemplifies some of the reasons why broadcast producers left the state broadcasting system to join digital streaming services where creative expression is empowered by the commercially run platform model and integrated internet services. From a female perspective, *In Conversation with Strangers* embodies a set of inclusive and compassionate storytelling strategies for marginalized communities to express their voices and stories to millions of online viewers. The online series offers a public space for ordinary people from all walks of life to participate in public debates and social commentaries due to the rapid development of Chinese SVOD commissions that have helped end the discursive domination of state-owned broadcasters. *In Conversation with Strangers* poses a stark contrast to mainstream narratives on Chinese broadcast channels, most of which promote socialist core values and CPC ideology as compulsory editorial guidelines. These two Tencent original talk shows have forged a new set of storytelling norms and modes of address, giving voices to ordinary citizens as well as digital elites, and telling personal stories that would not be heard in a traditional broadcast context.

Conclusion

This chapter examines how Tencent original commissions have both liberalized and rejuvenated Chinese talk shows by creating a public space for personal expression, diverse voices, and creative and intellectual freedoms. Chinese SVOD commissions such as Tencent originals have intervened in the historical trajectory of storytelling norms and modes of address in Chinese talk shows and enabled citizens to discuss societal issues relatively freely in an online public space that mediates

between society and state. Rather than confronting the political regime directly in news reporting, Tencent originals offer an online alternative space for personal expression and sociopolitical commentaries through the deployment of *edge ball* strategies among Chinese media producers. As one of China's leading video services, Tencent Video has engendered an inclusive production culture attractive to aspiring television producers who challenge the existing genre conventions of Chinese talk shows with authenticity and creative expression. This has been encouraged by the lower regulatory burden of streaming services as compared to broadcast services and allows for more sociopolitical commentary and personal expression in original SVOD commissions. I argue that the shifting aesthetics, conventions, and storytelling norms of online talk shows commissioned by Tencent Video amount to a sociocultural phenomenon that is enabled and empowered by the rise of the Chinese platform economy in a post-socialist society.

Tencent talk shows such as *13 Invites* and *In Conversation with Strangers* have epitomized several key transformations in production cultures and narrative aesthetics in post-broadcast China, exploring an alternative space for authentic personal expression and diverse voices in non-news genres. Commissioned by Chinese SVOD services such as Tencent Video and iQiyi, online talk shows and factual entertainment programs, such as *Only Three Days Visible (仅三天可见)* (Tencent Video, [2019–], presented by Chinese LGBT artist Sida Jiang) increasingly feature participants from diverse backgrounds and demographics.[15] With the burgeoning growth of digital streaming services and online advertising revenues, Chinese digital producers embrace abundant financial and editorial support to experiment with innovative forms of factual storytelling and narrative strategies in the online space using new technologies and platform models. Noticeably, creative and political freedoms in China are much less confrontational or overt; cultural values and creative autonomy are expressed through the deployment of *edge ball* strategies. Tightening media censorship exerted by the Chinese government since the COVID-19 outbreak has posed challenges

to aspiring digital producers who must tread the delicate balancing act between *edge ball* practices and censorship in their daily practices. These strategies allow Chinese digital producers to exercise their creative freedoms within certain boundaries and work through difficult sociopolitical issues in candid conversations and encounters across a range of nonfictional genres.

Notes

1 Although some leeway can be found in five-star hotels, international corporations, and ordinary households in Guangdong province, state control still restricts audiences from accessing foreign television channels.

2 In this chapter, I use the term *television* to denote professionally produced audio-visual content in standardized forms and genres across broadcast television and digital streaming services.

3 Initially launched as a peer video-sharing website with real-time on-screen comments, Bilibili has started commissioning a wide range of original factual entertainment and online drama series since 2018.

4 Original production at Chinese streaming services echoes the social movement of *Created in China* across creative and cultural industries.

5 Fieldwork data from the author's interview at Tencent Beijing Headquarters in December 2016, Beijing.

6 Author's interview at Tencent Beijing Headquarters in November 2016, Beijing.

7 Ibid.

8 Author's fieldwork data, 2017.

9 In January 2021, Chinese authorities started banning self-publishing by broadcast journalists on social media accounts. See The International Federation of Journalists 2021.

10 *Where am I Coming from?* (CCTV-1, 2014–2015) is a Chinese adaptation of the British genealogy series *Who Do You Think You Are?* in which celebrities trace their family tree and follow in their ancestors' footsteps.

11 For example, in the usage of music, Debussy's *Clair de lune* was chosen alongside the tracking shots of the film extras eating takeaway food together in the middle of the night.

12 Founded in 2014, Luoji Siwei is one of the most successful of the Chinese app developers that have been reaping profits from the country's flourishing middle class by providing high-quality online courses that cover various fields of study. Luo first created his mobile talk show *Luogic Talkshow*, an online educational program that, likewise, is designed to teach rational thinking to his WeChat followers via sixty-second voice recordings at six a.m. every morning.

13 Ma Dong created an online debate show called *U Can U BiBi* for iQiyi before launching his own production company, MeWe Media.

14 The term "Chinese Dream" was first used by President Xi Jinping in 2012 to refer to the "great rejuvenation of the Chinese nation," which became the core slogan of the CPC political ideology under his leadership.

15 As an artist and online content creator, Sida Jiang frequently advocates his view that "humans are born to be equal and born to be free" in his talk shows and arts exhibitions such as F*ck Me 爱我 exhibition at X Museum in Beijing in 2021. See https://xmuseum.org/portal/exhibitions/6.

References

Benjamin, Walter. 1928. *Einbahnstraße/One Way Street*. Leipzig: Rowohlt Verlag.

Berry, Chris. 2009. "Shanghai Television's Documentary Channel: Chinese Television as Public Space." In *TV China*, edited by Chris Berry and Ying Zhu, 71–89. Bloomington: Indiana University Press.

CNNIC. 2021. "The 47th Official Report of Chinese Internet Development [第47次中国互联网发展报告]." April, 2021. https://www.cnnic.com.cn/IDR/ReportDownloads/202104/P020210420557302172744.pdf.

Curtin, Michael. 2012. "Chinese Media and Globalization." *Chinese Journal of Communication* 5 (1): 1–9.

Curtin, Michael, and Li, Yongli. 2018. "iQiyi: China's Internet Tigers Take Television." In *From Networks to Netflix: A Guide to Changing Channels*, edited by Derek Johnson, 343–53. New York: Routledge.

Davies, Gloria. 2007. "Habermas in China: Theory as Catalyst." *The China Journal* 57 (January): 61–85.

Ellis, John. 2012. *Documentary: Witness and Self-Revelation*. Abingdon: Routledge.

Fung, Y.H. Anthony. 2008. *Global Capital, Local Culture: Transnational Media Corporations in China*. New York: Peter Lang.

Grierson, John. 1971. *Grierson on Documentary*. Oakland: University of California Press.

Habermas, Jurgen. 1989. *The Structural Transformation of the Public Sphere: An Inquiry into a Category of Bourgeois Society*. Cambridge: Polity Press.

International Federation of Journalists. 2021. "China: Authorities Ban Self-Publishing by Journalists and Censor Online Content." January 28, 2021. https://www.ifj.org/media-centre/news/detail/category/press-releases/article/china-authorities-ban-self-publishing-by-journalists-and-censor-online-content.html.

Johnson, Catherine. 2019. *Online TV*. London: Routledge.

Keane, Michael. 2001. "Broadcasting Policy, Creative Compliance and the Myth of Civil Society in China." *Media, Culture & Society* 23 (6): 783–798.

Keane, Michael. 2015. *The Chinese Television Industry*. London: BFI.

Shambaugh, David. 2016. *China's Future*. Cambridge: Polity.

Sina Tech. 2021. "Tencent's Fourth-Quarter Net Profit of 59.3 Billion Yuan, Increased by 175% Year-on-Year [腾讯2020第四季度净利润593亿元同比增长175%]." March 24, 2021. https://finance.sina.com.cn/tech/2021-03-24/doc-ikknscsko717487.shtml.

Sohu Entertainment. 2006. "Audience Demand on Zhu Jun to Stop Teaching People [艺术人生策划人回应"朱军下课"呼声]." February 21, 2006. https://yule.sohu.com /20060221/n227768285.shtml.

Tencent Video. 2018. "In Conversation with Strangers Special Season Tabooed [和陌生人说话–不可说特辑]." https://v.qq.com/detail/7/79600.html.

van Dijck, José. 2013. *The Culture of Connectivity: A Critical History of Social Media*. Oxford: Oxford University Press.

Viviani, Margherita. 2014. "Chinese Independent Documentary Films: Alternative Media, Public Spheres and the Emergence of the Citizen Activist." *Asian Studies Review* 38 (1): 107–23.

Wang, Wilfred Yang, and Lobato, Ramon. 2019. "Chinese Video Streaming Services in the Context of Global Platform Studies." *Chinese Journal of Communication* 12 (3): 356–71.

Zeng, Yuli. 2019. "Only Three Days: Jiang's Version of *13 Invites* [仅三天可见: 姜思达版十三邀]." *The Paper*, November 6, 2019. https://www.thepaper.cn/newsDetail _forward_4877934.

Zhong, Yong. 2004. "CCTV *Dialogue* = Speaking + Listening: A Case Analysis of a Prestigious CCTV Talk Show Series Dialogue." *Media, Culture & Society* 26 (6): 821–840.

12

Long Live the Rainbow Nation?

How Showmax and Netflix Originals Narrate Cultural Diversity in South Africa

COLLEN CHAMBWERA

The onset of democracy in South Africa in 1994 led the country to adopt the moniker "rainbow nation" as a reference to the national aspiration towards coexistence and harmony among all races and cultures. The metaphor is attributed to Archbishop Desmond Tutu, who used the term as chair of a post-apartheid Truth and Reconciliation Commission to imagine the new integrated South Africa where the diverse cultures and races of South Africa live harmoniously together (Baines 1998; Møller, Dickow, and Harris 1999).

The aspiration of "rainbowism" has since come under scrutiny as racial tensions flare and racism has proven difficult to surmount, but the metaphor nonetheless served to shape the structure and content of post-apartheid South African broadcasting. For example, many television productions that aired on traditional advertising-supported television channels embraced the rainbow ideal. Part of what forms ideas of a rainbow nation is the multiplicity of languages in South Africa; with eleven official languages, there is a sense of pride in how all these languages are able to coexist. The public broadcaster, South African Broadcasting Corporation (SABC), modeled its public service television channels to cater to different linguistic and cultural groups; SABC1 largely broadcasts in English and Nguni languages, and SABC2 broadcasts mostly in Afrikaans and English with some Venda and Tsonga, while its commercial channel, SABC3, uses almost entirely English. Similarly, Multichoice, a

subscription satellite television provider operating across sub-Saharan Africa, followed the same strategy, with its Mzansi channels targeting Black viewers and its Kyknet channels catering to Afrikaans-speaking groups. Furthermore, productions have tended to have casts that reflect the cultural diversity of the country. Different cultures and languages coexist in many television productions and include appropriate subtitles for South Africa's multilingual population. Storylines often depict a new South Africa where all its peoples live side by side, although such narratives remain more aspirational than realistic. This is not to say that storylines fail to reflect contemporary tension; however, depiction of ongoing tension has often served to demonstrate that the rainbow nation remains a work in progress, with different races and cultures resolving their differences progressively.

The recent explosion of subscription video-on-demand (SVOD) services from global players such as Netflix, Prime Video, AppleTV+, and Disney+ has reanimated discussions of representation in South Africa and brought a transnational focus to television drama production (Lotz 2021). Netflix launched in South Africa in 2016 and released its first original series in the country, *Queen Sono*, in 2020. Its main competitor in South Africa is Showmax, a service launched by Multichoice in 2015.

When Netflix ventured into original productions in Africa, it sought to bring "African stories to a global audience," according to its Chief Content Officer Ted Sarandos (Vourlias 2020). At the launch of *Queen Sono*, Netflix's head of African originals, Dorothy Ghettuba, stated that they were excited "to be reaffirmed that we have stories to tell" and that "we are telling local stories by local storytellers from the inside-out" (*City Press* 2020). In contrast, Showmax senior executive Yolisa Phahle explains that Showmax produces stories by Africans primarily for African audiences: "For us, it really is about getting the local entertainment which we know African audiences enjoy, programming in their languages, stories reflecting their realities, their hopes and their dreams" (Mohammed 2021). However, Showmax also has a diasporic strategy: it is available in approximately thirty countries across Europe, the Caribbean, and Australasia, and caters

to African migrants and workers living in these countries. Despite the differences in strategy, the two services still offer the usual international content from established studios. One of Showmax's selling points is "Watch the best of HBO online." Thus, the services offer both overlapping and distinctive value propositions to prospective subscribers.

While the two services compete for market share, they also compete— more subtly—for cultural impact. These two things cannot be easily separated. The competition for subscribers led the two services to produce original content that appeals to their intended subscribers. Both have produced a number of original series. It is undeniable that the stories in these original productions help "provide the symbols, myths, and resources which help constitute a common culture for the majority of individuals" who consume them (Kellner 1995, 1). Thus, an analysis of leading South African SVOD services must interrogate how the nature of storytelling is informed by the audiences they address. In particular, this study examines how Netflix and Showmax construct the idea of South Africa as the rainbow nation.

At the time of writing, there were two original series in the Showmax library: *Tali's Wedding Diary* and *The Girl from St. Agnes*. For comparison, two original series from Netflix are also considered: *Queen Sono* and *Blood and Water*. Showmax's *Tali's Wedding Diary* is a mockumentary that features Tali, a girl who grew up in Johannesburg and moved to Cape Town and is obsessed with the idea of having a perfect wedding with her partner Darren. The story follows the hilarious unintended consequences of Tali's obsession and how Darren, negotiating a struggling property business, handles Tali's obsession. *The Girl from St. Agnes* is a mystery drama series that follows a drama teacher, Kate Ballard, at a private boarding high school as she tries to figure out how a popular student died on the school premises. Netflix's *Queen Sono* features a highly trained South African spy, Queen Sono, as she takes on a powerful criminal network. Queen Sono is the daughter of late anti-apartheid icon Safiya Sono, and she negotiates the demands and complications of her job while dealing with her own trauma that emanates from the death of her mother. Meanwhile, Netflix's

Blood and Water is a teen drama series about Puleng Kumalo, who after a chance encounter at a party, tries to prove that a star swimmer at an elite high school, Fikile Bhele, is her long-missing sister.

The chapter uses narrative analysis to compare how the two services approach South Africa's diversity and the idea of a rainbow nation. Both services also license locally produced titles, but this study focuses only on original productions. The series selected are among the earliest originals and help reveal the initial approach of the two services, though their early strategies may prove inconsistent with later commissions.

Imagining the Post-Apartheid Nation

The media play a significant role in how specific communities imagine themselves (Anderson 2006). Anderson (2006, 6) defines a nation as "an imagined political community," and such a concept suggests why the rainbow nation metaphor was popular in South Africa, especially in the aftermath of apartheid. It became a rallying point for the unification of races and cultures that had lived divided during apartheid. Anderson (2006, 6) explains that nationhood is "imagined because the members of even the smallest nation will never know most of their fellow-members, meet them, or even hear of them, yet in the minds of each lives the image of their communion." Thus, South Africans of all races and cultures took to the possibility of an imagined rainbow nation where the past would give way to a future characterized by unity and prosperity. It was an appropriate metaphor for people who were aware of their racial and cultural differences but saw the possibility of thriving in diversity.

The idea of a nation as an imagined community is also taken up by Bhabha (1990), who argues that narratives of the nation, just like the nation itself, evolve over time and remain only present in imaginations. This explains the process through which the idea of South Africa as a rainbow nation has come under immense scrutiny. The idea of a nation is marked by ambivalence between "the language of those who write of it and the lives of those who live it" (Bhabha 1990, 1). Thus, while the idea

of the rainbow nation still resonates with some politicians, it seems to have become utopian impossibility in the experience of those who live it; these contradictions between ideals and reality often emerge in media, especially digital services.

Culture industries play a key role in the construction of a nation (Cann 2013), especially through their ability to advance ideas of sameness and "us" versus "them" identities (Costelloe 2014). Through its ability to permeate our everyday lives, television has the power to build our ideas of ourselves (Edensor 2002). Local programming is especially good at enabling imaginations of a nation due to cultural proximity. This is because audiences tend to gravitate towards domestically produced content with local languages as opposed to imported programming (Eriksen 2007; Moran 2009). Since language constitutes a large part of the everyday, the media play a significant role in representing such languages as a key aspect of a nation's identity (Silverstone 1994; Kellner 1995).

As traditional media lose their dominance over message circulation, digital media have gained significant influence. Individuals are increasingly looking to cyberspace for the (re)negotiation of their identities (Nakamura 2008; Szulc 2017). The internet has become "another archive, mirror and laboratory for the negotiation of national and ethnic identity" (Diamandaki 2003, 4). This includes SVOD services that have become key players in recent years as consumption habits change. Szulc (2017) argues that there is need to rethink the relationship between nations, nationalism, and the media due to transformations that have happened in the media space. It is therefore necessary to interrogate how new forms of media such as SVOD services articulate key ideas of the nation such as South Africa's rainbow nation status. The dominant SVOD services have ventured into original productions, allowing some form of control over their content. While there have been arguments that multinational SVODs commission content with a global rather than local appeal, this has been disputed by some who argue that SVODs still make culturally specific content (Doyle, Paterson, and Barr 2021). Through commissions and co-commissions, SVODs such as Netflix and

Showmax can exercise some creative control and stamp their identity and strategic aims on productions (Lotz 2021).

The Many Colors of the Rainbow

Netflix and Showmax approach the issue of cultural diversity differently. In its first two original series from South Africa, Netflix attends to the racial and cultural diversity of the country. The country is majority Black, and this is apparent in *Queen Sono*. Most of the actors who play significant roles are Black including the main actress Pearl Thusi who plays Queen Sono. There is fair representation of White, Indian, and mixed-race (colored) characters in the series. For example, the main villain in the story, Ekaterina, is White, and one of the vice president's security team, Ulrich, is Indian. The same is evident in *Blood and Water*. The main character, Puleng, is Black but there is fair representation of other races as well who play significant roles. For example, the party where Puleng first meets Fikile was hosted by Chris, who is White and plays a significant role throughout the story. Puleng also made a colored friend, Wade, at the same party.

In contrast, the two Showmax series approach race from an almost apartheid-era angle. Under apartheid, Whites—despite being in the minority—were the "significant" race in South Africa. In similar fashion, these two series are led by White characters: Tali in *Tali's Wedding Diary* and Kate in *The Girl from St. Agnes*. While other races (particularly Blacks) are not entirely absent, they appear mostly as extras or as peripheral characters. In *The Girl from St. Agnes*, characters such as Moipone (one of the students) and Kgalala (a lawyer) play small but significant roles in the context of race relations in South Africa. They both challenge racist tendencies by students and staff at St. Agnes.

Showmax's decision to downplay race in its first two originals can be explained by both its history and its regulatory environment. As Teer-Tomaselli, Tomaselli, and Dludla (2019) note, MultiChoice's parent company, Naspers, received support from the apartheid regime and

was consequently a supporter of the regime.[1] After 1994, Naspers worked to be more representative of a democratic South Africa and professed to be moving from exclusive nationalism to inclusive nationalism (Teer-Tomaselli, Tomaselli, and Dludla 2019). This led to efforts to be more inclusive in its DStv content by creating channels such as Mzansi Magic and Mzansi Wethu, whose key target audience is the country's majority Black population. Furthermore, conditions of its license in South Africa require Multichoice to be more representative in its local programming. However, some producers reportedly criticized this "politically correct" approach on the grounds that it constrained their creative freedom (Chambwera 2021).

Showmax is internet-distributed and therefore not subject to the same regulatory oversight as satellite channels or broadcasters. Unshackled from regulatory demands, Showmax was given the freedom to pay little attention to the nation building project. *Tali's Wedding Diary* is therefore a story that might be understood as taking advantage of creative freedom rather than contributing to the effort to acknowledge the rainbow nation. Netflix's approach may also be tied to strategy. Starting off with original productions that are more racially representative could potentially draw more subscribers, not only in South Africa but across sub-Saharan Africa. This is further evidenced in that *Queen Sono* was shot in locations across Africa including Zanzibar, Nairobi, and Harare. There is therefore a convergence of the quest for subscribers and ideas of the rainbow nation.

The rainbow nation envisioned by Archbishop Desmond Tutu and Nelson Mandela was diverse, not only in terms of race but culture as well, including language. The first two original series from Netflix made an effort to include multilingual dialogue. This helps to capture the language diversity in a country that has so many official languages. Naturally, English dominates dialogue, perhaps due to the targeted international market as well as it being the common language spoken among all communities in South Africa. Non-English dialogue is used with English subtitles. In *Queen Sono*, isiZulu, Afrikaans, and Setswana

are used. For example, Mazet, Queen Sono's grandmother, speaks in isi-Zulu often though she is well conversant in English. This is also the case in *Blood and Water* in some conversations, for example, between friends Puleng and Zama. In contrast, Showmax's series feature very limited use of local languages. Afrikaans is the language spoken most often in *Tali's Wedding Diary* apart from English; in *The Girl from St. Agnes* there is only a little isiZulu spoken.

Cyberspace has become a mirror and laboratory for the negotiation of national and ethnic identity (Diamandaki 2003; Nakamura 2008). Inclusion and exclusion or near exclusion of different languages and ethnicities in some of the first original productions commissioned by the two major streaming services can provide a mirror into how different races and ethnic groups imagine their presence in or absence from the rainbow nation. As argued by Benedict Anderson (2006), the media play a significant role in how specific communities imagine themselves. Where different languages and ethnicities are included, they are more likely to imagine themselves as part of a rainbow nation. Netflix, in two of its first original series in South Africa, provided a platform for positive imagination of the rainbow—in the sense that all languages and ethnicities are equally significant. Audiences could see a reflection of themselves in the languages spoken in the series. Thus, the rainbow nation could be viewed as still alive, at least in films produced in South Africa but available to international audiences. A sense of pride was possible.

In contrast, Showmax provided a platform for imagination of a rainbow nation still marked by White privilege and peripheral representation of people of color. This makes business sense for Multichoice because Showmax was primarily targeted at African audiences, but more importantly its most profitable market, South Africa. Due to limited internet access, Showmax is available to South Africa's mostly White middle and upper classes. These audiences could relate with the dominant languages and ethnicities represented in the two series. This is also a group that has lately been accused of being insincere to the rainbow nation idea as they seek to maintain their privilege.

South Africa is ranked as one of the most unequal societies in the world (The World Bank 2021), a reality that ties not only to race, but also to class status. Class difference is problematized in the first two original series from Netflix. In *Blood and Water* Puleng first experiences a vastly different world from her own when she accompanies her friend Zama to a party in a rich neighborhood. The difference between her own circumstances and the rich world is further highlighted when she moves to Parkhurst High School, for students from wealthy families. While Puleng's family is not necessarily poor, the upper-class world she experiences at her new school is far from her lower-middle-class world. In *Queen Sono* the cause of the Wetu Wema group that bring conflict is partly to address the class differences that they believe have not been tackled by politicians since the end of apartheid. In one conversation between Queen Sono and her grandmother, Mazet laments how graves in the poor areas are neglected. She says, "Just look at this. They don't look after our grave areas. But if you go to the White areas, everything is neat." It is a reference to how those privileged during apartheid have continued to enjoy privilege while previously disadvantaged groups continue to suffer neglect.

For Showmax, class difference is discussed more in *The Girl from St. Agnes* than in *Tali's Wedding Diary*. In *The Girl from St. Agnes*, the school is dominated by children from well-to-do families. The lack of a sense of belonging among Black girls in the school is a result of both racial and class differences. In one conversation between Moipone and Kholwa, both Black students, Moipone, referring to Whites, says, "We are the rats, and they eat us for dinner." However, there is an attempt to demystify class differences based on race. One of the key characters, Jenna, is part of what Moipone calls the "Pure White Girls" group but comes from poverty, and she is only in the school because she got a scholarship. She suffers from panic attacks, demonstrating the pressure to perform well in school to maintain her scholarship.

Acknowledging that addressing inequalities in the rainbow nation is a work in progress is crucial to the imagination of the nation. By tell-

ing stories of inequalities in South African societies, both Netflix and Showmax demonstrate the need to acknowledge that the situation is not ideal. The two services commissioned original series that, in varying degrees, demonstrate the two nations spoken about by Thabo Mbeki. For Netflix, class struggle is evident in both *Queen Sono* and *Blood and Water*. For Showmax, there is more of the nation dominated by "White and relatively prosperous individuals." This tendency is more noticeable in *Tali's Wedding Diary* than in *The Girl from St. Agnes*, where some effort is made to highlight the inequalities. By commissioning productions that highlight the continued race and class inequalities, both Netflix and Showmax demonstrate the view that digital services are not only commissioning content that is globally relevant but culturally specific as well (Doyle, Paterson, and Barr 2021). However, Netflix is more explicit in highlighting South Africa's unequal society than Showmax. *Tali's Wedding Diary* is a series that could easily have been set in a high-income European country.

Narrating the Legacies of Apartheid

Albeit to varying degrees, both Netflix and Showmax tell the story of a rainbow nation troubled by the legacy of apartheid. In recent times there has been discussion, especially from the opposition Economic Freedom Fighters (EFF) party, that post-apartheid reconciliation benefited those who committed atrocities during apartheid more than those who suffered. Some have even accused Nelson Mandela of "selling out" the majority Blacks when he negotiated the end of apartheid.

For Netflix, the legacy of apartheid in the rainbow nation is explored in both *Queen Sono* and *Blood and Water*. In *Queen Sono*, the impending release on medical parole of an apartheid agent named Hendrikus, who was imprisoned for the assassination of anti-apartheid activist Safiya Sono, is met with dismay from Black people in the story. Mazet, speaking to her granddaughter Queen Sono, remarks that "if they grant that racist criminal parole, bad things will happen to this country." Queen Sono

takes the law into her hands by killing Hendrikus before he is released from prison. Furthermore, Black women speaking on a bus highlight that the rainbow nation is not working, as many Blacks are still suffering. In *Blood and Water* political tension is demonstrated through activism by Wendy Dlamini, whose mother is a government minister. In Puleng's first class at Parkhurst High School, Wendy and her history teacher engage in the following dialogue:

WENDY: While I find this rehashing of *Schindler's List* riveting, if the department insists on teaching us White male domination in ancient wars, wouldn't it be more enlightening to us as students of the continent if we studied Darwin's impact on historical events closer to home?

TEACHER: The holocaust affected many people, Miss Shlamini.

WENDY: Of course, but we've had our own horror stories with relics such as Leopold, who murdered millions of Africans but is never discussed . . . What about the ten million people in the DRC that King Leopold killed? [After some interruption, Wendy is undeterred and continues] . . . As I was saying, by discussing African history, perhaps more specifically the influence Darwin's theory had on the apartheid regime, maybe we as South Africans can better understand and address the systems governing our country today.

In his forthcoming book *Apartheid Studies, a Manifesto*, Nyasha Mboti asks why there are holocaust studies and yet no apartheid studies. He raises a similar argument to Wendy's in the above dialogue. There seems to be a lack of interest in highlighting the atrocities committed during apartheid while similar atrocities in the West are discussed. The lack of interest in the class, as demonstrated by students engaging in other conversations while Wendy is speaking, serves to highlight how little importance is placed upon conversations that unsettle those who benefited from apartheid.

Through the character of Wendy in *Blood and Water*, Netflix highlights contemporary fissures in the rainbow. The current political dis-

course is characterized by discontent from mainly Black South Africans who argue that the end of apartheid did not result in any meaningful change in their circumstances. They are disillusioned by the continued high levels of poverty particularly in previously marginalized areas. The opposition EFF party became popular in a short period of time largely by highlighting issues of continued economic domination by those who benefitted from apartheid. They call it White monopoly capital. Their message also seems to resonate with the young as evidenced by their domination of student representative councils (SRCs) in a majority of universities in the country.

For Showmax, post-apartheid conflict is discussed only in *The Girl from St. Agnes* and demonstrated in the feud between Gary, an influential teacher, and Kgalala. Gary's status results from his financial support to the school, and he is portrayed as a corrupt and unrepentant White racist who gets his way. Kgalala, a Black lawyer who sits on the school's governance board, challenges Gary's racist ways. The two engage in a verbal altercation during the memorial service for a student who dies (Lexi), and their argument makes national news. Gary is widely condemned for his views, highlighting how such behavior is no longer tolerated. Eventually Gary and Kgalala get to sit down. Exposed and at a disadvantage, Gary is arm-twisted into issuing an apology and attending diversity classes. Additionally, a conversation between Gary and a police officer, Marius, touches on some prominent cases of racist behavior exhibited in the recent past: the cases of Vicky Momberg and Adam Catzavalos are referenced to illustrate the persistent legacy of apartheid.[2]

The tension between Moipone and her group of friends (Blacks) and Lexi and her group (Whites) demonstrates the hollow dream of "rainbowness" as racial tension remains high among both young and old. However, *The Girl from St. Agnes* offers a glimpse of hope. The secret friendship between Moipone and Lexi and the subsequent secret mourning by Moipone, suggest that while racial integration in post-apartheid South Africa is still complicated, it is possible for Blacks and Whites to get along. Showmax thus demonstrates an awareness of not

only post-apartheid racial tension in *The Girl from St. Agnes*, but also the possibility of overcoming this tension regardless of the challenges.

Both Netflix and Showmax tell the story of a rainbow dream that is receding. The promise of a rainbow seems more utopian by the day as the legacy of apartheid (racism), threats of "spontaneous" redistribution of resources (land occupations, expropriation without compensation, and reverse racism), and governance shortcomings (corruption), combine to produce a toxic brew of intolerance. Mofu (2020, 66) argues that "these challenges reflect everything that goes against rainbow idealism." Leonard (2019) contends that despite the abolition of racial segregation as apartheid ended, racialized zones are still evident economically, socially, and spatially. Both Netflix and Showmax tackle these issues and highlight that the rainbow nation is an idea yet to fully materialize.

Conclusion

This chapter sought to analyze how two services, U.S.-based Netflix and South Africa's Showmax, approach the idea of the rainbow nation in their original content commissions. Unlike previous discourses in which Western media were found to often misrepresent African issues, Netflix tends to espouse the idea of a rainbow nation. In contrast, Showmax tends to downplay the rainbow nation idea. This can be explained by the differences in how the two services have established themselves in South Africa. Netflix entered the market without the baggage of national history. It came without any responsibility to be a platform for nation-building. Showmax, on the other hand, is owned by Multichoice, whose parent company, Naspers, benefited historically from apartheid-era policies. Later, it was required both legally and morally to promote nation-building. Since Showmax is internet-distributed, it is free from the legal requirements that so far apply to traditional media. Unshackled from these requirements, Showmax has the liberty to take risks with its moral responsibilities.

In addition, the two series from each service underline the difference in their audience focus. Netflix takes a more international approach

while Showmax's productions are targeted more at South African sub-scribers. Netflix acknowledges the idea of South Africa as a rainbow nation by demonstrating diversity in cast and storylines, as well as setting. *Queen Sono*'s primary locations are in South Africa although it includes other locations across Africa. The cast is predominantly South African to appeal to Netflix's South African subscribers. The cast is further diverse in terms of race and cultures, thus embracing the idea of the rainbow nation. The story explores the legacies of apartheid in a way that resonates with South African audiences. Some of the storylines include the little-resolved racial prejudices, and corruption among the country's leaders. Despite the South African focus, the story is still made to appeal to international audiences as a spy thriller. It is an imitation of a James Bond movie, only with a female lead. *Blood and Water* highlights the challenges of living up to the idea of a rainbow nation as inequalities widen. This is a story that resonates with South African audiences but also is told in a way that appeals to an international audience by recalling series like *Gossip Girl*. Meanwhile, Showmax betrays its focus on wealthy and middle-class South African audiences in *Tali's Wedding Diary*, which is almost a rebellion against the idea of a rainbow nation as the cast is all White in a country that is majority Black. Likewise, *The Girl from St. Agnes* has a predominantly White cast, with a few roles for Black actors.

The storylines for both series Showmax series are relevant for middle-class and wealthy audiences in the country. These are the audiences that Multichoice, owner of Showmax, targets. Showmax comes free on DStv's premium subscription, priced from R934 (about USD$60). While it is cheaper than Netflix as a stand-alone service at R99 (about USD$6.50 at current exchange rates), many South Africans do not have access to unlimited Wi-Fi. Showmax, like all SVOD services that require internet connection, remains mostly affordable to middle-class and wealthy individuals. Thus, Showmax could take a moral risk in the knowledge that a story such as *Tali's Wedding Diary* could be well received at least by its White audience, which constitutes a good percentage of the middle-class to wealthy individuals in the country. *The Girl from St. Agnes*, set at an

elite private boarding high school with majority White students, could also resonate with the same audience.

As this analysis suggests, creative freedom unburdened from the moral responsibility of fostering nation-building enabled Netflix and Showmax to follow different strategies and ultimately offer different takes on the idea of a rainbow nation. Notably, Netflix's support for this idea, and its preference to commission stories appealing to both South African and international audiences, stands in contrast to Showmax's tendency to largely ignore the idea while appealing to elite South African audiences.

Notes

1 MultiChoice was part of Naspers until February 2019, when MultiChoice was listed separately on the Johannesburg Stock Exchange to unlock shareholder value.
2 Vikki Momberg was imprisoned in 2018 for a racist rant towards a police officer that was caught on video. She used the word *kaffir* (often simply referred to as the k-word) forty-eight times as she ranted and expressed that she hated all Black people. The k-word has its roots in apartheid South Africa and is extremely offensive to Black people in the country. Adam Catzavalos was recorded on video on a Greek island expressing his joy that there were no Black people in sight. He used the k-word as well.

References

Anderson, Benedict. 2006. *Imagined Communities: Reflections on the Origin and Spread of Nationalism*. London: Verso.

Baines, Gary. 1998. "The Rainbow Nation? Identity and Nation Building in Post-Apartheid South Africa." *Mots pluriels* 7:1–10.

Bhabha, Homi K. 1990. "Introduction: Narrating the Nation." In *Nation and Narration*, edited by Homi K. Bhabha, 1–7. London: Routledge.

Cann, Victoria. 2013. "Constructing the Nation in Reality TV: A Comparative Study." *Continuum* 27 (5): 729–39.

Chambwera, Collen. 2021. "Understanding Netflix's Foray into Original Productions in South Africa: A 'Jet Plane' and 'Helicopter' View." In *Television in Africa in the Digital Age*, edited by Gilbert Motsaathebe and Sarah H. Chiumbu, 39–57. Cham: Palgrave Macmillan.

City Press. 2020. "Netflix Strengthens Its Strategic Investments in South Africa." January 22, 2020. https://www.news24.com/citypress/business/netflix-strengthens-its-strategic -investments-in-south-africa-20200122.

Costelloe, Laura. 2014. "Discourses of Sameness: Expressions of Nationalism in Newspaper Discourse on French Urban Violence in 2005." *Discourse & Society* 25 (3): 315–40.

Diamandaki, Katerina. 2003. "Virtual Ethnicity and Digital Diasporas: Identity Construction in Cyberspace." *Global Media Journal* 2 (2): 1–14.

Doyle, Gillian, Richard Paterson, and Kenneth Barr. 2021. *Television Production in Transition: Independence, Scale, Sustainability and the Digital Challenge.* Cham: Springer Nature.

Edensor, Tim. 2002. *National Identity, Popular Culture and Everyday Life.* Oxford: Berg.

Eriksen, Thomas Hylland. 2007. "Nationalism and the Internet." *Nations and Nationalism* 13 (1): 1–17.

Kellner, Douglas. 1995. *Cultural Studies, Identity and Politics between the Modern and the Post-Modern.* London: Routledge.

Leonard, Pauline. 2019. "Reimagining Racism: Understanding the Whiteness and Nationhood Strategies of British-Born South Africans." *Identities* 26 (5): 579–94.

Lotz, Amanda. D. 2021. "In between the Global and the Local: Mapping the Geographies of Netflix as a Multinational Service." *International Journal of Cultural Studies* 24 (2): 195–215.

Mboti, Nyasha. Forthcoming. *Closing the Loophole: Apartheid Studies.* Trenton: Africa World Press.

Mofu, Buhle. 2020. "South Africa: Re-Imagining the Rainbow Nation." *Sociology International Journal* 4 (3): 67–68.

Mohammed, Omar. 2021. "MultiChoice's Showmax Invests in African Content for Growth." *Reuters*, April 27, 2021. https://www.reuters.com/world/africa /multichoices-showmax-invests-african-content-growth-2021-04-27/.

Møller, Valerie, Helga Dickow, and Mari Harris. 1999. "South Africa's 'Rainbow People,' National Pride and Happiness." *Social Indicators Research* 47 (3): 245–80.

Moran, Albert. 2009. "Reasserting the National? Program Formats, International Television and Domestic Culture." In *Television Studies After TV: Understanding Television in the Post-Broadcast Era*, edited by Graeme Turner and Jinna Tay, 149–58. London: Routledge.

Nakamura, Lisa. 2008. *Digitizing Race: Visual Cultures of the Internet.* Minneapolis: University of Minnesota Press.

Silverstone, Roger. 1994. *Television and Everyday Life.* London: Routledge.

Szulc, Lukasz. 2017. "Banal Nationalism in the Internet Age: Rethinking the Relationship between Nations, Nationalisms and the Media." In *Everyday Nationhood*, edited by Michael Skey and Marco Antonsich, 53–74. London: Palgrave Macmillan.

Teer-Tomaselli, Ruth, Keyan Tomaselli, and Mpumelelo Dludla. 2019. "Peripheral Capital Goes Global: Naspers, Globalization and Global Media Contraflow." *Media, Culture & Society* 41 (8): 1142–59.

Vourlias, Christopher. 2020. "Netflix's Head of African Originals Lays Out Streamer's Plans for the Continent." *Variety*, February 28, 2020. https://variety.com/2020/digital/news/netflix-head-african-originals-lays-out-plans-for-continent-1203518648/.

World Bank, The. 2021. "The World Bank in South Africa." October 5, 2021. https://www.worldbank.org/en/country/southafrica/overview#1.

13

The Return of Indigenismo in Netflix Mexico

JUAN LLAMAS-RODRÍGUEZ

Indigenous presence in mainstream Mexican television has long been characterized by exclusion and misrepresentation. The popular telenovelas produced by the country's monopoly network Televisa in the 1980s and 1990s frequently relegated indigenous characters to the role of housemaid or farm worker, and the actors portraying these characters were rarely indigenous themselves. In particular, if the purportedly indigenous character was the telenovela protagonist meant to rise in class status by the end of the narrative, the role would be played by a White celebrity within Televisa's star roster (Rios 2015). The lack of indigenous writers, actors, and producers also meant that these characters were often poorly conceived stereotypes: shy, socially awkward rubes who spoke broken Spanish (Muñiz et al 2013). Popular television thus contributed to the longstanding state-building project of Mexican *indigenismo*, a national ideology that celebrates the country's indigenous past by incorporating indigenous culture while excluding the surviving indigenous populations from the body politic. Televisual representations of indigenous peoples in the late twentieth century aligned with the nation-building projects that characterized Mexico in the late nineteenth and early twentieth centuries: an emphasis on the modernity of the country with an eye towards European and North American acceptability; a distinct desire to appeal to the cosmopolitan publics of the world; and the mobilization of "tradition," metonymized by indigenous symbols, as a token of difference for global appeal. The Mexican elite's exaltation of the country's indigenous past, without including surviving indigenous communities, and the increasing Whitening of national identity marked

the entrance of Mexico to global modernity throughout the twentieth century. Legacy television networks broadcast this entrance.

Fast forward two decades into the twenty-first century to a different media landscape characterized by active social media engagement, the adoption of video technologies by indigenous activist movements (Wortham 2004), and increasing competition to Televisa from foreign-owned content providers. Netflix's entry into the country in 2015 and its rapid growth over the next five years were central to this expanding competitive field. As Mexico became a cornerstone market for Netflix, the platform announced plans in 2019 to launch fifty new original productions based out of the country and announced the relocation of its regional offices to Mexico City in 2021 (Shaw 2020). The opportunity Netflix sees in Mexico as a hub for continental production is likewise an opportunity for the country's media creators to fashion a national image on the global stage. At a press conference in Mexico City for the Netflix original show *Monarca* (2019–2021), producer Salma Hayek explained her vision of the show as an opportunity to portray the country as "cosmopolitan, vibrant, interesting, culinary . . . [as well as] a rich, vast province with traditions, mystery, beauty" (EFE 2019). Hayek's productorial vision for *Monarca* as a mix of tradition and cosmopolitanism, vibrant cities and beautiful provinces, recalls the long history of Mexican elites drawing on the country's precolonial and postcolonial pasts as a selling point for the country's modern appeal.

In this chapter, I argue that little has changed in the discursive and ideological maneuvers used to fashion Mexico's international image. Through its popular cultural productions, the Mexican elite classes continue to celebrate indigenismo as a form of difference while foregrounding and aspiring towards a global form of Whiteness. At the same time, the Mexican original productions commissioned by Netflix illustrate how this ideological maneuver now intersects with another popular creative move: drawing on the country's recent past for narrative inspiration. This creative strategy has been central to the slate of Netflix original productions, from narco-themed fictional retellings like

Narcos: Mexico (2018–2021) and *Somos* (2021); to various seasons of the anthology series *Historia de un crimen* (2019–2020); and documentary fare like *1994* (2019) and *Las tres muertes de marisela escobedo* (2020). While legacy networks Televisa and TV Azteca have produced politically themed television content before, they often only tangentially allude to the real-life referents. Netflix's separation from the established corporate media powerhouses in Mexico has allowed its producers to address more explicitly specific historical events and well-known politicians' lives in the platform's original productions.

The two original series discussed in this chapter—*Luis Miguel: La serie* (2018–2021) and *Ingobernable* (2019–)—likewise reference events and figures that captured the public's attention in the two decades before and after the turn of the twenty-first century. Whether promoted as biographical, as in the case of *Luis Miguel*, or fictionalized, as in the case of *Ingobernable*, these popular historical references drive the narrative of each show. Drawing on the nation's recent past for narrative inspiration is not an entirely new concept, and in fact is something that we see in other national markets,[1] but what interests me here is how these creative decisions intersect with older tropes inherited from indigenismo. This strategy illustrates a self-sabotaging approach to the treatment of political topics in streaming narrative storytelling: despite drawing its purported importance from both the nation's indigenous past and the country's recent history, such storytelling often ends up failing to make meaningful connections between how the legacies of the former inform the events of the latter.

Indigenismo and *Blanqueamiento* in Mexican Popular Culture

To discuss the politics of indigeneity in the Mexican context is to contend with the legacy and shifting valences of *mestizaje*, the ideology of racial intermingling first popularized by Mexican philosopher Jose Vasconcelos (1997). Despite its erstwhile influence in Chicana/o thought because of its celebration of the mixing between European colonizers and Indigenous peoples, Vasconcelos's treatise has been rightly criticized

for relying on racist stereotypes and for its aspirational gestures towards Whiteness despite its purported multiculturalism (Juárez 1972, Palacios 2017). Nowadays, the uncritical embrace of mestizaje must be questioned lest it continue "to privilege lighter-skinned people while ignoring the continued oppression of darker-skinned peoples as the dominant culture seeks out the familiar (the Whiteness) within the other" (Bost 2003, 24).

Mestizaje triangulates two key components: *indigenismo* and *blanqueamiento*. Indigenismo acts, on the one hand, as "a search for the creative dimensions of nationalism through the symbolism of an indigenous past" and, on the other hand, as "a social-political-literary symbol that conveys the mood of remorse over the living conditions of contemporary 'acculturated Indians'" (Torres and Whitten 1998, 7). In twentieth-century Mexico, post-revolutionary governments viewed Indigenous peoples simultaneously as "a national problem and a national icon" (Dawson 2004, 143) and attempted to incorporate them into the state's national project of mestizaje. These attempts have been criticized as institutional maneuvers to "de-Indianize" Indigenous peoples by tamping down attempts at self-determination (Batalla 1996). Indigenismo thus allowed the ruling classes to benefit both symbolically from the legacy of the precolonial indigenous past and materially from the contemporary exclusion of native peoples from the affairs of the nation-state. The twin component to indigenismo is blanqueamiento, which translates to "Whitening" and refers to the process of tying one's increasing social acceptability to one's identification as "White" (Torres and Whitten 1998, 8). By privileging Whiteness and tying it to the notion of development, blanqueamiento accepts Europe and the United States as the standards for modernization and blames any failures of the Latin American nation-state's ability to meet those standards on its Black and Indigenous peoples.[2]

I am interested in how these twin ideologies continue to inform the narratives of the original series of Netflix Mexico. Following the Mexican elite's strategies of the early twentieth century, Mexican creatives nowadays embrace the symbolism of the country's indigenous past as a part of the conscious creative decisions shaping current storytelling—

even if this past is often invoked uncritically. The tropes, spaces, and narratives of that indigenous past act as a (creative) reservoir for new media content creators who draw on these features to inject local flair into their narratives of global aspiration.

The dynamic of drawing on indigenous cultures and symbols as a source of creativity for global elite recognition is not pervasive within all of the current Netflix original productions, but it does stand out as a crucial component for some of the platform's most popular content. For example, indigenous responses to the widely acclaimed Netflix original film *Roma* (Alfonso Cuarón, 2018) see it as a "continuation of an imaginary that can only see Indigenous women as the surrogate life force of a still-colonial society that is oblivious to its hubris, and its past, and its ongoing indifference toward the survival of Indigenous women" (Pierce 2018). Indigenous scholar Joseph M. Pierce indicts *Roma* as "a film that both stars an Indigenous woman and harnesses indigeneity to do the work of White supremacy at the same time" (2018).[3] The episodic plots in the series *Monarca* likewise reference indigenous tales and allude to the mysticism of rural southern Mexico yet keep the powerful elite family at the center of the story. The original Netflix series *Las Leyendas* (2017–2019), based on the popular Mexican animated franchise, draws its entire first-season arc from the Aztec mythology surrounding Quetzalcoatl. Although the main characters themselves are not indigenous, the series nonetheless borrows indigenous imagery to introduce the characters' world and even re-imagines Quetzalcoatl's story to fit the series' global scope, positioning him as a vengeful god that pushes the heroes to travel the world engaging other mythical creatures in order to come back and defeat him.

Here I focus on two other examples of how the country's indigenous past continues to be invoked and set aside in popular Netflix content that addresses a dual local and global audience. First, in *Luis Miguel: La serie*, the appearance of the "wise Indian" trope as a stand-alone fabrication in the otherwise ostensibly faithful biopic series reveals the endurance of Indigenous characters as a reservoir to be exploited for narrative

heft. Second, in *Ingobernable*, the narrative relies on the Mexico City neighborhood of Tepito, with its pre- and postcolonial baggage, as a space that escapes the control of the neoliberal state. Analyzing how these tropes operate within each of the shows reveals different facets of the resurgence of indigenismo and blanqueamiento. Such resurgence, I propose, illustrates one strategy creatives turn towards to make nationally specific and globally appealing content within new media platforms.

Television Streaming in the Age of the Fourth Transformation

The persistence of early twentieth-century ideologies of race and nation-building in twenty-first century Mexican productions is not surprising. Noteworthy in their re-emergence in the original productions of Netflix Mexico is that, within these narratives, the dual ideologies of indigenismo and blanqueamiento interact with the mining of the country's recent past for original storylines. The repetitive restaging of collective memory both illustrates creative variations in storytelling conventions at the level of specific productions and affects the broader cultural significance of Netflix original productions for domestic audiences. The sociocultural relevance of the stories drawn from the nation's recent past grants these series a certain heft by covering "quality" topics within serialized narratives, which enables critics and commentators to distinguish the streaming platform's content from the standard telenovela fare of the country's broadcast networks.[4] This creative approach has also allowed Netflix to differentiate itself from its closest competitor in the streaming market, Televisa's Blim, which has shied away from politically relevant topics, opting for original series that replicate its traditional broadcast offerings or American-inspired genre programming.

The political fare in Netflix Mexico's original content interpellates a specific class-based local audience by implicitly reimagining the country's recent history—even though it is hardly past yet. In fact, despite President Andrés Manuel López Obrador's calls in 2018 for a "Fourth

Transformation"—the historical shift that he considered the revolutionary potential of his presidency—the current material conditions of Mexican society belie any talk of a break with the politics of the past. Still, the symbolic destruction of the Institutional Revolutionary Party (PRI), the ruling party during most of the twentieth century, remains significant for what it has meant for the creative output of the country's cultural industries: a series of creative productions that directly address the politics of corruption and public scandals that dominated the PRI decades.[5]

Both *Luis Miguel: La serie* and *Ingobernable* address these scandals. The former is an authorized fictionalized account of the life of Mexican pop superstar Luis Miguel. The show's first season, based on the biography *Luis mi rey* by Javier León Herrera, premiered in April 2018, with a new episode every Sunday until July (Aguilar 2021). The season covers the artist's rise to fame in the late 1980s and the familial drama of his younger years. As I have previously argued (Llamas-Rodríguez 2020b), the weekly episode releases in the run-up to the 2018 presidential election functioned as (class-inflected) national ritual in which audiences could relive their recent history through the eyes of one of the country's most notorious public figures. Further, like other Netflix series about famed politicians and drug traffickers, the show presents audiences with the opportunity to "reconstruct a living legend" since the authorized depictions of significant life events "put an end to the silence and mystery" that have always surrounded the renowned artist (Fariña 2018).

Ingobernable is a political thriller starring Kate del Castillo as the fictional first lady of Mexico, Emilia Urquiza.[6] The fifteen-episode first season premiered in March 2017, followed by a second season in 2018. In the series premiere, the Mexican president is murdered and Emilia becomes the primary suspect. Most of the series' first and second seasons concern her life as a fugitive on the run. While the main narrative centers on the search to find out who murdered the president and framed Emilia, the series incorporates several plot twists that are thinly veiled stories that have been ripped from the headlines, including notorious cases of high-level corruption and instances of collusion between government officials

and drug gangs. As an executive producer of the series, del Castillo has insisted that their aim has been to portray "the real stuff that's going on in Mexico," even if fictionalized (Miller 2017). The show's fictional status is often dubious: the president is heavily stylized as Enrique Peña Nieto, the Mexican president when the show premiered, and the main social issue addressed in the first season recalls the forty-three students disappeared by the Mexican government in Iguala, Guerrero, in 2014.[7] Whether it is by building on the biography of a notorious national figure or by recalling infamous tragedies of the recent past, each of these shows banks on the audience's familiarity and interest in the real-life referents to make sense of, and keep tuning into, the fictional narratives. At the same time, the creative choices employed to represent the country's recent past intermingle with and build on the dual ideologies of indigenismo and blanqueamiento. While combining the two offers an opportunity for political media content to draw attention to how postcolonial legacies continue to shape Mexico's inequalities today, the shows ultimately reduce such concerns to a backdrop for the individualistic narratives of their White, affluent protagonists. The appearance of this narrative strategy in two of Netflix Mexico's most popular original series reveals the appeal and the failure of merging indigenismo tropes with politically relevant content.

Luis Miguel: La serie and the Wise Indian Trope

In episode six of the first season, Luis Miguel shoots a *Top Gun*-inspired music video for his hit song "La Incondicional" at the barracks of the Mexican army. The event was a publicity stunt that benefited the armed forces as much as it did the singer, but the show presents this storyline as a formative turning point for the young protagonist, who learns hard life lessons by doing a three-week basic training with the Mexican military. Notable in this episode is the introduction of the popular character Cadete Tello, an army recruit in charge of supervising the singer dur-

ing basic training (Ignorosa 2018; Noriega 2018). As an entirely fictional construct, Tello's presence obscures the fact that Luis Miguel was trained by a ranking general, not a cadet. According to José Luis Gutiérrez Arias, one of the show's writers, in this case the writing team did not care to "stick to the real-life references, [but instead] find a character who was endearing, young, and full of conviction" (Ortiz 2018). The popular character also ended up being a useful inaccuracy for the narrative. Changing Luis Miguel's contact with the army from a general to a recruit means the new character is more amenable to bending to the singer's wishes and ultimately acts in a way that will advance the lead's narrative arc. Ideologically, this fictional change also ends up further obscuring the involvement of those in power and the intentions underpinning the alliance between the state and the entertainment industries (Villagrán 2018) while using an Indigenous character as the foil for furthering the main character's narrative.

Tello's implied indigeneity stands in contrast to Luis Miguel's famed Whiteness. Born in Puerto Rico to a Spaniard father and an Italian mother, Luis Miguel epitomizes the White aspirations of mestizaje ideology. His nickname "El Sol de México" (the sun of Mexico) aptly describes the Vasconcelian idea of celebrating the country's racial intermingling as long as it tends towards a White cosmopolitan ideal. Meanwhile, Tello is introduced as a young man from Ocosingo, Chiapas, a city best known as one of the strongholds of the Zapatista uprising of 1994 (Diaz 1995).[8] The series briefly acknowledges the contrast between Luis Miguel and Tello in an early scene when, after hearing that Tello is from Ocosingo, Luis Miguel replies, "That's cool." To this, Tello jokingly quips, "What do you know about where I come from?" Despite this acknowledgment, the episode's narrative concerns the characters' evolving affinity for each other and, ultimately, the singer's personal growth.

Tello and Luis Miguel's relationship develops in-between sprints and reps of crunches. While initially failing the physical tasks, Luis Miguel manages to fulfill the minimum requirements for basic training needed

FIGURE 13.1. Cadete Tello's implied indigeneity stands in contrast to Luis Miguel's famed Whiteness. Source: Netflix.

to film his music video in the military field. Tello warms up to the singer, even admitting that his mother is an ardent fan. At the end of the weeks-long training, the two characters become friendly enough that the singer invites the cadet to one of his lavish parties at his mansion. The latter accepts on the condition of being back in the barracks early in the morning, but after drinking too much, Tello is unable to wake up in time for his training and he is immediately suspended from the army.

Throughout the episode, the two characters' interaction brings them to the other's starting point: Luis Miguel learns discipline and hard work while Tello makes irresponsible choices. In the end, Luis Miguel "learns" the real-life consequences of partying too much from Tello's misfortune. Tello, meanwhile, temporarily loses his income and his avenue for social mobility, yet the series spends merely a second on what would be a life-altering moment in this character's life. Instead, the episode neatly wraps up his storyline with a later scene, set in some ambiguous future, wherein Tello arrives at the army quarters to find a gift from Luis Miguel with the card inscription "Thank you for everything you taught me."

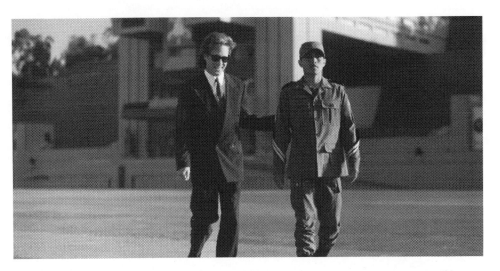

FIGURE 13.2. The episode's odd coupling concludes with each character at the other's starting point: Luis Miguel learns discipline and hard work while Tello makes irresponsible choices. Source: Netflix.

In describing the narrative choices of *Luis Miguel: La serie*, scholar Ariel Gómez Ponce (2019) argues that the show constructs its protagonist through a series of "tests" in which every obstacle yields a new life lesson and every episode presents a new moral message. Such serial structure means that the show's investment in its lead dictates the introduction of new supporting characters. In regard to Cadete Tello, Gómez Ponce notes that, despite his "ephemeral appearance on the show," the character possesses an "ethical force such that will set [Luis Miguel] on the right path" and concludes by stating that Tello recalls "characters of classic fables" (2019, 32.) Ponce rightly notes the fable-like quality of the character in terms of his brief appearance in the narrative and his ultimate function as a cautionary tale for the protagonist. Yet Tello's coding as indigenous mestizo grafts the service, sacrifice, and "unconditional" admiration of the cadet as specifically part of the indigenismo-blanqueamiento dynamic.

The inclusion of Indigenous and other marginalized characters as foils for the White character's journey has a long tradition. As scholar

Richard Rogers notes, "For Westerners looking to compensate for what is lacking in contemporary existence (e.g., physical survival challenges, a close relationship to nature, and spiritual wisdom), the image[s] of Native [male] figures offer a rich resource for appropriation and projection" (2007, 104–5). Wisdom is reflected in the "lessons learned" by the protagonist at the end of the narrative. In the case of *Luis Miguel: La serie*, the progressive serial development of the character through "life lessons," as Ponce argues, means that supporting characters—and particularly episodic characters—pave the way for Luis Miguel's journey of self-improvement by acting as foils through which the main character sees his own failures reflected.

However, such perfunctory roles can end up perpetuating racial stereotypes. Specifically, Cadete Tello epitomizes the role of the "magical or wise Indian," which like the "magical negro" is a common racist trope in media storytelling that casts Black, Brown, or Indigenous supporting characters whose sole purpose is to help the White protagonists see the error of their ways. The magical negro trope situates Black people as "mascots, inspirations, and/or surrogates for the celebration or affirmation of White humanity" (Ikard 2017, 10). In his parting remarks, Tello affirms Luis Miguel's sense of self-worth, a necessary pivot for the protagonist to move forward into the latter half of the season. The series reminds us in Tello's last appearance on-screen that his value was in "everything he taught" the protagonist. Tello's short-lived appearance positions him as a disposable trope in service of the series' lead, yet his character's usefulness also lies in his marginality since his identity marks him as someone "from a different walk of life" than Luis Miguel. Luis Miguel can move forward with a new sense of awareness after seeing his failures refracted in a secondary character, but the character's standing outside of Luis Miguel's sphere means that the lead—and the audience—never has to worry about Tello again.

Indeed, the show is uninterested in examining the singer's privileged position. The series thus replays the dynamic of indigenismo and blan-

queamiento by creating an indigenous character to help further the White protagonist's personal narrative. Through these dual ideologies, the protagonist's personal privilege, tied to his structural position close to power, remains unexamined and thereby reaffirmed. Introducing a fictional indigenous low-ranking cadet into the celebrity's fictional biopic only to disturb that cadet's life in order to extract a moral lesson for the celebrity presents us with one example of restaging the country's recent past that simultaneously reaffirms centuries-long racial dynamics of the nation.

Ingobernable and the Colonial Legacies of Unruly Spaces

Throughout its first season, *Ingobernable* draws on the indigenous symbolism invoked by the urban space that the narrative takes place in, Tepito. From the start, the show uses Emilia's journey on the run to present Mexico simultaneously from both the high echelons of power and the underworld. In the second episode, a fugitive Emilia finds help from the family of Dolores, her children's nanny, in the Mexico City neighborhood of Tepito. Emilia admits that she came to them because she knew "that the police don't come to Tepito." Her closest ally is Canek, Dolores's son whom Emilia once helped get released from jail.[9] Initially, Canek's friends are hesitant to help Emilia out, but Canek arranges a plan for Emilia to leave the city undetected through underground tunnels regularly used by drug cartels. The plan fails because Canek's contact person has other plans for Emilia: he hopes to trade her into the police for ransom or revenge for the suffering her late husband's government had wrought on their community.

In episode four, a local Tepito man named Chris brings Emilia face-to-face with a mural depicting the people abducted months earlier by the Mexican army during an official raid on the barrio, which served as an excuse to find and capture the "Cabronas de Tepito," a women-only community group tasked with defending the neighborhood.[10] The

banner drawn across the mural reads: "Tepito exists because it resists" (Figure 13.3). Chris pontificates on the abuses his friends have endured at the hands of armed forces: "The soldiers came to do the only thing they know how to do. They laid waste to everything and everyone . . . They stole, they beat people, they killed. . . . You came to my neighborhood. You took my sister. You took them all." That local raid turns out to be part of a larger conspiracy to undo the humanitarian work Emilia was spearheading and the social reforms her husband sought before being murdered. This mural makes another brief appearance in episode eleven, when it signals a touchstone for the characters to remember what has been taken from them and to gain resolve for their resistance (Figure 13.4).

Although the community group of the "Cabronas de Tepito" and the specific raid are fictions created by the show, their inclusion in *Ingobernable* invokes the infamous case of the forty-three students from a teacher training school who disappeared (and were subsequently murdered) in Iguala, Guerrero, on September 26, 2014. The official state-approved version originally claimed the students were mistaken for drug traffickers and killed by a rival gang. However, subsequent investigations discovered the involvement of several government officials, including the Iguala mayor and members of the Mexican federal police force, to conscript the unknowing students' buses to transport heroin—a plan that failed when a rival drug gang intercepted the buses to steal said drugs (Hernández 2018, 326–327). The ripple effects from several national and international investigations into the incident reverberated across Guerrero state politics, leading to the arrest of several high-ranking federal police officers and the near collapse of the state's reigning political party (PRD), and all the way to the federal level, including the resignation of the Mexican attorney general.[11] The show's fictional referent localizes the events to Tepito partly out of narrative economy: Emilia never leaves the urban metropolis of Mexico City so as to keep the series' storylines contained to one setting. Yet, it is no coincidence that the local analogue in *Ingobernable* for a place haunted by government conspiracies and violent intervention becomes Tepito.

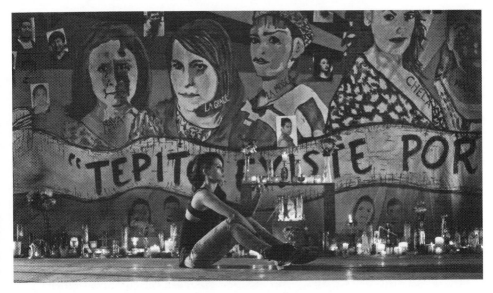

FIGURES 13.3 AND 13.4. The mural-altar symbolic of the missing members of the "Cabronas de Tepito" group connects the place of Tepito with the Iguala disappearance of the forty-three students and becomes a touchstone for *Ingobernable's* rebel characters. Source: Netflix.

The violent legacy of Tepito harkens back to colonial dispossession and the segregation of unwanted Indigenous populations. When colonizer Hernán Cortés captured and resettled the new city of Mexico in the sixteenth century, the Spaniards decreed that that city would be inhabited only by "people of reason." The Indigenous peoples already living there were displaced into the outer perimeter of the ditches that surrounded the metropolis. Tepito emerged as one of the first of many "misery belts" that would line the settlers' city. Throughout the colonial period and into the first few decades of the newly formed country of Mexico, these outlying districts would remain colloquially known as "Indian neighborhoods," half urban, half rural establishments ignored by local authorities and thus reliant on themselves to make do. During the twentieth century, noted Mexico City chroniclers ventured into Tepito to report back on its "otherworldliness" to those of the higher social strata. Writer Adolfo Dollero (1911) described witnessing adobe houses about to fall apart lining streets with no names and encountering the faces of "women who look more like witches and old men with a sinister and sickly demeanor." The chronicler for the popular newspaper *El Universal*, Fernando Ramírez de Aguilar, characterized the neighborhood as the "refuge of the underworld" (de Mauleón 2015), infamy that the neighborhood still carries today.[12]

The colonial heritage and postcolonial endurance of Tepito resonates throughout the first half of season one of *Ingobernable* both as a place and as an idea for the coalitional organizing of subaltern groups. After her failed attempt to escape Tepito, Emilia decides to team up with a rag-tag group that includes: Canek; Chris; Chela, the only member of the Cabronas de Tepito not captured by the government; Zyan, matron of a local bar and lucha libre ring; and Ovni, a hacker and seller of pirated movies living in Tepito to hide from Interpol. The "Tepito crew," as they are called, becomes a metonym for the disenfranchised groups of the country: women, the poor, the Indigenous, the informal workers. The neighborhood also becomes the space for retreat and insurgency. Chris's statement—"the barrio didn't back down: we regrouped and we retaliated in any way we

FIGURE 13.5. In a flashback sequence, the show momentarily grounds the remembrance of people disappeared by the army within Tepito's historical resistance to state incursions. Source: Netflix.

could"—becomes a rallying cry for the group that will eventually allow Emilia to regain her credibility and bring down those who framed her.

For a brief instance, the show explicitly connects the country's recent past with the indigenous legacies of its setting. In episode nine, when the Tepito crew prepares to break into one of the army black sites to rescue his abducted sister Citlali, Chris stands in front of an outside mural commemorating those who were taken while having flashbacks to the night of the raid when she was captured (Figure 13.5). In these flashbacks, Citlali runs through the iconic pirate market stalls of Tepito to avoid the army coming to apprehend her. The flashback structure thus grounds the remembrance of those people disappeared by the army within Tepito's historical connections to resisting the violent incursions of the state. The fictionalization of the Iguala massacre and its relocalization to *Ingobernable*'s version of Tepito offer the opportunity to signal the importance of coalition building between groups variously

targeted by the nation-state. Although these instances are geographically separated in reality, their simultaneous invocation here illustrates a structural continuity between the state violence of centuries ago and its twenty-first century iterations.

However, the series does not build further on this potential for critique. After the rescue mission in episode nine, the fictional Tepito and the fictionalized version of the Iguala massacre take a back seat to the series' central concerns with the political maneuverings within the government and Emilia's further discoveries into the broader conspiracy against her. The sudden narrative sidelining of the Tepito-Iguala worldbuilding belie *Ingobernable*'s purported attempts at drawing attention to Mexico's past. While the show's invocation of the country's recent history and the city's colonial legacies offer a real-life connection that adds dramatic heft to the fictional narrative, these narrative elements quickly become secondary to the White protagonist's redemption story. The references to Tepito as a ground for coalitional organizing turn out to be "plastic" signifiers that look like "meaningful imagery" but do not "survive close scrutiny" (Warner 2017) as the show's examination of historic class politics falls by the wayside. Tepito's "underworld" status becomes reduced to a temporary exile from which the protagonist emerges stronger.

Conclusion: Back in Time

Analyzed comparatively, *Luis Miguel: La serie* and *Ingobernable* present two different approaches to narrativizing the country's recent past as a biographical narrative or through ripped-from-the-headlines storylines. The shows also present the ideology of indigenismo in inverse fashion. While *Luis Miguel: La serie* furthers indigenismo with the "wise Indian" trope without acknowledging it, *Ingobernable* is at pains to make sure its subaltern references are evident while diluting their postcolonial and rural indigenous significance. The fact that both shows choose to center the trials and misfortunes of characters already in significant positions of power is no coincidence. In both cases, the narrative moves that betray

an indigenismo ideology are in the service of the main thrust of each storyline: a coming-of-age or coming-to-consciousness of the series' White, affluent, upper-middle-class protagonists. The series' blanqueamiento then becomes doubly significant when the narratives told are those of the country's recent past as seen from the perspective of the privileged few. In these two shows, restaging collective memory means rewatching through the eyes of the rich and powerful and reimagining the nation on their terms to reinforce aspirational Whiteness.

That two of Netflix Mexico's original series rely on this narrative strategy reveals the appeal and the failure of addressing politically relevant topics within new media platforms. Basing season- or series-long stories on fictionalized versions of the country's recent past affords these shows a greater level of interest from local audiences as an alternative to the more cautious offerings from legacy television networks like Televisa and their online platform Blim. Centering such stories on White, upper-middle-class protagonists then allows the shows to be marketed to a global audience. Still, the potential for more meaningful engagement with such political topics has yet to be realized. The incorporation of indigenismo tropes, whether at the level of character, setting, or narrative, does nothing to boost the inclusion of indigenous voices within a new media content. These tropes serve mainly the White-focused protagonists and, ultimately, the shows' narratives by drawing on the country's precolonial past as a selling point for its modern appeal. In this regard, the twenty-first century content offered by Netflix Mexico ends up reiterating the nation-building ideas of the twentieth century.

Notes

1 See, for instance, *O Mecanismo* (2018–2019) from Brazil or *Jamtara: Sabka Number Aayega* (2020–) from India.

2 The symbolic elevation of Mexico's indigenous people has always accompanied the rejection of Mexico's African roots (Lewis 2000). To further entrench this symbolic reformulation, during the nineteenth and twentieth centuries the Mexican government actively sought out White European immigration and

prohibited immigration by Asians and Blacks (Yankelevich 2012). While the rejection of Blackness from the national identity has played a role in the development of mestizaje in Mexico—and the near absence of Black actors in all the Netflix productions set in the country—this specific dynamic is beyond the scope of this chapter.

3 Also see de la Mora 2019.

4 See, for instance, Resendiz 2018 and Tenenbaum 2018.

5 See Casillas and Mújica 2003 and Klesner 2001.

6 Though it is beyond the scope of this chapter, it is worth noting that *Ingobernable* implicitly brings together two celebrity personas into the character of Emilia: Angélica Rivera, former telenovela actress and first lady of Mexico at the time, who was variously portrayed as an accomplice in or unwilling victim of her husband's crimes; and Kate del Castillo's own persona as an actress with intimate encounters with illicit power brokers in Mexico. On the former, see Kahn 2015. On the latter see Llamas-Rodriguez 2021.

7 This case was later the subject of the documentary *Ayotzinapa: El Paso de la Tortuga* (Enrique García Meza, 2018), coproduced by Guillermo del Toro and distributed by Netflix.

8 The character is brought to life by Antonio Guerrero, who also played Fermín, the indigenous boyfriend of protagonist Cleo in the film *Roma*.

9 Canek's name is distinctive in the culture and invokes the royal Mayan title or the eighteenth-century Mayan revolutionary who fought against the Spanish in the Yucatán Peninsula (see Wells 2001). The character, however, is played by Cuban actor Alberto Guerra, underlying the symbolic use of the name for the narrative and the lack of indigenous representation in the show's casting.

10 The English subtitles translate the "Cabronas de Tepito" as the "Bitches of Tepito." When used as an epithet against someone, cabron or cabrona can mean jerk or bitch. However, used as a self-identifier, cabron/a is closer in meaning to "badass." Here I retain the Spanish term for the group.

11 See Beauregard 2014; Ware 2015.

12 Elsewhere I have described Tepito's underworld stature as a prototypical "piratical space": see Llamas-Rodríguez 2020a.

References

Aguilar, Carlos. 2021. "How Do You Play a Notoriously Guarded Musician? Agree to Take His Secrets to the Grave." *Los Angeles Times*, May 21, 2021. https://www.latimes.com/entertainment-arts/tv/story/2021-05-21/netflix-luis-miguel-the-series-diego-boneta.

Batalla, Guillermo Bonfil. 1996. *México Profundo: Reclaiming a Civilization*. Translated by Philip A. Dennis. Austin: University of Texas Press.

Beauregard, Luis Pablo. 2014. "La matanza de Iguala agrava la crisis de la izquierda Mexicana." *El País*, November 12, 2014. https://elpais.com/internacional/2014/11/12 /actualidad/1415825349_089539.html.

Bost, Suzanne. 2003. *Mulattas and Mestizas: Representing Mixed Identities in the Americas, 1850–2000*. Athens: University of Georgia Press.

Casillas, Carlos E., and Alejandro Mújica. 2003. "Mexico: New Democracy with Old Parties?" *Politics* 23 (3): 172–80.

Dawson, Alexander S. 2004. *Indian and Nation in Revolutionary Mexico*. Tucson: University of Arizona Press.

de la Mora, Sergio. 2019. "Roma: Repatriation vs. Exploitation." *Film Quarterly* 72 (4). https://filmquarterly.org/2019/06/07/roma-repatriation-vs-exploitation/.

de Mauleón, Héctor. 2015. "Tepito: Un eterno barrio de indios." *Nexos*, September 1, 2015. https://www.nexos.com.mx/?p=26076.

Díaz, Carlos Tello. 1995. "Chiapas: La línea de fuego." *Nexos*, January 1, 1995. https:// www.nexos.com.mx/?p=7272.

Dollero, Adolfo. 1911. *México al Día (Impresiones y notas de viaje)*. Paris: C. Bouret.

EFE. 2019. "La serie *Monarca* retrata un México 'que no anda en burro ni trae sombrero.'" *Los Angeles Times*, September 10, 2019. https://www.latimes.com/espanol /entretenimiento/articulo/2019-09-10/efe-4060954-15755869-20190910.

Fariña, Noelia. 2018. "La resurrección de Luis Miguel: el artista que gustaba a tu madre es hoy el gran héroe de Netflix." *El País*, July 9, 2018. https://elpais.com/elpais/2018 /07/06/icon/1530869381_822663.html.

Hernández, Anabel. 2018. *A Massacre in Mexico: The True Story Behind the Missing Forty-Three Students*. Translated by John Washington. New York: Verso.

Ignorosa, Brenda. 2018. "El cadete Tello y todo lo que desencadenó en la red." *Quien*, May 28, 2018. https://www.quien.com/espectaculos/2018/05/28/las-lecciones-y -reacciones-del-cadete-tello.

Ikard, David. 2017. *Lovable Racists, Magical Negroes, and White Messiahs*. Chicago: University of Chicago Press.

Juárez, Nicandro F. 1972. "José Vasconcelos and La Raza Cósmica," *Aztlán: A Journal of Chicano Studies* 3:51–82.

Kahn, Carrie. 2015. "Allegations of Corruption Dog Mexico's First Lady Angélica Rivera." NPR, August 3, 2015. https://www.npr.org/sections/parallels/2015 /08/03/428171924/allegations-of-corruption-dog-mexicos-first-lady-ang-lica -rivera.

Klesner, Joseph L. 2001. "The End of Mexico's One-Party Regime." *PS: Political Science and Politics* 34 (1): 107–14.

Lewis, Laura A. 2000. "Blacks, Black Indians, Afromexicans: The Dynamics of Race, Nation, and Identity in a Mexican 'Moreno' Community (Guerrero)." *American Ethnologist* 27 (4): 898–926.

Llamas-Rodríguez, Juan. 2020a. "'Feeling Pirate' as Media Affect in Mexican-American Experience." In *Piracy and Intellectual Property in Latin America: Rethinking*

Creativity and the Common Good, edited by Victor Goldgel-Carballo and Juan Poblete, 106–20. New York: Routledge.

Llamas-Rodríguez, Juan. 2020b. "*Luis Miguel: La serie*, Class-based Collective Memory, and Streaming Television in Mexico." *Journal of Cinema and Media Studies* 59 (3): 137–43.

Llamas-Rodríguez, Juan. 2021. "The 'Narco-Stories' of Kate del Castillo: Stardom, Gender, and Entrepreneurship in the Age of Narcotrafficking." *Television and New Media* 22 (3): 317–34.

Miller, Liz Shannon. 2017. "Kate del Castillo on Being the Mexican Lady Jason Bourne (with a Political Edge) in Netflix's *Ingobernable*." *IndieWire*, April 3, 2017. https://www.indiewire.com/2017/04/kate-del-castillo-ingobernable-netflix-interview-1201799773/.

Muñiz, C., AR Saldierna, FJ Marañón, and AB Rodríguez. 2013. "Pantallas para ver el mundo: Estereotipación televisiva de la población indígena mexicana y generación de prejuicio." *Revista Latina de Comunicación Social* 68:290–308.

Noriega, Sergio. 2018. "#QUÉPASA: El cadete Tello se roba el sexto capítulo de *Luis Miguel La serie*." *Sexenio*, May 27, 2018. Link last accessed May 5, 2021' may no longer be active. http://www.sexenio.com.mx/aplicaciones/articulo/default.aspx?Id=29450.

Ortiz, César Huerta. 2018. "Cadete Tello de la serie de Luismi no existe." *El Universal*, May 28, 2018. https://www.eluniversal.com.mx/espectaculos/television/el-cadete-tello-de-la-serie-de-luis-miguel-no-existe.

Palacios, Agustin. 2017. "Multicultural Vasconcelos: The Optimistic, and at Times Willful, Misreading of La Raza Cósmica." *Latino Studies* 15:416–38.

Pierce, Joseph M. 2018. "Roma Is a Beautiful Film of Indigenous Erasure." *Indian Country Today*, December 29, 2018. https://www.josephmpierce.com/post/roma-is-a-beautiful-film-of-indigenous-erasure.

Ponce, Ariel Gómez. 2019. "Hacia una concepción compleja de la serialización televisiva en Latinoamérica: un análisis semiótico de *Luis Miguel, la serie*." *Dixit* 30:22–39.

Resendiz, Luis. 2018. "La reinvención parricida de Luis Miguel." *Letras Libres*, October 11, 2018. https://www.letraslibres.com/mexico/cinetv/la-reinvencion-parricida-luis-miguel.

Rios, Sofia. 2015. "Representation and Disjunction: Made-Up Maids in Mexican Telenovelas." *Journal of Iberian and Latin American Research* 21 (2): 223–33.

Rogers, Richard A. 2007. "From Hunting Magic to Shamanism: Interpretations of Native American Rock Art and the Contemporary Crisis in Masculinity." *Women's Studies in Communication* 30 (1): 78–110.

Shaw, Lucas. 2020. "Netflix Moving Latin American Base to Mexico as Ambitions Grow." *Bloomberg*, January 31, 2020. https://www.bloomberg.com/news/articles/2020-01-31/netflix-moving-latin-american-base-to-mexico-as-ambitions-grow.

Tenenbaum, Tamara. 2018. "¿Estamos viviendo la revancha de las telenovelas?" *La Nacion*, June 23, 2018. https://www.lanacion.com.ar/2146560-estamos-viviendo-la-revan-cha-de-las-telenovelas.

Torres, Arlene, and Norman E. Whitten Jr. 1998. "To Forge the Future in the Fires of the Past." In *Blackness in Latin America and the Caribbean: Social Dynamics and Cultural Transformations Vol 1*, edited by Arlene Torres and Norman E. Whitten Jr., 3–33. Bloomington: Indiana University Press.

Vasconselos, José. 1997. *La raza cósmica/The Cosmic Race*. Translated by Didier T. Jaen. Baltimore: Johns Hopkins University Press.

Villagrán, Mario. 2018. "Los secretos revelados del video 'La incondicional' de Luis Miguel." *Quien*, May 27, 2018. https://www.quien.com/espectaculos/2018/05/27/los -secretos-revelados-del-video-la-incondicional-de-luis-miguel.

Ware, Doug G. 2015. "Scandal-Tainted Mexican Attorney General Resigns." *United Press International*, February 27, 2015. https://www.upi.com/Top_News /World-News/2015/02/27/Scandal-tainted-Mexican-attorney-general-resigns /5971425082999/.

Warner, Kristen. 2017. "In the Time of Plastic Representation." *Film Quarterly* 71 (2). https://filmquarterly.org/2017/12/04/in-the-time-of-plastic-representation/.

Wells, Allen. 2001. "Canek, Jacinto." In *The Oxford Encyclopedia of Mesoamerican Cultures Vol 1*, edited by David Carrasco, 134–36. New York: Oxford University Press.

Wortham, Erica Cusi. 2004. "Between the State and Indigenous Autonomy: Unpacking Video Indígena in Mexico." *American Anthropologist* 106 (2): 363–68.

Yankelevich, Pablo. 2012. "Mexico for the Mexicans: Immigration, National Sovereignty and the Promotion of Mestizaje." *The Americas* 68 (3): 405–36.

14

Dark Narratives or Sunny Stories?

Appropriating Global Teen Drama in Italian Netflix Originals

LUCA BARRA

It is undoubtedly a very effective image: Netflix CEO Reed Hastings approaches a bulky old black-and-white television set, about to turn the knob. The accompanying caption, "This gentleman will switch off old television forever," underlines his imminent intention. This is the cover of the June 2015 *Wired Italia*, which announced the Italian launch of subscription video-on-demand (SVOD) service. From the outset streaming video was presented as a revolution that would transform audience consumption and change the face of the national audiovisual industry.

After a promotional launch carefully planned across the whole summer, Netflix Italia officially went live in October 2015 amid high hopes. Audiences' and industry professionals' expectations centered on the platform itself: the catalog, the interface, and the unprecedented freedom in comparison to other ways to watch television, as well as the chance to shake up a national industry deemed static and lifeless. Also, there was immediate, keen interest in the original productions that Netflix would be creating in the Italian market for its national yet global audience—the company would not only be a force on the distribution front but also by producing original content. In the months leading up to the national launch, various rumors emerged about the first Italian original titles in the library and potential collaborations, major and minor (Barra 2017). The theatrical release of the film *Suburra* (Stefano Sollima, 2015) was the perfect moment to announce that the first local Netflix TV series, a prequel to the movie, was in the pipeline.

A two-pronged effort to introduce Netflix in Italy was underway: first, with haphazard hints and more calculated disclosures about an embryonic original production strategy; second, with dialogues "behind the scenes"—some ham-fisted, others more fruitful—between the global giant trying to establish itself in the Italian media arena and a local audiovisual industry that was starstruck by this new partner (and which had long embarked on a process of industrialization and internationalization of its own). In this heralded streaming revolution, Italian series were of great economic and symbolic value. Netflix brought with it, and to Italy in particular, the promise of innovation in language, aesthetics, and content; of better productions; and of a broadening audiovisual market beyond the established players (the public-service and commercial networks) and more recent entrants (pay-TV), in a blend of continuity and renewal.

Among Netflix's strategies in Italy thus far, the most significant seems to be the (re)discovery of teen drama with a local sensibility. Netflix has identified a different target, one usually neglected both by generalist Italian screen fiction that often includes teen storylines among the many interwoven plot threads in family comedies and family dramas, and by original premium productions that foreground challenging themes and literary tie-ins (Buonanno 2012; Barra and Scaglioni 2015). Through this approach to teen drama, Netflix has sought to develop an original strategy to give this audience segment a distinctive, bolder offering—but as is often the case, the reality has struggled to live up to the hype.

This chapter begins with an overview of Netflix's strategy in Italy before taking a close look at its first Italian teen drama commissions. Using a media industry studies perspective (Herbert, Lotz, and Punathambekar 2020) and approaches from production and distribution studies (Caldwell 2008; Barra, Bonini, and Splendore 2016), I analyze the two most important teen series: *Baby* (2018–2020) and *Summertime* (2020–2022). These related series, which both contrast and overlap, have made an impact and shaped an imaginary. Drawing on in-depth interviews with writers and directors, augmented by more informal conversations, informational and promotional material and other data, the article

provides a partial outline of the attempt to mold a genre that was at least partly new to Italian TV, to connect it to a geography, and to bring it to a global audience.

Netflix's Original Italian Series Output in Three (Initial) Phases

Before examining Netflix's teen dramas, let us consider the history of its series production strategy in Italy. The first original Netflix series—*Suburra: la serie*, a prequel of the homonymous film, adapted in turn from the novel by renowned author Giancarlo De Cataldo—arrived in October 2017, two years after the service's Italian launch. In this first phase of original production, Netflix imported its existing approach of commissioning material that was already playing well in each country, essentially rehashing existing shows in often obvious copies.

The recent success in Italy of globally oriented premium series, such as Sky Italia's *Romanzo criminale* (2008–10) and *Gomorra* (2014–21), led Netflix to reproduce and apply the "Sky model" (Scaglioni and Barra 2013, Barra and Scaglioni 2021). This model relied on several distinct characteristics: strong, well-known screen brands; a sharp focus on the writing and visual style; antihero characters and edgy storylines; and story themes with international appeal, to support foreign sales or transnational coproductions. *Suburra* shared with *Romanzo criminale* both the original novelist and the head-writer team (Barbara Petronio and Daniele Cesarano); with *Gomorra*, it shared a director (Stefano Sollima) and the ashen cinematography. All three series were the latest incarnation of stories that had gone through several media iterations as books then films.

As crime narratives, these shows made ample use of easily decodable stereotypes, including a web of mafia crime, and political corruption and religious intrigue in the Vatican, set against a backdrop of Rome's monumental center and picturesque suburbs (almost a checklist of a certain Italian-made imaginary, as seen from outside Italy). Therefore, *Suburra* continued a tradition; though seemingly revolutionary, it was

really a paragon of continuity with the earlier premium dramas. During this first phase of Italian original production, Netflix maintained a "foreign" style, hiring the same professionals and production companies used by other internationally successful premium series.

The second phase of Netflix production in Italy began roughly in 2018 and was characterized by increasing investment that lacked a clear strategy. This second step was rather vague and confused, with many flops (attested by the lack of a second season, in the absence of official metrics) and some titles that received a lukewarm response despite heavy promotion. This is arguably characteristic of Netflix: it seeks virgin territory to cultivate and identifies specific genres but then struggles to create real buzz. The few successful shows are dropped after their third season.

After a confident start with *Suburra*, Netflix began to experiment with different kinds of narratives and a wider range of creative and production teams. As Netflix has done elsewhere—in the United States and related markets—it was arguably trying to develop a coherent positioning. It was at this point that teen drama, with many nuanced variations, emerged as a genre of special interest. Consider Netflix's second Italian original series, *Baby*. Its three seasons were laced with dark moods and crime storylines, written by emerging screenwriters, and produced by a then minor production company, Fabula Pictures. Another example is *Summertime*, a Cattleya production that frames its story in the bright light of summer love. *Zero* (2021) is an eight-episode production about young adults set in suburban Milan with second-generation migrant characters and a supernatural vibe. *Fate: The Winx Saga* (2021) is a female-led live-action adaptation of a global hit Italian franchise. *SKAM Italia* (2018–, TIMvision)—a local version of a Norwegian teen drama format that began elsewhere—moved to Netflix in 2020, reflecting the service's growing commitment to production (Antonioni, Barra, and Checcaglini 2021). An interwoven strand of supernatural tales also developed, including *Zero*; the six-episode *Luna Nera* (2020), a female-led production set in the seventeenth century where the fight against witches also represented the imposition of the male viewpoint and the triumph of

reason over emotion; and the single season of *Curòn* (2020), in which an artificial lake floods the remains of an old village that is the gateway separating the living and the dead, people and their doppelgangers—another tale with teenagers figuring prominently within the cast.

The third phase of Netflix's Italian productions began in early 2020. Given the consistently protracted timescales for development and production, this began to take shape only in the second half of 2021. After five years' operating from the Netherlands, Netflix opened an Italian office—not in Milan, the national broadcasting hub, but in Rome, the center of film and television production, in a clear sign of its local priorities. The company appointed an original-production manager in Eleonora Andreatta, former head of fiction production at Rai, the Italian public-service broadcaster, and the main architect of its enduring success. During this phase, the emphasis on teen drama continued with titles that also included other generations. *Generazione 56K* (2021) added an element of nostalgia; *Luna Park* (2021) was a costume drama with soap influences; *Guida astrologica per cuori infranti* (2021) took a lighter, more romantic turn; and *Strappare lungo i bordi* (2021) brought the authorial voice and intergenerational musings of renowned cartoonist Zerocalcare to the animation genre. In parallel, other Italian titles reworked classic mainstream approaches, albeit with a stronger focus on premium quality and an eye to marketing by adapting successful novels into series like *Fedeltà* (2022) and *La vita bugiarda degli adulti*, from Elena Ferrante's book. It is too soon, however, to tell if this new approach will endure, or whether it is still a stepping-stone towards a clearer, more precise model.

In this rich, contradictory, and still-evolving production strategy, the most interesting aspect is Netflix's use of Italian teen drama. This constant interest suggests the importance of younger audiences for on-demand services, an experience other European countries have shared—consider Netflix's *Élite* (Spain, 2018–) and *Sex Education* (UK, 2019–). In many markets, the public-service and commercial broadcasters had neglected this area, and targeting such a visible and loyal audience little-served elsewhere can help to position the platforms as innovators

in languages and plotlines—and support subscriber growth. This was precisely the gap that Netflix targeted with its Italian commissions. On the one hand, it positioned its series as teen dramas for teen audiences, highlighting this aspect especially in the promotion phase; on the other, it also tried to appeal, with its narratives, to a larger, multigenerational and transversal audience.

Constructing a Genre: *Baby* and *Summertime*

In its original Italian series output, Netflix presented itself as a major innovator on the creative, narrative, and industrial fronts. The results have not always lived up to Netflix's ambitions, but the platform's innovations in the Italian media scene have undoubtedly included opening a space for stories centered on teen characters and aimed mainly, if not exclusively, at a teen audience, also impacting Italian commissions by other platforms (including Prime Video, with *Prisma* [2022]) and Italy's public-service broadcaster, RAI (see *Mare fuori*, Raidue, 2020–).

It is no coincidence, then, that Netflix's second Italian series—and the first to depart from the paths charted by pay television—was *Baby*, a provocative series about an elite private high school centering on two girls who choose to become prostitutes. *Baby*'s production journey, especially for season one, was far from smooth. The series was announced well in advance; the writing provoked controversy and involved major changes along the way; the production team was reorganized several times; and the writing and production timescales were tight or overlapping. The inexperience of *Baby*'s screenwriters—scouted from the GRAMS* collective, a group of five writers under 20 at their first series (the collective is named after their initials) and supported during season one by a pair of more established head writers—prompted tensions and naive missteps. Netflix's requests and goals became clear only as the process went on, as the instructions gradually became more focused and precise. This difficulty impacted strongly on the end product, the integrity of the storyline, the character development, and the choice of style. Of

particular interest is *Baby*'s progressive honing of the teen drama genre as suitable for the service's multi-territory aims, which would emerge with clarity only later in the series. These stumbles and contradictions reflect the transition from a series based on the challenging themes and controversial characters typical of Italian premium TV to those suitable for a transnational teen drama.

Baby did not start out as a teen drama; it became one. When producer Fabula Pictures made its pitch, the news story that inspired the plot interested Netflix: the so-called *baby-squillo* (little call-girls) case, in which young schoolgirls from the affluent Roman suburb of Parioli consorted with older men for payment, despite not needing the money. It became a national scandal, prompting investigations and a court case that indirectly affected Italian politics. As Antonio Le Fosse (2020), one of the GRAMS* writers, observes, "The [Netflix] commissioner's eyes lit up about the baby-squillo, and the producer came back to Rome and told us: 'Guys, this series is gonna happen.'" The news story was only ever going to be a springboard. The plot would obviously be fictional, although the first draft did center on the murky side of a privileged yet problematic world: "None of us is from Parioli, but we dived into that world that we discovered a few hundred yards from us, into a story that was well worth telling." (Le Fosse 2020).

Netflix's vision for the show then changed, also due to some changes in Netflix U.S. strategies towards foreign national production and in their management chain, and they gave Fabula Pictures clear directions to focus on the story's teen aspect. The show's structure therefore had to be completely rethought, as season one head writer Giacomo Durzi (2020) confirms: "They ripped up the original concept. They asked us to slow the story down, to define the main characters' problems and inner conflicts more sharply before moving on to [the characters'] exploration of the adult world, in what they initially experienced as a game more than something prurient and disturbing." This was a key moment in the show's production history that reveals Netflix's intentions and shaping of *Baby*'s generic identity as a teen drama. As writer Le Fosse (2020)

observes, "Now our aim was to go ahead and tell these kids' stories— above all, to make them into a teen drama, not to dramatize a specific news story."

Whereas the initial intention was to produce an ambitious, unsettling drama with a strong crime slant that could appeal to a broad audience, along the way *Baby* became less brutal and problematic yet more focused on its targeted demographic—the teen audience. As Le Fosse (2000) explains, "We chose to tell a story about kids who had adult problems and adults who played at being kids, and to contrast one with the other. This is important because in Italian society you have to grow up before anyone listens to you, and having a series that speaks to you like an adult means I am interested in hearing your voice. We wanted to make a series not just for teens, but then we realized we'd touched the right chord with that age group." The repositioning of *Baby* as a teen show led to a rethink. As Durzi (2020) remarks, *Baby*'s story was initially considered "too dark and explicit," and Netflix was concerned that viewers might "empathize too much" with the girls' actions. "They wanted to tread carefully," Durzi explains. "Being escorts started out as more of a game, a reaction to an inadequate adult world, to the little golden cage that the protagonist lived in, to class conditioning."

Originally taken for granted, the characters' backgrounds became the core of the narrative, a shift that diluted the sensationalist power of the ripped-from-the-headlines story. Instead, the distinct family dynamics, class backgrounds, and personalities of the two main characters, Chiara and Ludovica, became a focus of the script. Le Fosse (2020) observes that "season one should have been about how the girls became prostitutes, whereas we had centered much of the plot on the actual prostitution already. It was about pacing it. [Netflix] wanted—as it's a teen series and there are teen characters to get your head around—to know clearly why they entered that world, whereas we'd already dived right in."

Netflix's input made the story development less frenetic and risky: "We were asked to remove disturbing material, to slow the story down and make it explode only later" (Durzi 2020). At the same time, this

more measured approach paved the way not just to a story but to the exploration of an entire social milieu, a group of schoolchildren: "They kept repeating the mantra 'slow down, slow down,' for they felt the story was in a big rush to be overt; they asked for greater circumspection, more description of the world and the school arena" (Durzi 2020). The characters' motivations also had to be partly reshaped to make them more acceptable: "We found a new narrative driver that convinced them: it wasn't about money but a desire for emancipation and to save the boy that main character Chiara was in love with, Damiano, the new boy, who became entwined with Chiara's big secret" (Durzi 2020). The series centered on a "dark coming of age," on being forced to grow up in a hostile, spiteful world, and on the naivety that turned to awareness as seasons progressed.

The promotion of the series followed a similar process. Whereas Netflix's early public relations focused entirely on the prurient aspects of the story, upon release *Baby*'s promotional strategy foregrounded the teen story and the claim that it was devised and scripted by writers who were almost as young as the characters. "From Netflix's viewpoint, it was a selling point, a lever. 'You have to watch the series, because these young people have written it, this group of guys [GRAMS*] who got to make a series on Netflix about young people'—although we were actually much older than the teen characters" (Le Fosse 2020).

In Italy and elsewhere, Netflix has worked by divide and rule, giving little information away to creatives and producers. Thus, those working on *Baby* in Italy did so in parallel with, and unaware of, the creative teams developing *Élite* in Spain and *Sex Education* in Britain—"twin productions" that only revealed themselves *ex post* as part of a wider pattern. Without knowledge of these and other Netflix teen shows, Italian producers used *Baby* as their main reference point.

Summertime, for instance, was immediately positioned in contrast to *Baby*: day versus night, light versus dark. As Mirko Cetrangolo, one of its creators, admits, "It was an obvious, natural thing to steer well clear of *Baby*" (2020) in the mood and plot. *Summertime* tells of the encoun-

ter between two contrasting characters and their carefree summer love against the backdrop of a Romagna Riviera packed with young people. However here too, the production journey was anything but simple. *Summertime*'s writing group changed radically during season one, with alterations to the line-up of directors too, despite the well-established nature of the Cattleya production company, which was surely more robust than Fabula, including in its relationship with Netflix. Each season's summer-centered concept tightly constrained the filming and hence the writing timeframes. The series featured a young, diverse cast of first-timers, dreamy cinematography, an exquisite and sensitive soundtrack, and a romantic, upbeat story. It began as a teen drama and remained one—slowly becoming more committed to the genre while evolving away from its original starting point.

Summertime is the adaptation of *Tre metri sopra il cielo* (*Three Steps Over Heaven*, Federico Moccia's bestselling novel, later also a film); it even retains this title in some international markets, including Latin America. As in *Baby*, the original text served as a springboard and the screenwriters took considerable liberties, although "some things did not change," observes *Summertime* creator Cetrangolo (2020): "The Romeo and Juliet dynamic had to stay, as did the polarization of the characters. There was a big conflict, the big difference, although the Step character is more violent in the book, with a monster in him that he struggles to keep at bay . . . but we had huge leeway from the start to rework the book and find new hooks. It wasn't always easy, of course: the further we moved away, the more we needed to understand what kind of balance to keep between the original and new versions."

Summertime's story moved from Rome to the Romagna Riviera; the male lead became a sportsman—a motorcyclist—and the links between characters were reshaped. Screenwriter Enrico Audenino explains, "We took Federico Moccia's love story between a boy who was a bit of a lost cause and a more ordinary girl who was dipping her toe into the world of relationships, and we added the idea of Romagna; it may seem trite, but it isn't, with that kind of atmosphere and imaginary" (Audenino

2020). After reconnoitering locations, chatting to local young people, and securing support from the Emilia-Romagna Film Commission, the project advanced, gradually focusing on the story of a particular summer. The idea was to tell "a summer love story, with the joys and hurts of those transient relationships that seem essential and momentous at the time" (Audenino 2020). The novel was a spark soon forgotten; the story developed with a choral cast and the typical rituals of a classic teen drama (parties, groups, loneliness, and running away).

Both *Summertime* and *Baby* reflect a process progressively influenced by both the national industry and the national audience to create stories that are at least partly original. They developed an "Italian approach to Netflix teen drama" informed by and adapted from the U.S. model from different starting points (a news story and a literary adaptation). First *Baby* and then *Summertime* built narrative worlds with contrasting moods—dark and challenging versus sparkling and romantic—that were clear both on the surface features such as visual styles and soundtracks as well as in the tone and structure. Netflix and its competitors have since sought to position other similar series amid these poles.

Redefining the Sense of Place

Beyond their expansion of a little-used genre, Netflix's Italian originals also illuminate the complex, layered, and contradictory negotiation between national stereotypes that are universally recognizable by a broader, transnational audience and the local/national traits typical of series made for the Italian audience. On one hand, screenwriters and creatives understand the need to appeal to not just Italian viewers but to foreign audiences. As *Summertime* screenwriter Enrico Audenino says, it was "a new experience with specific limits due to the stories' global dimension; writing for a broad international audience is not the same thing" (Audenino 2020). On the other hand, mediation was needed, through the Italian professionals who provided a bridge between two industries and two audiences. As *Summertime* director Francesco Lagi

comments, "The producer filters, steers, helps, explains, and defends decisions not instantly embraced; for we work in Italian, in our culture, in our world, while Netflix doesn't use that language and doesn't live in our world" (Lagi 2020).

The use of precise localization helped to construct the sense of authenticity while supplying a shared reference for a national community and an existing or developing stereotype. *Baby* depicts a less commonly depicted side of Rome, a specific district that was presented as aloof, affluent, and cold: "We wanted to emphasize as much as we could the authenticity of the social setting, of the Parioli district, to afford it great importance until it became the story's key asset" (Durzi 2020). The location received special attention regarding its representation and language—"You have to do your research; naturally, it has different slang from other parts of Rome" (Le Fosse 2020). This helped to anchor the discourse to an explicitly local dimension: "Initially, we wanted to make it as local as possible, at Netflix's behest. They gave us ample scope, as they wanted it to be a proper Italian thing" (Le Fosse 2020). Similarly, in *Summertime*, the town of Cesenatico in Romagna provides a canvas of Italianness on which a more universal story plays out: "We wanted to convey something very Italian and specific: the Riviera" (Lagi 2020).

As if to counterbalance the localization, a second tendency was to deploy the style and tropes of a specific genre—teen drama—that could function as a shared global language that would make bits of Italian specificity broadly recognizable. As the *Baby* screenwriter affirms, "It helped to have a conventional dynamic. School life is always more or less the same: boy falls for girl; another girl joins the group; the relationships with parents; the adults' inability to understand their children's world. We worked on this as well as on the other narrative component of the forbidden world. By juxtaposing teen relationships and prostitution, we could reach a broad, universal audience" (Durzi 2020).

Adaptation, with a few tweaks, became the way to find resonances between models of the teen drama produced in the United States and widely circulated in recent decades and Italian reality. As Le Fosse (2020)

explains, "The private high school served to emphasize that although we grew up with lockers, quarterbacks, and cheerleaders, these things don't exist in Italy. And we tried to introduce them anyway into the teens' world, so they were growing up with a certain imaginary through this device." With the *Summertime* story too, teen drama helped to provide a universal context: "Our characters are adolescents, and Italian or European adolescents aren't exactly the same as American ones, of course, in how they behave, at school or in the street. But talk of feelings, first love, the enveloping magic of summer . . . it all taps into shared feelings. It's the key to speaking to such a broad audience. We can't depersonalize the story; we want to be rooted in the world we know and to convey that, but to do so by talking about things that affect many people" (Lagi 2020).

Friction can arise between global standards and local flavors. The alternative sense of place can require rethinking certain things. In *Summertime*, for example, "we were lucky, because we're already drawing on something super-universal: teenage summer love," explains screenwriter Audenino (2020). "At the same time, you get the feeling that the idea of Italy was crucial for Netflix. As an Italian, you're creating an abstraction of your own country, a world that's a bit detached from reality, a little nostalgic and with some clichés."

In production terms, the tension between national and global—in the English-speaking world from which Netflix draws most of its subscribers—emerges in the memos and recommendations from Netflix that reveal the need to fine-tune certain passages and to anticipate and fix any ambiguous meanings. This clearly has an impact in narrative and textual terms that shape audience engagement both in Italy and abroad. For instance, in *Baby*, the portrayal of sex is minimalist, almost nonexistent. "All teen dramas have sex scenes—except *Baby*," explains Le Fosse (2020). "In a series about underage prostitution, Netflix wanted to avoid people watching it only out of sexual aestheticism and pruriency. We showed sex only where it had psychological implications for the girls, and this approach paid off." As Le Fosse explains, *Baby*'s writers also sought to avoid

offending part of the global audience through explicit depiction of what Italian viewers would probably already infer. "There were little things, like cigarette ends, which they censor in Saudi Arabia, you know" (2020).

Likewise, in *Summertime*, narrative passages that carry different connotations for local and English-speaking audiences are carefully explained and smoothed over: "Sometimes there are ethical problems. The pilot includes a scene where the main character Summer is at school sitting a test, and she shows her answers to her friend. Netflix sent a memo saying this was not okay: copying is bad. We realized the sensibilities were different, so we changed it to make Summer say, 'This is the last time.' It's a world with values that differ, even in little things, from your own. The same goes for irony." (Audenino 2020)

These are valid considerations for the writing, but they affect all aspects of the creative process including the casting and locations. The global dimension of SVOD distribution "spurs you to ask yourself questions that in Italy you wouldn't and sometimes to tackle or do things you wouldn't consider here," explains Audenino (2020). "In *Summertime*, the character is crucial: we cast a girl of color, a second-generation Italian, although we didn't address the issue directly. It is aspirational—although you're writing for Italy, there's the rest of the world beyond."

The Italian-style Netflix teen drama ends up giving top priority to clarity and glosses over potential complexities and facilitating dialogue between an Italian scenario and a broader (even global) audience: "You have to question everything you're writing; is it all clear; does everyone get it, this world we're in? Sure, it's easier for a teen love story than for other narratives more deeply rooted in a place" (Cetrangolo 2020). What is standard practice elsewhere can seem as innovation or challenging tradition in other contexts. In situations requiring negotiation, producers sought to find a common denominator among different audiences' needs to reconcile contradictory desires. "Netflix asked for a series that worked globally but was also Italian," Cetrangolo (2020) explains—with changes of direction, sometimes at short notice, both behind the scenes

of the production and between seasons. It is a challenge faced with passion and well received by the audience. "If you think how many people can watch this thing and in how many different frames of reference it can be seen, understood, and digested, you freeze," explains Lagi (2020). "We try to do our job as well as possible, to engage and excite."

These Netflix Italia teen dramas are titles that occupy a specific space in the library, seeking a middle way rather than innovation: "Netflix doesn't come to us asking what innovation Italy has got that will wow the world; sure, they focus on opening up markets rather than really developing them, enabling them to create an original imaginary" (Le Fosse 2020). With *Baby* and *Summertime*, and with Netflix's Italian series in general, they have developed from fertile terrain to expand less-explored genres and negotiate from the local and national to the transnational and global. It is a work in progress. The squaring of the circle is still some distance off, but the way there already looks quite interesting.

References

Antonioni, Stefania, Luca Barra, and Chiara Checcaglini. 2021. "'SKAM Italia Did It Again.' The Multiple Lives of a Format Adaptation from Production to Audience Experience." *Critical Studies in Television* 16 (4): 433–54.

Audenino, Enrico. 2020. Interview with Luca Barra, June 15, 2020.

Barra, Luca. 2017. "On-Demand Isn't Built in a Day: Promotional Rhetoric and the Challenges of Netflix's Arrival in Italy." *Cinéma&Cie* 17 (29): 19–32.

Barra, Luca, Tiziano Bonini, and Sergio Splendore, eds. 2016. *Backstage. Studi sulla produzione dei media in Italia*. Milan: Unicopli.

Barra, Luca, and Massimo Scaglioni. 2015. "Saints, Cops and Camorristi. Editorial Policies and Production Models of Italian TV Fiction." *SERIES International Journal of TV Serial Narratives* 1 (1): 65–75.

Barra, Luca, and Massimo Scaglioni, eds. 2021. *A European Television Fiction Renaissance. Premium Production Models and Transnational Circulation*. London: Routledge.

Buonanno, Milly. 2012. *Italian TV Drama and Beyond. Stories from the Soil, Stories from the Sea*. London: Intellect.

Caldwell, John T. 2008. *Production Culture. Industrial Reflexivity and Critical Practice in Film and Television*. Durham: Duke University Press.

Cetrangolo, Mirko. 2020. Interview with Luca Barra, June 16, 2020.

Durzi, Giacomo. 2020. Interview with Luca Barra, May 19, 2020.

Herbert, Daniel, Amanda D. Lotz, and Aswin Punathambekar. 2020. *Media Industry Studies*. Cambridge: Polity.

Lagi, Francesco. 2020. Interview with Luca Barra, June 15, 2020.

Le Fosse, Antonio. 2020. Interview with Luca Barra, May 15, 2020.

Scaglioni, Massimo, and Luca Barra, eds. 2013. *Tutta un'altra fiction. La serialità pay in Italia e nel mondo: il modello Sky*. Rome: Carocci.

15

SVODs' Innovation in Children's Content

ANNA POTTER

Much focus on subscription video-on-demand (SVOD) services tends to their programming for adults, but streaming services have significantly changed the content landscape for children of all ages. Children are a crucial audience for SVODs. Content for children and families anchors the offerings of many providers, encourages uptake of family subscription packages, and ensures audiences are captured at every stage of their life cycle (Potter 2018, 2020). Parents have demonstrated their enthusiasm for quality children's content available on demand from an advertising-free service; families with children have higher uptake rates than families without (Ampere 2019).

An audience historically undervalued by advertiser-supported broadcasters and largely the preserve of public service broadcasters (PSBs) and satellite and cable brands, children now enjoy an abundance of age-specific content available on demand (Potter and Steemers 2020). Although streamers license and commission content across the childhood spectrum—preschool, children, tweens, teens—this chapter focuses on storytelling offered to tweens and young teens. This age group, from around ten to fifteen years, has historically been underserved in linear ecosystems. Perceived difficulties in creating appealing content for an apparently fickle audience have long discouraged both commercial and public service broadcasters from investing in programming for them.

The analysis here concentrates on Netflix and Disney+ because they have been most widely adopted by families and because they commission the largest amounts of content for audiences aged ten to fifteen. Netflix is the leading SVOD service for children, with usage at 43 percent globally,

while Prime Video is second with 20 percent. Disney+ ranks third and is currently used by 18 percent of children worldwide (Richardson 2021). Although Prime Video is marginally ahead of Disney+ in global uptake, the service commissions less original content for this age group than its rivals, which leads it to rely on acquired content to attract young audiences.

Three key characteristics that distinguish SVODs from linear broadcasters are particularly significant in their shaping of new norms in storytelling for tweens and teens. First, the ability of SVODs to aggregate audiences globally provides significant economies of scale to recoup content costs associated with serving narrow audience groups (Lotz 2022). This aggregation allows streamers to invest in stories for niche young audiences, including tweens and teens, at levels impossible for linear broadcasters catering to national audiences.

Second, freedom from the constraints of a linear schedule allows SVODs unlimited shelf space for teen and tween dramas. Linear broadcasters, even those with dedicated children's channels, must cater to children of all ages within particular, finite time slots. Schedules are not a concern for SVODs. Freedom from such linear conventions removes any limits on the number of drama series that SVODs can provide. It also allows them to commission exclusive dramas that do not conform to season lengths for children's scripted genres established in linear ecologies. A trend towards shorter series duration is already emerging that encourages variety and renewal in drama offerings. Recognizable intellectual property (IP) is popular in these endeavors and allows additional stories with multigenerational appeal to be developed from original texts.

Finally, the need to appeal to children—and parents—from geographically and culturally diverse backgrounds in multiple territories encourages greater diversity of representation in commissioned drama series including of race, gender, and body types. It is unclear at this stage, however, if improved representation automatically leads to greater diversity in the *stories* that Netflix and Disney provide for tweens and teens. The enduring appeal of teen broadcast drama and high levels of creative expertise in its production at both SVODs appear to encourage the use of

longstanding narrative conventions and tropes such as the use of music to add complexity to storylines, the "girl next door" as romantic lead, and the importance of friendship, teamwork, and the pursuit of excellence. These stories are nonetheless far more inclusive than earlier teen series made for cable distribution such as the Disney Channel's *Shake It Up* (2010–13) and *Good Luck Charlie* (2010–14) that tended towards "diversity casting" in which multicultural actors are cast but their cultural and social differences are ignored (Turner and Nilsen 2014). Teen drama produced by streamers contains more grounded representations of diverse communities.

So-called clean teen drama, a term that emerged in 1950s America, consists of stories about teenagers made specifically for teenagers themselves—they don't aim to also appeal to adults as in the case of teen series such as *Dawson Creek* or movies such as *The Breakfast Club*. Devoid of drugs, alcohol, violence, and explicit sexual content, they can also be safely watched by younger children. The genre has its origins in Hollywood's clean teen films of the 1950s that featured "an aggressively normal, traditionally good-looking crew of fresh young faces, 'good kids' who preferred dates to drugs and crushes to crime" (Doherty 2010, 159). Clean teen TV drama was a key part of a lucrative U.S. market for teen-oriented screen content—and music—that developed during the 1950s and '60s (Doherty 2010). Another wave of clean teen screen production occurred during the 1990s, courtesy of U.S. children's brands Nickelodeon and Disney. Satellite technology opened new international markets for their clean teen dramas, sitcoms, and made-for-TV movies and created significant economies of scale at a time of growing media conglomeration (Blue 2017). While aimed primarily at ten- to fifteen-year-old audiences, the clean teen genre is suitable for family viewing, which broadens its appeal and value to providers.[1]

Globally, Netflix and Disney+ are the largest commissioners of children's content among all SVOD services. In 2016 Netflix then-head of content Ted Sarandos announced the service was doubling its children's commissions and that he was focused on "building a slate that

today's kids will grow up loving" (Jarvie and Goldberg 2016). The creation of first-run, exclusive children's content was an important part of Netflix's brand strategy, as well as a strategy to mitigate content supply risks. Examples of the SVOD's clean teen drama commissions include *Project Mc2* (2015), *Free Rein* (2017), *Anne with an E* (2017–19), *The A List* (2018), *Malibu Rescue* (2019), *The Baby-Sitters Club* (2020), and the U.S. musical drama *Julie and the Phantoms* (2020).

For Disney, a corporation that has long specialized in the monetization of its IP across cinemas, ad-supported media networks, cable channels, merchandise, and theme parks (Bryman 2004), the launch of Disney+ in 2019 represented another window for content distribution and a direct-to-consumer connection to households around the globe. Disney has also created new clean teen drama for its streaming service, including *Diary of a Future President* (2020). Existing stories have been redeveloped and extended in exclusive content as well, such as in the mockumentary musical drama *High School Musical: The Musical: The Series* (2019–20), inspired by Disney's 2006 made-for-TV movie *High School Musical*. As the largest commissioners of children's content, both Disney and Netflix exert significant influence in storytelling for young audiences.

Aggregate Young Audiences in Multiple Territories to Achieve Scale

The capacity of SVODs to aggregate audiences globally creates economies of scale that support increased drama provision for previously underserved segments of the child audience including in commissioned, exclusive series. Linear broadcasters have traditionally seen tweens and particularly teens as an elusive and unpredictable demographic. Public service broadcasters have been reluctant to risk scant resources on television's "missing" audience, instead allowing ten-to-fifteen-year-olds to fall between the stools of adults' and younger children's programming (Davison et al. 2020, 4). SVODs' popularity with teen and tween audiences

has recently led some PSBs to increase their teen provision amid concerns they will lose this audience permanently. Norwegian public service broadcaster NRK created *Skam* (2015) for example, a gritty—and enormously popular—girl-skewing drama delivered on social media and on television (see Sundet 2021). However the cost of developing and producing content primarily for a niche domestic audience continues to limit the stories that can be told by national broadcasters. In contrast, the audience aggregation enabled by global distribution allows much greater investment in clean teen drama with female and male protagonists. The ability to recoup content costs across multiple territories thus allows SVODs to provide a far broader selection and greater range of age-specific stories to tweens and teens than linear broadcasters could ever do.

SVODs can use teen and tween dramas to aggregate globally underserved audiences. This affordance enables tweens and teens for whom stories were in short supply in linear ecologies on-demand access to more stories. Previously, pre-SVODs, teens and tweens were often pushed into mature teen content on commercial providers, with prime-time shows such as *Beverly Hills, 90210* (1990–2000, Fox), *Buffy the Vampire Slayer* (1997–2003, The WB/UPN), and *Dawson's Creek* (1998–2003, The WB), that sought broad audiences including those well into adulthood.

From 2018 Netflix increased its clean teen commissions of original and exclusive series. The hiring of choreographer Kenny Ortega, whose credits include Disney made-for-TV movies *High School Musical* (2006) and *Descendants* (2105), allowed Netflix to create the kind of clean teen drama in which Disney has long specialized. Ortega's first drama for Netflix, *Julie and the Phantoms* (2020), is typical of the genre and indicative of Netflix's attempts to compete directly with Disney for this important audience. Adapted from Brazilian sitcom *Julie e os fantasmas* (2011–12), the series has a female lead character, fifteen-year-old Julie, played by a Puerto Rican American actor. Julie is a teenage musical prodigy whose mother has recently died (a marked plot difference from the Brazilian version).

Julie is part of a Latinx, middle-class family (protagonists tend to be normalized as financially comfortable but not obviously wealthy in U.S. clean teen drama) and lives with her widowed father and young brother. She forms a band with three teenage ghost musicians, Luke, Alex, and Reggie, who died in 1995 just as their own band, Sunset Curve, was on the cusp of success. The ghosts are only visible to Julie until they all perform together in the band, at which point their audience can see them too. As Julie begins to come to terms with the loss of her mother and starts making music again, her three bandmates are also able to achieve the career success that was cut short when they died while gradually accepting that they are ghosts.

As the series' main protagonist, Julie conforms to the "girl next door" trope widely used in clean teen drama; she is not overtly sexualized and tends to dress in a tomboyish style. Julie's nemesis, Carrie Wilson, is a rich White girl—ostentatious wealth often characterizes clean teen antagonists—and the lead singer of rival band Dirty Candy. The all-girl band features four singers, each of whom has signature colors for her much more revealing costumes and wigs. Carrie is also the daughter of Trevor Wilson, the surviving band member from Sunset Curve who made millions after taking the credit for the songs his dead bandmates wrote. The family's ostentatious wealth, accumulated through nefarious means, confirms their clean teen "bad guy" status.

Julie and the Phantoms embraces themes that are common to clean teen drama series: the value of working hard, striving for excellence, inclusion, teamwork, friendship, the girl next door as romantic ideal, and the importance of never giving up. As such, clean teen stories articulate a "moral mainstream" indicating what their young audiences should aspire to grow up to be (Driscoll 2011, 40). The series' emotional range also extends to grieving processes for Julie's family in the aftermath of her mother's death. As befits a story with multigenerational appeal, the three ghosts who died in 1995 provide plenty of opportunity for '90s nostalgia in their clothing, hairstyles, and speech, for parents watching with their children.

Described as "Bill and Ted Meet Ghost" (Ashurst 2021), *Julie and the Phantoms* is largely set in Los Feliz High School where students are taking part in a special music program for talented teenagers. Music is critical to and drives the narrative, as is typical for the clean teen genre that "consistently uses song and dance to add narrative complexity" (Driscoll 2011, 137). Thus Julie sings the first track of the series, "Wake Up," in her mother's studio when she finally returns to singing after being unable to do so since her mother's death. It is a key moment as Julie rediscovers her musical confidence and the three ghosts secretly witness her performance and recognize her talent. After its launch in 2020, *Julie and the Phantoms* consistently ranked in the top ten Netflix series lists, including in Australia, Canada, and the United States (Horgan 2020). A second series is currently in development.

Disney has also invested in clean teen drama for its streaming service, including a musical mockumentary series with a storyline that references Kenny Ortega's enormously successful 2006 made-for-TV movie *High School Musical*. Premiering on Disney+, *High School Musical: The Musical: The Series* is set in a fictional version of East High, the actual school in which the *High School Musical* movie was filmed. In season one, a group of students produces a stage version of the original movie, led by somewhat mysterious drama teacher Miss Jenn. In one of multiple intertextual references in the series, Miss Jenn claims to have worked as a dancer on the original movie. The mockumentary device also allows the inclusion of the original characters who are seen in the stage version of the musical singing the movie's well-known songs as well as an entirely new cast and musical score.

High School Musical: The Musical: The Series contains conventional clean teen themes including wholesome girl-next-door protagonist Nini. Just as in *Julie and the Phantoms*, the series' music provides narrative complexity including in the new songs written by Nini and love interest Ricky that reveal their emotions as they struggle to reconcile their feelings for each other—and for other cast members.

Like *Julie and the Phantoms*, the series also features middle-class teens striving to be the best they can be, several extremely chaste romances, and strong friendships. The series emphasizes the value of perseverance in the face of adversity, which, for Ricky, includes the disruption caused by parental separation. Teamwork is critical, with the musical performances providing the perfect vehicle for the development of such skills. After Miss Jenn is almost sacked for having embellished her qualifications on her CV, the cast unite in song at her disciplinary hearing. Their performance convinces the school board, and their parents, of the value of Miss Jenn's creative talent and the positive effects the school musical preparations are having on the cast.

Both *Julie and the Phantoms* and *High School Musical: The Musical: The Series* illustrate how SVODs have created new textual opportunities for previously underserved niche children's demographics worldwide.

Freedom from the Constraints of the Linear Schedule

SVODs have unlimited space for children's content including teen and tween drama in their catalogs, although not unlimited budgets. The affordance of on-demand delivery leads to profoundly different conditions from broadcast children's television, in which only a finite number of scheduled hours exist. Even public service broadcasters with dedicated children's channels such as the UK's BBC face such scheduling and program-length constraints. With unlimited shelf space, however, SVODs like Disney+ and Netflix can make available a far greater amount of age-specific drama than was possible in linear ecologies. They can provide newly commissioned content produced specifically for on-demand delivery, and in Disney's case at least, a back catalog of clean teen dramas such as *Hannah Montana*, *That's So Raven*, *Lizzie McGuire*, and *The Wizards of Waverley Place* new to today's tweens. Similarly, Netflix can license clean teen drama initially made for broadcast television, such as the Australian mermaid series *H2o: Just Add Water* (2006), first seen internationally on Nickelodeon's cable channels.

Freedom from the constraints of the linear schedule also allows SVODs to vary season length in scripted drama commissions. A trend towards shorter seasons appears to be developing in exclusive and original content, which at this early stage is around ten episodes per season, of which there may only be one or two. Shorter seasons accommodate SVODs' requirements for variety and constant renewal in drama provision and may well lead to more range and greater plurality in the stories made available to teens and tweens. In tandem with the need to appeal to ten-to-fifteen-year-olds in multiple territories, this renewal appears to lead to an increased supply of new stories. Shorter seasons also change *how* stories are told.

Shorter seasons encourage narrative complexity in individual episodes and hooks at the end of each to encourage binge-viewing. A season of ten half-hour episodes can be binge-viewed over one or two days, meaning stories are told, and consumed by audiences far more quickly than in the past. Self-contained whole season narratives that deliver a satisfying story conclusion in return for young audiences' viewing commitment also appear to be more commonplace. Producers have suggested that while a first season can be left slightly open for a second, the chances of a third season in teen and tween drama produced outside the United States are much lower (Stokes 2021).

For U.S. clean teen dramas such as *Julie and the Phantoms* (season one had nine episodes) and *High School Musical: The Musical: The Series* (two seasons of ten episodes each to date), a second series is more likely. Nonetheless even U.S.-produced clean teen drama in the on-demand age is far shorter than previous Disney series made for satellite and cable such as *Hannah Montana* (2006–11) which produced one hundred episodes over four seasons. These new structural narrative norms appear to encourage a greater range of stories as providers develop more titles rather than devising additional narratives based around existing characters and settings.

The A List (2020–21), one of Netflix's clean teen drama commissions, is emblematic of these emerging norms in drama production. Filmed in Scotland, on the fictitious Peregrine Island, *The A List* is about a group

of teens attending a summer camp a year after the mysterious disappearance of another girl, Midge, at a similar camp. Initially the teens seem headed for an idyllic summer camp, but intense rivalries quickly develop between lead female characters Mia and late arrival Amber. Possessor of a mysterious power, Amber only needs to touch people for them to fall completely under her control, and she soon becomes far more popular—and powerful—than Mia. Pitched by its creators as "*Mean Girls* meets *Lost*," the series contains familiar clean teen themes: friendship, romance, teamwork, rivalry, and betrayal.

The first series of *The A List* was commissioned by the UK's BBC for its free streaming service iPlayer in an effort to retain teen audiences in the face of intense competition from SVODs. Series one consisted of thirteen twenty-four-minute episodes, with all but the final episode ending with a hook. Series one largely resolved the storyline but left sufficient narrative space for a second series to be created. As a chaste, clean teen drama that had rated well with national teen audiences in the UK, *The A List* appealed to Netflix. Despite emerging from the UK's grittier teen drama production culture, *The A List* also conformed to Netflix's content requirement that its clean teen drama be suitable for family audiences, including younger children. The SVOD acquired series one of *The A List* after its UK transmission by the BBC. The SVOD then commissioned a second series consisting of eight twenty-four-minute episodes for global audiences, without any BBC involvement. The narrative concludes in the second season and Netflix has made it clear to its producers that there won't be a third.

Unlimited space in SVOD catalogs delivers considerable freedom to streamers to increase drama provision for underserved teen and tween audiences. This affordance combined with what appears to be an emerging preference for shorter seasons and possibly fewer seasons overall seems to be leading to a greater number—and variety—of stories available to teens and tweens. Clean teen television dramas made for satellite and cable distribution produced up to one hundred episodes. In contrast, the constant offering of new teen drama titles by SVODs—instead of

continuing the same title for many seasons—may reduce the chances that a service will fall out of favor, risking subscriber churn in crowded video markets.

Representations of Diversity

In order to successfully aggregate teen and tween audiences on a global scale, SVODs require their clean teen dramas to have wide geographic and cultural appeal. As a result, the exclusive and original clean teen dramas commissioned by Disney and Netflix feature greater representational diversity, including of nondominant ethnicities, sexualities, and body types, than previously seen in the clean teen content on satellite and cable. The trend towards greater diversity of representation can be seen in Disney's *High School Musical: The Musical: The Series* (2019) and *Diary of a Future President* (2020). The improved diversity within these series allows more teens and tweens to see themselves and their peers represented on screen, including groups whose existence was previously only hinted at or entirely ignored in the past.

Disney's second major commission for its streaming service, *High School Musical: The Musical: The Series*, is much more diverse than its 2006 namesake. The original made-for-TV movie had visual racial and ethnic diversity, including Filipino American actor Vanessa Hudgens in the lead role, but the character's cultural background was not represented in any meaningful way. The cast included only one plus-sized actor and a single character, Ryan, who could be read as gay. In contrast the 2020 mockumentary's lead character, Nini, also played by a Filipino American actor, Olivia Rodrigo, has mixed-race, same-sex parents; the cast includes several plus-sized dancers, an openly gay theater student named Carlos, and leading characters played by actors of color "whose characters' access to success and relationships have nothing to do with their racial identity" (Bhagwat 2020). The series improved representation of (chaste) teen sexuality, including the *High School Musical* movie brand's first gay couple.

The developing romance between Carlos (the stage version's musical choreographer) and cast member Seb is revealed halfway through season one when Carlos asks Seb to be his date for the homecoming dance. Seb arrives so late that Carlos has begun to believe he had changed his mind, and his relief is palpable. The boys slow dance together in front of all their peers without any sense of judgement. Their relationship is accepted without question by the other students and normalized within the narrative rather than being a source of angst or distress for the couple. The fifth episode of season two (in which the students are putting on a stage version of *Beauty and the Beast*) was released during Pride Week in the United States. Seb organizes a spontaneous quinceañera (a traditional coming-of-age birthday celebration for young Latinas) for Carlos's fifteenth birthday at his family's barn. Seb reveals during the party that a video Carlos posted to Instagram helped give him the courage to come out, before singing a solo cover of Miley Cyrus's "The Climb" from *Hannah Montana: The Movie*. In both seasons of the drama, the boys' relationship is portrayed without any of the angst, conflict, or struggle that is often integral to storylines involving gay characters in teen dramas, when they are included. The clean teen drama made for SVODs allows teens and tweens to see new representations of sexuality, and for some, to see themselves and their relationships represented on screen for the first time.

In *Diary of a Future President* the lead character, twelve-year-old Elena Cañero-Reed (who will eventually become president of the United States) is a Cuban American growing up in Miami Glades. Elena's father died three years earlier and she and her brother Bobby are being raised by their mother Gabi, a lawyer. The narrative device uses excerpts from Elena's seventh-grade diary to portray her journey from the tricky phases of adolescence to her ascension to the White House. The series has been applauded for its representation of a Latinx tween and her extended family and for avoiding the cliched character norms of Latinx characters as "undocumented, maids or narcos" (Brasero 2020). It has also attracted praise for its LGBTQ representation as her brother Bobby is gay.

Created by Ilana Pena (showrunner of the romantic comedy series *Crazy Ex-Girlfriend*), *Diary of a Future President* had a deliberately diverse writers' room, including younger writers, and is unusual in American children's drama—or American drama generally—for having a predominantly Latinx cast. The series is unquestionably innovative in its representation of Cuban Americans and also in its depiction of the racism and microaggressions Elena and Bobby face. For example, Elena has to correct her White teacher for mispronouncing her name, while Bobby is bullied and called a worm because of the tilde on his surname, Cañero-Reed, which his tormentors (and tennis rivals) claim looks like a worm. Bobby is on the brink of losing a tennis match because he is so upset by the bullying (that includes filling his sports bag with worms) when all his teammates add a tilde to their names on the back of their team jackets. Buoyed by their support, Bobby wins his match.

In the past, Disney clean teen drama has tended to avoid the political. *Diary of a Future President* adroitly embraces twenty-first century identity politics in a manner likely appealing to Latinx teen and tween audiences, including in growing markets in South America. Disney+ launched in South America in November 2020, a year after the United States. The SVOD commissions depict what in the past were rare portrayals in clean teen drama of the microaggressions and racism that Latinx children encounter. This representation is culturally important for both non-White and White teen and tween audiences. The show's remaining themes of perseverance, striving for excellence, teamwork, and the importance of family and friends are consistent with previous Disney clean teen drama series designed for global consumption.

Commissioning practices in children's drama by Disney+ and Netflix appear to be leading to greater diversity of representation in clean teen drama created for young audiences living in multiple cultural contexts. Greater diversity in storytelling allows previously unrepresented groups of children to see themselves on screen. Stories are now available on SVODs that normalize aspects of young people's lives, including gay teens, that were previously ignored, or treated as problematic.

Conclusion

Teens and tweens who were previously underserved in linear ecologies are an important audience for SVODs that offer them abundant choice in age-specific content. With distinctive affordances including the ability to aggregate child audiences globally, freedom from the constraints of the linear schedule, and an economic need to appeal to children and their families from diverse cultural and geographic backgrounds, SVODs are transforming the amount and the range of stories available to niche audiences in the on-demand environment. This can be seen clearly in exclusive and original clean teen drama available on Disney+ and Netflix.

The United States is a large single-language market with decades of expertise in the production and circulation of clean teen drama in global markets, particularly by the Disney Corporation. Netflix's commissioning of the clean teen genre also appears to favor U.S.-based productions, in contrast to the SVOD's demonstrated willingness to invest in local drama for adults from territories outside the United States. Although Netflix has co-commissioned clean teen drama in other English-language markets, including with Australian and UK PSBs, these arrangements in which rights are shared with linear broadcasters are becoming rarer as the SVOD seeks global, exclusive ownership of its clean teen dramas.

This chapter's analysis suggests that SVOD involvement in the creation of clean teen drama for global audiences supports the perpetuation of U.S. narrative devices and tropes for the genre first refined in cable and satellite production during the 1990s and 2000s. Differences exist, however. SVOD preference for high-concept, high-end, shorter series that allow new offerings to constantly be made available leads to greater variety in stories for tweens and teens. Further, these stories are far more representative of their diverse communities than clean teen drama has been in the past and address issues such as racism in a way that diversity casting alone has not.

Given the still nascent development of multi-territory SVODs, long-term strategies and implications remain unknown. Are shorter, new

series enjoyed by children and are they sustainable for the children's screen production sector? Are SVODs increasing available funding for children's programs? Are they creating a broader range of offerings or merely replacing those previously supplied by advertiser-funded broadcasters? And can SVODs continue to produce drama that can be understood and enjoyed by children in multiple territories and from diverse cultural backgrounds? While key content trends are becoming clearer, many uncertainties remain.

Note

1 In the catalog they are classified as family content, in contrast with children's, which is aimed primarily at children viewing on their own.

References

Ampere Analysis. 2019. "What Children's Content do Facebook, Amazon, Apple, Netflix and YouTube Want?" Presentation to the Children's Media Conference, July 4, 2019, Sheffield, UK.

Ashurst, Sam. 2021. "*Julie and the Phantoms* Season 2 Release Date, Cast, Plot and Everything You Need to Know." *Digital Spy*, September 15, 2021. https://www .digitalspy.com/tv/ustv/a34011338/julie-and-the-phantoms-season-2-release-date -netflix/.

Bhagwat, Ria. 2020. "*High School Musical: The Musical: The Series* Revolutionizes Disney's Diversity and Inclusion." *14EAST*, May 15, 2020. http://fourteeneastmag.com /index.php/2020/05/15/high-school-musical-the-musical-the-series-revolutionizes -disneys-diversity-and-inclusion/.

Blue, Morgan G. 2017. *Girlhood on Disney Channel: Branding, Celebrity, and Femininity*. London: Routledge.

Brasero, Maria. 2020. "Why *Diary of a Future President* is Must-Watch Show." *LATV*, January 13, 2020. https://latv.com/why-diary-of-a-future-president-is-such-a-cool -show.

Bryman, Alan. 2004. *The Disneyization of Society*. London: SAGE.

Davison, Patrick, Monica Bulger, and Mary Madden. 2020. *Navigating Youth Media Landscape: Challenges and Opportunities for Public Media*. New York: Joan Ganz Cooney Center at Sesame Workshop.

Doherty, Thomas. 2010. *Teenagers and Teenpics: The Juvenilization of American Movies in the 1950s*. Philadelphia: Temple University Press.

Driscoll, Catherine. 2011. *Teen Film: A Critical Introduction*. London: Bloomsbury.

Horgan, Emily. 2020. "Is *Julie and the Phantoms* Netflix's Best Attempt at a Kids Franchise to Date?" *What's on Netflix*, October 16, 2020. https://www.whats-on-netflix.com/news/is-julie-and-the-phantoms-netflixs-best-attempt-at-a-kids-franchise-to-date/.

Jarvie, Natalie, and Lesley Goldberg. 2016. "Ted Sarandos on Netflix Programming Budget: 'It'll Go Up' from $6 Billion." *Hollywood Reporter*, July 27, 2016. http://www.hollywoodreporter.com/live-feed/ted-sarandos-netflix-programming-budget-915020.

Lotz, Amanda. 2022. *Netflix and Streaming Video: The Business of Subscriber-Funded Video on Demand*. London: Polity Press.

Potter, Anna. 2018. "Creating Children's Television for SVODs: The Alignment of Global Production Practices with National Screen Policies in the Netflix Original *Bottersnikes and Gumbles*." *Media Industries* 5 (2): 111–27.

Potter, Anna. 2020. *Producing Children's Television in the On-Demand Age*. Bristol: Intellect.

Potter, Anna, and Jeanette Steemers. 2020. "Transforming Markets for Children's Media Industries." In *The Routledge Companion to Global Television*, edited by Shawn Shimpach, 131–40. Milton: Routledge.

Richardson, Nick. 2021. "Why Kids are Key to the Entertainment Wars." *C21*, Aug. 24, 2021. https://www.c21media.net/perspective/why-kids-are-key-to-the-entertainment-wars/?ss=children%27s.

Stokes, M. 2021. Interview with Anna Potter, September 11, 2021.

Sundet, Vilde Schanke. 2021. "'Youthification' of Drama Through Real-Time Storytelling: A Production Study of *Blank* and the Legacy of *SKAM*." *Critical Studies in Television* 16 (2): 145–62.

Turner, Sarah E., and Sarah Nilsen. 2014, *The Colorblind Screen: Television in Post-Racial America*. New York: NYU Press.

16

SVOD Original Film Commissioning

Expanding the Boundaries of Commercial Film?

CHRISTOPHER MEIR

Much of the key academic writing about subscription video-on-demand (SVOD) platforms to date has focused on the ability of the technology itself and the companies that operate these platforms to "disrupt" various aspects of the television industry (e.g., Lotz 2017; Jenner 2018; Lobato 2019). In comparison, very little scholarly attention has been paid to the impact of SVOD on other screen industries, such as the film industry. This topic has instead largely been dealt with in journalistic circles and by the industry itself and has typically been concerned with the extent to which SVODs stand to undermine theaters or other forms of film exhibition and consumption. This chapter explores the question of whether Netflix, Prime Video, and to a lesser extent Apple TV+ have "disrupted" the global film business in ways different from services that are attached to legacy studios such as Disney+, Paramount+, or HBO Max.

Instead of fixating on the threats that these disruptive SVOD players supposedly pose to the film industry, this chapter explores the contributions of these companies to global film industries and cultures through their investments in the production of original films. The chapter focuses on two types of films that SVOD services have produced, both of which diversify cinema away from big-budget Hollywood franchise productions. The first is *monumental auteur filmmaking*, which describes works directed by recognized auteur filmmakers who were not otherwise able to find the funding and other types of support necessary to realize their creative visions within the existing film establishment.

"Monumental" here refers to the alleged impossibility of the projects as well as the scale of financial investment often required to make them. In contrast to monumental auteur works that are projects of experienced and famous figures, the second type of SVOD original film is just the opposite: *films made by early-career directors*, in this case, defined as filmmakers who had less than three features to their names before their films were commissioned by the SVOD services. Many of these films are made more notable by their inclusion of directors historically underrepresented in Hollywood or the various production centers in question.

Together, monumental auteur works and works from early-career filmmakers constitute an important element of SVOD services' original film output and are significant for the film industry, film culture more broadly, and the branding of the services themselves. In focusing on directors specifically, this chapter does not endorse auteur theory—a contentious, and sometimes, in its worst iterations, naïve theory of film creativity that focuses exclusively on directors—even if it has clearly influenced the discourses surrounding these films. Instead, this chapter explores these figures as one group of artistic laborers that are indeed very important in cinematic expression.

To fully appreciate what is or is not unique about this current period of industrial disruption, it is crucial to historicize SVOD services in relation to other studios that have sought to disrupt the American film industry in the past by establishing themselves as vertically integrated producer-distributors and (less often, since the Paramount decrees at least) exhibitors. Hollywood, understood here as the economic center of the American film industry and a defining force globally, has been run by a relatively stable corporate oligopoly since World War I, although there have been many companies that have tried to join that oligopoly. Notable examples in the historiography of the American film industry include United Artists (Balio 1987a; 1987b), Polygram Filmed Entertainment, and Miramax (Perren 2012), as well as contenders from outside the United States such as Studiocanal and other European studios (Meir 2019). As we will see, in attempting to integrate film production into what were previously distribution-led

businesses, SVOD players have pursued strategies that mirror those of many of these predecessors, even while crucial differences can also be found. Chief among these strategies is the need to not only compete with the Hollywood oligopoly but also to contend with various national media oligopolies found around the world, as the services have sought to compete for production resources and audiences across the globe.

Monumental Auteurism in SVOD Film Production

Monumental auteurism involves established directors who have been able to make what are often described as "passion projects" with the help of an SVOD service. Two qualities recur in many of the production stories of these cases, besides of course the involvement of the aforementioned celebrity directors. First, the projects have usually been gestating for a very long time and have been rejected by other studios. The conventional wisdom of the established film industry is implicitly and sometimes explicitly framed as an impediment to the auteurs' ability to express themselves. The films are often said to be too expensive given their commercial prospects or too esoteric: both criticisms that faced Scorsese's *The Irishman* (2019, Netflix), for example (Mendelson 2019). Secondly, the projects are depicted as showcases for the unique talent and authorial signature of the auteur figures—an opportunity for exhibiting their stylistic tendencies, political convictions, and/or their personal thematic obsessions. In enabling their filmmaking, these corporate patrons allow the auteurs to reach their fullest potential in their respective crafts.

Among the three services discussed in this chapter, Amazon was the first to eagerly adopt this sort of filmmaking model. When the company launched its original production strategy for Prime Video in 2015, it announced its participation in the production of Spike Lee's film *Chi-Raq* (2015) and subsequently unveiled what would prove to be an ill-fated deal with Woody Allen for multiple films and an original series.[1] This was followed by the commissioning or coproduction of numerous films by established auteur directors such as Todd Haynes (*Wonderstruck*, 2017), Mike

Leigh (*Peterloo*, 2018), Luca Guadagnino (*Suspiria*, 2019), and Gus Van Sant (*Don't Worry, He Won't Get Far on Foot*, 2018), among others.

Netflix also launched its original film strategy in 2015 with *Beasts of No Nation*, an acquisition directed by Cary Fukunaga, who is a writer/director of some critical reputation. Although Netflix also produces other, more conventionally "Hollywood" films, serious and challenging auteur cinema remains a staple of Netflix's original film strategy. The SVOD has commissioned films from a long list of established auteur directors such as Joel and Ethan Coen (*The Ballad of Buster Scruggs*, 2018), Martin Scorsese (*The Irishman*, 2019), Steven Soderbergh (*The Laundromat*, 2019), David Fincher (*Mank*, 2020), and Spike Lee (*Da 5 Bloods*, 2020), among others. Being the most internationally diversified of all the SVOD services, Netflix has also commissioned monumental auteur films from national industries beyond the Anglophone world, including works from Spanish auteurs Ramón Salazar (*Sunday's Illness*, 2018) and Isabel Coixet (*Elisa & Marcela*, 2019), Indian filmmaker Anurag Kashyap (*Choked*, 2020), and Italian director Paolo Sorrentino (*The Hand of God*, 2021).

The aforementioned discourses of impossibility—of grand, unrealized projects shunned by risk-averse studios—unite many of these works. Isabel Coixet, for example, reportedly worked on her film for ten years before Netflix stepped into finance its production (Netflix 2018). In the course of promoting *Mank*, David Fincher told the trade press that he had been looking for finance for the film since his Hollywood breakthrough in the late 1990s (Lang 2020). In perhaps the most extreme example of monumental auteur filmmaking, Netflix financed the "completion" of an unfinished feature film project from the long-departed auteur Orson Welles called *The Other Side of Wind* in 2018. This was a project that Welles was forced to abandon in the 1970s despite having shot a great deal of footage. Besides the difficult production processes, the films themselves are often artistically and or/politically challenging. For example, *Da 5 Bloods* takes on American racial politics; *Elisa & Marcela* offers a lesbian/transgender story; and *Choked* provides a dark satire of Indian Prime Minister Narendra Modi's policies. Numerous films

utilize black-and-white cinematography (*Elisa & Marcela* and *Mank*, as well as *Roma* [Alfonso Cuarón, 2018], a notable acquisition that fits the mold of the monumental auteur film in many ways), feature antihero protagonists who are not sympathetic or likeable in the conventional sense (*The Irishman*, *Sunday's Illness*), and use other aesthetic techniques influenced by art cinema conventions.

No film from this period typifies the monumental auteurism at Netflix better than *The Irishman*, which features all the hallmarks of this particular kind of SVOD original film commission. The film was a passion project for Scorsese and DeNiro that they had unsuccessfully been trying to finance for decades, despite their legendary track records in their respective crafts and their innumerable connections with Hollywood studios and financiers. For Scorsese it was also another meditation on the themes that have obsessed him throughout his career: morality, guilt, and the possibility of personal redemption. The film was set to be the director's next project with Paramount after the release of *The Silence* (2017), but its budget escalated during development (due to expensive digital de-aging techniques that would be needed to tell the film's sweeping historical narrative), and *The Silence* also proved to be a commercial failure. This led Paramount to sell off the international distribution rights to the film to STX Entertainment and later back out of financing Scorsese's next film altogether. It was at this point, in 2017, that Netflix agreed to fully finance the project in exchange for global rights. The final budget was reported to be over US$150 million and possibly as high as US$250 million, sums unheard of for auteur filmmaking, never mind for a film that would have only limited distribution in theaters or on home video beyond Netflix itself (Kit 2020). Its budget was not the only daunting aspect of the project, however. While ostensibly a gangster film, *The Irishman* was a very subdued, melancholic, and moralistic take on the genre that dwells on the guilt antihero protagonist Frank Sheeran (Robert De Niro) feels about his life of crime and his ultimate lack of redemption. As such, the film is far from the garrulous, vivacious tone of Scorsese's most commercially successful films such as *Goodfellas* (1990) and *The*

Wolf of Wall Street (2013). Besides its somber moralizing, the film was also concerned with the intricacies of real historical American corruption in the 1950s and 1960s, such as Jimmy Hoffa's exploitation of trade unions to support the American mafia—themes that addressed a discerning, committed audience. Finally, at over three-and-a-half hours, *The Irishman* was far longer than typical feature films, which added yet another monumental dimension to the project.

The Irishman was one of Netflix's most important films in its awards season campaign of 2019/2020 and suggests the purpose that these auteur projects often serve. *The Irishman* was ultimately nominated for ten Academy Awards; though it did not win any of these, the nominations alone ensured that Netflix was part of the awards-season cultural conversation and earned it considerable unpaid promotion. Its inclusion among the nominees provided further cultural legitimation needed as a new entrant in the film industry. While other monumental auteur works from SVOD services have similarly succeeded in accruing cultural prestige, at the time of writing Netflix has produced more tangible awards successes than its competitors. That said, Netflix has had more nominations than it has had major award wins for its original commissions, and the acquisition *Roma* remains its most decorated "original" film (with it having won the Golden Lion at the Venice Film Festival and the Academy Award for Best Director). Notable Netflix original commissions that have received multiple nominations for major awards include Fincher's *Mank* (ten Oscar nominations), Noah Baumbach's *Marriage Story* (six Oscar nods), and the Coen brothers' *The Ballad of Buster Scruggs* (three Oscar nominations). Not every SVOD auteur film has been successful in this regard; most of Amazon's auteur productions have failed to make waves in awards circles, as have a number of Netflix's, such as *The Laundromat* and *Elisa & Marcela*.

Support for auteur directors and the simultaneous pursuit of cultural legitimation, industrial acceptance, and long-term talent relationships is by no means unique to SVOD services. These are arguably crucial strategies for any new entrants needing the validation of the creative

establishment. The viability of this strategy going forward, including the investment of SVOD services in auteur cinema in the long term, is less clear. This question takes on further complexity given that the business models of the individual services are varied—Netflix is pure-play, while Prime Video and Apple TV+ are loss-leaders for their parent companies' other revenue streams—and unconventional from the perspective of traditional film industry economics: how does one measure the profitability of a film like *The Irishman*? But if history is any guide, few companies are able to sustainably adhere to the monumental auteur strategy for an extended period of time using traditional business models. Auteur films can function in the short term to bring artistic credibility to a studio and to establish talent relationships, but beyond that, these types of films make up only a small portion (financially and numerically) of most studios' slates and have typically been delegated to specialized divisions (for example, Disney's Searchlight; Universal's Focus Features).

Besides historical precedent and contemporary practices among the legacy studios, there have been some other indications that suggest the SVOD services are scaling back their investments in monumental auteurist filmmaking. Prime Video's dramatic shift in strategy in late 2017/early 2018 demonstrates this most vividly. Monumental auteur works were initially central to the company's strategy for original films, but that has diminished in recent years as the company has focused instead on big-budget genre cinema, as seen in the recent acquisitions of films such as *The Tomorrow War* (Chris McKay, 2021) and *Coming 2 America* (Craig Brewer, 2021). Netflix has continued to commission and acquire several auteur films annually for release largely during awards season (from September to late December), but the company has shown little willingness to take on another monumental project of the scale and cost of *The Irishman*. Instead, the company has turned to producing more moderately budgeted fare in this vein, as typified by recent auteur films like *Mank* and *Da 5 Bloods*. Production budgets for these films are estimated to be in the range of $20–$30 million and $35–$50 million respectively (Lang 2020).

Netflix's hesitance to commit to big-budget auteur filmmaking was also demonstrated by its failure in 2020 to outbid rival platforms for Scorsese's feature *Killers of the Flower Moon*. Apple TV+ eventually won this auction, reportedly offering a budget of over US$200 million (Kit 2020). Apple had already made a number of acquisitions in the auteur cinema vein, including *Cherry* (Joe Russo and Anthony Russo, 2020) and *Wolfwalkers* (Tomm Moore and Ross Stewart, 2020). Apple TV+ may have entered the streaming market much later but now appears to be embracing the same monumental auteur strategy first used by Prime Video and Netflix to establish their own legitimacy.

"Discovering" New Talents: SVOD Services and Early-Career Film Directors

The entrance of new corporations into the film industry has often been accompanied by the emergence of new creative talents who were able to make a name for themselves in large part due to the support of these new players. Studios like United Artists, Miramax, Polygram, and others were often willing to take a chance on new artists for pragmatic reasons: as untested talents, early-career directors worked for lower fees, and established studios were not always disposed to work with them until they were legitimized. These studios also relied on new artists as a point of differentiation from the establishment. So it was that the films of Steven Soderbergh, Jane Campion, and Quentin Tarantino helped to establish Miramax as a new studio in the Hollywood firmament, and Polygram attempted to break into the Hollywood power structure with career-making opportunities for David Fincher, the Coen brothers, and screenwriter Charlie Kaufman, among others. Indeed, it is one of the historical ironies of the SVOD era that many of its major auteur works have been made by directors who got their early career starts in previous eras of industry disruption.

Will SVOD disruption lead to the emergence of a similar group of fresh talents? Can it do one better and begin to correct the systemic

biases that have led White men to dominate the current field of auteur cinema? During a press conference promoting the 2021 Cannes Film Festival—an institution which famously banned Netflix's original films from competing for its top prizes in 2017—festival director Thierry Frémaux responded to a question about the exclusion of Netflix films by challenging the reporters in attendance to name a film director that Netflix had discovered. He then asserted that Cannes had a long history of uncovering new talent and that this made it a more valuable contributor to global film culture (Rose 2021). Frémaux's criticism, however illogical given the institutional differences between a film festival and an SVOD operator, does speak to an assumption that studios are judged by cultural critics and industry stakeholders alike on their ability to empower new artists. Have the SVOD disruptors been able to do this?

It is important to distinguish between instances in which SVODs acquire and distribute films by early-career directors and those they actually finance and produce. The latter is a much riskier endeavor than the former and creates a new work, though distribution too is a valuable contribution. This distinction is particularly important given that all three of the services discussed in this chapter have been very active in acquiring finished films by new and emerging filmmakers, often from marginalized social groups, and also in promoting them widely and presenting them for awards consideration. Examples include Amazon's acquisition of the films *One Night in Miami* (Regina King, 2020) and *Time* (Garrett Bradley, 2020), both of which were made by early-career African American women. *Hala* (2019), a film written and directed by Minhal Baig, an American woman of South Asian descent (her parents moved to the United States from Pakistan before she was born), was among the first feature film releases on Apple TV+. The film engages with the experiences of a teenage Muslim girl growing up in the United States. Finally, Netflix has also been very aggressive in acquiring and promoting films in this vein; consider *Mudbound* (Dee Rees, 2017), *Atlantics* (Mati Diop, 2019), and *Cuties* (Maïmouna Doucouré, 2020), all of which were directed by early-career Black women. All three services

have performed a discursive sleight of hand by distributing the films as "originals" even though they did not actually produce them.

Among the SVOD services discussed here, Netflix is the most prolific commissioner of films by early-career filmmakers by some distance. In order to contextualize the company's activities, it is important to look at how few of these works Netflix's peers have commissioned (notwithstanding their active acquisition strategies as described above). Apple TV+'s track record as a commissioner of original films is admittedly brief, which in part explains its lack of genuine productions directed by early-career filmmakers, at least as of 2022.[2] It is less understandable why Prime Video, which has been making original films for as long as Netflix and at one time aligned its brand with the empowerment of auteur directors, has not also dedicated more resources to supporting early-career filmmakers and potential auteurs of the future. Whatever its reasons for this commissioning strategy—be they related to creative risk aversion, the company's business model, or other factors—up to the end of 2021, Prime Video's original productions by "new talents" are limited to nine films in total, the bulk of which were microbudget horror films. These begin with the film *Troop Zero* (2019), directed by the duo Bert and Bertie, the second feature for the two women. The other films commissioned by the company encompass a group of eight horror/thriller movies that were produced by Hollywood low-budget horror veterans Blumhouse Pictures and directed by early-career filmmakers. When announcing the deal, Amazon and Blumhouse highlighted the fact that the deal called for the films to be directed by "diverse and emerging filmmakers" (as quoted in Rubin 2020).

Returning to Netflix, the company has been the clear leader among the SVOD services in producing films by early-career directors. Several examples of debut feature films can be identified: *Set It Up* (2018), which was the first feature for Claire Scanlon; *Like Father* (2018), the feature debut for Lauren Miller Rogen; *Always Be My Maybe* (2019), Nahnatchka Khan's debut feature; and the action film *Extraction* (2020), which was the first feature for director Sam Hargrave. In addition, Netflix has also made several

small-scale features (in budgetary and also promotional terms) with first-time directors such as Stefon Bristol (*See You Yesterday*, 2019), Jennifer Kaytin Robinson (*Someone Great*, 2019), and Alan Yang (*Tigertail*, 2020).

Further, Netflix has done this kind of commissioning extensively in the anglophone world and beyond. Working with new directing talents has been a defining feature of Netflix's localization efforts in various countries. In France, for example, Netflix's first film productions included *Je ne suis pas un homme facile*/*I Am Not an Easy Man* (Eléonore Pourriat, 2018) and *Banlieusards*/*Street Flow* (Kery James and Leïla Sy, 2019), the debut features of their respective directors. In Italy Netflix announced a coproduction deal with broadcaster Mediaset in 2019 for a total of seven features. The agreement stipulated that the directors involved would be in the early stage of their careers: "We will be working with new professionals who up until now have not had the opportunity to tell their stories to the world," said Netflix CEO Reed Hastings when announcing the deal (as quoted in Vivarelli 2019). To date, Netflix has released five feature films under the pact—*Ultras* (Francesco Lettieri, 2020), *Sotto il sole di Riccione*/*Under the Riccione Sun* (Younuts, 2020), *L'ultimo paradiso*/*The Last Paradiso* (Rocco Ricciardulli, 2021), *Sulla stessa onda*/*Caught by a Wave* (Massimiliano Camaiti, 2021), and *Il divin codino*/*Baggio: The Divine Ponytail* (Letizia Lamartire, 2021)—and all have indeed been directed by filmmakers in the early stages of their directing careers, including several debut features. In India, where Netflix has been very active in film commissioning, there has been no formal agreement to produce films with early-career directors, but this has nevertheless been the case with *Guilty* (Ruchi Narain, 2020) and *Bulbbul* (Anvita Dutt, 2020), among many others. Besides the fact that many of these directors were new to the craft, many were also either from racial or ethnic minorities (such as Kery James and Leïla Sy), women (numerous examples including Eléonore Pourriat, Letizia Lamartire, Anvita Dutt, etc.), or both (in the case of Sy and others).

Tellingly, Netflix has gone to some lengths to point out its endeavors to support underrepresented filmmakers around the world, with

press releases, social media promotion (often under a range of accounts targeted at niche audiences), press events, and even an academic study sponsored by Netflix from the University of Southern California's Annenberg Inclusion Initiative to highlight its track record in commissioning films made by women (Smith et al. 2021). While these publicity materials typically feature some kind of acknowledgement of shortcomings and areas for improvement, they nonetheless collectively present Netflix as an agent of change toward inclusivity in the film industry.

As Kristen Warner (2021) has pointed out, this self-promotion by Netflix is exaggerated and problematic. So too is the accompanying optimism surrounding the ability of SVOD platforms to bring, as Warner puts it, "meaningful and long-lasting change" to the screen industries. But then it is also difficult to predict how these interventions will ultimately end up shaping the film industry. It will be important to monitor the subsequent career success of these early-career filmmakers to assess the long-term impact that Netflix is having with these efforts. Several of these film directors have gone on to direct subsequent projects for Netflix, including Stefon Bristol's *Gordon Hemingway & The Realm of Cthulu*, Jennifer Kaytin Robinson's *Strangers*, and Anuvita Dutt's *Qala*. These aspiring directors have taken steps with Netflix that they might not have been able to otherwise, and this does add more creative voices to the broader film industry, even if achieving more profound structural change will mean nurturing new and emerging producers, screenwriters, actors, and other artists as well. Whatever the results of these efforts are in the long term, one cannot deny for the time being at least that Netflix is still far and away the leader among the major SVOD players in terms of its support for emerging filmmakers.

Conclusion

This chapter has explored the feature-film commissioning and acquisition strategies used by leading SVODs. From one perspective, SVODs have diversified the modes of storytelling found in the global film industry

by investing in new films that are not subject to industrial logics that dominate Hollywood and existing power structures in other parts of the world. By both centering on experienced auteur directors and emerging directors, these services have enhanced the availability of films that were unlikely to have been otherwise produced and made them more accessible than a theatrical release afforded. Both forms of cinema analyzed in this chapter—monumental auteurist and early-career filmmaking—are under threat in the broader industry due to industrial conditions that have prioritized franchise filmmaking in recognizable popular genres made by a relatively small group of experienced industry insiders. In such an environment, both of the practices discussed here represent valuable interventions in contemporary film culture. It is not overstating the case to say that the willingness of SVODs to make or distribute such films has helped to keep certain kinds of artistically ambitious filmmaking alive and has provided new filmmakers with life-changing opportunities and experience.

We can make some critical observations about these strategies and how they are implemented by the companies considered. First, the production of auteur cinema makes up a much larger part of the streamers' strategies and financial commitments than does early-career filmmaking. Of the big three new entrants to the film industry (Apple, Amazon, Netflix), two companies barely commission films by early-career filmmakers, while all three have spent great sums of money on supporting filmmaking by big-name directors. When one compares the budgets allotted to Martin Scorsese's two original films for streaming services, for example—US$150 million-plus for *The Irishman* and US$200 million for *Killers of the Flower Moon*—to the €2 million reportedly spent on *Street Flow* (El Abadi 2019), the disparity is obvious. Put crudely, dozens of early-career filmmakers' projects could be produced for what the average monumental auteur work costs, and that is before considering marketing costs.

A second, perhaps even more worrisome problem from the point of view of artistic diversity lies not in the dedication of resources to works by established auteurs but instead in the newfound interest in big-budget,

spectacle-driven franchise filmmaking at Prime Video and Netflix especially. Amazon's strategy turned in this direction recently and somewhat opportunistically during the COVID-19 crisis, when it acquired a number of titles from other studios that were originally intended as theatrical releases. In so doing, the company reportedly spent large sums of money acquiring films that were either sequels (such as *Coming 2 America*, purchased for a reported US$125 million [Fleming 2020a]) or big-budget spectacle-driven films from which the company hopes to build franchises. The latter group includes action thriller *Without Remorse* (Stefan Sollima, 2021) and the science fiction film *The Tomorrow War* (Chris McKay, 2021), for which Amazon reportedly paid US$200 million, with a forthcoming sequel reportedly in development (D'Alessandro 2021). Netflix, which has been involved in big-budget spectacle filmmaking since it produced *Bright* (David Ayer) in 2017 for a reported US$90 million (Fleming 2016), has recently grown its ambitions in this regard, financing films such as *6 Underground* (Michael Bay, 2019) to the tune of a reported US$150 million (Fleming 2018), and *The Gray Man* (Joe and Anthony Russo, 2022) which is said to cost at least US$200 million (Fleming 2020b). All of these works and others were made with Hollywood veterans, using established stars; and in all cases, Netflix hopes to launch franchises around them.

In other words, both Netflix and Prime Video are spending vast sums of money following strategies that are remarkably similar to those found at their legacy studio counterparts: essentially producing and acquiring blockbuster Hollywood fare, presumably to compete with the Hollywood studios. After all, this push for blockbuster filmmaking has come as nearly all of the legacy studios have launched their own SVOD services. A crucial element of the studios' conglomerate strategies in the years ahead is said to be licensing their feature films exclusively to their corporate siblings, meaning that Disney's Marvel films would only be available through Disney+ and Disney's linear networks, for example. With Warner Bros. following suit with HBO Max, Paramount with Paramount+, and Comcast/Universal with its Peacock SVOD service, Netflix, Prime

Video, and Apple TV+ all face the prospect of missing out on the ability to license studio blockbusters. This, combined with a historical pattern of growing risk aversion by studios as they establish themselves in their respective industries (see for instance Miramax's trajectory as a film studio or Fox's development as a television broadcaster), at least raises the possibility that the "disruptors" could move away from the practices discussed in this chapter. For now, however, it does not seem to be a zero-sum game, as Netflix, Prime Video, and Apple TV+ continue to make and distribute diverse content while taking steps toward the aforementioned Hollywood studio model. One should not be overly optimistic that the kinds of film-making analyzed in this chapter will be prioritized over the long term by the SVODs. The question of balance between the different forms of film commissioning discussed here will thus be very important for SVOD scholarship going forward.

Notes

1 Allen initially signed a deal to direct four features for Amazon, but Amazon backed out of the deal when sexual abuse allegations against Allen resurfaced in 2018. Allen denied the charges and later sued Amazon for breach of contract. The suit settled for an undisclosed amount in 2019.
2 The company did also release the film *CODA*, which won the Oscar for Best Picture in 2022, and which was directed by Sian Heder, an early-career filmmaker. Apple acquired this film but has since signed a long-term deal to collaborate with Heder on the development of future projects.

References

Balio, Tino. 1987a. *United Artists: The Company Built by the Stars, Vol. 1, 1919–1950*. Madison: University of Wisconsin Press.

Balio, Tino. 1987b. *United Artists: The Company that Changed the Film Industry, Vol. 2, 1951–1978*. Madison: University of Wisconsin Press.

D'Alessandro, Anthony. 2021. "*The Tomorrow War 2*: Amazon & Skydance Already in Talks for Sequel Reteaming with Chris Pratt, Director Chris McKay and More." *Deadline Hollywood*, July 8, 2021. https://deadline.com/2021/07/chris-pratt -tomorrow-war-2-amazon-skydance-in-talks-1234788748/.

El Abadi, Saïd. 2019. "Leïla Sy and Kery James: 'Un banlieusard est capable de trans-former les inconvenients en avantages.'" *CNews*, October 11, 2019. https://www.cnews.fr/culture/2019-10-11/leila-sy-et-kery-james-un-banlieusard-est-capable-de-transformer-les.

Fleming, Mike. 2016. "Netflix Commits $90 Million+ for David Ayer-Directed Will Smith-Joel Edgerton Pic *Bright*; $3 Million+ for Max Landis Script." *Deadline Hollywood*, March 18, 2016. https://deadline.com/2016/03/netflix-bright-will-smith-90-million-deal-david-ayer-joel-edgerton-max-landis-1201721574/.

Fleming, Mike. 2018. "Netflix, Michael Bay, Ryan Reynolds & Skydance Set Action Franchise *Six Underground*." *Deadline Hollywood*, May 22, 2018. https://deadline.com/2018/05/ryan-reynolds-michael-bay-netflix-six-underground-skydance-film-franchise-1202394010/.

Fleming, Mike. 2020a. "Amazon Will Stream Eddie Murphy's *Coming 2 America* Sequel Because of Uncertain Theatrical Marketplace." *Deadline Hollywood*, October 13, 2020. https://deadline.com/2020/10/eddie-murphy-coming-to-america-in-amazon-streaming-talks-uncertain-theatrical-marketplace-1234596555/.

Fleming, Mike. 2020b. "Netflix Commits Largest Budget So Far for *The Gray Man*; Ryan Gosling, Chris Evans Star, AGBO's Joe and Anthony Russo Direct Mano a Mano Espionage Thriller." *Deadline Hollywood*, July 17, 2020. https://deadline.com/2020/07/netflix-the-gray-man-ryan-gosling-chris-evans-joe-russo-anthony-russo-directing-1202987267/.

Jenner, Mareike. 2018. *Netflix and the Re-Invention of Television*. London: Palgrave Macmillan.

Kit, Borys. 2020. "Apple to Partner with Paramount for Martin Scorsese's *Killers of the Flower Moon*." *The Hollywood Reporter*, May 27, 2020. https://www.hollywoodreporter.com/news/general-news/apple-partner-paramount-martin-scorseses-killers-flower-moon-1287944/.

Lang, Brent. 2020. "Magnificent Obsession: David Fincher on His Three-Decade Quest to Bring *Mank* to Life." *Variety*, November 18, 2020. https://variety.com/2020/film/news/david-fincher-mank-netflix-citizen-kane-1234834134/.

Lobato, Ramon. 2019. *Netflix Nations: The Geography of Digital Distribution*. New York: NYU Press.

Lotz, Amanda. 2017. *Portals: A Treatise on Internet-Distributed Television*. Ann Arbor: Michigan Publishing.

Mendelson, Scott. 2019. "*The Irishman* was an Offer that Hollywood Had to Refuse (and Only Netflix Could Accept)." *Forbes*, July 31, 2019. https://www.forbes.com/sites/scottmendelson/2019/07/31/scorsese-de-niro-pacino-pesci-irishman-hoffa-trailer-netflix-oscars-box-office/?sh=3206e5457d92.

Meir, Christopher. 2019. *Mass Producing European Cinema: Studiocanal and Its Works*. London: Bloomsbury.

Netflix. 2018. "*Elisa & Marcela* Written and Directed by Isabel Coixet, Set to Be Next Spanish Netflix Original Film." *Netflix Media Center*, May 7, 2018. https://about

.netflix.com/en/news/elisa-marcela-written-and-directed-by-isabel-coixet-set-to-be
-next-spanish-netflix-original-film.

Perren, Alisa. 2012. *Indie Inc.: Miramax and the Transformation of Hollywood in the 1990s*. Austin: University of Texas Press.

Rose, Steve. 2021. "The Stream Runs Dry: Why Hasn't Netflix Discovered Any Big Directors?" *The Guardian*, July 19, 2021. https://www.theguardian.com/film/2021/jul/19/has-netflix-ever-discovered-any-major-directors-or-franchises.

Rubin, Rebecca. 2020. "Eight New Blumhouse Horror Films Coming to Amazon." *Variety*, August 13, 2020. https://variety.com/2020/film/news/blumhouse-movies-amazon-1234733954/.

Smith, Stacy L., Katherine Pieper, Marc Choueiti, Kevin Yao, Ariana Case, Karla Hernandez, and Zoe Moore. 2021. "Inclusion in Netflix US Original Scripted Series and Films." USC Annenberg Inclusion Initiative. https://annenberg.usc.edu/news/research-and-impact/annenberg-inclusion-initiative-releases-study-representation-netflix.

Vivarelli, Nick. 2019. "Netflix and Mediaset Announce Details of Major Italian Production Agreement." *Variety*, October 8, 2019. https://variety.com/2019/digital/news/netflix-and-mediaset-announce-details-of-italian-agreement-1203363016/.

Warner, Kristen. 2021. "Blue Skies Again: Streamers and the Impossible Promise of Diversity." *Los Angeles Review of Books*, June 24, 2021. https://lareviewofbooks.org/article/blue-skies-again-streamers-and-the-impossible-promise-of-diversity/.

17

To All the Romantic Comedies I've Loved Before

How Netflix Reinvigorated a Genre

ALEXA SCARLATA

During the 1980s and 1990s, the Hollywood romantic comedy was a date night and box office staple. At the time, the genre was both economical to produce and relatively high grossing, and it capitalized on a period of prosperity and positivity. Over the last two decades however, the studio system has gradually abandoned the romcom, leaving it "temporarily dormant or dead" (Obst 2013, 250) in favor of properties with a pre-awareness that can be marketed into international franchises. In 2018–19 the genre's U.S. box office market share was only 2–2.5 percent as compared to nearly 11 percent in 1999.[1]

Nevertheless, the romantic comedy remains a durable, flexible, and valuable genre, as demonstrated by recent shifts in the production and distribution of these films by Netflix. A genre decreasingly "profitable enough" for studio fates tied to box office sales presented an opportunity for the subscription video-on-demand (SVOD) service. Since 2017, Netflix has been responsible for instigating what the news media eagerly dubbed a "rom com renaissance" (Wilkinson et al. 2018). This began with holiday films like *A Christmas Prince* (2017), but the 2018 slate of *The Kissing Booth, Set It Up, To All the Boys I've Loved Before,* and *Sierra Burgess is a Loser* saw the genre generate significant attention to the service. Netflix reports more than eighty million household accounts watched one or more of these titles (Netflix 2018b). A new Netflix romantic comedy has been released almost monthly ever since, and these movies now account for more than 10 percent of the service's suite of

original feature films, with many more currently in development around the world.

This chapter investigates two aspects of this romcom revitalization. First, I explain how the affordances of SVOD—namely the private nature of consumption and repeat-viewing encouraged by a fixed monthly price—are well suited to the genre, and how the production costs and promotional opportunities of romantic comedies offer strategic value to Netflix. Second, I consider how Netflix's slate of romcoms has experimented with the genre to reach previously underserved niche audiences and reflect evolving romantic norms. I focus here on those movies that address a tween/teen audience (like *To All the Boys I've Loved Before* and *Tall Girl*) and those that champion diverse cultures and sexualities at the lead-level (such as *Always Be My Maybe* and *Let it Snow*). SVOD industrial conditions allow for the remodeling of the storytelling conventions of the romantic comedy. To date, Netflix romcoms have both embraced formulaic conventions and reflected a diverse global video-on-demand audience that is quite distinct from the demographic for the genre long imagined by the theatrical box office. Netflix has reinvigorated the genre, ushering in the next phase of the romcom.

It's Not You, It's Me: Why Hollywood Broke Up with the Romantic Comedy

The romantic comedy has "long been regarded as an inferior film genre by critics and scholars alike, accused of maintaining a strict narrative formula which is considered superficial and highly predictable" (Kaklamanidou 2013, i). Additionally, films that have a quest for love as their central narrative can be stigmatized in terms that "link the low value placed on the form to its feminization—its orientation toward and consumption by female audiences"; it is "persistently cast as a (at best) guilty pleasure and (at worst) shameful vice" (San Filippo 2021, 6, 13). That being said, romantic comedy scholars—including Paul (2002), Deleyto (2003, 2009), Jeffers McDonald (2007), Grindon (2011), and, more re-

cently, the many contributors to San Filippo's edited collections (2020, 2021)—have firmly rejected the tendency to approach the romantic comedy as an inherently bad object. Their respective chronicles of the various cycles, clusters, and periods of the genre have established that it "presents a process of transformation, an ongoing negotiation between a flexible body of convention and changes in the culture at large" (Grindon 2011, 65–6). Since the screwball and home-front romantic comedies of the 1930s and 1940s, these films have reflected society's melancholies, anxieties, and ambivalences. They are valuable, complex works that "express our own conflicting desires and flawed impulses" (San Filippo 2021, 15), and in the evolution of these they "mediate between a body of conventionalized generic rules . . . and a shifting environment of sexual-cultural codifications" (Krutnik 1990, 58).

Perhaps it is for this reason that, despite its dogged denigration, the romcom has been "a staple in the Hollywood machine for as long as movies have been around" (Guerrasio 2017). Romantic comedies may in fact be, as Jeffers McDonald (2007) suggested in her account of the genre's history, Hollywood's most consistently popular genre. Cheap to produce and star-driven, they represent an industrially structured genre that has served a very specific audience and therefore commercial function. Romcoms have created icons, won awards, underpinned our pop culture references, and fortified date nights. So why is it now a relative oddity to see a romantic comedy on a big screen?

In 1999 the romantic comedy genre accounted for nearly 11 percent of the U.S. box office. While theatrical earnings remained relatively stable up until 2019, the romantic comedy's market share has dropped significantly since 2011, with an average market share of 2 percent from 2011 to 2019 (The Numbers 2021). Many of the best performing romantic comedies are now decades old. Though there have been recent standouts within the genre—most notably *Trainwreck*, *Just Go with It*, and *Crazy Rich Asians*—that have performed impressively at the U.S. box office, not one of the ten top-grossing romantic comedies was produced after 2009's *The Proposal* (The Numbers 2021).

Some have attributed this drop to the withdrawal of big-name performers (and their loyal audiences) from the genre and the struggle to launch a new generation of actors who can become romantic comedy fixtures (Laman 2021). Others have credited changing attitudes towards love and relationships since the early 2000s. Since these films serve to reflect and engage with evolving societal conventions, an increased audience skepticism or apathy towards the genre's romanticizing tendencies has arguably seen "modern" theatrical examples somewhat disguised or subsumed—"laced with raunch or tweaked just enough thematically to make them more marketable in today's less-idealized world" (Cunningham 2016). Titles like *Knocked Up*, *Silver Linings Playbook*, and *How to Be Single*, for example, were "more than frothy flirt-fests. For all the laughs, they were unflinching takes on tough issues like commitment and mental illness" (Cunningham 2016). Love stories that leaned into schmaltz, froth, and earnestness have been largely incorporated as secondary plot-points of works that "configure romance in politically and representationally radical ways" and that "subvert rom-com fantasy and formula and reflect critically on the realities and complexities of intimacy" (San Filippo 2020, 3), while disguised as other genres entirely.

However, the romantic comedy's fall from cinematic grace is not merely attributable to frustrations with its formulaic tendencies—it remains just as consistently popular with audiences. Instead, broader industrial changes have made the theatrical release of other genres—namely action/adventure and horror/thriller—more commercially sustainable for studios. Interest in the middle-tier, midbudget adult movie has diminished. Fewer have been released in favor of a focus on big-budget film franchises like comic book movies that can spawn multiple sequels and bring in big grosses internationally (Figure 17.1).

In her 2013 book *Sleepless in Hollywood*, veteran producer Lynda Obst (*Sleepless in Seattle* and *How to Lose a Guy in 10 Days*) chronicled how the collapse of the DVD market and the rise of piracy ushered in what she calls the "New Abnormal" (because there wasn't anything normal about Hollywood to begin with). With studios now heavily dependent

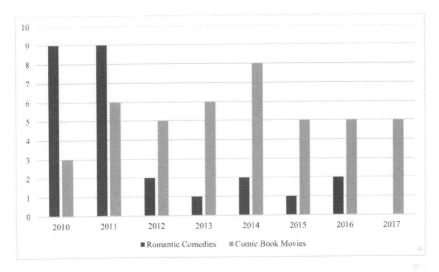

FIGURE 17.1. Romantic comedy and comic book movie releases, 2010–2017. Data source: Boxofficemojo.com in Guerrasio 2017.

on international markets for profit, they have grown their slates into a diet of either enormous "tentpoles" (franchises of sequels, prequels and reboots built on familiar properties with a built-in audience) or extremely low-risk "tadpoles" (tiny indies), leaving producers to "fight for the precious diminishing space you could justifiably call the 'in-between'" (Obst 2013, 6). According to Nancy Meyers, director of rom-coms *The Holiday* and *Something's Gotta Give*, "Once superhero movies really became the only [ones] movie studios cared about, the experience of making a movie like mine changed" (Handler 2020).

Romantic comedies are not particularly malleable. The resolution implicitly required by the genre—that is, the happy ending—means that these have largely been treated as standalone titles, unable to yield cinematic universes.[2] They cannot fall back on distracting with explosions and superheroes, but instead hinge on the elusive chemistry of the leads. As one studio executive cited in *The Wrap* remarked, "If you make an action movie and it doesn't have punch, you can add another set piece . . . If you have a comedy that doesn't click, you can add more jokes. But if you have a

romantic comedy and there's no chemistry between your stars, there's not much you can do" (as quoted in Cunningham 2016). Essentially, there is nothing inherent in romcoms that benefits from being on the big screen. "People never stopped craving comedies or dramas. But not enough people would pay to go see them in a theatre to make the economics as lucrative for a movie studio as Untitled Marvel Movie No. 7" (Shaw 2020). So, the romantic comedy's "valence and viewership" (San Filippo 2021, 3) was instead revived by the world's most popular SVOD service.

Netflix Romcoms: Not Just a Summer Fling

Though Netflix was initially known globally for its popular original series, films are increasingly important to the Netflix proposition: the service stated its intention to release at least one new original film every week in 2021 (Sperling 2021) and has achieved this goal, so far. As of April 2022, Netflix had distributed just over 530 original feature films.[3] These titles—either commissioned or acquired by the company for exclusive release—have earned the company deafening condemnation from cinephiles, filmmakers, film festivals and the theatrical establishment. They have also offered filmmakers unprecedented creative, technological, and financial support to produce critically acclaimed, award-winning movies, and many have ultimately proved popular with subscribers. Netflix original movies made the top ten most popular releases annually in many regions (Andreeva 2019; White and Kanter 2019).[4] Notably, romantic comedies featured frequently in these lists.

Netflix executives identified the trends outlined above: that the studios had largely abandoned the genre, that there were a lot of scripts out there that "nobody was making" (Sandberg 2018), and that existing licensed romcom titles already drew a well-defined audience on the service. According to Netflix's then director of original film, Matt Brodlie, executives began to observe how many users were opting to watch old romantic comedies from Netflix's extensive catalog of films. "We realized there weren't a lot of these films being made theatrically anymore, and we wanted to fulfil

the need for people to watch a satisfying romantic comedy . . . As the theatrical marketplace has gotten more competitive, distributors have been wanting—and needing—to make four-quadrant films. So there's a space for other films that may be more targeted" (as quoted in Kaufman 2018).

Since new Hollywood romcoms were few and far between, Netflix has commissioned and produced more romantic comedies than it has exclusively licensed. At the time of writing, 13 percent of all Netflix's globally available original feature films (69 of 536 titles) are romantic comedies. The service has not just instigated something of a "rom-com renaissance": it "built a rom-com factory" (Bonos 2018).

This revitalization commenced with the release of Netflix's first original romcom, *A Christmas Prince*, in November 2017. Shortly after its release, the service revealed that fifty-three subscribers had watched the Christmas film *every day* for eighteen days in a row (Figure 17.2). This was a rare insight into Netflix's direct access to viewing data and contravened the strict antitransparency policies maintained until late 2018 (Wayne 2021).

A Christmas Prince went on to spur two sequels and a spate of holiday-themed titles, including *The Holiday Calendar*, *The Princess Switch*, *Let It Snow*, and *The Knight Before Christmas*. However, its release signified more than just the beginning of seasonal battles with Hallmark and Disney for Christmas audiences; it foreshadowed Netflix's self-proclaimed "Summer of Love" in 2018. The wave of original romcoms that flowed,

Netflix ✔
@netflix

To the 53 people who've watched A Christmas Prince every day for the past 18 days: Who hurt you?

1:52 PM · Dec 11, 2017 · Twitter for iPhone

FIGURE 17.2. Netflix tweet, December 11, 2017. Source: Twitter, screenshot by author.

from *The Kissing Booth* (May) and *Set It Up* (June), to *To All the Boys I've Loved Before* (August) and *Sierra Burgess is a Loser* (September) garnered significant attention. Netflix original romcoms were "ubiquitous" that summer, during what was described as a "steady onslaught" (Andrews 2018). One in three viewers reportedly went back to rewatch *The Kissing Booth* (Lindsay 2018). According to Netflix's 2018 Q3 letter to shareholders, *To All the Boys* was one of the service's most viewed original films ever at that point, with strong repeat viewing: "More than 80 million accounts have watched one or more of the *Summer of Love* films globally and we are already in production for the next set of original romcoms for our members" (Netflix 2018b, 4).

Netflix went on to commission and release not just another set of romantic comedies, but to churn these films out with regularity. The streaming service has utilized the traditional studio strategy of Valentine's Day and Christmas releases, but additionally has drip-fed romcoms almost every month since. In 2019, notable releases included *The Perfect Date* (April), *Someone Great* (April), *The Last Summer* (May), *Always Be My Maybe* (May), and *Tall Girl* (September). It began 2020 with the February drop of *To All the Boys: P.S. I Still Love You*, followed by *Love Wedding Repeat* (April), *The Lovebirds* (May), *Desperados* (July), *Love, Guaranteed* (September), and *Holidate* (October). Sixty-six-million-member households watched *The Kissing Booth 2* (July 2020) in the first 28 days from release (Netflix 2020). The final installment of the *To All the Boys* trilogy (February 2021) was listed in the top movies of the first quarter of 2021 (Netflix 2021) and was followed by *He's All That* (August, a remake of 1999's *She's All That*), *Love Hard* (November), and *Single All the Way* (December).

Since 2020, Netflix has also amassed a robust slate of romantic comedies in languages other than English (Table 17.1) by commissioning titles from around the world. While there has been an emphasis on producing this content for the Spanish language and Latin American markets, it is interesting to note that the first Zimbabwean film on Netflix was the low-budget romcom *Cook Off* (Cotterill 2020). There have also been

TABLE 17.1. Netflix romantic comedies in languages other than English released since 2020

Netflix Release	Title (English translation)	Country of Origin
Feb 2020	*Issi & Ossi*	Germany
Mar 2020	*Maska*	India
Apr 2020	*Rich in Love*	Brazil
Sep 2020	*Whipped*	Indonesia
Oct 2020	*You've Got This*	Mexico
Oct 2020	*Ginny Weds Sunny*	India
Feb 2021	*Squared Love*	Poland
Feb 2021	*Crazy About Her*	Spain
Apr 2021	*Just Say Yes*	Netherlands
Jul 2021	*A Perfect Fit*	Indonesia
Aug 2021	*The Secret Diary of an Exchange Student*	Brazil
Sep 2021	*Friendzone*	France
Sep 2021	*Sounds Like Love*	Spain
Nov 2021	*Meenakshi Sundareshwar*	India
Nov 2021	*Just Short of Perfect*	Brazil
Dec 2021	*Anonymously Yours*	Mexico
Jan 2022	*Four to Dinner*	Italy
Feb 2022	*Love and Leashes*	South Korea
Mar 2022	*Without Saying Goodbye*	Peru
Mar 2022	*In Good Hands*	Turkey

several commissions of the genre announced in India and South Korea recently. This points to an enduring and global appetite for the genre. It also suggests that the romcom is particularly well suited to the affordances of a multinational SVOD.

Romcom Cents and Sensibilities

The romcom has thrived on Netflix for several reasons. First, the 2018 "Summer of Love" slate and many of the "satisfying and sincere" (Brodlie as quoted in Sandberg 2018) romcoms that followed marked the end of what Grindon described as a "grotesque and ambivalent cycle" of the genre (2011, 26) and represented a return to the schmaltzy romcoms of the '80s and '90s. While largely poorly received by critics, they were, as

Vulture described of *The Kissing Booth*, "bad in a comforting way. Most of the plot points and supporting characters are blatant rip-offs of earlier teen films, which gives the film a similar quality to those pop songs that build their hooks by sampling previous hits" (Jones 2018).

This is of course part of a wider strategy at Netflix to exploit nostalgia (Pallister 2019). It also uses the affordances of video-on-demand to the service's advantage. Despite the persistent popularity of the genre, romantic comedies are often branded as trivial and their audiences frivolous, but Netflix provides a space to make viewing choices free from judgment. Suddenly, unabashedly sincere romantic comedies could now be (and evidently were) voraciously consumed on Netflix in homes. The largely private nature of SVOD engagement and the repeat-viewing encouraged by a fixed monthly price has enabled audiences to lean into the type of predictable, sappy content that might see them publicly ridiculed at the box office. It is difficult to quantify the value of the significant rewatching of these texts, which Netflix has identified. However, to the extent that rewatch potential is "one of the forces driving a spate of blockbuster TV deals" (Jurgensen 2019) to help gain and retain subscribers, original romantic comedies appear to provide Netflix with a valuable proposition.

The production costs and cross-promotional opportunities of the genre also offer strategic branding value to Netflix. While increasingly risky for studios, romantic comedies are cost-effective, midbudget opportunities to help cross-promote Netflix's own stable of stars. The service could afford to take a bet on picking up *Set It Up*, for example, when it was abandoned by MGM, and cast a relative unknown who would go on to star in several Netflix titles.[5] There have been some romcom film spin-offs from commissioned stand-up specials—such as *When We First Met* and *Always Be My Maybe*—and instances where Netflix series regulars from shows like *Riverdale* and *Stranger Things* have made the jump to star in their own romcoms.[6] Netflix has proudly pointed to cast Instagram followings pre- and post-release of some of their 2018 romcoms as indicators of their success (Roettgers 2018).[7]

Netflix romantic comedies have also, over time, somewhat nullified the negative connotations surrounding the genre, enticing some big names who had abandoned it to return to the fold. Reese Witherspoon, for example, is currently producing and starring in two such films for the streaming service (Fleming Jr. 2020). Similarly, the SVOD service has provided a space for creatives who had been abandoned by the studio model: in April 2022 it was announced that after a five-year hiatus, Nancy Meyers would make her return to directing with a feature for Netflix (Galuppo 2022). Finally, while the genre has proven hard for studios to franchise, Netflix has been able to maneuver multiple sequels and spin-offs out of several concepts: *A Christmas Prince, The Kissing Booth, To All the Boys I've Loved Before,* and *The Princess Switch.*

There is no singular "type" of Netflix romantic comedy: many adopt a formulaic and predictable happy ending, but others have more of a friendship or road-trip focus; several employ a "they didn't get the girl but learned a valuable lesson about themselves" approach. Some are saccharine, others confronting. But as Lobato and Ryan (2011, 188) note, "contingencies of distribution play an important role in determining the content of individual texts and the characteristics of film genres; they enable new genres to emerge at the same time as they impose limits on generic change." As a global SVOD, Netflix has been able to remodel the romantic comedy in interesting ways. One example is how the service's slate has experimented with the parameters of the genre to reach previously overlooked niche audiences, like tweens.

In the early 2000s, Hollywood "went after" a female tween (ages 8–14) audience. "Chick flicks" like *The Princess Diaries, Legally Blonde, Save the Last Dance, Freaky Friday,* and *The Sisterhood of the Traveling Pants* were successful in part because they drew a large contingent of tweens. As Tally wrote, this consumer group was attractive to studios for a number of reasons. "Tween girls [were] considered to be very large consumers themselves as well as being highly influential in their parents' purchasing decisions" (Tally 2005, 313). They were also inclined to repeat watch, were

relatively inexpensive to market to, were susceptible to word-of-mouth advertising, and "unlike many blockbuster films which are directed towards teenage boys, younger 'chick flick' movies generally cost a lot less to make, so the potential for profit [was] not offset by high production costs" (Tally 2005, 314). It's no surprise then that as Hollywood shifted focus to the economies of scale that the blockbuster franchise could provide, Netflix would try to break into this valuable market. *The Kissing Booth*, *To All the Boys I've Loved Before*, and *Tall Girl* are all relatively uncontroversial high school romcoms that can appeal to many taste communities, but especially to this demographic. "While they aspire to being teenagers, this does not necessarily mean that [tweens] are comfortable watching films that feature more sophisticated teen themes involving sex, drugs, or alcohol" (Tally 2005, 316). For the obedient, respectful, and "normal" protagonists in these texts, Elle, Lara Jean, and Jodi, the overwhelming emphasis was not so much on them "getting the guy" but rather becoming confident and empowered by the closing credit sequence. *To All the Boys* screenwriter Sofia Alvarez described Lara Jean's story as being one "about a young girl who is comfortable being the sidekick in her own narrative, before suddenly finding herself to be the heroine: 'I wrote [Lara Jean] for the girls who aren't quite ready for the next steps'" (quoted in Mei 2018). The result here is an array of relatable and seemingly "realistic" romantic comedies that can ingratiate Netflix with a passionate audience at an impressionable age, without antagonizing their parents, who are footing the bill. Win-win.

Finally, the SVOD has also been able to remodel the genre to reflect more contemporary gender politics and a wider swathe of the community. Hollywood romcoms have historically been overwhelmingly White and heterosexual, but Netflix romcoms have featured culturally and sexually diverse protagonists. U.S.-produced *To All the Boys*, *Set it Up*, and *Always Be My Maybe*, for example, have been widely praised for centering their narratives around Asian American protagonists without fetishizing their race. While Wong and Park's Asian heritage influences the ways in which their characters interact and the humor that they employ in *Always Be My Maybe*, this is by no means the entire story, which

is a spin on the familiar premise of "the one that got away." *Someone Great* and *Let It Snow* present diverse sexualities in an entirely prosaic manner. Recent Netflix commission announcements suggest a future proliferation of LGBTQI+ romcoms. Importantly, the texts produced so far have not ignored ethnicity and sexuality altogether, but rather normalized a diversity of identities that reflects the global Netflix audience and evolving relationship norms.

As these developments suggest, the romantic comedy has well and truly emerged from its theatrical dormancy. In 2018 Netflix advised its shareholders: "As traditional exhibition focuses increasingly on superheroes and sequels, our on-demand service allows us to serve a wide variety of tastes" (2018a, 3). The service has clearly seen value in catering to an ardent but diffident romantic comedy audience. However, the affordances of SVOD have also enabled a remodeling of the genre to cater to underserved tweens and a more culturally and sexually diverse viewership. The case of the romcom is a good illustration of how it is not a zero-sum battle between theatrical release and streaming services. Rather, the particular affordances of streaming services enable different types of movies to be commercially valuable than the dominant, theatrical window-driven value system characteristic of pre-streaming.

Notes

1 Film industry data website *The Numbers* (2021) categorizes U.S. theatrical releases according to creative type, source, genre, MPAA rating, production method, and distributor to chart year-by-year trends across these categories. "In order to provide a fair comparison between movies released in different years, all rankings are based on ticket sales, which are calculated using average ticket prices announced by the MPAA in their annual state of the industry report" (The Numbers 2021).

2 Using the same stars in multiple romcoms has been a common strategy, however: consider Meg Ryan and Tom Hanks's success across multiple titles, and the many romantic comedies of Katherine Heigl or Matthew McConaughey in the early 2000s.

3 This figure does not include documentary titles.

4 Netflix did not share a comparable series of format-agnostic "most popular" lists for its content from 2020, and independent trackers have focused on ranking only the success of Netflix original series.

5 MGM halted the development of *Set It Up* after *Game of Thrones* star Emilia Clarke dropped out of the lead role. Netflix's replacement for her, Zoey Deutch, went on to star in Ryan Murphy's Netflix original series *The Politician* and is teaming back up with *Set It Up* creators and cast for another Netflix romantic comedy (Galuppo 2019).

6 For example, *Riverdale*'s KJ Apa went on to helm *The Last Summer*; Gillian Jacobs followed *Love* with *Ibiza*; *Stranger Things*' Shannon Purser played the titular role in *Sierra Burgess is a Loser*; and Kiernan Shipka supplemented *Chilling Adventures of Sabrina* with *Let it Snow*.

7 What's more, the service rode the wave of actor Noah Centineo's newfound popularity spurred by the first *To All the Boys I've Loved Before* installment, for example, by licensing several of his existing movies and casting him as the lead in even more original romcoms to meet demand.

References

Andreeva, Nellie. 2019. "*Murder Mystery, Stranger Things* Lead Netflix's List of Most Popular Movies, TV Series & Specials of 2019." *Deadline*, December 30, 2019. https://deadline.com/2019/12/murder-mystery-stranger-things-3-netflix-list-of -most-popular-movies-tv-series-of-2019-the-witcher-you-netflix-what-we-watched -2019-1202818337/.

Andrews, Jared. 2018. "What Netflix's 'Summer of Love' Does Right." *Vox*, August 29, 2018. https://www.voxmagazine.com/arts/what-netflixs-summer-of-love-does-right /article_b068be4a-aa26-11e8-9f14-f329abf8193a.html.

Bonos, Lisa. 2018. "Netflix Knows We Need an Escape. So It Built a Rom-Com Factory." *The Washington Post*, July 27, 2018. https://www.washingtonpost.com/news /soloish/wp/2018/07/26/netflix-knows-we-need-an-escape-so-it-built-a-rom-com -factory/.

Cotterill, Joseph. 2020. "The Zimbabwean Romcom and Netflix: 'Now It's Africans Telling Stories.'" *Financial Times*, July 4, 2020. https://www.ft.com/content /be04b6b1-d4ef-48d4-a9de-0df596c9345e.

Cunningham, Todd. 2016. "The Romantic Comedy Isn't Dead—It's Just Gotten Raunchier." *The Wrap*, February 12, 2016. https://www.thewrap.com/the-romantic -comedy-isnt-dead-its-just-gotten-raunchier/.

Deleyto, Celestino. 2003 "Between Friends: Love and Friendship in Contemporary Hollywood Romantic Comedy." *Screen* 44 (2): 167–82.

Deleyto, Celestino. 2009. *The Secret Life of Romantic Comedy*. Manchester: Manchester University Press.

Fleming Jr., Mike. 2020. "Reese Witherspoon to Star in Two Netflix Romcoms from Hello Sunshine: Aggregate-Produced, Aline Brosh McKenna-Helmed *Your Place or Mine* & *The Cactus*." *Deadline*, May 12, 2020. https://deadline.com/2020/05 /reese-witherspoon-two-netflix-romantic-comedies-hello-sunshine-the-cactus -aggregate-films-aline-brosh-mckenna-the-cactus-1202932978/.

Galuppo, Mia. 2019. "Zoey Deutch, Glen Powell, *Set It Up* Filmmakers Reteam for New Rom-Com (Exclusive)." *The Hollywood Reporter*, May 2, 2019. https://www .hollywoodreporter.com/news/glen-powell-zoey-deutch-set-it-up-team-set-new -rom-1206576.

Galuppo, Mia. 2022. "Nancy Meyers to Make Directing Return with Netflix Movie." *The Hollywood Reporter*, April 5, 2022. https://www.hollywoodreporter .com/movies/movie-news/nancy-meyers-directing-return-netflix-movie -1235125515/.

Grindon, Leger. 2011. *The Hollywood Romantic Comedy*. Malden, MA: Wiley.

Guerrasio, Jason. 2017. "The Big Hollywood Romantic Comedy Is Dead—Here's What Happened to It." *Business Insider Australia*, August 8, 2017. https://www .businessinsider.com.au/why-movie-studios-no-longer-make-romantic-comedies -2017-8.

Handler, Rachel. 2020. "Nancy Meyers Searches for Her Own Comfort." *Vulture*, December 14, 2020. https://www.vulture.com/2020/12/nancy-meyers-interview-on -retirement-hygge-and-her-career.html.

Jeffers McDonald, Tamar. 2007. *Romantic Comedy: Boy Meets Girl Meets Genre*. New York: Columbia University Press.

Jones, Nate. 2018. "Your Guide to *The Kissing Booth*, the New Netflix Movie All the Teens Are Wild for." *Vulture*, June 6, 2018. https://www.vulture.com/2018/06/kissing -booth-joey-king-jacob-elordi.html.

Jurgensen, John. 2019. "Déjà View: The Psychology Behind The 'Rewatch.'" *The Wall Street Journal*, October 8, 2019. https://www.wsj.com/articles/deja-view-the -psychology-behind-the-rewatch-11570549278.

Kaklamanidou, Betty. 2013. *Genre, Gender and the Effects of Neoliberalism: The New Millennium Hollywood Rom Com*. London: Routledge.

Kaufman, Amy. 2018. "Where Has the Romantic Comedy Gone? To Netflix." *Los Angeles Times*, August 3, 2018. https://www.latimes.com/entertainment/movies/la-ca-mn -netflix-summer-of-love-movies-20180803-story.html.

Krutnik, Frank. 1990. "The Faint Aroma of Performing Seals: The 'Nervous' Romance and the Comedy of the Sexes." *Velvet Light Trap* 26:57–72.

Laman, Douglas. 2021. "The Real Reason Big-Screen Romantic Comedies Stopped Being Made." *Looper*, January 6, 2021. https://www.looper.com/308278/the-real -reason-big-screen-romantic-comedies-stopped-being-made/.

Lindsay, Kathryn. 2018. "The Rom-Com Renaissance Is Here Thanks to Netflix." *Refinery29*, June 23, 2018. https://www.refinery29.com/en-us/2018/06/202326/netflix-is -bringing-back-romantic-comedies.

Lobato, Ramon, and Mark David Ryan. 2011. "Rethinking Genre Studies Through Distribution Analysis: Issues in International Horror Movie Circuits." *New Review of Film and Television Studies* 9 (2): 188–203.

Mei, Gina. 2018. "*To All the Boys I've Loved Before* Is an Extraordinary Rom-Com About Ordinary Teens." *Vanity Fair*, August 16, 2018. https://www.vanityfair.com/hollywood/2018/08/to-all-the-boys-ive-loved-before-netflix-romantic-comedy-jenny-han-interview.

Netflix. 2018a. Q2-18-Shareholder Letter, July 16, 2018. Available at https://ir.netflix.net/financials/quarterly-earnings/default.aspx.

Netflix. 2018b. Q3-18-Shareholder Letter, October 16, 2018. Available at https://ir.netflix.net/financials/quarterly-earnings/default.aspx.

Netflix. 2020. Q3-20-Shareholder Letter, October 20, 2020. Available at https://ir.netflix.net/financials/quarterly-earnings/default.aspx.

Netflix. 2021. Q1-21-Shareholder Letter, April 20, 2021. Available at https://ir.netflix.net/financials/quarterly-earnings/default.aspx.

Netflix Twitter. 2017. December 11, 2017. https://twitter.com/netflix/status/940051734650503168?lang=en.

Numbers, The. 2021. "Box Office History for Romantic Comedy." August 6, 2021. https://www.the-numbers.com/market/genre/Romantic-Comedy.

Obst, Lynda. 2013. *Sleepless in Hollywood: Tales from the New Abnormal in the Movie Business*. New York: Simon & Schuster.

Pallister, Kathryn, ed. 2019. *Netflix Nostalgia: Streaming the Past on Demand*. Lanham, MD: Lexington.

Paul, William. 2002. "The Impossibility of Romance: Hollywood Comedy, 1978–1999." In *Genre and Contemporary Hollywood*, edited by Steve Neale, 117–29. London: BFI.

Roettgers, Janko. 2018. "More Than 80 Million Subscribers Watched Netflix Rom-Coms This Summer." *Variety*, October 16, 2018. https://variety.com/2018/digital/news/netflix-rom-coms-80-million-1202981966/.

San Filippo, Maria. 2020. "Radical Rom-Com: Not an Oxymoron." *New Review of Film and Television Studies* 18 (1): 3–7.

San Filippo, Maria, ed. 2021. *After "Happily Ever After": Romantic Comedy in the Post-Romantic Age*. Detroit: Wayne State University Press.

Sandberg, Bryn. 2018. "How Netflix Revived the Rom-Com Genre: 'Nobody Was Making Them.'" *The Hollywood Reporter*, December 21, 2018. https://www.hollywoodreporter.com/news/how-netflix-revived-rom-genre-1169776.

Shaw, Lucas. 2020. "Netflix Reveals the Next Phase in Its Original Movie Strategy." *Bloomberg*, July 20, 2020. https://www.bloomberg.com/news/newsletters/2020-07-19/netflix-reveals-the-next-phase-in-its-original-movie-strategy.

Sperling, Nicole. 2021. "Netflix, Flexing Its Muscles, Announces 2021 Film Slate." *The New York Times*, January 12, 2021. https://www.nytimes.com/2021/01/12/business/media/netflix-2021-movies.html.

Tally, Peggy. 2005. "Re-imagining Girlhood: Hollywood and the Tween Girl Market." *Counterpoints* 245:311–329.

Wayne, Michael L. 2021. "Netflix Audience Data, Streaming Industry Discourse, and the Emerging Realities of 'Popular' Television." *Media, Culture & Society*, June 2021. https://doi.org/10.1177/01634437211022723.

White, Peter, and Jake Kanter. 2019. "Netflix Reveals Most Popular International Titles of 2019: Madeleine McCann True-Crime Doc Tops UK, *Murder Mystery* Leads in Australia." *Deadline*, December 20, 2019. https://deadline.com/2019/12/netflix-reveals-most-popular-international-titles-of-2019-madeleine-mccann-true-crime-doc-tops-uk-murder-mystery-leads-in-australia-1202818375/.

Wilkinson, Alissa, Aja Romano, Genevieve Koski, Emily VanDerWerff, and Constance Grady. 2018. "Why Romantic Comedies Matter." *Vox*, August 29, 2018. https://www.vox.com/culture/2018/8/29/17769168/romantic-comedies-crazy-rich-asians-all-the-boys-set-it-up.

18

iROKOtv Originals and the Construction of Gender Relations in Nollywood Family Films

GODWIN SIMON

In 2010 iROKOtv emerged as the pioneer streaming service for Nollywood films, and it continues to tell stories that appeal to its subscribers across the globe. The Lagos-based subscription video-on-demand (SVOD) service has the largest catalog of Nigerian films in the world, with new titles added every week. It offers over 5,000 films for its 500,000 subscribers across 178 countries. The company's CEO Jason Njoku is vocal about the centrality of relatable Nigerian stories to the growth of the streaming service, noting that iROKOtv subscribers have increased over the years mainly because of their appetite for the catalog of films that it offers (Njoku 2018).

Though iROKOtv is based in Nigeria, its subscribers are largely Africans located outside the continent, with only a few paying subscribers from Nigeria. Notably, in 2020, Njoku announced that iROKOtv was shifting its focus on its African markets to the diaspora markets, which provide significantly higher average revenue per user (ARPU) (Charles 2020). It maintains its transnational subscribers by using viewing data to inform the content acquisition and production strategies of the service (Njoku 2016). The service has emphasized narratives and themes uncommon in the dominant Nigerian video business, while storylines and patterns of representations that do not align with its data about viewing behavior are most likely to be rejected. The technological, audience, and economic dynamics that underscore the operations of SVODs such as iROKOtv enable distinctive patterns of storytelling and representations, a development explored in this chapter's analysis of gender repre-

sentation in a category of films identified as "family films" in Nigerian storytelling.

"Family films" classify films with subject matters that focus on tensions in marital relationships in many Nigerian homes. The films are mostly devoted to fertility problems, scandal mongering, and revealing secrets, sexual infidelities, loss of jobs, and the accruing tensions in a family setting (Haynes 2016). Scholars have raised concerns that the mainstream narratives perpetuate sexist tendencies against women in African societies (Utoh-Ojemudia et al. 2018; Alola and Alola 2019). Nollywood family films are known for unequal gender representations that portray married women as weak, economically dependent, domestic, and materialistic (Endong and Obonganwan 2015; Uto-Ezeajugh and Anijah 2017; Onyenankenya et al. 2019). Drawing from critical textual analysis of iROKOtv original family films and semistructured interviews with five iROKOtv producers, I examine how iROKOtv's original productions deviate from the mainstream representations by privileging depictions of married women as independent, strong, and economically productive.[1] The analysis focuses on commissioned films because they are developed directly to reflect the industrial dynamics of SVODs.[2] Specifically, I interrogate the depiction of women in marital relationships in these films, bringing out points of distinction from mainstream Nollywood.[3]

This negative framing of women in mainstream family films can be attributed to how the stories connect with the experiences, realities, and cultural expectations of the target viewers (outside of streaming) who are mostly uneducated, conservative, and dependent full-time housewives (Abah 2008; Azeez 2010). Mainstream Nollywood producers keep making such films based on past success; however, new distribution technologies such as SVODs have different commercial imperatives. A service such as iROKOtv is targeted at "Africans somewhere in the world seeking a connection with home" (Njoku quoted in Adejunmobi 2014, 85), but iROKOtv is mostly patronized by Africans in the global diaspora, of elite class, and more exposed to modernity, which leads to different cultural preferences (Hoffmann 2012; Jedlowski 2013; Birch-Jeffrey 2019).

The distinctive logics of iROKOtv provide alternative frames for gender representation. Unlike existing depictions associated with mainstream Nollywood, iROKOtv family films portray women as independent, strong, and economically productive. Also, marital responsibilities required of wives in mainstream Nollywood films are depicted as joint tasks for couples in iROKOtv films.

The key intervention of this chapter is to use the changing gender relations in iROKOtv family films as a starting point for understanding how the different economic, technological, and audience logics that impact the operations of SVODs such as iROKOtv enable different patterns of storytelling and narratives. To be clear, what follows is not genre analysis. Genre analysis can be useful for film and television studies beyond being a classification element (Mittell 2004), but here genre serves as a tool for categorization (Dibeltulo and Barrett 2018). *Family film genre* identifies the category of films upon which the chapter focuses.

Family Films in Nollywood: Gender Relations and Commercial Forces

African film scholars have provided comprehensive critical analysis of the unequal and patriarchal representation of gender roles in Nollywood films and interrogated their themes of male domination (Abah 2008; Azeez 2010; Adewoye et al. 2014; Onyenankenya et al. 2019). For instance, Alola and Alola (2019) note that Nollywood films largely depict women as incompetent, dangerous (*the femme fatale*), lazy, dependent, and as sexual objects and "trophy wives," while the men are depicted as rich, successful, independent, and responsible. Ukata (2010) notes that some films depict women in a binary as either traditional or urban. Traditional women are depicted to be loyal, submissive, childbearing, and committed housewives. In contrast, the urban women are depicted as career directed and are framed as aggressive, critical, and less responsible in handling family issues. This binary suggests that educated career women may not be good wives and may be problematic in a

family, while traditional women are more resourceful in ensuring marital stability.

The commercial orientation that drives filmmakers is understood as the main motivation for the persistent portrayal of unequal gender relations in mainstream Nollywood films (Abah 2008). As a producer explained, mainstream Nollywood films are popularly called "home videos" because they are usually watched on the television in the home and full-time housewives constitute their primary audience. He explained, "The notion is that when men have gone to work and the children have gone to school, wives are left at home, and they spend time watching films". Women are also understood to be the buyers and renters of video CDs. The movies available in these formats typically feature female characters negotiating issues and challenges familiar to many housewives. Such issues include domestic abuse, childlessness, infidelity, and husbands' loss of jobs, among others (Abah 2008; Aromona and Waters 2017). Thus, filmmakers appeal to their constructed audiences by reproducing the fears and anxieties that they deal with in real life (Ukata 2010) while also offering them moral lessons about the "evil" of infidelity, greed, and showing lack of respect to their husbands by depicting offending women facing consequences for such behavior (Shaka and Uchendu 2012).

Scholarly accounts about Nollywood's economy often emphasize the problematic nexus between culture and commerce as well as between producers and the constructed audience (Larkin 2008; Obiaya 2019). Producers are known for sacrificing cinematic ideology for commerce and churning out films just for profit without considering societal implications (Akpabio 2007). In this sense, negative depictions of women result from the interlocking dynamics of profit-driven filmmakers and their assumed preference of the constructed audience—housewives believed more interested in narratives that conform with their realities. Notably, scholarship has also identified other representational characteristics resulting from commerce-driven priorities (Doane 1987; Lotz 2006; Bhandari 2018). However, in the case of Nollywood, unequal gender relations are being challenged by the SVOD logics of iROKOtv.

iROKOtv's SVOD Content Model

Prior to the creation of iROKOtv in 2010, distribution in Nollywood was mainly through video (VCD/DVD). Nollywood's diasporic audiences had to wait for weeks and months to access newly released films due to the slow pace at which copies moved beyond the shores of Nigeria. Jason Njoku, CEO of iROKOtv and a British-Nigerian, was based in the UK and noticed the great appetite of Nigerians in diaspora for Nollywood films, as well as the difficulty in accessing them. This propelled him to create iROKOtv as a solution to this challenge (Miller 2016; Adejunmobi 2019). The challenges of building an SVOD service in Africa also fuel the focus on the diaspora. As of 2010, broadband connection was limited in Nigeria and many African countries. Consequently, Africans in diaspora constituted the bulk of iROKOtv's initial subscribers, and they have remained pivotal to the streaming service to the extent that it now focuses its growth effort on the diaspora.

The streaming service ventured into original productions in 2013 partly due to the desire to have more control over the production processes including screenwriting and equipment. It had been inundated with complaints from subscribers over poor production quality and storylines that subscribers found to be unappealing. The need to forestall such negative reactions from subscribers partly informed the need to commence original productions that give the company the latitude to get involved from the story development stage (Simon 2021). Njoku created a Lagos-based production company called ROK Studios to oversee original productions. By shifting focus to original productions, the streaming service has been able to offer higher quality content that viewers have found desirable (Njoku 2019). Canal Plus acquired ROK Studios in 2019, but the deal allows the studio to keep producing iROKOtv originals (Bright 2019).

As an SVOD service, iROKOtv is keen on maintaining existing subscribers and attracting new users. To achieve this, it has consistently emphasized insights about subscribers' viewing behavior and preferences in content licensing and production strategies. Arthur (2019) argues that

the streaming service provides a socially constructed digital community where contents are informed by subscribers' preferences. This finding also aligns with my interviews with iROKOtv producers who emphasized that subscribers are at the center of content decisions. As one described it, "We know our audiences and what they want, and we have to tell stories relatable to them." Njoku supports these assertions: "We look at the data patterns of our viewers to help inform our purchasing and commissioning decisions. We spend a lot of time analysing data, but importantly, we never stop speaking to our customers—on Facebook/Twitter/Instagram. We are always getting feedback. We also have a big customer service team based in Lagos, who speak to iROKO customers from around the world, all the time. So, we just make sure we never lose touch with our customers and take their feedback on board" (Njoku 2016).

The drive to adjust to subscribers' feedback resulted in the development of in-house guidelines that shape iROKOtv productions. For instance, producers observed that iROKOtv does not fund "ritual films" and some kinds of traditional "epic films" that have scenes of bloodshed and metaphysical activities because such films are seen as regressive and incompatible with the expectations of its transnational audiences.[4] Thus, producers know that there are certain film genres and storylines that will not pass iROKOtv's scrutiny. To avoid script rejection, producers also have informal interactions with executives to get an idea about preferred genres and stories.

In addition to in-house guidelines, iROKOtv operates a public rating system on the iROKOtv app and web versions. Its producers revealed that they usually visit the website or the app to identify films that are rated highly by subscribers before pitching their scripts and propose new projects that align with genres popular among subscribers. The public accessibility of preferences enables subscriber responses to be integrated within the cultural logics of iROKOtv, and family films are not exempt from these practices.

According to interviewed iROKOtv producers, chasing subscriber satisfaction has led to a focus on modernized stories in place of traditional representations. Its construction of its primary audience impacts

content decisions, which in turn affects storylines and representations. In the following sections, I examine such changes through analysis of gender relations in iROKOtv original films to explore the implications of SVODs in screen media industries.

Gender Relations in iROKOtv's Original Family Films

Analysis of the iROKOtv films selected for this research explores three representational themes that are uncommon in comparison with typical depictions of married women in mainstream Nollywood family films.[5] Films by iROKOtv represent married women as productively independent wives and reframe marriage tensions to defocus on women as the recipients of blame. They persistently portray women as morally and emotionally strong and able to sustain their lives and families, which may seem unremarkable but is unusual in Nollywood films. These attributes signal a notable departure from women's framing in mainstream Nollywood films where they are depicted as weak and dependent.

Productively Independent Wives

Mainstream Nollywood sets family films in both modern and traditional settings. Modern settings feature aesthetics of modernity such as luxurious cars, malls, and corporate offices, while traditional settings revolve around villages and towns governed by customary institutions and local norms. Many tribes in Nigeria require women to submit to their husbands and act based on their husbands' instructions, while husbands are expected to provide for the family (Shaka and Uchendu 2012), although these conventions are changing with broader societal transformations. In mainstream Nollywood, traditional gender relations dominate narratives regardless of the settings employed. In contrast, iROKOtv family films typically depict modern Nigeria and likewise employ what might be described as "modern" gender relations between husbands and wives. Most

of the married women in the films analyzed are portrayed as young, working class, confident, and independent. None of the women were framed as being content to be a full-time housewife, and the majority were depicted as involved in either paid or self-employment. The few wives that were framed as unemployed, as in *The Family*, were depicted as challenging the practice of married women being prevented from working.

Most of the women presented in the films were educated. For instance, it is a mostly female media and publicity team that deliver victory for a gubernatorial candidate in *The Politician's Wife*, two of whom are married. The married women also perform their roles without the suggestion that their work yields negative impacts on their marital responsibilities, which is unusual in comparison with mainstream Nollywood where career wives are constructed as insubordinate (Adewoye et al. 2014). Films by iROKOtv tend to depict women as independent and assertive and deliberate in their actions. For instance, in *Stranger in My Bed*, a successful lawyer walks away from an abusive marriage. Such frames of women in family settings deviate from mainstream Nollywood where they are depicted as dependent full-time housewives that have no relevance outside being a wife and must endure the bad behavior of their husbands to be seen as good wives (Abah 2008).

In another distinction, iROKOtv films such as *What Other Couples Do, In Sickness and in Health, Glimpse*, and *Mr and Mrs Abakoba* show wives as less dependent on their husbands and as financial contributors to the family—not just as beneficiaries of husbands' resources. This contrasts with mainstream Nollywood films that often construct married women as gold diggers and whose love for their husbands derives from their husbands' wealth (Alola and Alola 2019).

Reframing Marital Responsibilities

Originals by iROKOtv challenge the mainstream Nollywood family film narrative in which women bear responsibility for every marital problem (Alzahrani 2016). Films such as *What Other Couples Do, The Innocent,*

Mr and Mrs Abakoba, and *In Sickness and In Health* present a range of family issues including sexual dissatisfaction, fertility problems, financial challenges, child-raising, adultery, and domestic violence. These films present husbands and wives as jointly responsible for the success or failure of their marriages; for instance, two of the films depict the couples jointly seeking professional help to address the tensions in their marriages, and the husbands are more eager to resolve marital issues deviating from the common framing of marital struggles as "women's problems" (Nwaogwugwu 2020).

The films also recast the gendered construction of fertility issues as a failing of the prospective mother. *What Other Couples Do* and *The Family* reveal that childlessness resulted from the husbands' underlying medical challenges despite everyone believing the wives were responsible. Such stories offer new perspectives on the complex factors that cause childlessness. Similarly, *The Innocent* questions the narrative that child-raising is exclusively reserved for the mother (Ukata 2010). In the film, a busy couple leave their only child in the care of a hired caregiver who sexually molests the young boy. Unlike the common trope in mainstream Nollywood that would construct this as the mother's failing, the couple jointly accept blame for neglecting their son while being too busy with their jobs.

Films by iROKOtv commonly depict both husbands and wives doing banal domestic tasks such as preparing family meals and doing the dishes to frame domestic functions as shared responsibilities. This sharply contrasts with mainstream Nollywood where the woman must kneel while serving food to the husband, almost in a master-servant manner, to be regarded as a good wife. Another key shift in the framing of the gendered roles is that the husbands who performed roles such as cooking and washing clothes, did so on their own volition and without manipulation or nagging. This deviates from mainstream Nollywood films where husbands only perform such roles only when their wives visit herbalists asking for their husbands to be manipulated through terrestrial powers (Ukata 2010). Such films frame women as powerful and

controlling in family settings, but their powers are a product of spiritual manipulations (Abah 2008). In that sense, only a husband whose mind has been supernaturally manipulated could descend so low as to partake in any form of household chores. In contrast, iROKOtv films normalize the practice of husbands contributing domestically as a show of love.

Wives as Strong and Virtuous

In iROKOtv family films, married women are not depicted as emotionally dependent, morally weak, or quick to weep or lose control of their emotions as normally seen in mainstream Nollywood films (Azeez 2010; Ukata 2010; Shaka and Uchendu 2012). For instance, in *Stranger in My Bed*, the wife, who is a renowned lawyer, catches her husband in an adultery scandal. Contrary to norms, she remains composed despite being visibly disturbed. Her professional associate, a man bemused at her emotional strength, notes, "You are a very strong woman. That is what I admire about you." The film *Glimpse*, about a family suffering from poverty arising from a husband's joblessness while the wife works in a small firm, explores the moral strength of women during financial crisis. Amid the hard times—the house rent expires, and the landlord threatens to eject the family—the wife's boss develops a sexual interest in her, but she discourages his advances, and a male client who knows about her family predicaments promises to help her if she agrees to sex. Despite being pestered to accept the advances, she refuses, claiming that this would go against the sanctity of her marriage.

Similarly, *A Chain Reaction* principally deconstructs the stereotyped complicity of married women in paternity fraud, which is a frame that often presents them as morally weak. The family's only son falls ill and requires a blood sample. Test results suggest that the man is not the biological father of the child, which leads to tensions in the family. Eventually, flashbacks reveal a nurse swapped the child at birth. This narrative offers a new way to consider paternity errors in families rather than the pervasive narrative that presents it as an act of deceit by the mother.

The three themes—productively independent wives, reframing marital responsibilities, and wives as strong and virtuous—reveal points of differentiation from common representations of women in mainstream Nollywood. Films by iROKOtv allow women a greater range of roles and depict them as productive partners in marital relationships. The streaming service is compelled by its different industrial norms and priorities to deviate from the representational norms of Nollywood. Interviews with iROKOtv producers and public statements from its executives also reveal other variables and raise questions about what the future of Nigerian video storytelling may hold in the face of SVOD logics that determine their original productions.

Conclusion

Representation of gender relations in iROKOtv films differs from mainstream Nollywood, and there are several industrial explanations that could account for these distinctions. A starting point could be the differences in the caliber of producers that operate in both "markets." For mainstream Nollywood, the producers and target audiences share common cultural orientations. Barber (1987) describes mainstream Nollywood films as a form of African popular art—a commerce-driven grassroots phenomenon expressing the consciousness of a heterogeneous, non-elite public, produced by people who are not very different from the intended audiences. Similarly, Haynes (2019) emphasizes the cultural proximity between mainstream producers and the audiences for video-distributed films: many mainstream producers have no formal education and are culturally conservative just like many full-time housewives (Novia 2012; Ernest-Samuel and Uduma 2019). This suggests that while the commercial imperative is central to unequal gender representations in mainstream Nollywood, the storylines are also in tandem with the patriarchal cultural beliefs of producers and their target audiences. For instance, a legendary filmmaker of mainstream Nollywood, Pete Edochie recently sparked controversies when he blamed women as the cause of domestic

violence, asserting they have increasingly failed in keeping their homes by neglecting domestic roles such as cooking for their husbands (Augoye 2021). This belief system is reflected in mainstream Nollywood films and is also upheld by the audience, as many dependent full-time housewives who are the ready market for VCD films continue to subscribe to such perspectives (Azeez 2010).

In contrast, iROKOtv filmmakers have formal education and are likely to have different viewpoints about issues of life. All my interviewees are university educated, while some worked in corporate institutions before becoming filmmakers. Also, many iROKOtv producers are known for using their large social media followings to advance women's rights. For example, Mary Njoku, a producer who is also the managing director of ROK Studios and oversees iROKOtv originals, is known for her radical social media comments on gender relations and her frequent calls for women's rights. In one of her recent Instagram posts (@maryremmyn-joku), she cautioned against the idea that family financial commitments are exclusively shouldered by husbands and emphasized that "marriage and parenting is partnership" while calling on couples to stand up to their responsibilities. The distinctive individual approaches to gender relations from the producers' perspective could be a considerable factor for the changing narrative in iROKOtv originals.

The different construction of audience in both "markets" provides another explanation for the distinctive patterns of gender representations. Mainstream Nollywood targets full-time housewives, while iROKOtv generally imagines its users as Africans in diaspora and the wealthy class in Africa. The iROKOtv subscriber base is not representative of the Nigerian population, and iROKOtv subscribers—both Africans in diaspora as well as financially stable resident Africans—are very likely to share similar cultural experiences to the films that iROKOtv produces because they are designed for this audience. Producers asserted during interviews that regardless of gender, subscribers are imagined as educated, financially stable, and sophisticated, with a broader worldview compared to the audience for mainstream Nollywood. The target audience

also prefers films about modern developments and the *progressive* aspects of African culture such as balanced gender relations, which leads iROKOtv to prioritize storylines that reflect such values.

The interconnections among producers' backgrounds and worldviews, the particular audience targeted, and unique distribution logics explain the divergence of iROKOtv's storytelling from mainstream Nollywood; they also suggest how SVODs can employ their peculiar operational logics to tell alternative stories and invent new representations that deviate from existing norms. Though both mainstream Nollywood and iROKOtv are commercial ventures aimed at profit-making, their discrepant "markets" allow different storytelling strategies.

Such shifts in cultural representations warrant continued critical analysis of storytelling as SVODs continue to expand in Nigeria and elsewhere. Broader consideration of the cultural implications of SVODs' textual practices is needed. Other patterns of storytelling and representation adjustment may be identified, especially if the Nigerian domestic market becomes more central to streamers.

There is also clearly a need for deeper investigation of the *Nigerianness* or *Africanness* in the storytelling of Nigerian-based SVODs like iROKOtv, especially given current priorities on a version of Nigeria constructed primarily for diasporic audiences. Contestation over *Nigerianness* or *Africanness* derives in part from the dichotomy of values associated with trends of modernization and globalization (Eze 2014), including practices of migration. The framing of women and wives in mainstream Nollywood films largely reflects the cultural norms in Nigeria in which wives are expected to submit to their husbands in all instances (Shaka and Uchendu 2012). By deviating from this, iROKOtv privileges a textual norm that disconnects from mainstream local traditions and introduces more feminist thinking into video cultures still identified as Nigerian. This is also the case of iROKOtv's unfavorable disposition to ritual films and portrayal of supernatural practices that are deep-rooted African cultural beliefs.

Broader, empirically based research that investigates the representation of traditional cultures and shared beliefs in different national contexts by SVODs is needed and may warrant policy interventions targeted at encouraging indigenous cultural productions, especially given the dominance of U.S.-based companies in providing such services. Notably, some cultural policy interventions have been recorded in places like Europe and Canada (Lobato 2019); however, wider research is needed in different national contexts. The ability of SVODs to understand patterns of viewing introduces significant new knowledge to the process of commissioning original productions. For iROKOtv, the focus on its transnational subscribers is a key factor in its divergent textual practices. Consequently, there is also a need to analyze how the emergence of SVODs complicates the meaning of "audience" for national screen media industries and the implications for cultural production. The growth of SVODs globally portends distinctive implications for media industries and new challenges for researchers in understanding how SVODs' operations impact existing industry practices and cultural norms in diverse contexts.

Notes

1 The producers opted to be anonymised.
2 iROKOtv has produced over 540 original films. To identify its original family films, I checked iROKOtv's "featured films" (that is all visible films in the library) as of September 30, 2020.
3 Mainstream Nollywood refers to the aspect of the industry that follows the logic of straight-to-video production and distribution.
4 Ritual films feature narratives of human sacrifice to appeal to the gods or for money ritual purposes. Traditional epic films are usually set in the historical past to narrate traditional myths, historical occurrences, and lived realities of ancient times in history. For more about ritual and epic films, see Haynes (2016).
5 The analyzed films are *A Chain Reaction* (2020); *Glimpse* (2017); *The Family* (2019); *My Forever* (2015); *Stranger in My Bed* (2016); *In Sickness and in Health* (2018); *Mr and Mrs Abakoba* (2018); *What other Couples Do* (2020); *The Innocent* (2020); and *The Politician's wife* (2020).

References

Abah, Ladigbolu, A. 2008. "One Step Forward, Two Steps Backward: African Women in Nigerian Video-Film." *Communication, Culture, and Critique* 1:335–57.

Adejunmobi, Moradewun. 2014. "Close-Up: Evolving Nollywood Templates for Minor Transnational Film." *Black Camera, An International Film Journal* 5 (2): 74–94.

Adejunmobi, Moradewun. 2019. "Streaming Quality, Streaming Cinema." In *A Companion to African Cinema*, edited by Kenneth W. Harrow and Carmela Garritano, 219–43. Hoboken, NJ: Wiley-Blackwell.

Adewoye, Omoniyi, Agboola Odesanya, Abdulmutallib Jimoh, and Olatunji Olorede. 2014. "Rise of the 'Homo Erotica'? Portrayal of Women and Gender Role Stereotyping in Movies: Analysis of Two Nigerian Movies." *Developing Country Studies* 4 (4): 103–10.

Alola, Mary, I., and Uju Alola. 2020. "Gender Stereotypes in Nigerian Films as a Portrayal of the African Womanhood: A Feminist Perspective." *Journal of Labour and Society* 23:221–243.

Akpabio, Eno. 2007. "Attitude of Audience Members to Nollywood Films." *Nordic Journal of African Studies* 16 (1): 90–100.

Alzahrani, Fahad. 2016. "The Portrayal of Women and Gender Roles in Films." *International Journal of Scientific & Engineering Research* 7 (4): 533–34.

Aromona, Olushola, and Susan Waters. 2017. "Portrayal of African Women in Nollywood Films over a Five-Year Period: A Content Analysis of Traits Applying the Stereotype Content Model." *Journal of Communication and Media Research* 9 (2): 149–64.

Arthur, Tori O. 2019. "The Performative Digital Africa: iROKOtv, Nollwood Televisuals, and Community Building in the African Digital Diaspora." In: *Handbook of Media and Migration*, edited by Kevin Smets, Koen Leurs, Myria Georgio, Saskia Witteborn, and Radhika Gajjala, 207–19. Thousand Oaks: SAGE.

Augoye, Jane. 2021. "Why Women are Beaten Up in Marriages—Pete Edochie," *Premium Times*, March 31, 2021. https://www.premiumtimesng.com/entertainment/naija-fashion/452445-why-women-are-beaten-up-in-marriages-pete-edochie.html.

Azeez, Adesina, L. 2010. "Audience Perception of Portrayals of Women in Nigerian Home Videos Films." *Journal of Media and Communication Studies* 2 (9): 200–207.

Barber, Karin. 1987. "Popular Arts in Africa." *African Studies Review* 30 (3): 1–78.

Bhandari, Ishdeep K. 2018. "Commodification of Women Body in Indian Media." *International Journal of Research and Analytical Reviews* 5 (3): 971–981.

Birch-Jeffrey, Sharon. 2019. "African Migrants Keen to Retain their Cultural Values Abroad: African Children Abroad Struggle Over Cultural Identity." *Africa Renewal* 32 (3):14–15.

Bright, Jake. 2019. "Canal+ Acquires Nollywood Studio ROK from iROKOtv to Grow African Film." *Tech Crunch*, July 15, 2019. https://techcrunch.com/2019/07/15/canal-acquires-african-film-studio-rok-from-irokotv-to-grow-nollywood/#:~:text

=French%20television%20company%20Canal%2B%20has,film%20content%20
in%20the%20world.

Charles, Udoh R. 2020. "Why Is iROKOtv Leaving Africa's Billion Dollar Industry So
Early, And What Does the Future Hold for Other Video-On-Demand Startups?"
Afrikan Heroes, September 13, 2020. https://afrikanheroes.com/2020/09/13/why-is
-irokotv-leaving-africas-billion-dollar-industry-so-early-and-what-does-the-future
-hold-for-other-video-on-demand-startups/.

Dibeltulo, Silvia, and Ciara Barrett. 2018. "Genre in Transition." In *Rethinking Genre
in Contemporary Global Cinema*, edited by Silvia Dibeltulo and Ciara Barrett, 1–11.
Cham: Palgrave.

Doane, Ann M. 1987. *The Desire to Desire: The Woman's Film of the 1940s*. Indiana
University Press.

Endong, Patrick F.C., and Edim Obonganwan. 2015. "Media (Mis) Representation of
the Nigerian Woman as a Product of the Society." *International Journal of Gender
and Women's Studies* 3 (1): 101–106.

Ernest-Samuel, Gloria, C., and Ngozi Uduma. 2019. "From Informality to 'New Nolly-
wood': Implications for the Audience." In *Nollywood in Glocal Perspective*, edited by
Bala A. Musa, 45–66. London: Palgrave Macmillan.

Eze, Dons. 2014. "Nigeria and the Crisis of Cultural Identity in the Age of Globaliza-
tion." *Journal of African Studies and Development* 6 (8): 140–47.

Haynes, Jonathan. 2016. *Nollywood: The Creation of Nigerian Film Genre*. Chicago:
University of Chicago Press.

Haynes, Jonathan. 2019. "Between the Informal Sector and Transnational Capi-
talism: Transformations of Nollywood." In *A Companion to African Cinema*,
edited by Kenneth W. Harrow and Carmela Garritano, 244–68. Hoboken,
NJ: Wiley-Blackwell.

Hoffmann, Claudia. 2012. "Nollywood in Transit: The Globalization of the Nigerian
Video Culture." In: *Postcolonial Cinema Studies*, edited by Sandra Ponzanesi and
Marguerite Waller, 218–32. New York: Routledge.

Jedlowski, Alessandro. 2013. "From Nollywood to Nollyworld: Processes of Transna-
tionalization in the Nigerian Video Film Industry." In *Global Nollywood: The Trans-
national Dimensions of an African Video Film Industry*, edited by Matthias Krings
and Onookome Okome, 25–45. Bloomington: Indiana University Press.

Larkin, Brian. 2008. *Signal and Noise: Media, Infrastructure, and Urban Culture in
Nigeria*. Durham: Duke University Press.

Lobato, Ramon. 2019. *Netflix Nations: The Geography of Digital Distribution*. New York:
NYU Press.

Lotz, Amanda D. 2006. *Redesigning Women: Television After the Network Era*. Chicago:
University of Illinois Press.

Miller, Jade. 2016. *Nollywood Central*. London: Palgrave.

Mittell, Jason. 2004. *Genre and Television: From Cop Shows to Cartoons in American
Culture*. New York: Routledge.

Njoku, Jason. 2016. "iROKOtv: The Home of Nollywood." *Business Chief*, 2016. https://businesschief.eu/.

Njoku, Jason. 2018. "Content is King. How I Ended Up Working for Mrs Njoku Part 1." *Nollyculture*, April 3, 2018. https://nollyculture.blogspot.com/.

Njoku, Mary. 2019. "[Interview] Mary Njoku, Director General, ROK Film Studios, Nigeria." *African Business Communities*, July 29, 2019. https://africabusinesscommunities.com/features/interview-mary-njoku-director-general-rok-film-studios-nigeria/.

Novia, Charles. 2012. *Nollywood Till November: Memoirs of a Nollywood Insider*. Bloomington: AuthorHouse.

Nwaogwugwu, Chinedum. 2020. "Examining the Sexist Representation of Career Women in Nigerian Films." MBA diss. University of Toronto.

Obiaya, Ikechukwu. 2019. "African Cinema in the Throes of Commercialism and Populism." In *Camera, Commerce and Conscience: Afrowood and the Crisis of Purpose*, edited by Ayobami Ojebode, Tunde Adegbola, Alemayehu Mekonnen, and Emilly Maractho, 165–81. Ibadan, Oyo: Greenminds Publishers.

Onyenankeya, Kevin U., Oluwayemisi Onyenankeya, and Oluyinka Osunkunle. 2019. "Sexism and Gender Profiling: Two Decades of Stereotypical Portrayal of Women in Nollywood Films." *Journal of International Women's Studies* 20 (2): 73–90.

Shaka, Okiremuette F. and Ola Uchendu. 2012. "Gender Representation in Nollywood Video Film Culture." *The Crab: Journal of Theatre and Media Arts* 7 (June 2012): 1–30.

Simon, Godwin I. 2021. "Adapting to Context: Creative Strategies of Video Streaming Services in Nigeria." *Convergence*: 1–19.

Ukata, Agatha. 2010. "Conflicting Image of Women in Africa." *Nebula* 1 (1): 65–75.

Utoh-Ezeajugh, Tracie C., and Ekene Anijah. 2017. "Gender Domination and Domestic Violence in Nigerian Video Films: A Paradigmatic Appraisal." *UJAH* 18 (3): 1–25.

Utoh-Ojemudia, Christine C., and Prisca Okeke. 2018. "Gender Construction, Domestic Crisis and the Communication of Femininity and Masculinity in Selected Nigerian Films." *Creative Artist: A Journal of Theatre and Media Studies* 12 (1): 43–61.

ACKNOWLEDGMENTS

We are grateful to the Australian Research Council (Discovery Project DP190100978) for financial support of this book. We are even more grateful to the book's nineteen contributors who embraced our challenging provocations and produced accounts that have taught us much. Also, our thanks to our colleagues who have generously shared ideas, critiques, and context along the way.

This book would not have been possible without the involvement of Alexa Scarlata, whose knowledge of streaming knows no bounds, and who provided essential research support, copyediting, and guidance. Thank you to Oliver Eklund and Claire Darling who provided important research assistance along the way.

Our co-investigator Stuart Cunningham, a pioneer of transnational television research, has been a source of insight and inspiration, and we dedicate this book to him in recognition of his path-charting collaborations a quarter century ago that prepared this book's research agenda.

Our colleagues in the Global Internet Television Consortium—Charles Acland, Mubarak Alkebaisi, Mads Møller T. Andersen, Luca Barra, Thomas Baudinette, Chris Baumann, Deborah Castro, Ester Corvi, Courtney Brannon Donoghue, Philip Drake, Tom Evens, Asli Ildir, Marion Jenke, Catherine Johnson, Heidi Keinonen, Michael Kho Lim, Aynne Kokas, Darshana Sreedhar Mini, Melina Meimaridis, Hyun Jung Stephany Noh, Ritika Pant, Ian Murphy, Lydia Papadimitriou, Valentina Re, Juan Llamas-Rodríguez, Joaquín Serpe, Jane Shattuc, Petr Szczepanik, Yu-Kei Tse, Ishita Tiwary, Ece Vitrinel, Patrick Vonderau, Ira Wagman, and Michael L. Wayne—have provided many stimulating exchanges over the last seven years. We continue to be enriched and humbled by your work.

It is a pleasure and privilege for this book to be published in the NYUP Critical Cultural Communication series. Thank you to series editors Jonathan Gray, Aswin Punathambekar, and Adrienne Shaw, and to Eric Zinner and Furqan Sayeed at NYUP, for their wise counsel and their support of the project.

ABOUT THE EDITORS

AMANDA D. LOTZ is Professor and the Program Leader of the Transforming Media Industries research program at the Digital Media Research Centre of Queensland University of Technology. She is the author of numerous titles, including most recently, *Netflix and Streaming Video: The Business of Subscriber-Funded Video on Demand* (2022) and *Media Disrupted: Surviving Pirates, Cannibals and Streaming Wars* (2021), among others. She is a Fellow of the International Communication Association.

RAMON LOBATO is Associate Professor at the School of Media and Communication at RMIT University, Melbourne. He is the author of *Netflix Nations* (2019), *The Informal Media Economy* (2015), and *Shadow Economies of Cinema: Mapping Informal Film Distribution* (2012). He is a former Chair of the International Communication Association's Media Industry Studies interest group and serves on the editorial boards of journals including *Media Industries* and *Journal of Digital Media and Policy*.

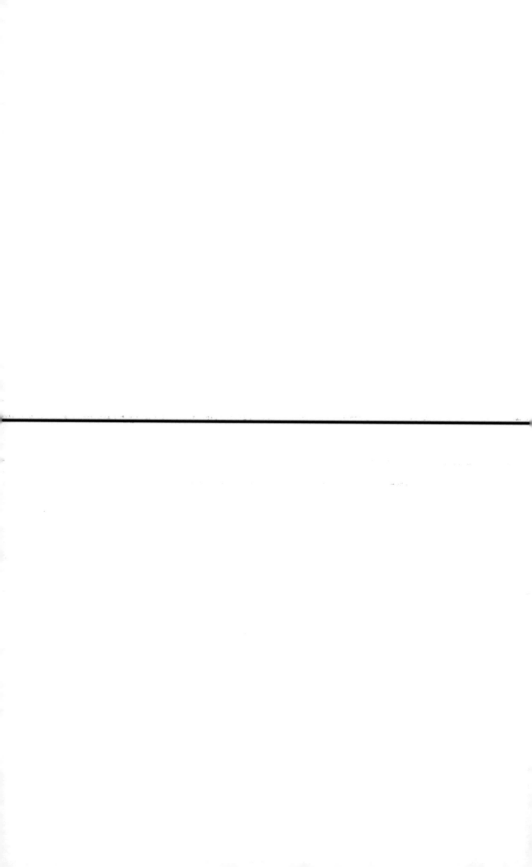

ABOUT THE CONTRIBUTORS

LIVIA MAIA ARANTES is a doctoral student in the Graduate Program in Social Communication at the Federal University of Minas Gerais (UFMG). She conducts research in the field of Television Studies in Brazil and Latin America focused on the transformations in the productive field of serial fiction, especially those stimulated by the entry of streaming services into the market.

LUCA BARRA is Associate Professor in Television and Media Studies at the Department of the Arts, Università di Bologna, Italy. His research focuses on television production and distribution cultures, comedy and humor TV genres, the international circulation of media products (and their national mediations), the history of Italian television, and the evolution of the contemporary media landscape. His books include *A European Television Fiction Renaissance* and *Taboo Comedy: TV and Controversial Humour.*

CONCEPCIÓN CASCAJOSA VIRINO is a Senior Lecturer in Television Studies at Carlos III University of Madrid, Spain. Her work has appeared in journals such as *Feminist Media Studies* and *Hispanic Research Journal.*

DEBORAH CASTRO is Assistant Professor in Media Studies at the University of Groningen, the Netherlands. Her main research interests lie in the field of audience and television studies. Her work has appeared in journals such as *European Journal of Cultural Studies, Convergence,* and *Television & New Media.*

COLLEN CHAMBWERA is a Creative Practice Research Lecturer at AFDA Film School in Johannesburg, South Africa. His research interests include screen studies and news production.

STUART CUNNINGHAM is Distinguished Emeritus Professor, Queensland University of Technology, and Professor, University of Canberra. He is a Fellow of the UK's Academy of Social Sciences and the International Communication Association, and an Inaugural Fellow in Cultural and Communication Studies at the Australian Academy of the Humanities. Recent books include *Creator Culture* (edited with David Craig) and *Wanghong as Social Media Entertainment in China* (with David Craig and Jian Lin).

ASLI ILDIR is a joint PhD student in the Film Studies & Visual Culture Program in University of Antwerp, and in Design, Technology and Society Program at Koç University. Her research interests include video-on-demand platforms and changing TV culture. Her work has appeared in *Convergence: The International Journal of Research into New Media Technologies*.

JENNIFER M. KANG is a Postdoctoral Research Fellow in the Digital Media Research Centre at Queensland University of Technology. Her research areas include global media industries, television studies, and Korean media cultures. Her work has appeared in *International Journal of Cultural Studies*, *Media, Culture & Society*, and *Celebrity Studies*.

LISA LIN is a documentary producer and media scholar affiliated with Anglia Ruskin University, specializing in convergent media, digital streaming aesthetics, and immersive documentary storytelling. She is the author of *Convergent Chinese Television Industries*. She has developed and produced impact-driven documentaries for Channel 4, National Geographic Asia, the BBC, and Channel News Asia in the UK, Singapore, and China.

JUAN LLAMAS-RODRÍGUEZ is Assistant Professor in the Annenberg School of Communication at the University of Pennsylvania. He has published research articles in the journals *Feminist Media Histories, Television & New Media, Lateral, Film Quarterly, Social Text,* and the *Journal of Cinema and Media Studies.* He is also the host of the Global Media Cultures podcast.

CHRISTOPHER MEIR is Assistant Professor in the Department of Communication at the Universidad Carlos III de Madrid. His most recent book is *Mass Producing European Cinema: Studiocanal and Its Works.* He is currently working on a project on the impact of SVOD platforms on the global film industry and is co-editing the scholarly collection *European Cinema in the Streaming Era* for Palgrave Macmillan.

ANNA POTTER is an Associate Professor of Creative Industries at the University of the Sunshine Coast in Queensland, Australia. She is the author of *Creativity, Culture, and Commerce: Producing Australian Children's Television with Public Value* and *Producing Children's Television in the On-Demand Age,* and multiple journal articles and book chapters.

SIMONE MARIA ROCHA is Full Professor in the Graduate Program in Social Communication at Federal University of Minas Gerais (UFMG) and head of the research group Communication and Culture in Televisualities (COMCULT). She researches in the field of Television Studies in Brazil and Latin America with a focus on internet-distributed television, audiovisual poetics, Latin American audiovisual market strategies and Latin American critical social theory.

FAIROOZ SAMY holds a doctorate from Victoria University of Wellington. Her research interests include television industry studies, intersectionality, and gender and class politics. She has professional experience in the education and humanitarian sectors and currently works in the media funding and commissioning space.

ALEXA SCARLATA is a Research Fellow at RMIT University. Her research considers the introduction and dynamics of online TV in Australia, the resulting impact on local production, the implications of the platform ecosystem enabled by smart TVs and the subsequent development of media policy in these areas. Alexa is the Book Reviews Editor of the *Journal of Digital Media and Policy* and has published in *Critical Studies in Television, Media International Australia*, and *Continuum*.

JOAQUÍN SERPE is a PhD candidate at Concordia University, Montreal, and affiliated faculty in the Department of Visual and Media Arts at Emerson College in Boston. His dissertation *The Progressive Imaginary: Intellectuals, Comedians, and Celebrities in Post-Crisis Argentina* explores the emergence of educational media across broadcasting, social media, and video-streaming platforms in Argentina after the 2001 economic crisis.

GODWIN SIMON holds a doctorate from the Queensland University of Technology where he is in a researcher in the Digital Media Research Centre and Sessional Academic in the School of Communication. His current research investigates the implications of digital distribution for the Nigerian video film industry (Nollywood).

ISHITA TIWARY is an Assistant Professor and Canada Research Chair in Media and Migration at the Mel Hoppenheim School of Cinema, Concordia University, Montreal.

MICHAEL L. WAYNE is an Assistant Professor of Media and Creative Industries in the Department of Media & Communication at Erasmus University Rotterdam. His work has appeared in a variety of journals including *Television & New Media, Media, Culture & Society*, and *Critical Studies in Television*.

INDEX

Acorn, 25

Adélia (fictional character, *Girls from Ipanema*), 130–31, 132, 134

ad-supported distribution, 21; subscriber funding contrasted with, 25, 29

adults, role of, in *Extracurricular*, 180

advertiser-supported television, 157, 208–9

aesthetic tendencies, of SVODs, 6

African outside the continent, iROKOTV and, 314

Africans in diaspora, iROKOTV and, 318

Afrikaans, in *Tali's Wedding Diary*, 215

Akin, Doğan, 93–94

Albert Meiser (fictional character, *Dogs of Berlin*), 61–62

Alberto Márquez (fictional character, *Velvet*), 147–48

The A List (TV show), 272–73

Allen, Woody, 282, 294n1

AlRawabi School for Girls (TV show), 11, 156, 159; characters as realistic teenagers in, 165–66, 167; female crew members of, 160; male characters in, 161; reception of, 164–65; violence against women in, 161–64

Alvarez, Sofia, 308

Alvart, Christian, 59

Always Be My Maybe (film), 308–9

amateur screenwriting manuals, 73

Amazon, 33, 282–83

Amazon Music, 47

Amazon Prime packages, 47

Amazon Unbox, 47

Amber (fictional character, *The A List*), 273

American mafia, in *The Irishman*, 285

Ampere Analysis, 47–48

Ana Ribera (fictional character, *Velvet*), 147–48

Andermann, Jens, 117

Anderson, Benedict, 211, 215

Andreatta, Eleonora, 252

Ángeles (fictional character, *Cable Girls*), 148

Anglophone world, creation of Netflix films beyond, 283

Angry Mom (TV show), 179

Anning, Kacie, 50

anti-hero detectives, 55

anti-immigrant policies: in *Dogs of Berlin*, 60–61; in *Young Wallander*, 55, 64–66

anti-immigration march, in *Young Wallander*, 65

anti-oligopoly regulations, Macri and, 111

anti-Turkish sentiment, in *Dogs of Berlin*, 61–62

apartheid, 211, 216, 217–18, 219–21; lack of study of, 218; Naspers and, 213–14, 222n1

Apartheid Studies (Mboti), 218

AppleTV+, 26, 286–87, 288, 289, 294n2

Aprea, Gustavo, 116–17, 121

Arabic-language TV, 156–57; western reviews of, 164

Arabic teenagers, contemporary portrayal of, 165

Printed in the United States
by Baker & Taylor Publisher Services